1/5/98 AAT 2264 61

THE RUSSIAN AVANT-GARDE IN THE 1920s–1930s

Preface dy *John Bowlt*

Introduction, documentary material, and annotations
by *Yevgeny Kovtun*

Selection by *Nina Barabanova, Liudmila Vostretsova, Anatoly Dmitrenko, Yelena Ivanova,
Natalia Kozyreva, Sergei Liubimtsev, Tatyana Manturova, Liubov Slavova,*
and *Olga Shikhireva*

Edited by *Irina Kharitonova*

Translated from the Russian by *Robert Goebel* and *Catherine Philips*

Designed by *Sergei Dyachenko*

Editor of the English text *Valery Fateyev*

Computer type-setting by *Nina Sokolova*

Editor's assistant *Yelena Shipova*

Printed by Albagraf (Italie) for Parkstone Publishers
Copyright 2st term 1996

© Parkstone Publishers, Bournemouth, England / Aurora Art Publishers, St. Petersburg, 1996

ISBN 1 85 995 124 4

YEVGENY KOVTUN

The RUSSIAN AVANT·GARDE

in the 1920s-1930s

PAINTINGS · GRAPHICS · SCULPTURE
· DECORATIVE ARTS

FROM THE RUSSIAN MUSEUM
IN ST. PETERSBURG

**PARKSTONE
AURORA**

PARKSTONE PUBLISHERS · BOURNEMOUTH
AURORA ART PUBLISHERS · ST. PETERSBURG

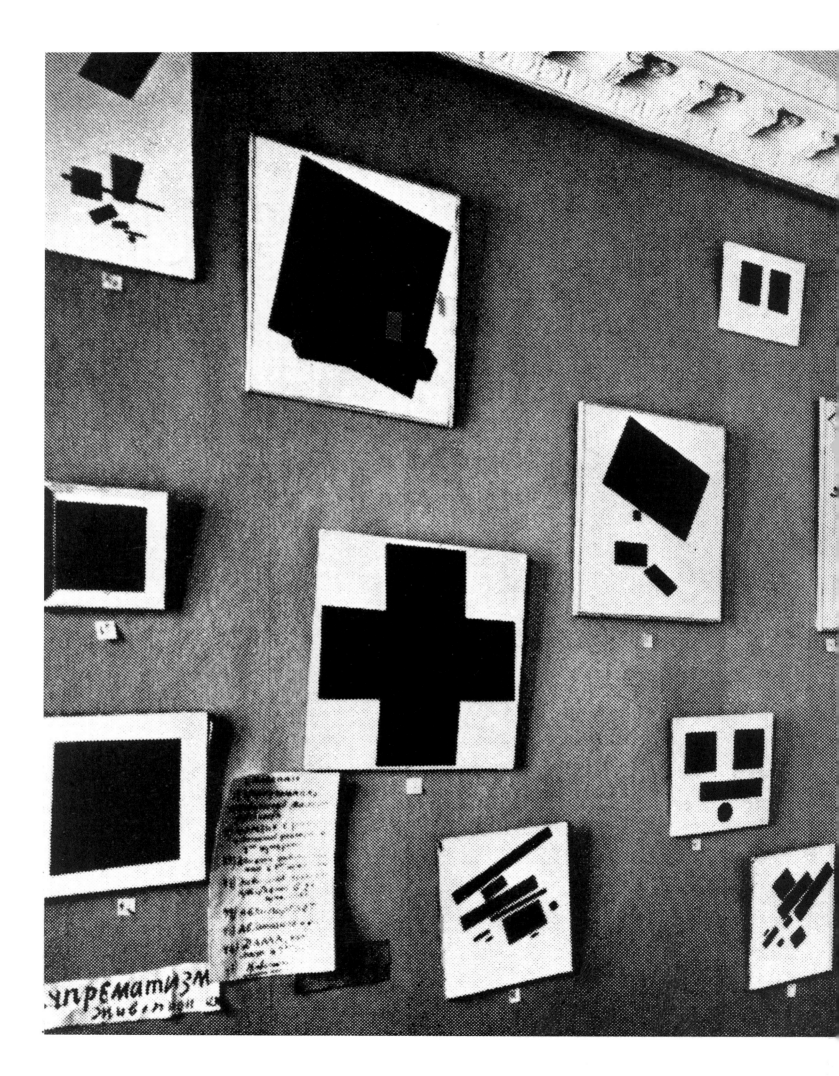

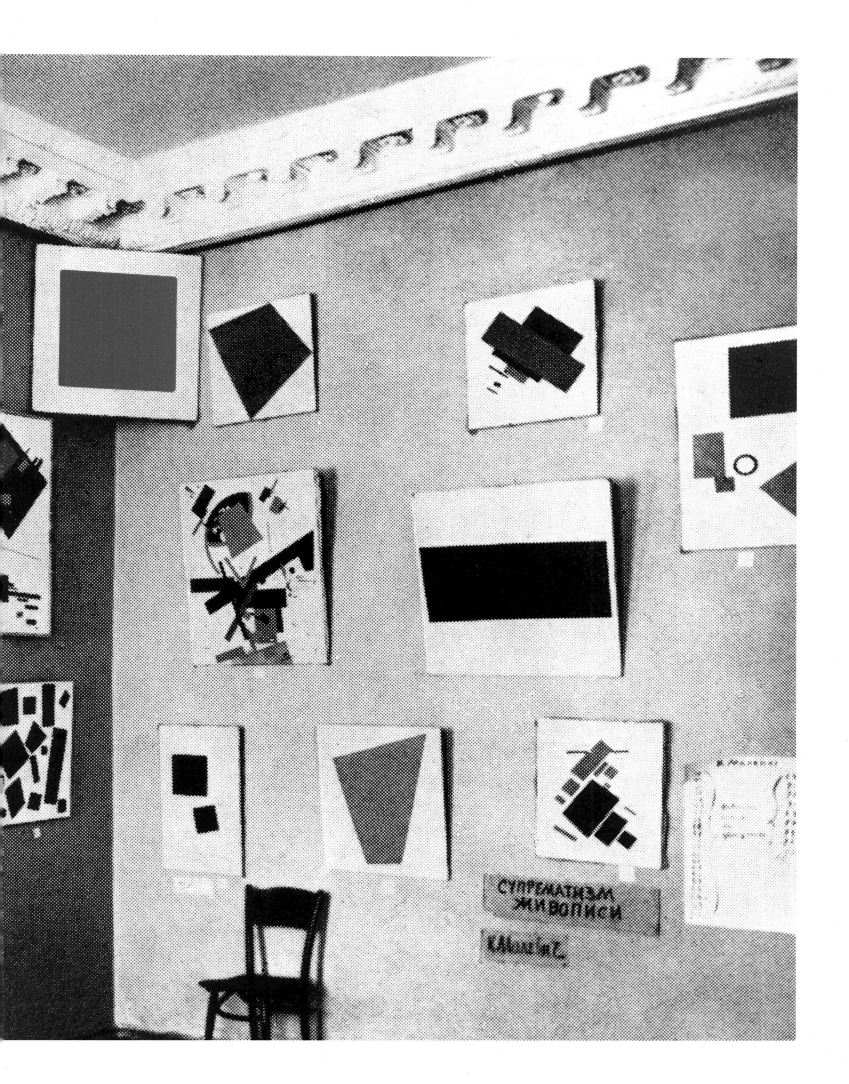

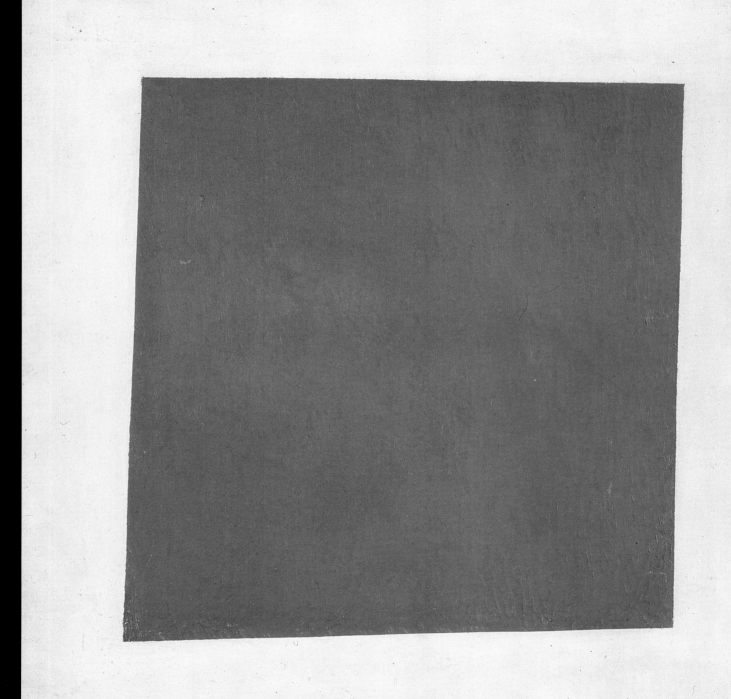

CONTENTS

←
The Last Futurist Exhibition "0.10."
1915. Petrograd

Kasimir Malevich
*Red Square. Painterly Realism
of a Peasant Woman
in Two Dimensions.* 1915.
Oil on canvas. 53 x 53 cm

→
Vladimir Tatlin by the model
of his Monument to
the 3rd International. 1920

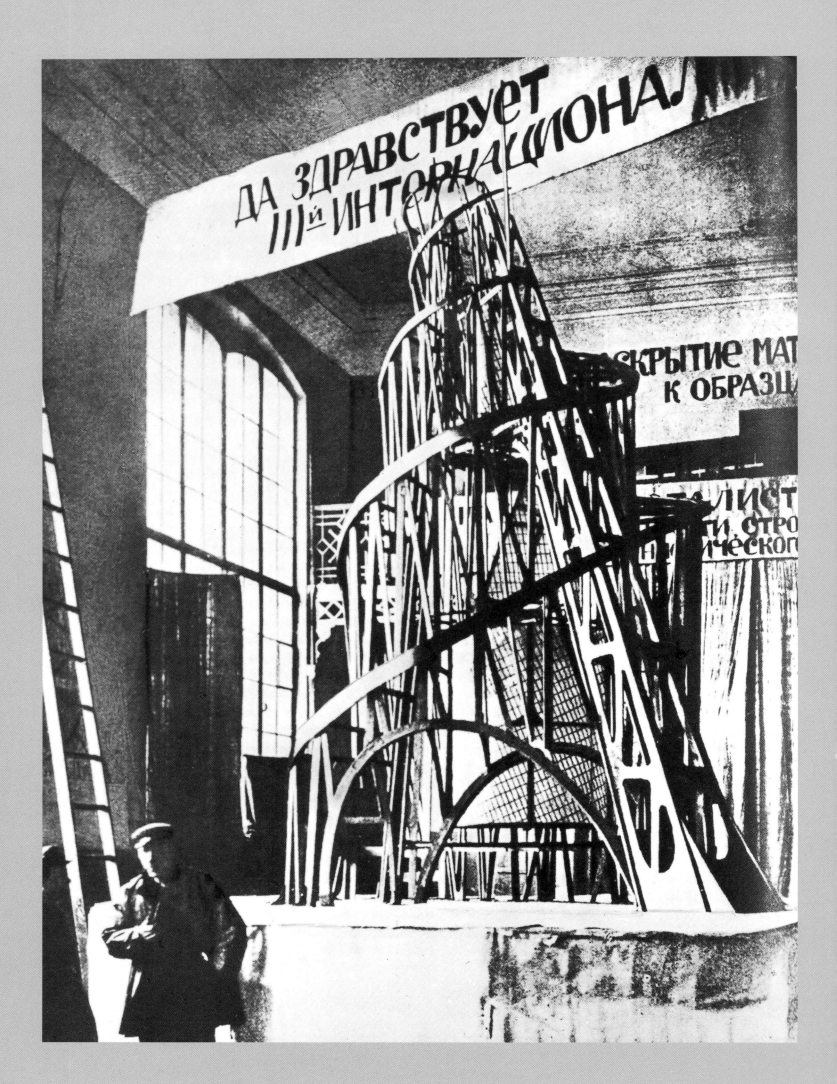

PREFACE

The painter Pavel Filonov, one of the primary representatives of the Russian avant-garde, maintained that the artist was confronted with two perceptual apparatuses — the "seeing eye" and the "knowing eye."[1] Rejecting the simple optical illusion of narrative Realism, artists such as Wassily Kandinsky, Kasimir Malevich, Mikhail Matiushin, Liubov Popova, Alexander Rodchenko, and Vladimir Tatlin tried to view reality through the complex mechanism of the "knowing eye." They were convinced that this would provide them with a truly synthetic comprehension of the world instead of its surface sheen.

Of course, all great artists aspire toward total perception, but the Russians, in particular, seem to have favored this attitude, for they attempted — and still attempt — to formulate and practise art as an instrument of great spiritual, transformative power. As Mr. Yevgeny Kovtun implies*, the artists of Russian Modernism were rarely satisfied with the painting on the easel, but wished instead to apply it to a broader, public environment and to connect it with the new and better society, they all imagined and projected. We cannot understand the achievements of the Russian avant-garde without taking account of this noble commitment. Malevich, for example, seems to have designed his cryptic "Mayan" trajectories of cosmic travel for a future society of streamlined immortals, and, surely, his robotic supermen were meant to possess the "Extended Viewing" that Matiushin elaborated in the 1910s–20s. No doubt, they would also have possessed Filonov's lucid vision of all the predicates of reality — "emanations, reactions, interfusions, geneses."[2] Only these "Men of the Future"[3] could have flown Tatlin's "Letatlin" glider or driven Piotr Miturich's undulator while living in one of Georgy Krutikov's suspended cities.[4] Even the most mundane activities of the Revolutionary period such as printing books for children at Detgiz (State Children's Publishing House) or mass producing broadsheets for the Okna ROSTA (Windows of the Russian Telegraph Agency) can be regarded as extensions of this messianic impulse.

Viewed against this background of grand extrinsic purpose, Picasso does, indeed, seem a little tame and academic and we can understand why his Russian colleagues were not entirely convinced of the genius of French Cubism. Mr. Kovtun's own patriotic enthusiasm for the Russian avant-garde may ruffle those readers who come to their appreciation of modern art only through the legacy of French Impressionism and Cubism. Obviously, the Western movements were well known in Russia and, in particular, left a deep imprint on the early work of Natalia Goncharova, Mikhail Larionov, Malevich, and Tatlin, but, as Mr. Kovtun and his heroes maintain, the Russians also drew strongly on their own traditions and were impelled as much by domestic stimulus as by foreign importation. There was, for example, the rich treasury of Russian Symbolist poetry and philosophy guarded by Andrei Bely and Alexander Blok — whose nascent ideas on artistic synthesism and abstract art coincided with the new pictorial resolutions of Victor Borisov-Musatov, Pavel Kuznetsov, Mikhail Vrubel, and other Symbolist painters. There was the curious philosophy of Nikolai Fiodorov who believed in the mass resurrection and transmigration of souls and whose ideas were pictured literally by Vasily Chekrygin of the Makovets group. There was the vast substratum of folk culture (icons, lubok, painted trays, etc.) to which the Jack of Diamonds artists turned in their aspiration to temper and challenge the hegemony of Henri Matisse and Henri-Julien Rousseau (le Douanier). Finally, there was that spirituality

[1] Filonov's concept of the "seeing eye" and the "knowing eye," a formula that he mentioned in several of his essays, is discussed by Vera Anikiyeva in her unpublished preface to the catalog of Filonov's one-man exhibition scheduled to open at the Russian Museum, Leningrad, in 1929 (see *Filonov: Katalog*, Leningrad, 1930). The catalog was published with an article by S. Isakov. For an English translation of Anikiyeva's text see N. Misler and J. Bowlt, *Pavel Filonov: A Hero and His Fate*, Austin: Silvergirl, 1983, pp. 53–61.
[2] P. Filonov, "Deklaratsiya 'Mirovogo rastsveta'," *Zhizn' iskusstva* ["Declaration of 'Universal Flowering'," *The Life of Art*], Petrograd, 1923, No. 20, p. 13. English translation in Misler and Bowlt, *op. cit.*, p. 168.
[3] "Men of the Future" translates the Russian word *budetliane* (singular: *budetlianin*), a denotation that some of the Russian Cubo-Futurists used in order to distinguish themselves from the Italian Futurists.
[4] On Georgy Krutikov see S. Khan-Magomedov, *Pioneers of Soviet Architecture*, New York, 1987.

* The preface was written before Yevgeny Kovtun's demise.

of "Russian soul" which, in spite of its diaphanous definition, imparted — and imparts — a unique trait to the physiognomy of modern Russian art.

As this study makes clear, the Russian avant-garde, composed of various experimental tendencies in Moscow, St. Petersburg/Petrograd/Leningrad, Kiev, and Kharkov of 1900–30, was an intricate mosaic of many different personalities and conflicting ideas. It is misleading to regard it as a cohesive movement. Rather, the Russian avant-garde evolved through the energy generated by its own frictions and contradictions, symbolized by Nikolai Punin's vivid description of Malevich and Tatlin as the dividers of the world into heavens (for the former) and the earth (for the latter).[1] Even though the practical results of the various isms, celestial and profane, sometimes seem rather similar (cf. Malevich's Suprematist and Popova's Constructivist textiles), their perpetrators were very different and often antagonistic: Malevich and Tatlin had little time for each other, Popova and Varvara Stepanova were the most jealous of rivals, Filonov had little patience with anyone and Kuzma Petrov-Vodkin, as Mr. Kovtun points out, was the butt of universal derision. Even so, they all "struggled with gravity" either theoretically as Petrov-Vodkin did with his spherical, non-Euclidian structure of space, or practically as Tatlin did with his one-man airplane.

Mr. Kovtun's survey also reminds us that the Russian avant-garde was an interdisciplinary Modernism that encompassed many other arts besides painting. Perhaps more by concurrence of circumstances, especially the accessibility and transportability of works, than by objective reasoning, we have tended to associate the Russian avant-garde too exclusively with the pictorial and applied works. The paintings of Filonov and Malevich are wonderful, the designs of Popova and Rodchenko exciting, but we should also remember that the creation and acceptance of sculptural forms also experienced profound change. This is true not only of the more famous constructive works by Naum Gabo, Ivan Puni, Rodchenko, and Tatlin, but also of sculpture in the round — by gifted sculptors such as Piotr Bromirsky, Iosif Chaikov, Boris Koroliov, Vera Mukhina, and Beatrisa Sandomirskaya. In the 1910s and 1920s these artists investigated a variety of modern styles, contributing to a veritable renaissance of Russian sculpture — which has still to be documented and described. The Russian avant-garde was indeed a heterogenous group of painters, sculptors, architects, and designers. However, they were united by their common position outside the orthodox cultural mainstream of their society and by their support of certain collective structures. The history of modern Russian art can, in fact, be written on the basis of groups, exhibitions, magazines, art schools, and research institutes rather than on the basis of individual geniuses. Certain entities, such as the Jack of Diamonds series of exhibitions (initiated in 1910), the Donkey's Tail, and 0.10, are now remembered as key manifestations of the avant-garde, but Mr. Kovtun reminds us that the new art schools and "think tanks" of post-Revolutionary Russia were also incubators of radical ideas. For example, the Vitebsk Popular Art Institute turned into a center for the propagation of Suprematism when Malevich took over its directorship from Marc Chagall in 1919: Ilya Chashnik, Vera Yermolayeva, El Lissitzky, and Nikolai Suetin are just a few of the talented artists that emerged from the UNOVIS (Affirmers of the New in Art) group. The same collective spirit prevailed at GINKhUK (State Institute of Artistic Culture) in Leningrad which, in spite of its short life (officially, 1924–26), functioned as a Russian Bauhaus with Filonov, Malevich, Pavel Mansurov, Matiushin, Punin, and Tatlin involved in its several departments. Obviously, there was much dissonance

[1] N. Punin, *Iskusstvo i revoliutsiya [Art and Revolution]*, 1930s. Manuscript. Punin family archive, St. Petersburg.

between these individuals, but even so GINKhUK emerged as a major research and resource center, articulating, categorizing, and elaborating new ideas on space, form, and color. After all, it was at GINKhUK that Mansurov developed his intriguing ideas on the relationship of natural form (fossils, butterflies, snails) to artistic form and that Matiushin, together with the Ender family, compiled the tabulations that served as the foundation of his 1932 compendium on color variability.[1] GINKhUK (which relied substantially on the experience of the Zubov Institute of Art History founded in St. Petersburg in 1912) was one of several fascinating centers of the early Soviet period that guided the cultural life of Moscow and Leningrad. The Decorative Institute founded in Petrograd in 1918, for example, attracted Yury Annenkov, Matiushin, Tatlin, and other important artists. RAKhN or GARKhN (State Academy of Artistic Sciences) which opened in Moscow in 1921, much under the influence of Kandinsky's theoretical programs, also produced a corpus of critical and analytical material on Western and Russian art that deserves to be rediscovered and evaluated. Such centers were progressive and productive, but they also represented a rapid institutionalization of culture that, in many cases, undermined rather than stimulated the creative initiative and imagination of the artists themselves. In this sense and perhaps paradoxically, they prepared the ground for a very different era, one that replaced the distinctive feature of the Russian avant-garde — its eccentric spontaneity — with a predictive combination of external decree and cultural stereotype. As Mr. Kovtun writes, in the early 1930s the avant-garde was stopped in its tracks, and what happened to Soviet art during the next quarter of a century is a history that still has to be written.

John E. Bowlt

[1] M. Matiushin, *Zakonomernost' izmeniayemosti tsvetovykh sochetaniy. Spravochnik po tsvetu* [*Regularity in the Changes of Color Combinations. Reference Book on Color*], Moscow–Leningrad, 1932.

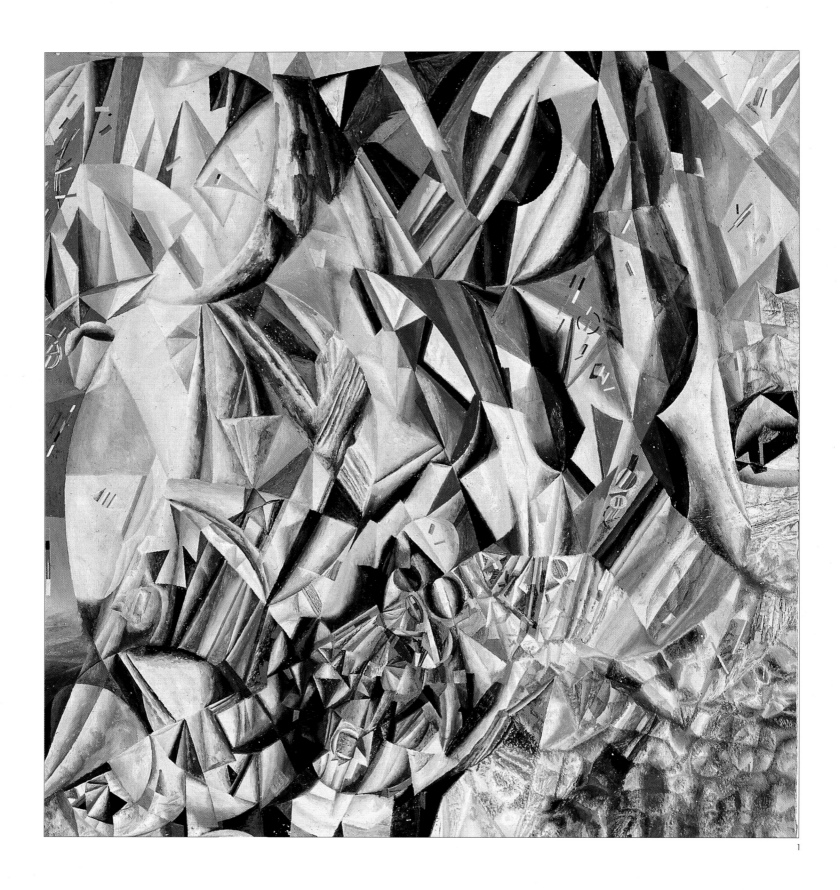

1
Pavel Filonov
Victory over Eternity. 1920–21
Oil on plywood. 41 x 37.5 cm

"PICASSO IS NOT NEW ART"

At the beginning of the twentieth century, Russian art was in the vanguard of the world artistic process. The decades which had gone into renewing painting in France were compressed into ten to fifteen years in Russia. The 1910s unfolded under the sign of the growing influence of Cubism, which changed the very face of the fine arts. Yet by 1913, a turning point could be seen. New plastic problems arose, opening for Russian painters a way into the unknown. The scales began to tip in the direction of the Russian avant-garde. In March 1914,

alley due to its mechanical and geometrical fundamental principles."[2] This pronouncement was made at a period when the new movement was going from one Russian exhibition to the next like a victory procession. The keenest Russian thinkers and artists saw in Cubism and the work of Picasso not the beginning of something new, but the culmination of the old line represented by Ingres. As the philosopher Nikolai Berdiayev put it, "Picasso is not new art. He is the end of the old art."[3] The artist Mikhail Matiushin said: "Picasso, by disintegrating materiality

2

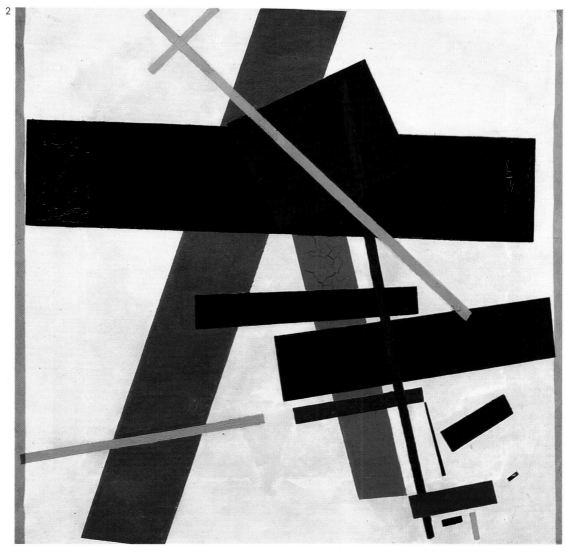

Pavel Filonov declared that "the center of gravity of art" had shifted to Russia.[1] Already in 1912, Filonov had come forth with criticism of Picasso and Cubo-Futurism, which had "wound up in a blind

through the new method of futuristic fragmentation, continues the previous photographic method of painting from nature, showing only a schematic outline of the movement of planes."[4] Mikhail

2
Kasimir Malevich
Suprematism. 1915
Oil on canvas. 80.5 x 81 cm

Le Dantu wrote: "It is a grave error to consider Picasso a beginning. He is more like a culmination and it is perhaps impossible to proceed along his path."[5] According to the art critic Nikolai Punin, "Picasso cannot be understood as the dawn of a new era."[6]

The French Cubists stopped before the boundary of abstraction. Their theoreticians wrote in 1912: "We must admit, however, that some reminder of existing forms should not be driven out conclusively, at least for the present."[7] Russian art decisively crossed this Rubicon in the works of Wassily Kandinsky and Mikhail Larionov, Pavel Filonov and Kasimir Malevich, Vladimir Tatlin and Mikhail Matiushin. The consequences of this step would long be felt in Russian art, especially in the 1920s.

On December 15, 1915, in Petrograd (St. Petersburg), an exhibition opened at Nadezhda Dobychina's artistic salon near the Field of Mars, at which Malevich showed a large selection of Suprematist works, forty-nine canvases in all, for the first time.

"The keys to Suprematism," Malevich wrote, "lead me to the discovery of what is still unrealized. My new painting does not belong exclusively to the Earth. The Earth is abandoned like a house that is eaten away by worms. And in fact within man, in his consciousness, lies a striving toward space, a desire to 'pull away from the globe.'"[8]

3
Kasimir Malevich
Peasants. 1928–32
Oil on canvas. 53.5 x 70 cm

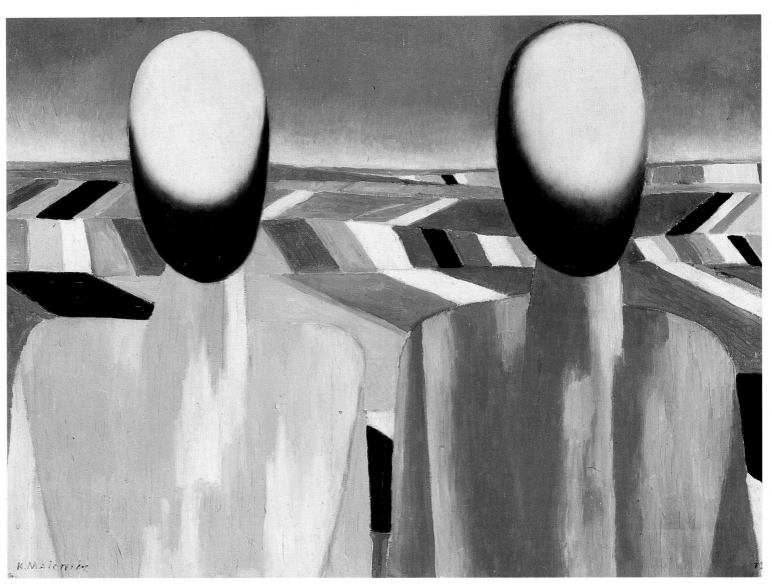

"THE SPIRITUAL UNIVERSE"

In spite of the discoveries of Galileo, Copernicus, and Giordano Bruno, for artists the Universe remained (emotionally and practically, i.e. in creative work) geocentric; their imagination and the structures which arose in their pictures were "on the leash" of earthly gravity; for them the presence of perspective and a horizon, the concepts of top and bottom, were self-evident. All this changed with the appearance of Suprematism. Malevich looked at the Earth as if from outer space, or to put it more exactly, an internal "spiritual universe" intimated this way of looking to him. Many Russian philosophers, poets, and artists of the beginning of the century returned to the idea of the early Christian gnostics and considered that the spiritual world of man was typologically the analog of the Universe. Malevich wrote: "The human skull represents the same kind of infinity for the development of ideas; it is equal to the Universe, for it contains everything which man sees in the Universe."[9] Man began to realize that he was not merely the son of the Earth, to sense his communion with the Universe. Physically man belongs to the Earth; spiritually he resembles the Universe. The spiritual motion which takes place in man's inner world produces subjective forms of space and time. From an understanding of the spiritual world as a little universe, a new understanding of the world arises and a consciousness which one might term "cosmic." This has led the twentieth century to radical changes in the sphere of art. In the non-figurative pictures of Malevich, who renounced earthly "guiding points," the idea of top and bottom, of left and right, disappeared. All directions were equal, as in the Universe. This implies a degree of "autonomy" in the structural organization of the work that leads to a break with the directions dictated by gravity.

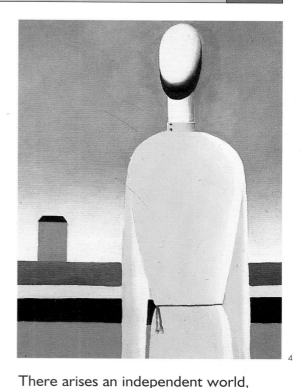

4

There arises an independent world, enclosed on itself and with its own "field" of linkages and attractions. This is a "little planet," which occupies its own place in the world harmony. Malevich's non-figurative canvases do not break with their origins in nature and it is small wonder that he defined them as "a new realism in painting."[10] Yet the "naturalness" of the canvases is expressed on another plane, one that is planetary and cosmic. Non-objectiveness — and herein lies its chief merit — opened up before artists not only a new picture of the world, but laid bare the fundamentals of artistic form, sharpening and enriching the language of painting. A very precise formulation of this was provided by the writer Victor Shklovsky in speaking of Malevich and his followers: "The Suprematists did in art what the chemists did in medicine. They extracted the active part of the material."[11]

4
Kasimir Malevich
Torso in a Yellow Shirt. 1928–32
Oil on canvas. 98.5 x 78.5 cm

THE FIRST POST-REVOLUTIONARY YEARS

*The thunder of the October cannon helped us to become innovators.
We came to clean out the academic paraphernalia surrounding the individual
so as to burn away the fungus of the past in the brain and to restore time,
space, tempo, rhythm, and movement, the fundamental elements
of the present day.*

Kasimir Malevich

*Let the pictures (color) spread like brilliant rainbows from house to house
on the streets and squares, bringing joy and ennobling the eye (the taste)
of the passer-by.*

Vladimir Mayakovsky, Vasily Kamensky, David Burliuk

5

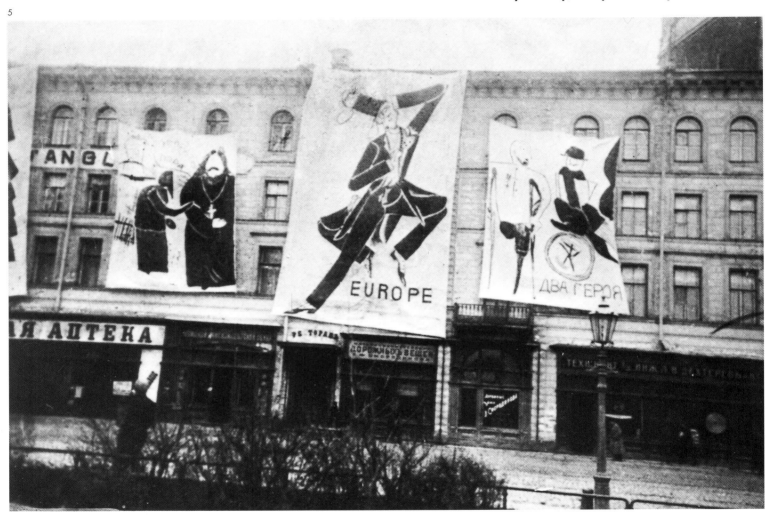

5
Pavel Mansurov's panel *Europe*
on the façade of the Hotel
Angleterre. 1918

6
Nathan Altman
Non-Figurative Composition: RSFSR.
1919–20
Oil and enamel on canvas.
48 x 59 cm

Russian art approached the demarca-
tion line of the year 1917 with a veri-
table panoply of conflicting trends and
tendencies. There were the Itinerants,
who were on the wane, and the World
of Art, which had lost its leadership,
the Cézannist group known as the Jack
of Diamonds, and Suprematism,
which was growing in strength, as well
as Constructivism and Analytic Art.

In characterizing post-revolutionary
avant-garde art and artistic life, we shall
concentrate only on the main phenome-
na and events, dwelling not so much
on concrete works as on the processes
that were taking place in art and on
the problems raised by the great mas-
ters who determined the milestones
in the art of these years.

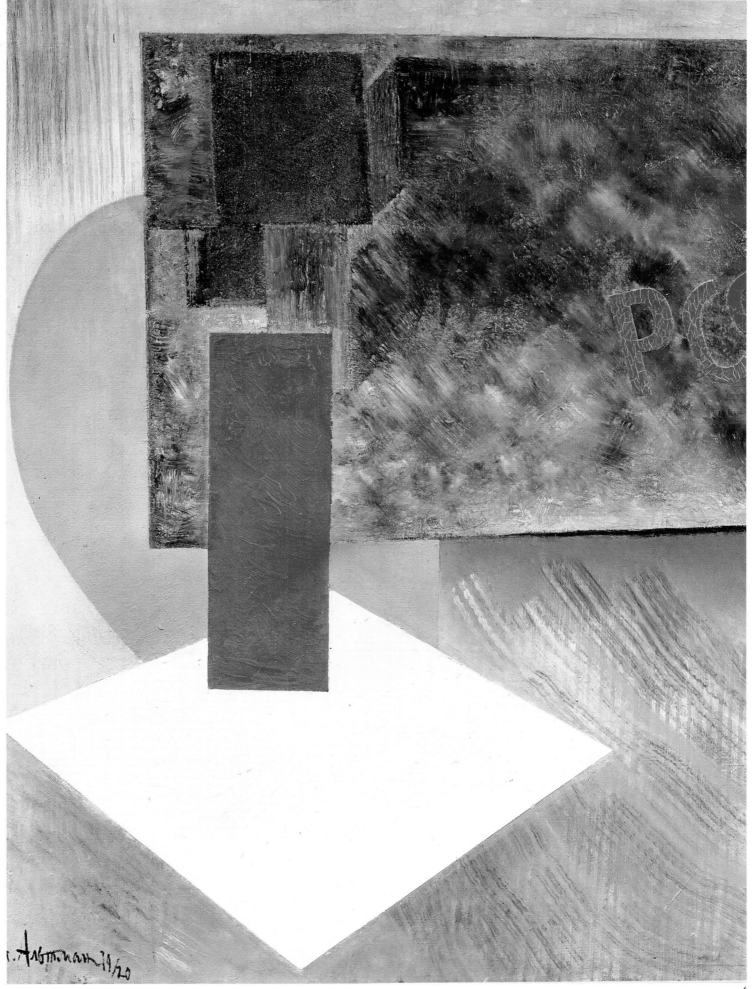

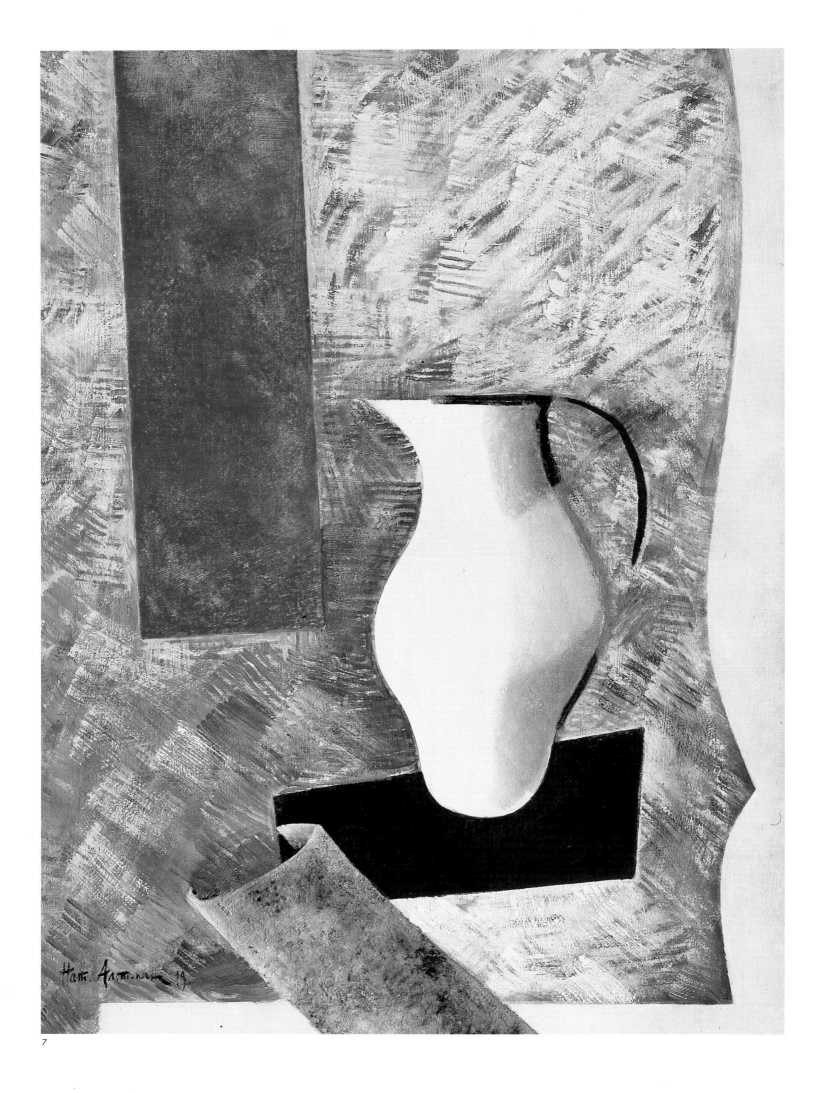

Soon after the October Revolution, a group of young artists united around the Fine Arts Department of the People's Commissariat for Education (Narkompros), headed by Anatoly Lunacharsky. The artists saw the Revolution as a complete renewal of all the foundations of life, as a liberation from all that had become decrepit, obsolete, and unjust. And in this process of purgation, they thought, art was called upon to play a signal role. "The thunder of the October cannon helped us to become innovators," Malevich wrote. "We came

8

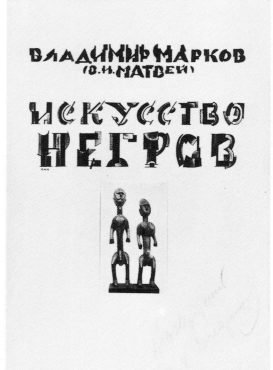

9

7
Nathan Altman
Material Painting. 1919
Oil, enamel, glue, stucco,
and sawdust on canvas.
83 x 65.5 cm (oval)

8
Nathan Altman at the Exhibition of the Fine Arts of the Russian Federation. Berlin. 1922

9
Nathan Altman
Cover of Vladimir Markov's book *Iskusstvo negrov*
[*The Art of the Negroes*]. 1919
Pen and India ink on paper.
36.1 x 23.8 cm

10
Nikolai Tyrsa
Design for the decoration of Nevsky Prospekt. 1918
Watercolor and India ink on paper. 20.7 x 29.4 cm

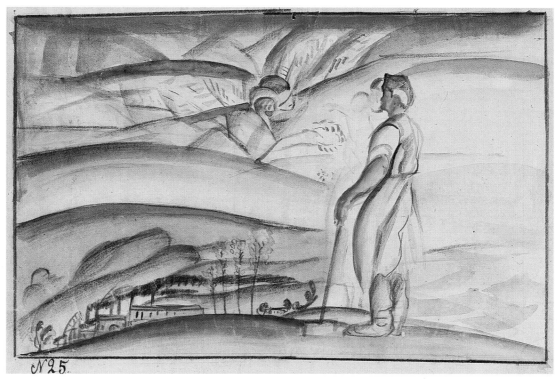

10

to clean out the academic paraphernalia surrounding the individual so as to burn away the fungus of the past in the brain and to restore time, space, tempo, rhythm, and movement, the fundamental elements of the present day."[12]

The young artists strove to democratize art, to bring it out onto the streets, to make it an active force in the revolutionary transformation of life. "Let the pictures (colors) spread like brilliant rainbows from house to house on the streets and squares, bringing joy and ennobling

and Xenia Boguslavskaya, Vladimir Lebedev and Vladimir Kozlinsky, Nathan Altman and Pavel Mansurov.

In a panel for Liteiny Bridge, Kozlinsky strove for simplicity and lapidary quality in his forms, seeking an image impregnated with meaning, free from chance and secondary elements. He knew how to build a composition using the relation of a few large patches of basic colors: the deep blue of the Neva River, the dark silhouettes of warships, the red flags of a procession moving along the embank-

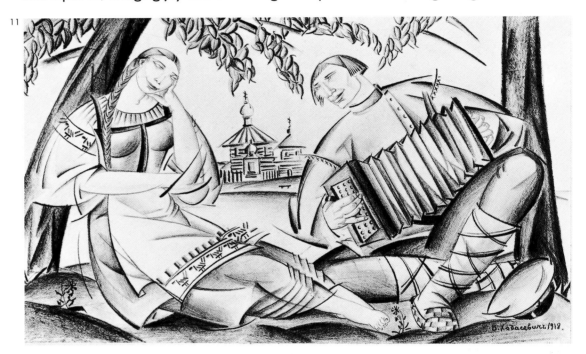

the eye (the taste) of the passer-by," Vladimir Mayakovsky, Vasily Kamensky, and David Burliuk proclaimed after the October Revolution.[13]

The first attempt at "bringing art out" onto the street was undertaken in Moscow. On March 15, 1918, three paintings by David Burliuk were hung out of the windows of the house on the corner of Kuznetsky Bridge Street and Neglinny Lane. This episode was taken as being just another prankish stunt of the Futurists, but it presaged the things to come. In 1918 Suprematism first came out of the artists' studios and onto the streets and squares of Petrograd, most notably as the decorative panels of Ivan Puni

ment. Kozlinsky's watercolor sketches are more than simply festively decorative, they possess a true monumentality, with a minimum of highly charged colored forms bearing the maximum conceptual load.

The Suprematist influence stands out clearly in the designs of Puni, Lebedev, and Boguslavskaya. Yet in these early experiments, the artists perceived Suprematist principles in a somewhat superficial manner. For them, these principles were only a new means of organizing a surface using color decoratively. The inner meaning of the new trend, its philosophical roots, remained inaccessible to them.

11
Valentina Khodasevich
A Country Couple. 1918
Lead pencil on paper.
22.3 x 35.8 cm

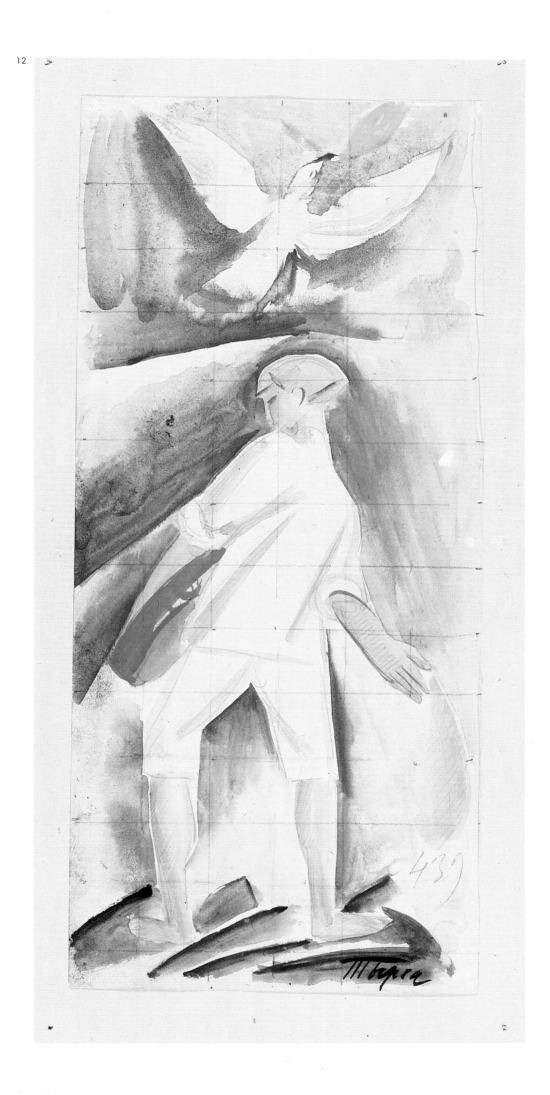

12
Nikolai Tyrsa
Sower. Decorative design. 1918–20 (?)
Watercolor and India ink on paper.
27.9 x 12.4 cm

On oceanic wings
We soar over earth
And fly to the
Great breakthrough.
On a tropical

Insland of palms
From nuts they swig
Wine
In the shady, southerly
Cool of bananas
The cockatoo.
Tonician
Musifies.

Wash in the true dew
And dry with the rain-
 bow's end
My soul is swept
By the wind
 [of my country]
And somehow I have no
 desire

To know of the earthly
Calcutta
 Bombay
Petrograd and
Kr.................................
no.................................
to paint
from nature

David Burliuk

13

13
David Burliuk
Portrait of the Futurist Poet Vasily
Kamensky. 1917
Oil on canvas. 104 x 104 cm
Vasily Kamensky was a Futurist poet, prose writer,
and one of the first Russian aviators. Around
the head runs the inscription: *King of Poets, the*
Song-Fighter, and Futurist Vasily Vasilyevich
Kamensky. 1917. The Russian Republic.
On the right are verses by David Burliuk.

14
Yury Annenkov
Portrait of Mikhail Kuzmin. 1919
Watercolor, colored pencils, and
graphite on paper. 68.4 x 50 cm
Mikhail Kuzmin was a Russian poet whose
work developed within the Symbolist trend
and who also reflected the poetic tenets of
Acmeism. He wrote a number of prose works.
He also composed music to his poems and
gave renditions of his songs.

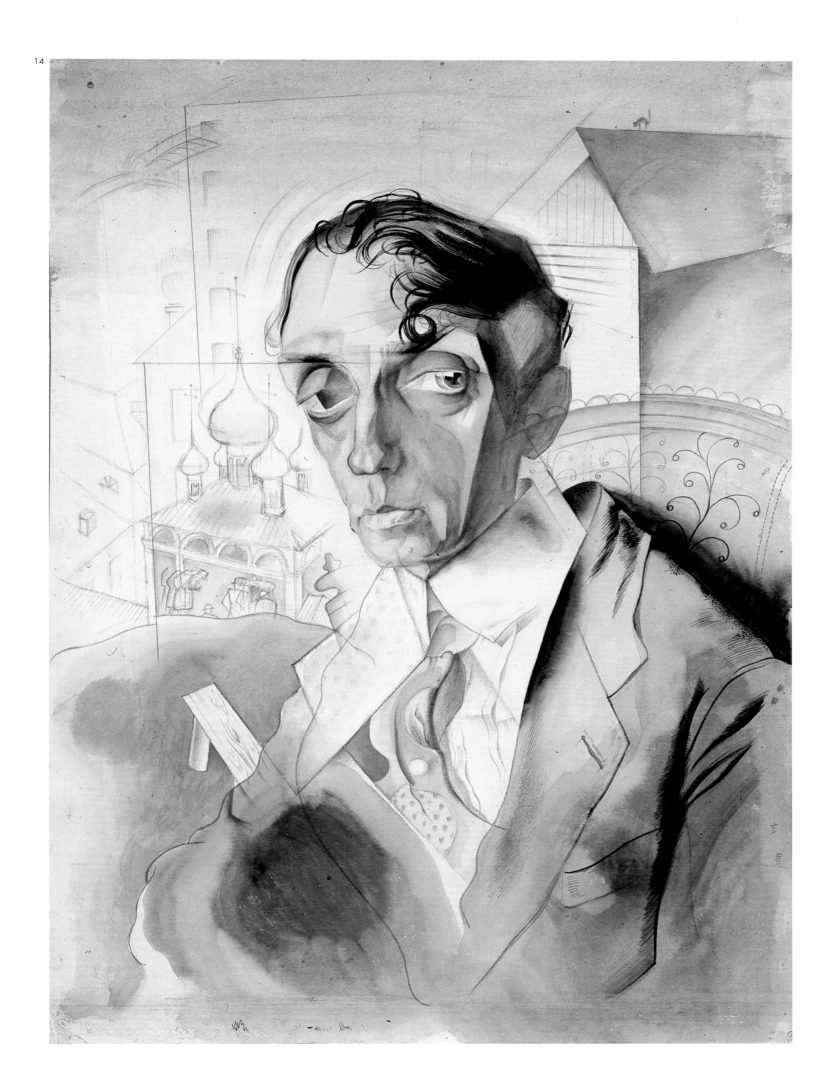

15

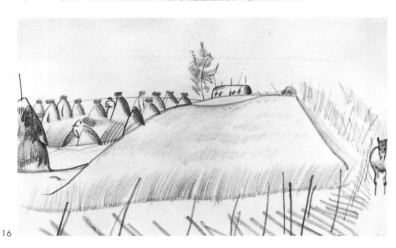

16

17 Борисъ Григорьевъ 918.

15
Boris Grigoryev
Illustrations to Vasily Pushkin's book
Opasny sosed [*A Dangerous Neighbor*]. 1918
Lead pencil on paper. 21.2 x 34.6 cm

16
Boris Grigoryev
Field. 1918. From the cycle *Russia*
Lead pencil on paper. 21.3 x 34.6 cm

17
Boris Grigoryev
Village. 1918. From the cycle *Russia*
Oil on canvas. 80.5 x 97.5 cm

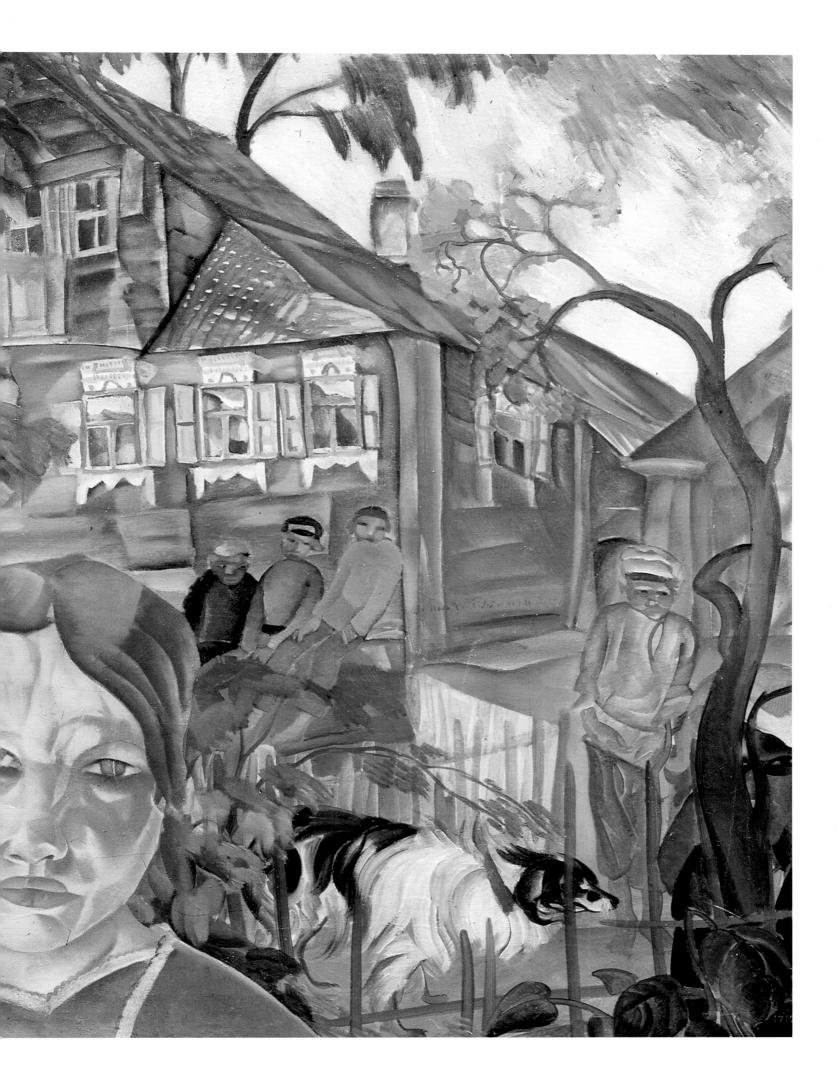

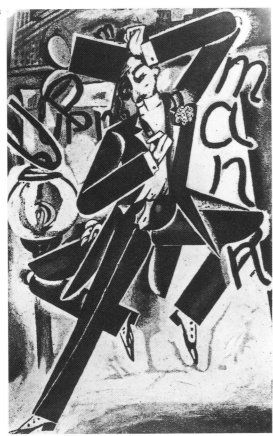

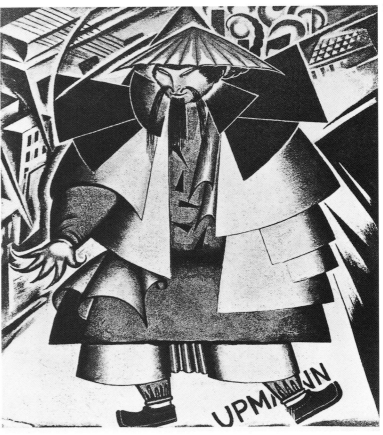

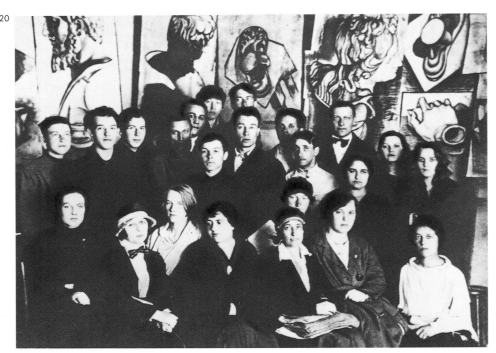

it was capable of any kind of stupid stunt and would even hire out its wives and children just so it could fleece the Chinaman or the Negro. My gaze rested on the Chinaman, around whom four fops dressed in tails were beating out a wild tapdance. Two of them were on each side of the China-man, seen against the background of skyscrapers. Those kinds of music boxes were not made in Russia and that's why I showed two drawings together with the costumes and sketches of the stage set for Lord Byron's *Manfred* to Meyerhold, who wanted to make a ballet based on the Chinaman. But he 'wanted' so long that Lurye wrote the music to my drawings."

Pavel Mansurov. Letter to Yevgeny Kovtun,
September 25, 1970. Ye. Kovtun archive, St. Petersburg

19
Pavel Mansurov
Chinaman. 1919. Illustration for the edition of the score of Arthur Lurye's ballet *Upmann. Smoking Joke*

20
Pavel Mansurov (center) with pupils from an art school. 1925

"But the thing that we worked on at great length and which we were fairly well carried away with — I won't hide the fact — was 'non-objective' composition. We seized on, as they would say today, 'cosmic tasks.' From lines — straight and curved — and from spirals and various geometrical figures we constructed dynamic, three-dimensional compo-sitions on planes; we created a whimsical play of color, imparting a symbolic meaning to the composition of multi-hued areas..."

V. Delacroix, *Neskol'ko beglykh vospominaniy
o zaniatiyakh abstraktnoi zhivopisyu v 1920–1921 gg.*
[A few brief reminiscences on work in abstract painting
in the years 1920–21]. Archive of the Academy of Arts,
St. Petersburg, part 64, No. 157

21
Ivan Puni
Street. 1920s
Watercolor, India ink, and colored pencils on paper. 31 x 21.3 cm

18
Pavel Mansurov
Dandy. Illustration for the score of Arthur Lurye's ballet *Upmann. Smoking Joke*. 1919

"I created Upmann in 1915 using India ink for the music box, which I had seen several times at the Pavlovsk Station near the chocolate stand. It consisted of a mechanism and dolls and their cavaliers dressed in 18th-century costumes. One inserted a silver ten-kopeck coin in the box and the music would begin to play and the dolls would dance very elegantly. I formed an opinion according to my own under-standing, without any political thoughts, of which I had none, but it always seemed to me when I saw the rich crowd that

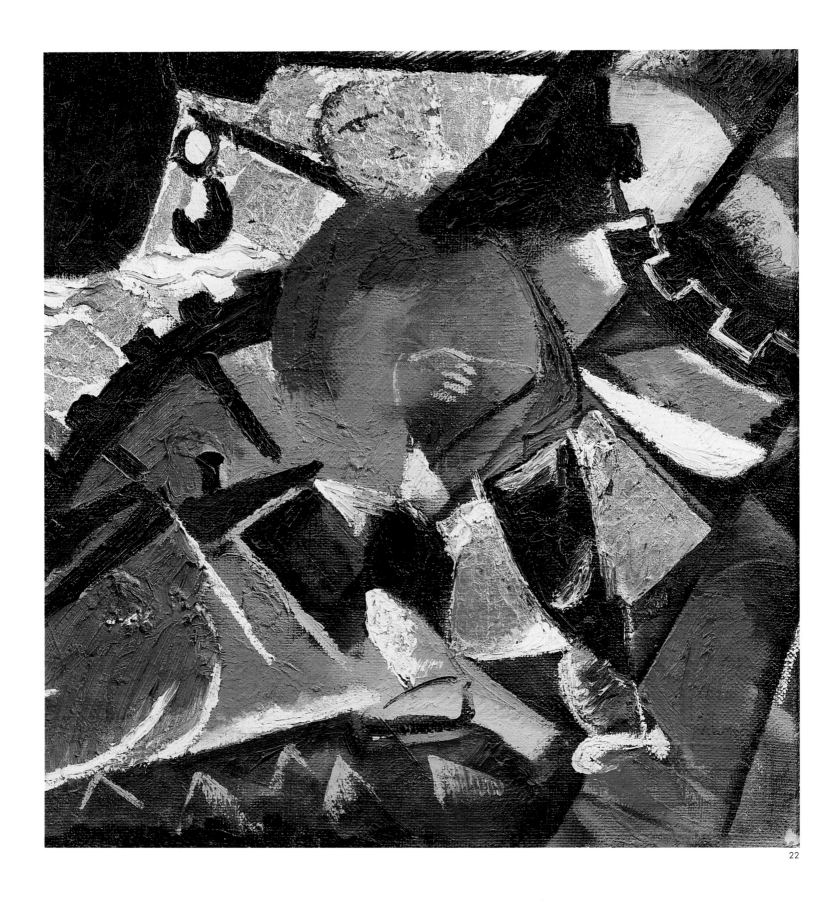

22
Victor Palmov
Composition. 1921
Foil and oil on canvas. 64 x 60 cm

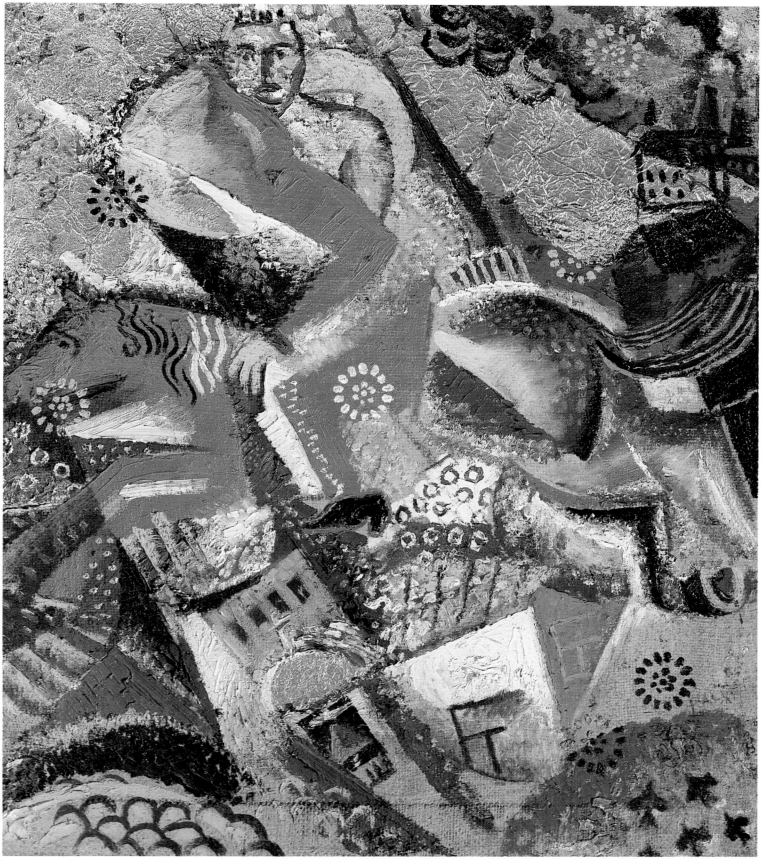

23

Victor Palmov
Composition with a Red Rider. 1920
Foil and oil on canvas. 63 x 53.5 cm

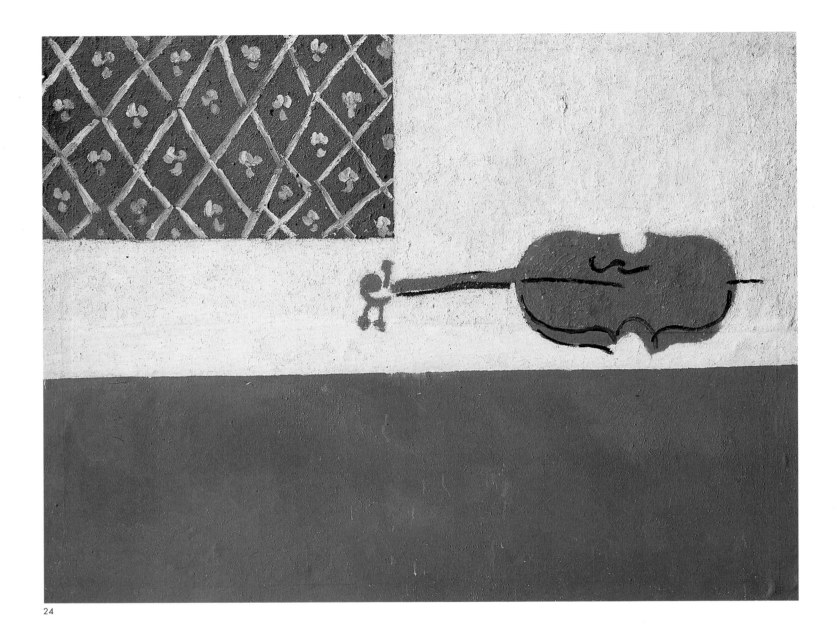

24

24
Ivan Puni
Still Life: Red Violin. 1919
Oil on canvas. 145 x 115 cm

25
Ivan Puni
Workers in a Car. Sketch
of the decorations for Liteiny
Prospect in Petrograd. 1918
Watercolor and India ink on paper.
38.3 x 34.4 cm

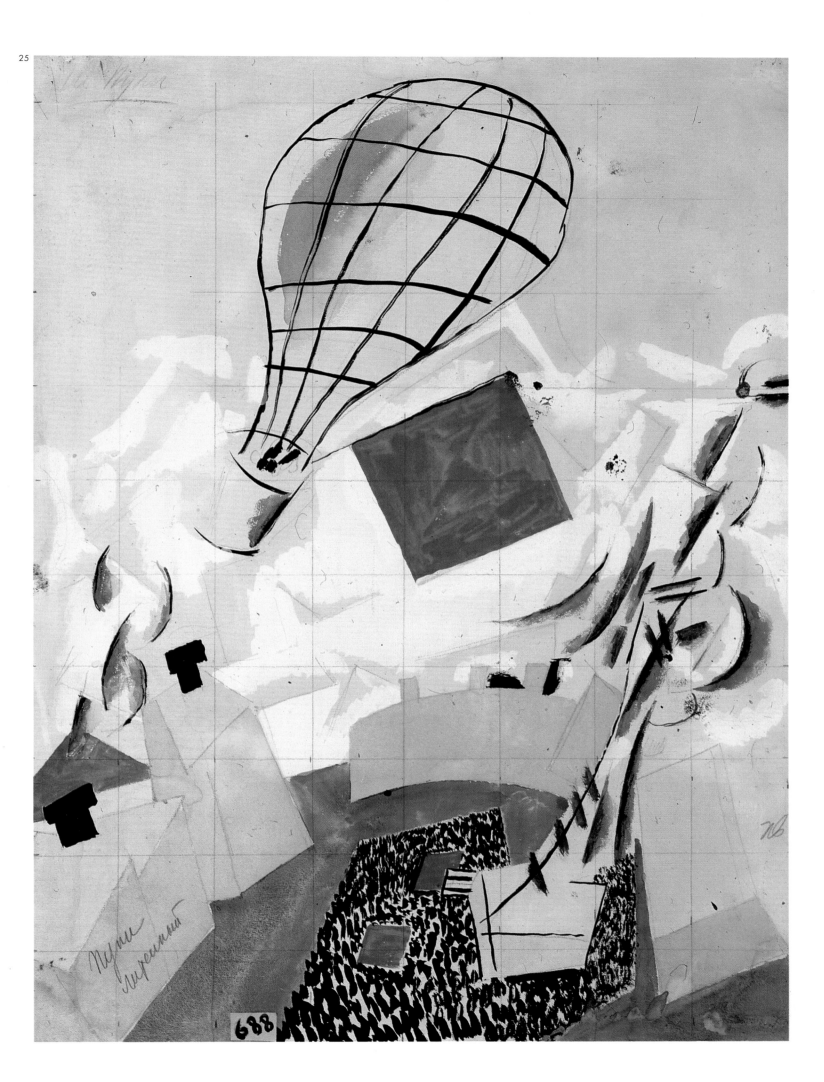

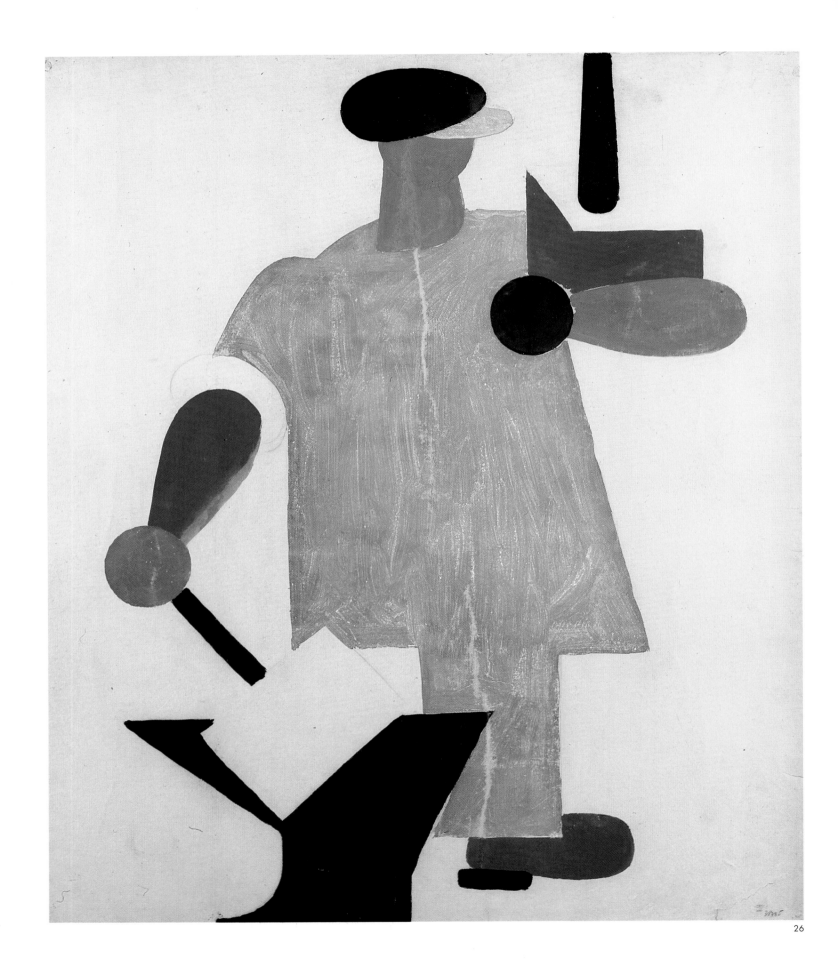

26
Vladimir Lebedev
Worker with Hammer. The ROSTA
Windows. 1920–21
Size paints on paper. 75.3 x 63.3 cm

The ROSTA Windows are a fantastic thing. This is service by a handful of artists, manually, for a huge nation of one hundred and fifty-nine million.

These are telegraph messages that are redone into posters in a jiffy; they are decrees which are now published in the form of *chastushka* songs.

The poetry has a stage review character, a "billboard" character — this is not only the lack of paper, it is the mad tempo of the Revolution which printing technology has not had the time to catch up with. This is a new form introduced directly by life.

V. Mayakovsky, *Polnoye sobraniye sochineniy* [*Complete Works*], vol. 12, Moscow, 1959, p. 153

In 1920–21, the appearance of the revolutionary poster created by Kozlinsky and Lebedev was transformed through the influence of Suprematism. The first "ROSTA Windows" (ROSTA is an acronym for Russian Telegraph Agency) originated in Moscow at the end of 1919, with Vladimir Mayakovsky taking an active part in their creation. At the beginning of 1920, Vladimir Kozlinsky was named head of the Art Department of the Petrograd ROSTA in a mandate signed by Platon Kerzhentsev and Vladimir Mayakovsky. Kozlinsky invited his friends Vladimir Lebedev

tic simplicity leading to an impressive monumentality.

In two years of work, no less than a thousand posters were created, of which several still survive. The overwhelming majority of prints are the work of two artists, Kozlinsky and Lebedev, and it was they who developed the peculiar style of the Petrograd posters. The posters of the "ROSTA Windows" were printed in large numbers. On several of the test proofs, we can still see the markings "Print 2,000 copies," "Print until materials run out (one and a half or two thousand)." Obviously,

and Lev Brodaty to design the posters. The pre-revolutionary poster lacked the artistry to serve as a model. The posters of different character produced by contemporaries displayed features and methods that contradicted the essence of the poster style: illustrativeness, verbosity, devices from easel painting or newspaper caricature, beautification, even the use of the vignette. The young ROSTA artists conceived the style of the poster differently. They saw in it the large form, constructivity, and plas-

the creator himself was not able to handtint such a large number of sheets, and he produced master-copies which were used by his assistants when tinting the entire edition. The linocuts were colored with pure, resonant aniline paints and the tinting as free and improvised, resulting in variously painted copies of one and the same poster. The color was applied not only along the contour of the design but often spread over the outlines in the manner of popular prints. This technical charac-

27
Vladimir Kozlinsky
Worker. 1919
Etching. 30.3 x 26 cm

28
Vladimir Kozlinsky
Meeting. 1919
Linocut. 29.5 x 21 cm

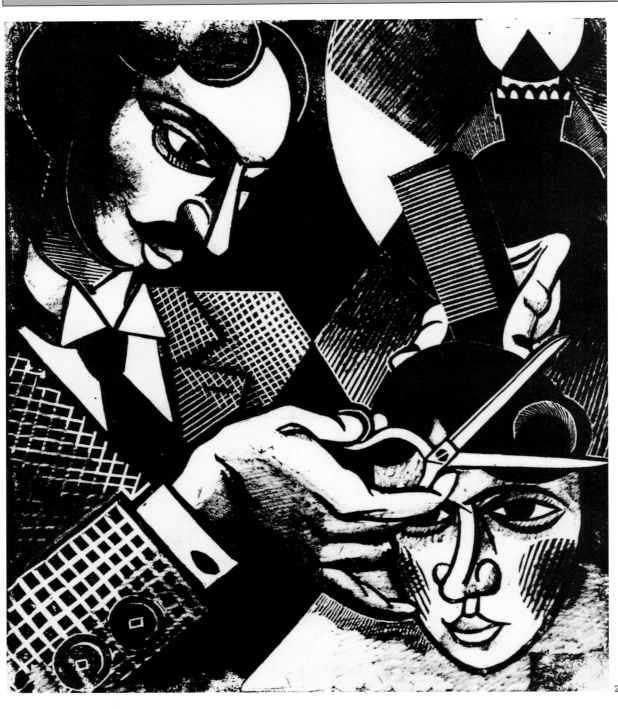

29

29
Nikolai Kupreyanov
The Beauty Parlor. 1920–22
Xylograph printed on paper
and touched up with lead pencil.
27.2 x 23.3 cm

30
Unknown artist
A Peasant Man. 1918 (?). Sketch
for a festive decoration
Gouache and white on cardboard.
41.8 x 28.8 cm

teristic, unavoidable in mass production, endowed the posters with the charm of "hand-made work," despite the obvious use of a printing press. Although the ROSTA posters employed a single set of plastic principles, the individual and artistic differences between Kozlinsky and Lebedev are self-evident. Both young masters passed through the same school and were attracted by Cubism, which can be clearly seen in many of the posters. Kozlinsky,

however, was softer and more lyrical than the sharp, cutting Lebedev. Kozlinsky was expansive and open in the expression of feelings. Lebedev was more rigorous, more conventional, with a greater emphasis on structural qualities. He surpasses Kozlinsky in achieving a more clear-cut delineation of form. His posters often exhibit the influence of Suprematism. Lebedev's posters are in essence visual formulas in which nothing can be deleted or added.

30

4. А, ДАЛЬШЕ — ВСЕ ШИРЕ... ВСЕ ШИРЕ ПОТОК,
ОКТЯБРЬ ЗАТРУБИЛ В СВОЙ НЕИСТОВЫЙ РОГ...
ВРАГИ ОКРУЖИЛИ... НЕ СТАЛО ДОРОГ...
МЫ ВЕСНЫ ВСТРЕЧАЛИ, СТРАНУ ЗАЩИЩАЯ —
ДА ЗДРАВСТВУЕТ 1ое МАЯ!

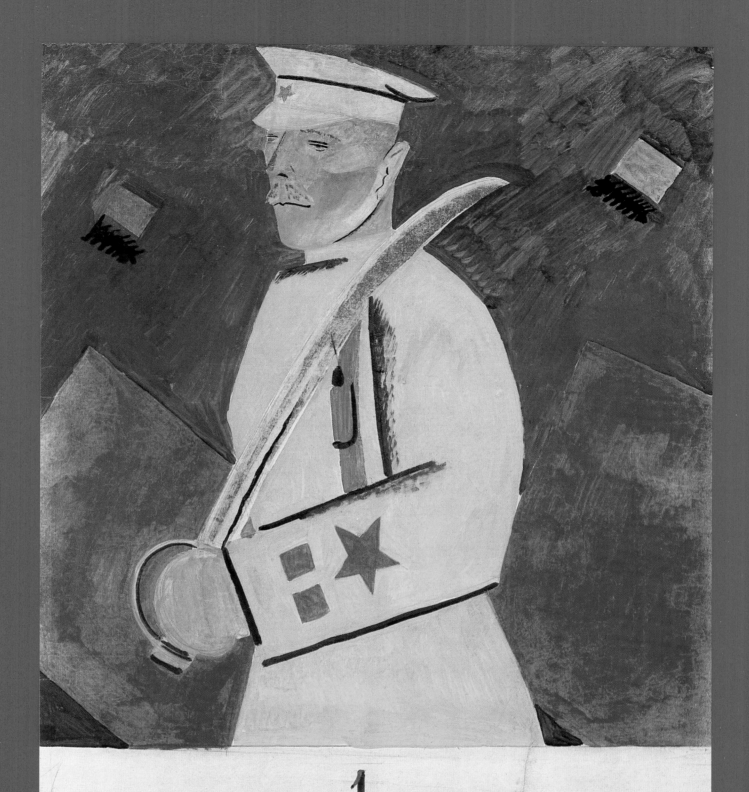

1.

Вот, граждане, разительный пример —
Не первый честный офицер
Несет нам знанье и труды,
Вступая в красные ряды.

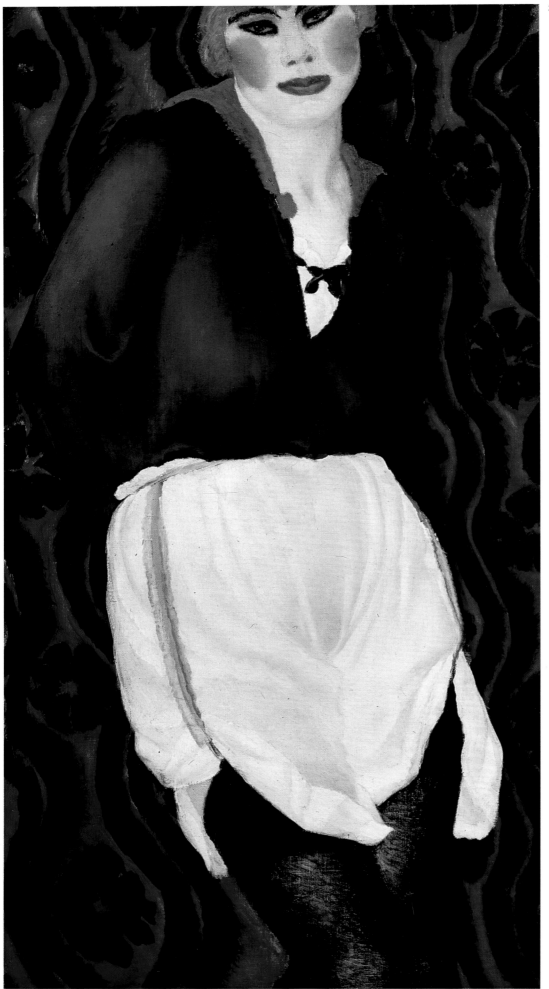

←
31
Vladimir Kozlinsky
Battle with White Guards and Interventionists. 1920–21. Sketch of the poster "Further ahead, ever wider, ever wider flows the river"
Size paints on paper. 100 x 66.5 cm

←
32
Vladimir Kozlinsky
Red Commander. 1920–21. Sketch of the poster "Here, citizens, is a stunning example"
Gouache and watercolor on paper. 109.7 x 72.3 cm

33
Vladimir Lebedev
Katka. 1918 (1916?)
Oil on canvas. 126 x 66 cm

34
Vladimir Lebedev
Woman Ironing. 1925
Gouache, charcoal, pencil, and paper cutouts on cardboard. 68 x 44.5 cm

→
35
Vladimir Lebedev
Cubism. 1922
Oil on canvas. 108 x 69 cm

→
36
Konstantin Medunetsky
Colored Construction. 1920
Oil on canvas. 87.6 x 61.5 cm

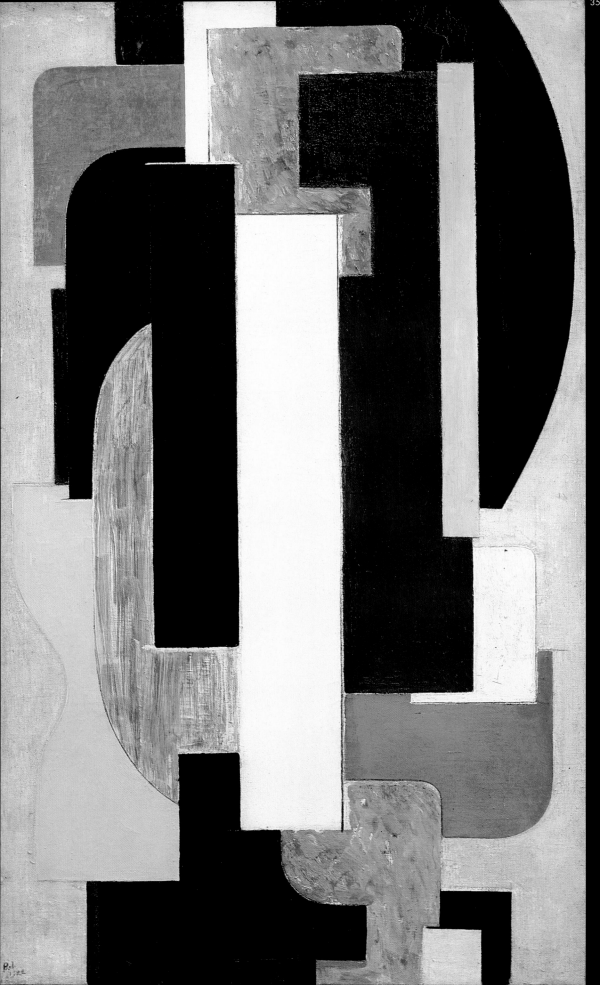

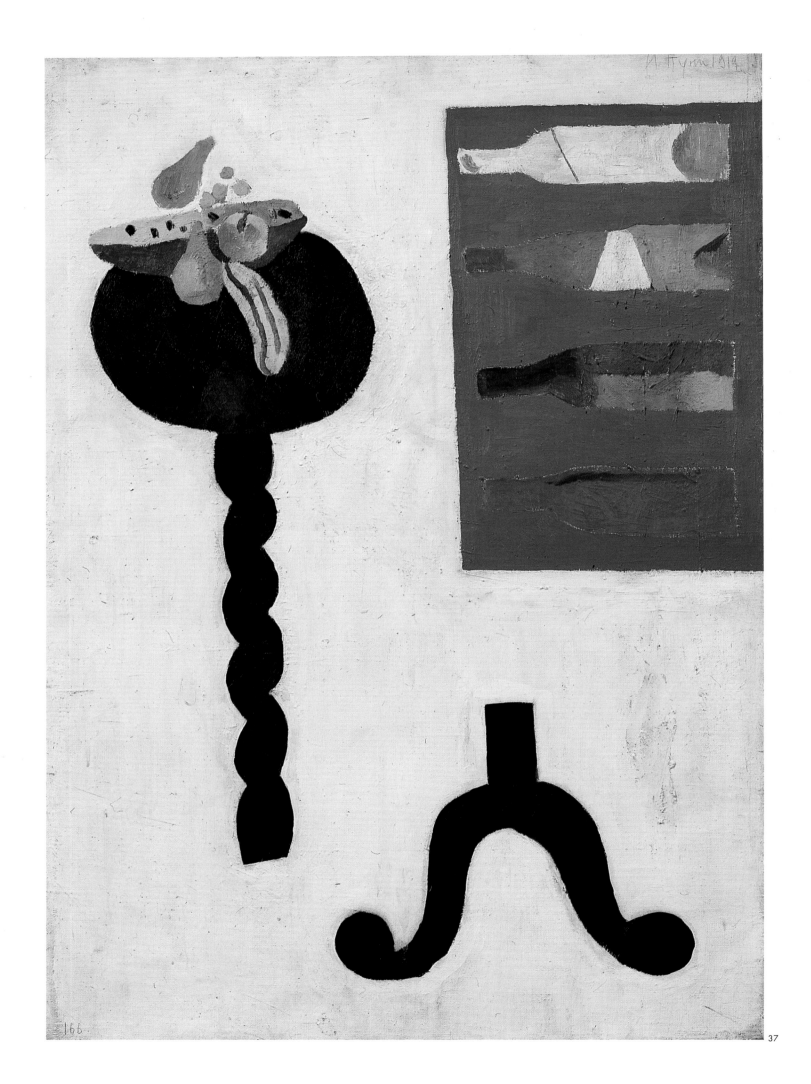

166

37

Noteworthy among the forgotten phenomena which the present book seeks to resurrect, is the "Today" Artists' Cooperative, which existed in Petrograd in 1918–19. Vera Yermolayeva's apartment was, in 1918, the meeting place of poets and artists. Among the regulars

Nathan Vengrov, and Sophia Dubnova. The painters and writers did everything themselves, from setting up the book to selling it. A contemporary observed: "The collapse of printing today has given birth to a new kind of 'handicraft' — art publishing. In St. Petersburg a cooperative

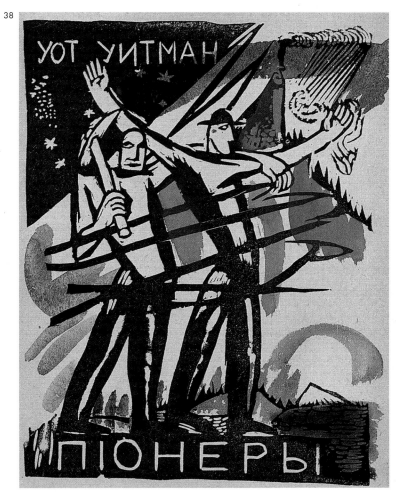

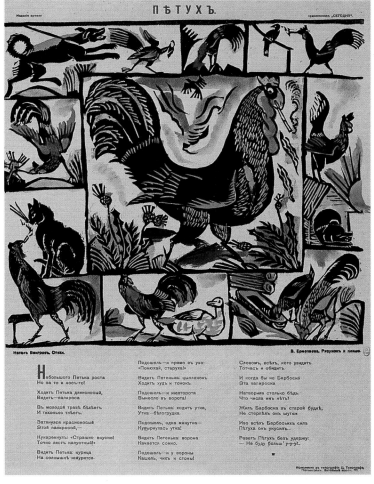

were Maxim Gorky and Vladimir Mayakovsky.[14] These meetings led to a friendship between artists and writers, who formed a close association for the joint creation of small format books, mainly for children. In this respect, the "Today" Cooperative was the precursor of the Leningrad Detgiz Publishers. Yermolayeva brought in Yury Annenkov, Nathan Altman, Nikolai Lapshin, Nadezhda Liubavina, and Yekaterina Turova. The writers who collaborated with Yermolayeva's group included Alexei Remizov, Sergei Yesenin, Mikhail Kuzmin, Yevgeny Zamiatin, Ivan Sokolov-Mikitov,

of writers and artists has grown up. They themselves compose and make the linocuts, they themselves set and print the work. One can find a measure of consolation in the fact that the present crisis makes us return to the fine old handicraft skills, which are now cheaper to use."[15] The books produced by the cooperative were quite small, consisting of only four pages, and were printed in editions of 125 copies each. The jacket and illustrations were printed from linocuts. Part of the edition was decorated by the artist himself, with variations in the painting so that each copy of the book

37
Ivan Puni
Still Life: Table. 1919
Oil on canvas. 103 x 73 cm

38
Vera Yermolayeva
Cover of Walt Whitman's book
Pionery [Pioneers! O Pioneers!]. 1918
Tinted linocut. 19 x 14.7 cm

39
Vera Yermolayeva
Rooster. Lubok (popular print) based on Nathan Vengrov's verse. 1918
Linocut tinted with watercolor.
27.7 x 28.9 cm

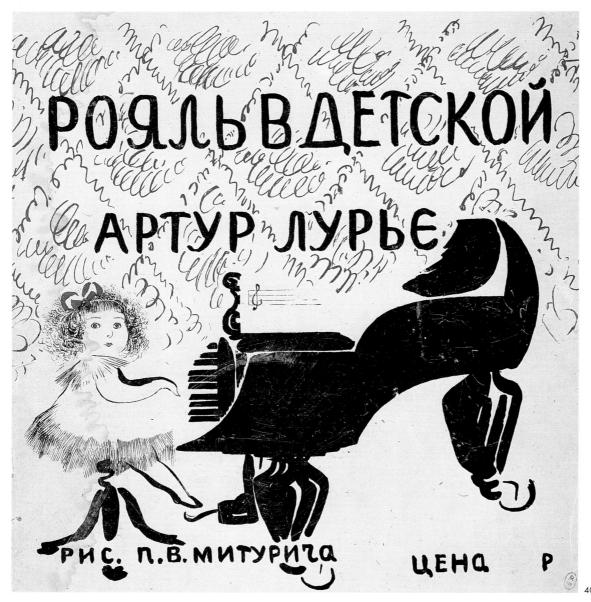

РОЯЛЬ В ДЕТСКОЙ

АРТУР ЛУРЬЕ

РИС. П.В. МИТУРИЧА ЦЕНА Р

40

40
Piotr Miturich
Cover for Arthur Lurye 's book
Royal' v detskoi
[*Piano in a Nursery*]. 1920
Colored lithograph. 27 x 24 cm

acquired the uniqueness and charm of "hand-made" work.

In a monumental conception for the dust jacket of Walt Whitman's *Pionery* [*Pioneers! O Pioneers!*] Yermolayeva was able to embody the free rhythm of the American poet's stanzas in visual form. With the same pictorial vigor, she also designed the dust jacket for Nathan Vengrov's book *Segodnia* [*Today*]. Standing out boldly and significantly is a seated figure set against a background of city buildings tilted in all directions. The great simplicity and cut-glass quality of the forms suggests the fact that the artist's work influenced by Cubism. The title and author's name are worked into the image as constituent elements of the composition. Here Yermolayeva follows the tradition of painted shop signs, an art form she was very interested in during these years. Among the best books published by the cooperative were Sergei Yesenin's *Isus mladenets* [*The Infant Jesus*], Nathan Vengrov's *Khvoi* [*Conifers*] (drawings by Yekaterina Turova) and Yury Annenkov's *1/4 deviatogo* [*Quarter Past Eight*] (drawings by the author). The "Today" Cooperative pursued its activities for only a short time. In the fall of 1919, the Fine Arts Department of the People's Commissariat for Education sent Vera Yermolayeva to the Byelorussian town of Vitebsk and the cooperative closed down.

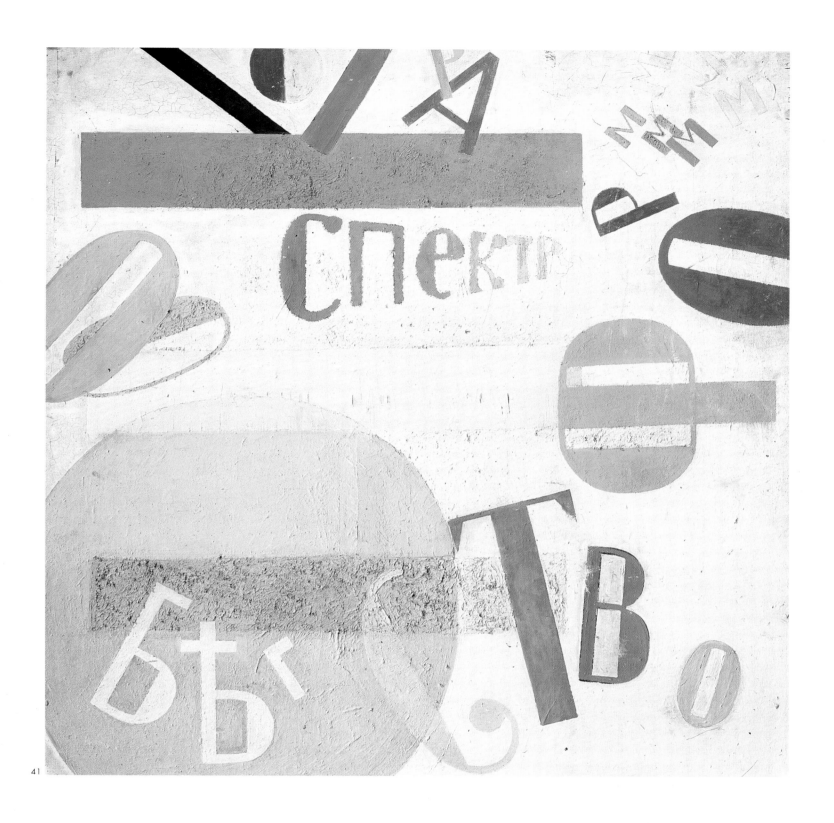

41

Ivan Puni

Still Life with Letters: Spectrum.
Flight. 1919
Oil on canvas. 124 x 127 cm

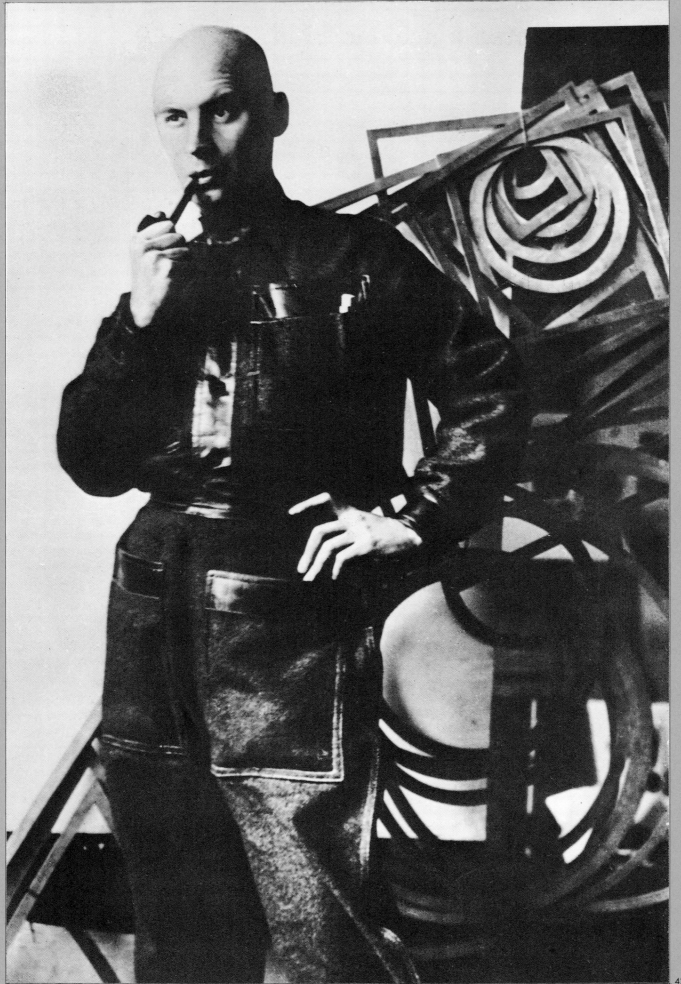

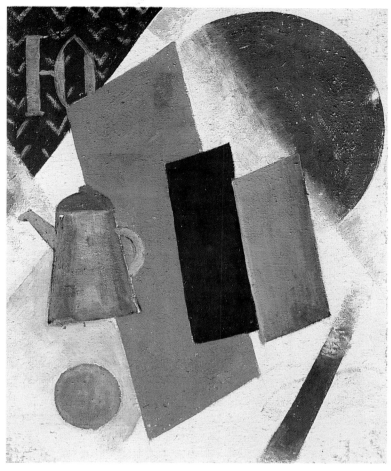

43

44

In Moscow, the forces of the new art grouped around VKhUTEMAS (an acronym for Higher Artistic and Technical Workshops). Nikolai Punin, who visited Moscow in February 1919, wrote: "Suprematism has blossomed out in magnificent color all over Moscow. Shop signs, exhibitions, cafés — everything is Suprematism."[16] Competing with it was Constructivism, a trend spawned in the pre-revolutionary years by the counter-reliefs of Vladimir Tatlin. The artist wrote: "By constructing angular and centrally oriented 'reliefs of a higher type'[17] I rejected as unnecessary a number of 'isms' — the chronic sickness of contemporary art."[18] Casting aside the aesthetic approach to creativity, the Constructivists turned their attention to the making of utilitarian objects, considering functional appropriateness to be the equivalent of artistic value.

The rivalry between Tatlin and Malevich ran throughout the 1920s. "When it began," wrote Nikolai Punin, "I don't know, but as far as I can recollect they were always dividing the world between themselves, both earth and sky and interplanetary space, everywhere establishing the sphere of their influence. Tatlin usually secured the earth for himself, trying to push Malevich off into the heavens, beyond non-materiality. Malevich, whilst not relinquishing the planets, did not surrender the earth, justly assuming that it too was a planet and, consequently, could be non-objective."[19]

42
Alexander Rodchenko wearing overalls of his own design. 1922

43
Alexander Rodchenko
Composition. 1918
Watercolor on paper. 26.6 x 20.3 cm

44
Alexei Morgunov
Picture with the Letter Ю. Late 1910s
Oil on canvas. 65 x 54 cm

→
45
Vladislav Strzheminsky
Tools and Manufactured Products. 1920
Cork, tin, metal elements, oil, and crumbs of plaster of Paris on canvas mounted on board. 44.5 x 33 cm

→
46
Alexander Rodchenko
Red and Yellow. 1918 (?)
Oil on canvas. 90 x 62 cm

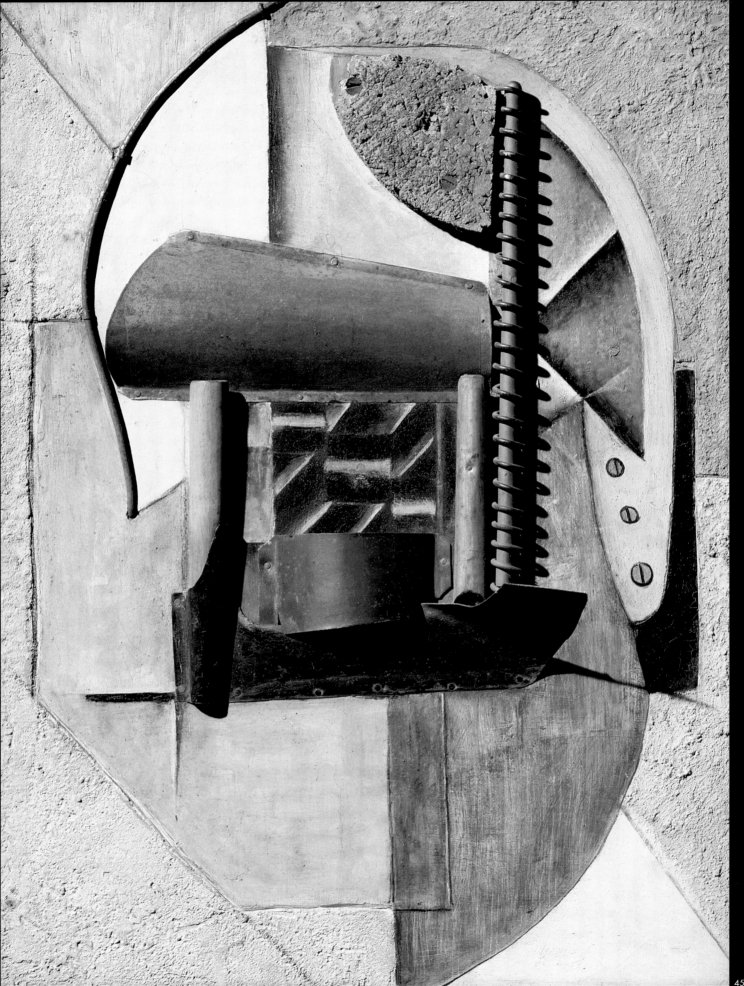

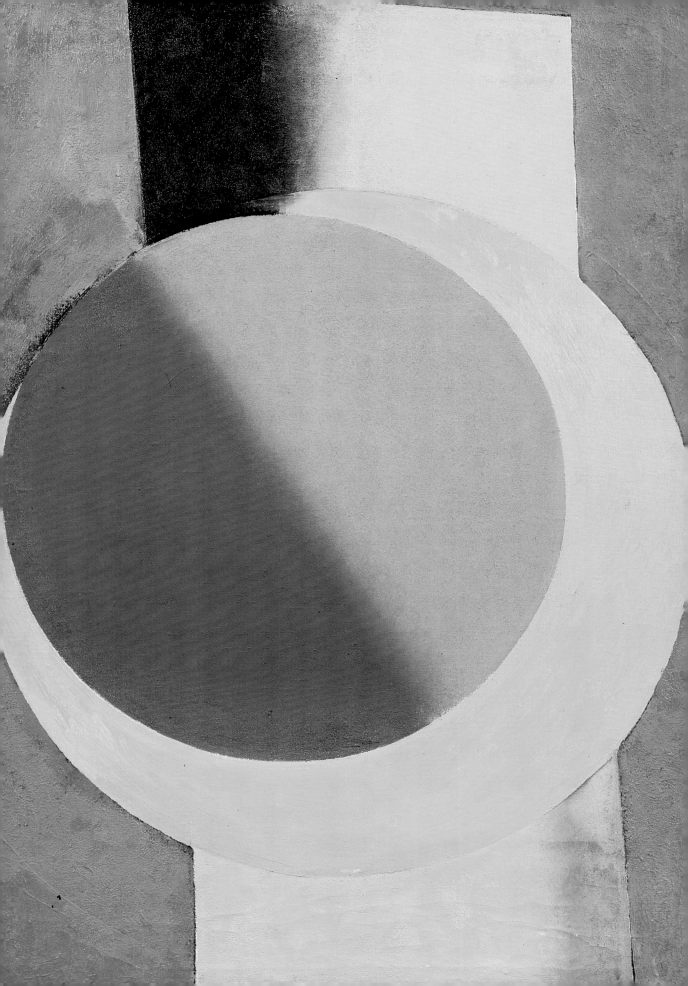

47

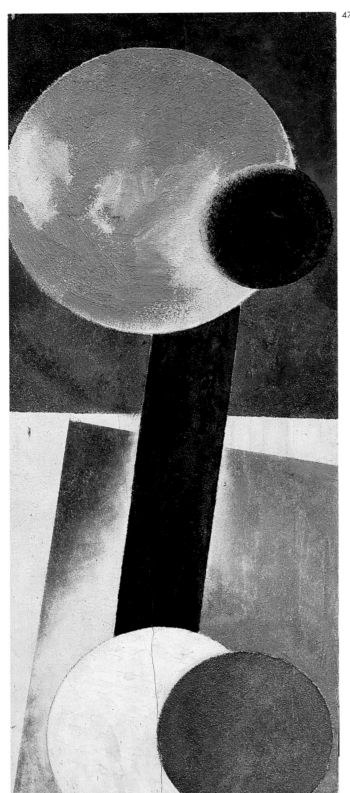

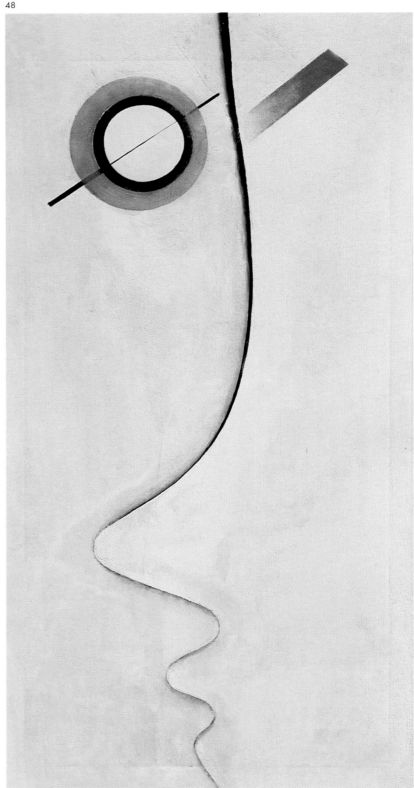

48
Vladimir Stenberg
Colored Construction No. 4. 1920
Oil on canvas. 75 x 38.5 cm

48

47
Alexander Rodchenko
Non-Figurative Composition. 1918
Oil on wood. 90 x 62 cm

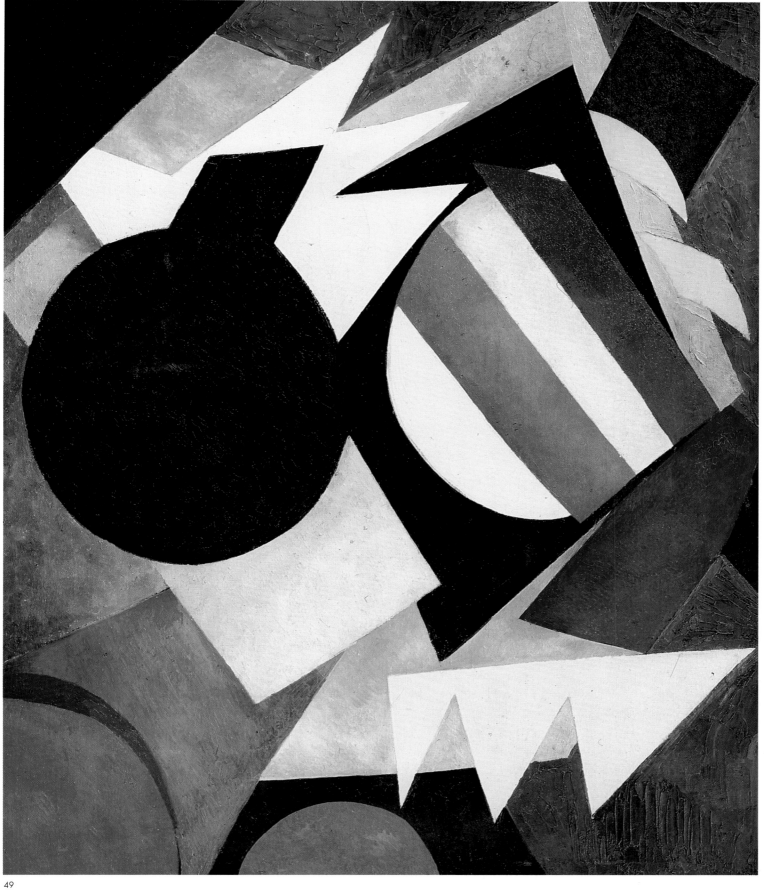

49

In the immediate post-revolutionary years Wassily Kandinsky displayed enormous creative activity: he published articles in the press, gave lectures, and was one of the organizers of the Moscow Institute of Artistic Culture (INKhUK). One of the first books put out by the Fine Arts Department of the People's Commissariat for Education was the artist's automonograph laconically entitled *Kandinsky*. For decades, Kandinsky was simply stricken from the history of Russian art and attached to German Expressionism. Although in the prewar edition of the anthology *Mastera iskusstv ob iskusstve* [*Masters of Art on Art*], Kandinsky's texts were included in the Russian section, in the last edition (1969), they were placed in the section "Germany"

on the grounds that his art was allegedly an alien flower on Russian soil.

Justice must be restored.

In his pictorial experiments, Kandinsky, as he himself indicated, relied on folk art, on the polychromatic quality of the Russian *lubok* or popular print. It is hard to find an artist at the beginning of the century who embraced the Russian popular print with such keen interest and excitement as Kandinsky did. When he learned that Nikolai Kulbin had sent him a *lubok* entitled *The Last Judgment*, Kandinsky wrote to him: "I must confess that my heart even beats faster when I think of it."[20] When in Moscow, he would always try to get hold of popular prints. The artist Pavel Mansurov told of these hunts, which were often

50
Wassily Kandinsky
Golden Cloud. 1918
Oil, lacquer, and bronze on glass.
24 x 31 cm

51
Wassily Kandinsky. Munich. 1913

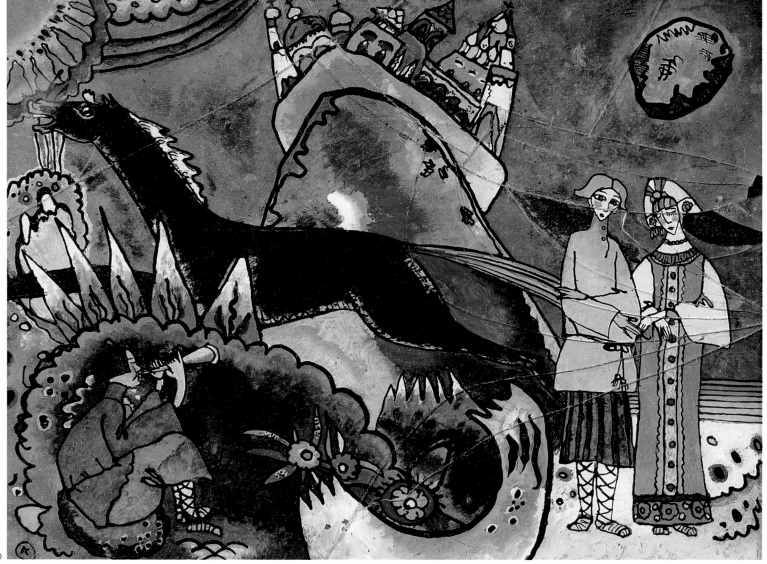

50

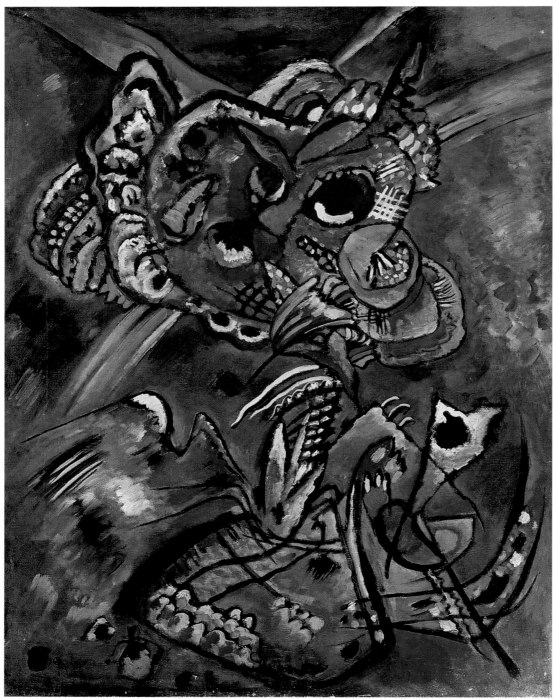

52

52
Wassily Kandinsky
Twilight Motif. 1917
Oil on canvas. 92 x 70 cm

undertaken together with Mikhail Larionov. "Above all he and Kandinsky would wander through the bazaars searching for prints by the local peasants. The folk hero Bova Korolevich and Tsar Saltan in the midst of a throng of angels and archangels 'shot through' with aniline every which way; this and not Cézanne was the true source of all the beginnings."[21] In the almanac *Der Blaue Reiter*, Kandinsky reproduced Russian popular prints, and in 1912, earlier than

Larionov, he organized an exhibition of *lubki* in Goltz's Munich gallery.

Kandinsky's first encounter with folk art took place in the early 1890s. After graduating from the Faculty of Law at Moscow University in 1892, he was sent to Vologda Province to investigate peasant households. It was there, in the villages, that he encountered the "wonder," which, as the artist wrote, subsequently became one of the elements of his works. Many years later, he still

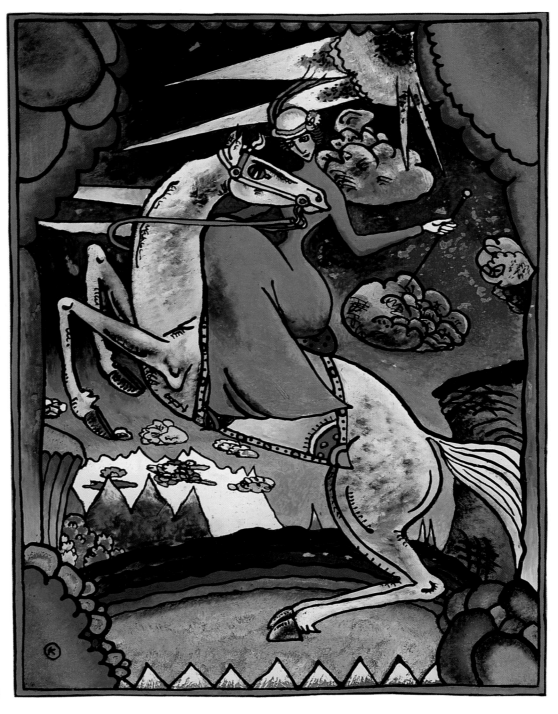

53

53
Wassily Kandinsky
Amazon in the Mountains.
1917–18
Pressed cardboard, foil, bronze, and oil on glass. 31 x 24.7 cm

→
54
Wassily Kandinsky
Blue Comb. 1917
Oil on canvas. 133 x 104 cm

→
55
Wassily Kandinsky
Composition No. 223. 1919
Oil on canvas. 126 x 95 cm

vividly retained the impression of his first visit to a peasant *izba*: "I vividly recall how I came to a stop on the threshold before that unexpected spectacle. A table, shelves, a huge and imposing stove, cupboards, and larders — everything was covered with brightly colored ornament painted in bold sweeping strokes. On the walls were *lubok* prints: a symbolic representation of a knight, battles, a song rendered in colors. The 'red corner' was filled with painted and printed icons, and before them hung a red icon-lamp glowing with warmth, as if knowing something about itself, living for itself, a secretly whispering, humble, and proud star. When I finally entered the room, painting surrounded me and I entered into it."[22] It is in these early impressions of folk art which opened up before the artist like "a song rendered in colors," that one must seek the plastic and, probably, the psychological sources of Kandinsky's work.

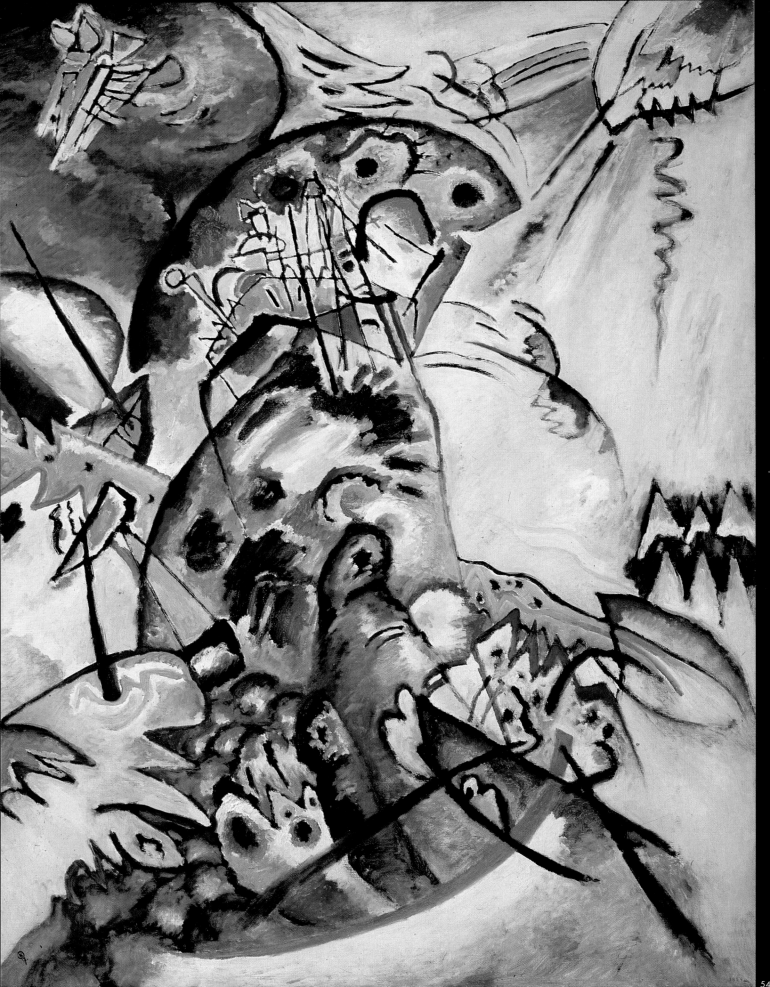

54

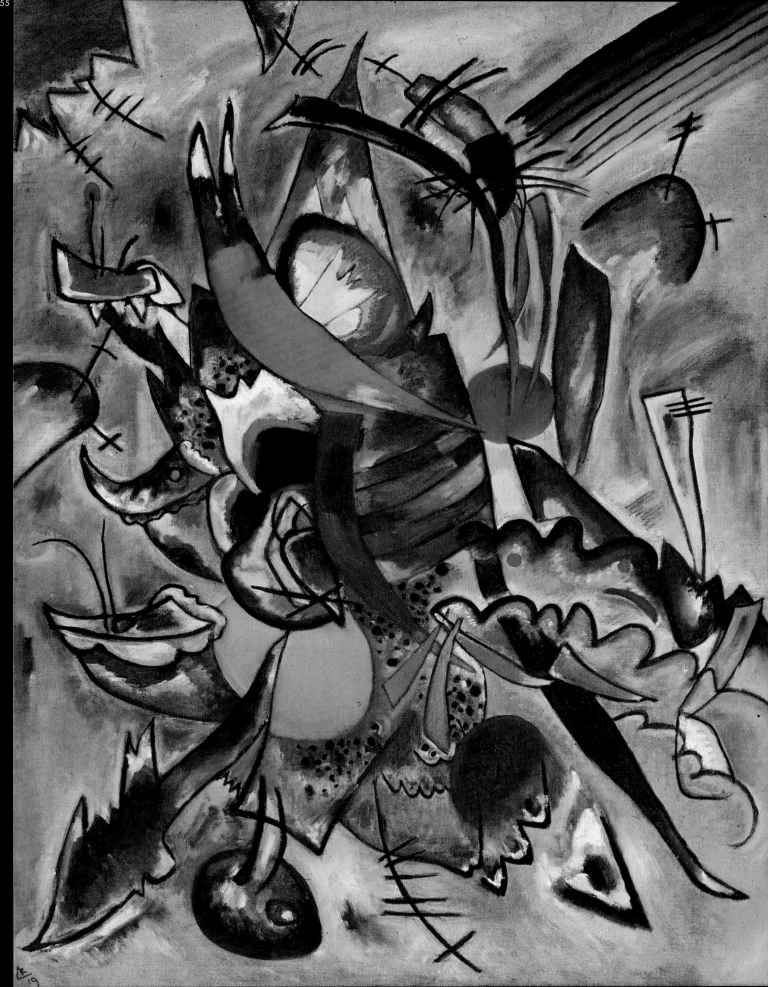

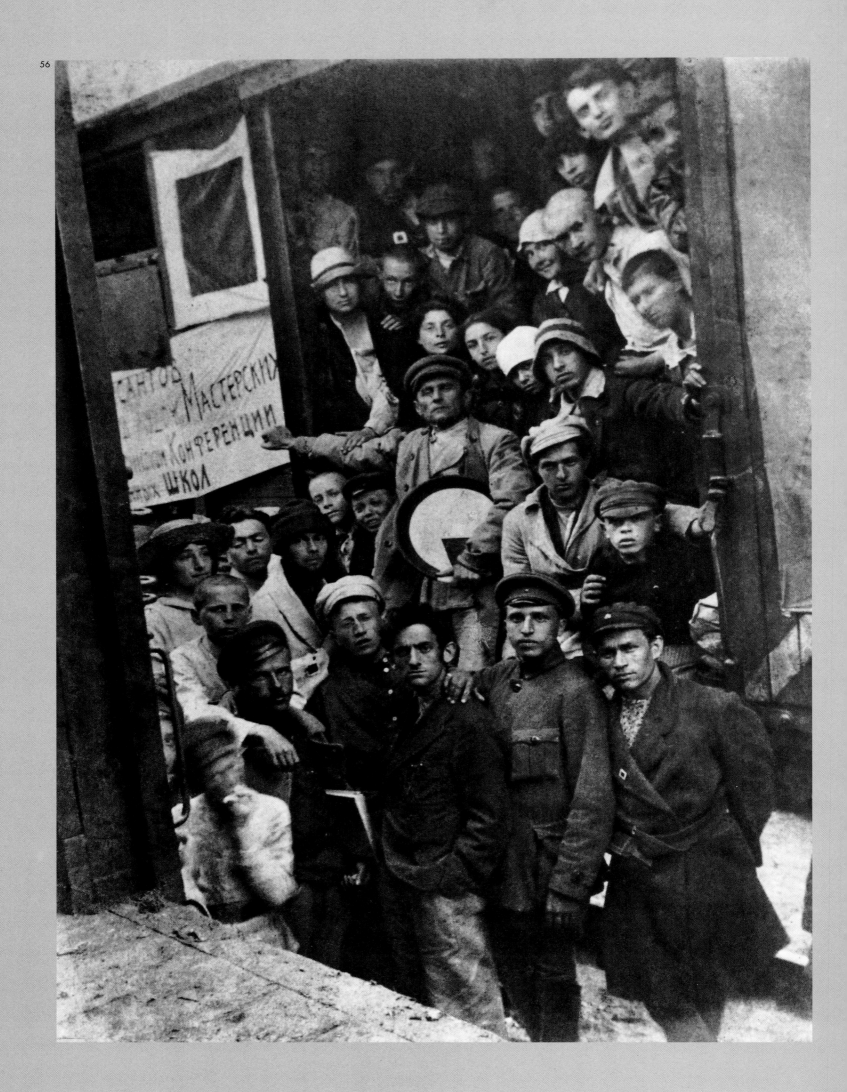

At the beginning of the twentieth century, Russian artists and poets explored in depth a new problem in the theory of art, one that was reflected in a number of terms employed by avant-garde artists: "the battle with gravity (Petrov-Vodkin), "the distribution of weight within a system of weightlessness" (Malevich), "the transformation of weight into weightlessness" (Yudin). The idea of a battle with gravity ("plastic weightlessness") became one of the leading principles in art at the beginning of the century. Artists are keenly aware that a work of art is an independent world with laws of its own, laws that are essentially spiritual and moral. True works of art have always been an autonomous world of this kind, but this world took on certain distinctive features in the work of artists early this century — organized like the Universe it relates to that, and not to the Earth with its particular laws, it "fits into" the Universe as an equal element. The sources of these ideas go back to the philosophical system of Nikolai Fiodorov.[23]

In one of his articles, Fiodorov wrote: "As long as the Earth was considered the center, we could be peaceful onlookers, taking the apparent for what is real and true; but as soon as this conviction vanished, the central location of thinking became a goal, a project."[24] For Fiodorov, one of the main tasks of this "project" consisted in humanity's venturing forth into outer space and organizing, on a cosmic scale, systems that would stand in opposition to "the forces of falling." He regarded cosmic space, the worlds of planets and stars, as the sphere of man's organizing activity in his creation of a new "architecture of the heavens" which would "serve the liberation of all worlds from the bounds of gravity, from the blind force of attraction."[25] In this case, mankind ceases to be an "idle passenger" of the Earth and becomes the "crew of this... earthly ship which is set in motion by yet unknown force."[26] Fiodorov's futurological "project" proved more radical than the boldest fantasies of the Futurists: the Earth, governed by the will of men, moves freely in the space like a vast comic ship. Fiodorov's philosophical conception also led him to a peculiar understanding of the nature of art. He was the first

56

A group of UNOVIS members ready to depart from Vitebsk for their exhibition in Moscow. 1921. In the center is Malevich and among the others traveling are Vera Yermolayeva, Lev Yudin, Yevgeniya Magaril, Ilya Chashnik, El Lissitzky, and Lazar Khidekel. The UNOVIS exhibition was given in the Cézanne Club at VKhUTEMAS.

57

Nikolai Suetin
Sketch for painting a fabric. 1920s
Watercolor on paper.
18.5 x 28.2 cm

person in the history of aesthetic theory to see the essence of artistic creation in a struggle against gravity. The philosopher wrote: "All structures erected by man, all architecture and sculpture are the expression of the same mental and material uprising or uplift."[27] He saw the special features of various architectural styles in their means of counteracting gravitation: "The relationship of the supports to the parts supported by them or the method of counteracting the falling of a body — this is the source of all different styles and serves to characterize them."[28]

Far in advance of their time, Fiodorov's ideas exercised a tremendous influence on the minds and imagination of the next generation. He created a grandiose picture of a titanic struggle with falling

and gravity; he saw humanity venturing forth into outer space and interplanetary flights. Invisible threads link Fiodorov to many phenomena in Russian art in the early years of the twentieth century. After the Revolution, Malevich frequently turned to ideas of overcoming gravity. His booklet *God Is Not Cast Down. Art, the Church, the Factory* was published in Vitebsk in 1922. Badly printed on poor paper, hard to read and still harder to understand, it was supersaturated with ideas, reminding one of a dense solution on the very point of crystallizing. One of its main concepts was the distribution of weight in a system of weightlessness, the creation of a plastic structure which would be devoid of gravity, i.e. of the dependence of the form on the conditions and logic of terrestrial laws. Another of Malevich's Vitebsk publications, *Suprematism. 34 Drawings*, also deals with ideas of plastic weightlessness, with the conception of a work of art as an independent planetary world. In this pamphlet, the artist draws a picture of mankind going forth into space — something which we are in fact witnessing today. The very concept of an "earth satellite," which signified an interplanetary flying machine, was first used by Malevich. It is important that this idea of Malevich's was not a fantastical invention but a conclusion drawn from the plastic principles of Suprematism.

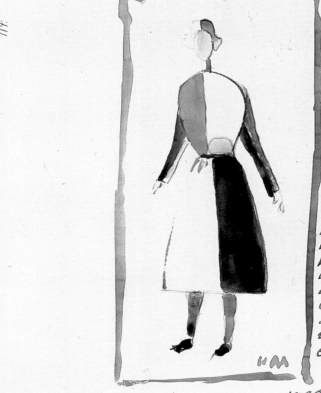

58

Kasimir Malevich
Suprematist Dress. 1923
Watercolor and graphite on paper.
19 x 17 cm

59

Kasimir Malevich
Principle of Painting a Wall: Vitebsk.
1919
Watercolor, gouache, and India ink on paper. 34 x 24.8 cm

Принцип росписи стены <u>плоскости</u> или всей
комнаты или целой квартиры по системе
Супрематизма (смерть обоям)
 К.Мельков
1919. Витебск.

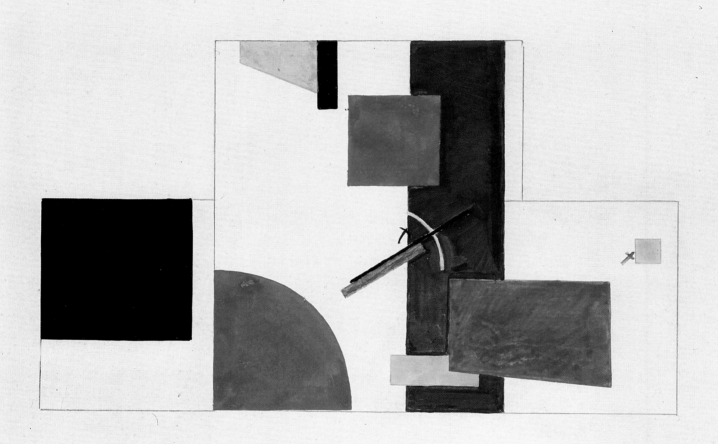

Это значит, что раскраска стен комнат или ансамбля
окрашивается по супрематическому цветному контрасту.
Окрасим окна рамы в один или два цвета, двери в другие
цвета, потолок в один оттенок, в другие принимается
во внимание объём, что все его стороны, могут быть
раскрашены в разные цвета, чтобы разная точка
смотрения была другого цвета, эта цветная таблица,
этот таблица изображающая пропорции цветов и их
отношений, а внешние элементы выполняются в архит.
 К.Мельк

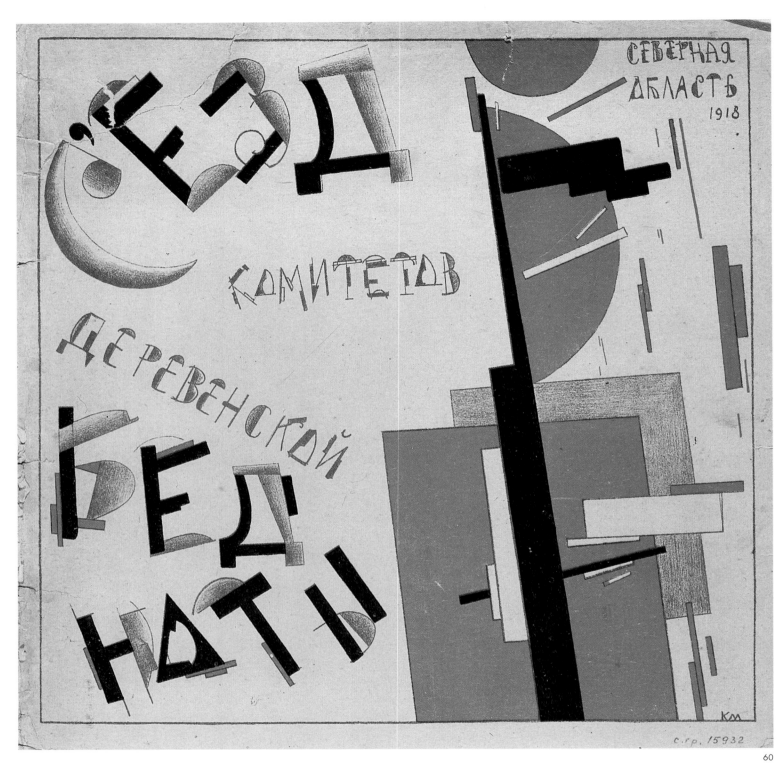

60
Kasimir Malevich
Congress of the Rural Poor. 1918
Colored lithograph. 28.9 x 29 cm

THE VITEBSK "RENAISSANCE"

In the immediate post-revolutionary years, a surprising destiny awaited the town of Vitebsk. For a short time, this quiet, provincial town became a turbulent center of artistic life. Marc Chagall, who had organized an artistic school there, wrote in December 1918: "The town of Vitebsk has begun to stir. In this provincial 'hole,' with its population of nearly 100,000, where once the likes of Yuly Klever stagnated and the pitiful Itinerants'

Education sent Vera Yermolayeva to Vitebsk. Having assumed directorship of the school, which had been converted into a "practical art" college, the 26-year-old artist became the head of one of the painting workshops. The teachers in the other workshops were Marc Chagall, as well as Yury Pen and David Yakerson, realists of the Itinerant trend. It was Chagall's workshop, however, that set the overall tone. "The students adored him at that time

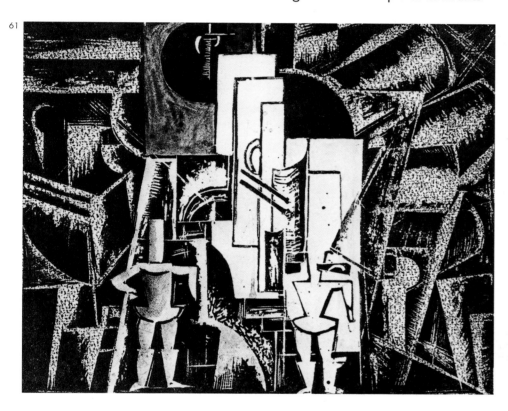

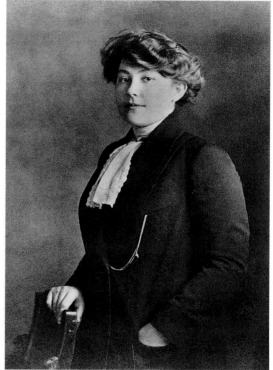

school of realists hangs on, today in these days of October developments, a boundless revolutionary art is all astir."[29]

The school of art was located in the large, airy rooms of the former mansion of a Vitebsk banker. On holidays, there would flutter above the roof a pennant with the figure of a man on a green horse and the inscription, "Chagall for Vitebsk." For two or three years eminent artists such as Chagall, Malevich, Mstislav Dobuzhinsky, Robert Falk, Ivan Puni, Xenia Boguslavskaya, Vera Yermolayeva, and Nadezhda Liubavina taught at the school. In the fall of 1919 the Fine Arts Department of the People's Commissariat for

and accordingly covered all the fences and shop signs that remained intact after the Revolution with little Chagallian cows and pigs, with legs pointing down and legs pointing up."[30]

But soon the situation changed. In November 1919, Kasimir Malevich arrived in Vitebsk at the invitation of Yermolayeva. He brought to the school the very latest word in modern art — Suprematism. Rapt with interest in his system and carried away by his preaching and personality, Chagall's students went over to Malevich one after the other. We are struck by the swiftness of the artistic conversions: within a month or so, El Lissitzky, who had just

61

Vera Yermolayeva
Set design for the opera *Victory over the Sun* by Alexei Kruchonykh and Mikhail Matiushin. Linocut. Vitebsk. 1920

62

Vera Yermolayeva. About 1917

published a completely "Chagallian" illustrated fairy-tale book with traditional little goats, became an orthodox Suprematist. Not only did Malevich know to talk but he could demonstrate and explain with pencil and brush in hand as well. Indomitable

63
Lazar Lissitzky (El Lissitzky)
Illustration to the Jewish folk tale
The Little Goat. 1919
Colored lithograph. 17 x 20 cm

energy, a belief in the correctness of his ideas which had opened up new horizons to art, and a creatively conceived program of action, helped Malevich to form a collective of artists who played a large role in the development of Soviet art. In Lev Yudin's diary of these years, we find a characteristic entry: "How firm K. S. [Kasimir Severinovich Malevich] is when our lot start to whimper and complain about how expensive everything is, it really begins to

appear like the end of the world. Then K. S. arrives and straightaway there is another atmosphere. He creates around himself another atmosphere. That is a real leader."[31] February 14, 1920, saw the founding in Vitebsk of UNOVIS (an acronym for Affirmers of the New Art). "Let the overthrow of the old world of art be traced indelibly on your palms" — under this slogan publications by UNOVIS appeared and debates were held. The core members of the new association, headed by Malevich, were Vera Yermolayeva, Lazar (El) Lissitzky, Nikolai Suetin, Lev Yudin, Ilya Chashnik, Nina Kogan, Lazar Khidekel, and Yevgenia Magaril.

UNOVIS came forth with a broad program for transforming all forms of the plastic arts, yet it was only able to realize this program to a very small extent. The proposed plan of works included the following points:

"1. Organizing the elaboration of designs for new forms of utilitarian structures and requirements as well as their implementation.
2. Working out the tasks of a new architecture.
3. Creating new ornamentation (for fabric, upholstery, casting, and related industries).
4. The designs of monumental decorations as a means of adorning the city during major holidays.
5. Designs for the decoration of the inside and outside of buildings and the realization of these works.
6. The creation of furniture and other utilitarian articles.
7. The creation of a contemporary form of book and other achievements in printing."[32]

Here in Vitebsk, Suprematism was for the first time seriously applied to the realm of decorative art and design, although the first experiments in this sphere had already been made in the pre-revolutionary years by Olga Rozanova, Xenia Boguslavskaya, and Malevich himself.

The artistic life which poured forth from the school forced its way into the drowsy atmosphere of the town. There were lectures and debates on new art, evening

In 1920, Chagall returned to Moscow from Vitebsk. In Vitebsk he had carried out a revolution in his own way. There he was like a small piece of the new power. He was a Soviet Commissar of Art. But then he got fed up and unshouldered the burden of a high title. This was his story at any rate. The truth was that after two years of exercising authority, he was unseated by the Suprematist Malevich, who took his pupils away from him and gained control of the art institute. He accused Chagall of moderation, saying that in the last analysis he was a neo-realist, that he was still fooling around with the representation of different sorts of things and figures, whereas the truly revolutionary art was non-objective. The pupils believed in the Revolution and artistic modernism was unbearable for them. Chagall tried to deliver some speeches, but they were confused and almost incoherent. Malevich retorted with strong and crushing words. Suprematism was declared to be the artistic hypostasis of the Revolution. Chagall was obliged to go away ("I almost wrote 'run away'") to Moscow.

A. Efros, *Profili [Profiles]*, Moscow, 1930, pp. 200, 201

demonstrations of drawing with lectures on the principles of Cubism, Futurism, and Suprematism, and exhibitions following on one after the other. And when there were revolutionary holidays, the town was decked out in a wondrous attire that was beyond the comprehension of common inhabitants. "I wound up in Vitebsk after the October celebrations," reminisced the artist Sophia Dymshits-Tolstaya. "But the town was already ablaze with designs by Malevich — circles, squares, dots, and lines of different colors, and flying people by Chagall. It seemed to me as if I had stumbled into a town over which a spell had been cast, but at that time everything was possible and wonderful and in that period Vitebsk folk had turned into Suprematists. In essence, the townsfolk probably thought of it as some kind of new attack,

cloth. Geometrical colored forms, interacting with one another, are subordinated in Suprematism to the laws of contrast and harmony. Each element of the form inevitably and naturally becomes part of the unified structure. In 1919, Malevich created a colored drawing which was a singular module for Suprematist constructions. In the margins the artist wrote: "Suprematist variations and proportions of colored forms for painting the walls of a house, cellular unit, book, poster, and podium." Painted within three "quadrates," as Malevich termed the rectangles and squares of his composition, were a triangle, a circle, and a square — the static elements, to which was opposed the "dynamic quadrate as a contrast." From these elements the members of UNOVIS created posters and decorative designs for factories (El Lissitzky), festive panels (Yermolayeva), a speaker's podium, and the decorative painting of a tram and train car (Suetin, Chashnik).

Almost none of Malevich's pupils became a Suprematist, but the Vitebsk school and the lessons in Suprematism gave each of them an electrical charge that lasted throughout their lives. With this experience as a starting point, El Lissitzky became a unique book-maker, while Yudin worked in a graphic idiom that retained much of the lessons on Cubism that were so deeply inculcated in Vitebsk. For the natural element of color, which had always exercised an attraction for Yermolayeva, Malevich provided a hard foundation, the culture of form. In the Russian Museum in St. Petersburg are sketches of shop signs created by Suetin for Vitebsk stores. In contrast to many of those who worked with Malevich and assimilated only the decorative side of Suprematism, Suetin was close to the inner philosophical principles of the new tendency. When many of Malevich's followers turned away from him at the beginning of the thirties, Suetin continued to develop the plastic structures of Suprematism, remaining true to Malevich to the end of his life.

64

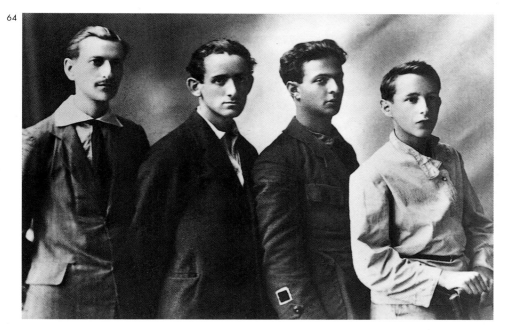

64

In Vitebsk. 1921. From left to right: Ivan Chervinka, Lazar Khidekel, Ilya Chashnik, and Lev Yudin.

"Things are very good. We all feel ourselves close to K. S. [Malevich]. I clearly sense the entire gulf between us and everything old. We are innovators and it is up to us to go through everything that K. S. and others have had to go through. A conversation with Malevich stressed the same point. We know a lot and have gone a long way."

From the Vitebsk *Diary* of Lev Yudin, entry for November 29, 1921 (Yudin family archive, St Petersburg)

something interesting and beyond understanding which had to be lived through."[33] Following the successful start in Vitebsk, UNOVIS groups sprang up in Smolensk, Kharkov, Moscow, Petrograd, Samara, Saratov, Perm, and other cities. In his Vitebsk period, Malevich worked a lot with architectonic designs and applied Suprematism. We still have some of his sketches for women's dresses and fabric designs, and even a fragment of block-printed

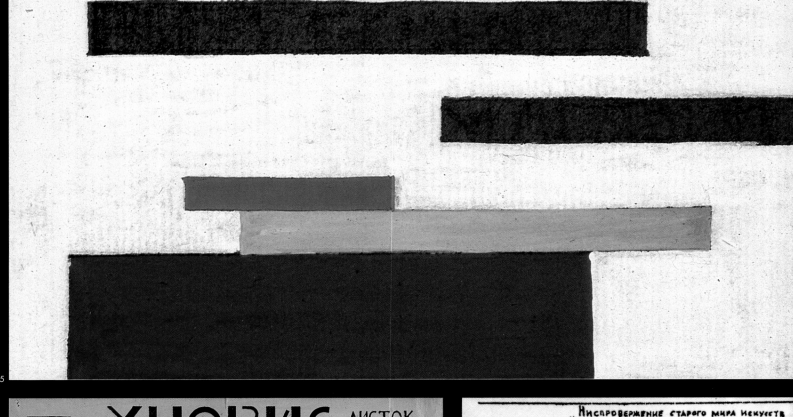

65

66

67

In Vitebsk, Malevich for the first time found himself surrounded by abundant material for pedagogical work, toward which the artist had always gravitated. This material consisted of young people who soaked up the preachings of the new art like a sponge. The learning process was built on the practical mastery of Cubism, Futurism, and Suprematism.

Particularly fruitful for the analysis of artistic structures were the evenings of experi-

mental drawing, the minutes of which have in part been preserved. Such an evening was organized on March 22, 1920, "with the object of showing that Cubism is not a flight of the imagination and not a trivial pursuit and that we are really doing something and are on the move. We will draw and discuss why we do it this way and not some other way."[34] Here is an excerpt from the minutes of that evening. "*Zuperman* (showing a painting): For me, the violin did not exist as an object; I constructed a specific rectilinear plane; I showed the depth. The entire construction should be reduced to the energy of pictorial masses,

to painting in its pure form, without objects. Within the framework of the canvas, forms intensively grow from bottom to top, forming a well balanced entity. In painting we have flowing colors and varied textures. *Malevich*: At this point in the development of Zuperman's work, we see a painter's approach. He does not need an object; the forms of the object were painterly masses which were reproduced in a purely arbitrary construction. We should look

on the object as being a purely pictorial outgrowth of content. Before us arises an organized body with its own diversity, like the unity of a common body; the forging of disparate elements into a unity within the artist will be an indicator of his truly ingenious, creative invention. Whereas previously what beckoned to the artist was an object and various episodes, now painting is becoming the very cause itself of creative organisms. Previously the theme for a picture *Court in Session* confined the artist to the order of the court in working out the composition; the placing of the judges, attorneys etc. were deter-

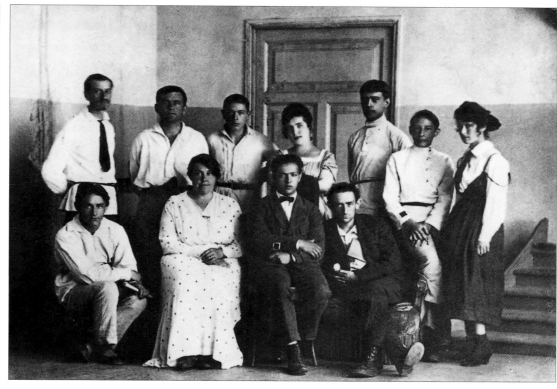

72

mined in advance; in such representation there is very little creativity. The artist's penetration has gone into psychology. Cubism places the artist in a position that is related solely to painting, involving him in naturally creative action. In this way, the artist evolves into a purely creative, painting-oriented, architectonic organism which is new in nature. The pictures of Yudin and Zuperman already indicate how close we are to the elucidation of the inherent natural meaning of pictorial development."[35]

The Vitebsk UNOVIS realized a number of theatrical productions. On February 6, 1920, there were productions of "a Suprematist ballet," based on sketches by Nina Kogan, and the opera *Victory over the Sun* by Alexei Kruchonykh and Mikhail Matiushin, in a dramatic presentation with designs by Vera Yermolayeva. On September 17 the same year, UNOVIS put on the prolog to Mayakovsky's *Mystery-Bouffe* as well as his *War and Peace*.

Several UNOVIS exhibitions were arranged in Vitebsk. Twice, in 1920 and 1921, the Vitebsk school demonstrated its works in Moscow at the Cézanne Club attached to VKhUTEMAS. At the Russian exhibition

in Berlin, organized in 1922 by the People's Commissariat for Education, the works of Malevich, Yermolayeva, El Lissitzky, and also a group of pupils of the Vitebsk school were shown. David Shterenberg, the commissar responsible for the exhibition, observed: "The works of the VKhUTEMAS pupils, the Vitebsk workshop and the Sytin school were greatly liked."[36]

The Vitebsk "Suprematist renaissance" came to an end as suddenly as it had begun. In 1922, Malevich left for Petrograd accompanied by the leading members of UNOVIS. The Vitebsk UNOVIS formed the basis of the Petrograd Institute of Artistic Culture (GINKhUK).

72

The Vitebsk UNOVIS in 1920. Standing, from left to right: Ivan Chervinka, Kasimir Malevich, Yefim Rayak, Nina Kogan, Nikolai Suetin, Lev Yudin, and Yevgeniya Magaril. Seated: unknown person, Vera Yermolayeva, Ilya Chashnik, and Lazar Khidekel

→
73

Ilya Chashnik
Sketch for the poster
Soviet Screen No. 4. 1920
Black and red India ink on paper.
98 x 66 cm

→
74

Nikolai Suetin
Sketch for a wall painting. Vitebsk. 1920
Colored India ink on paper.
20.3 x 18.2 cm

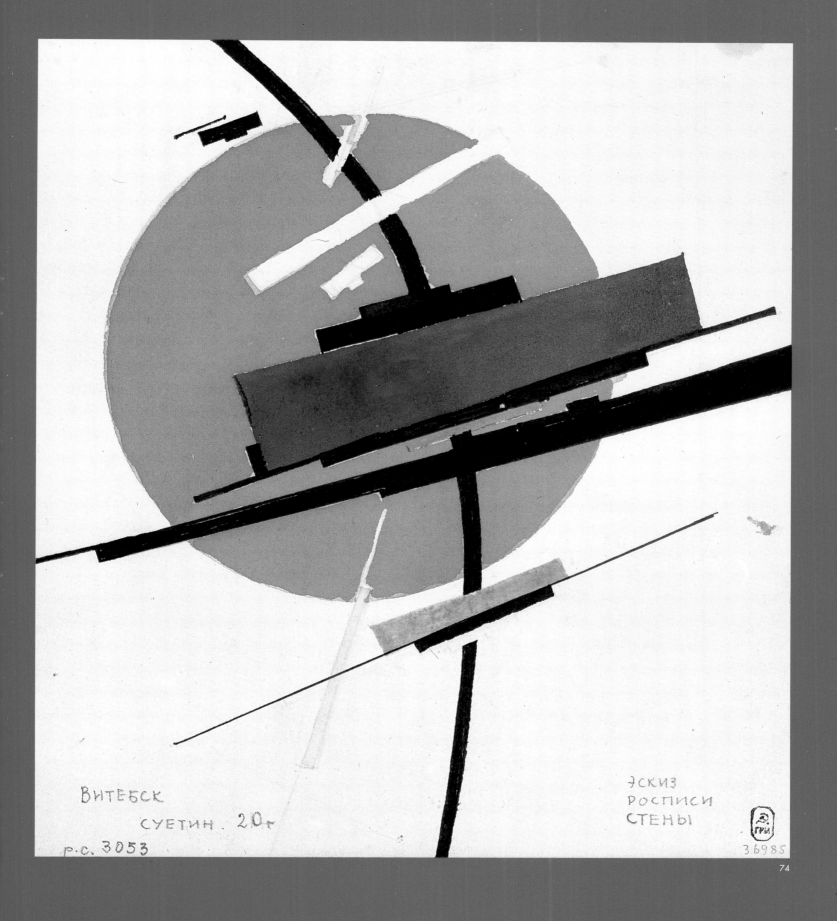

ВИТЕБСК

СУЕТИН. 20г

р.с. 3053

ЭСКИЗ
РОСПИСИ
СТЕНЫ

3.6985

74

THE WORLD'S FIRST MUSEUM
OF AVANT-GARDE ART

Power in artistic matters was placed in the hands of its representatives. This was a splendid moment, when the power over art was really in the hands of the artists themselves. It was a tremendous victory over criticism and collectors, the actual rulers of the fate of art and artists.

Kasimir Malevich

75
Vladimir Tatlin
Design of a monument to the
Third International. 1919–20

76
Exhibition of the Newest
Tendencies in Painting.
The Russian Museum, 1927
"The Department of Modern Art aims to collect and study contemporary works of art. Contemporary works of art are considered to be those pictures, statues, drawings, and other kinds of artistically valuable items which have come into being during approximately the last twenty years. Accordingly, the material that is the province of the department changes with the passage of time. Today, for example, the department is occupied with the study of painting during the period of 1907 to 1927. In five years time it will collect works of art that were created during the period from 1912 to 1932, and so forth."

N. Punin, *Noveyshiye techeniya v russkom iskusstve* [*The Newest Tendencies in Russian Art*], Leningrad, 1927, p. 8

Immediately after the Revolution, there arose among avant-garde artists the idea of organizing a museum of the latest art with the aim of showing its best accomplishments to the public at large. It was not until years had gone by and they had lost their novelty and timeliness that the works of this new art found their way into official museum collections.

On December 5, 1918, a meeting of the organizing committee of the Museum of Artistic Culture was held, its members including Nathan Altman, Alexei Karev, and Alexander Matveyev. The newspaper *Iskusstvo kommuny* [*The Art of the Commune*] published a list of the artists whose works would be acquired for the new museum. Among 143 representatives of the Russian avant-garde were the names of Malevich, Tatlin, Filonov, Rozanova, Larionov, Goncharova, Altman, Le Dantu, Matiushin, Mansurov, and Yermolayeva. On April 3, 1921, the Painting Department of the Museum of Artistic Culture was opened to visitors. It was located in the Miatlev house,

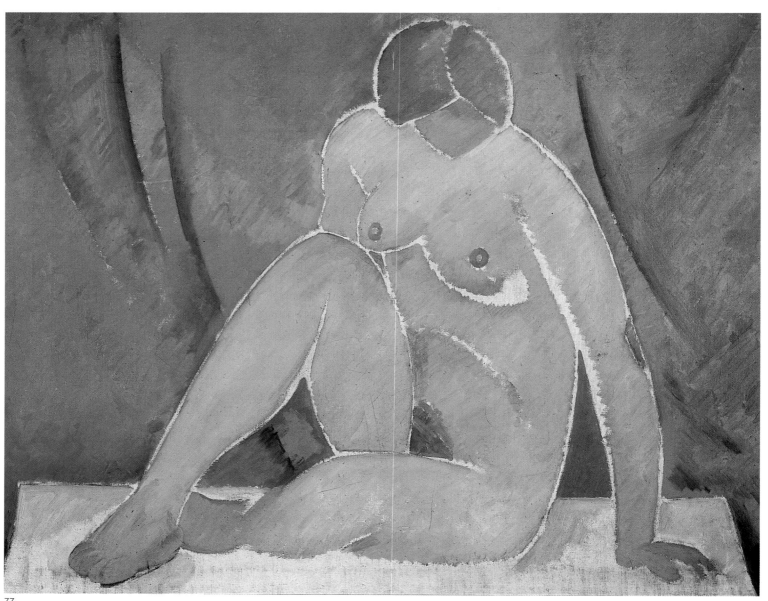

77

on Isaakievskaya (St. Isaac's) Square in Petrograd, which had formerly been occupied by the People's Commissariat for Education. The critic Vladimir Botsianovsky wrote: "So far, the most revealing and important event we have seen is the exhitition of artistic culture organized by the Fine Arts Department in the Miatlev house on St. Isaac's Square. Actually, this was not an exhibition but a full-fledged museum. And at present it has indeed been converted into one, and is even officially named a museum, which is under the curatorship of the artist A. I. Taran."[37] Later the museum opened up sections dedicated to drawing, icons, and industrial arts.

The Museum of Artistic Culture became the world's first museum of avant-garde art in which contemporary works by living masters were shown, works which in the usual course of events could prove their right to be exhibited in a museum only after many long years. The museum existed for only a few years. In 1926, its marvelous collections, reflecting the whole spectrum of the Russian avant-garde of the 1910s and 1920s, were handed over to the Russian Museum, where Nikolai Punin and Vera Anikiyeva organized a Department of the Latest Trends in Art, which was opened for the tenth anniversary of the Revolution.

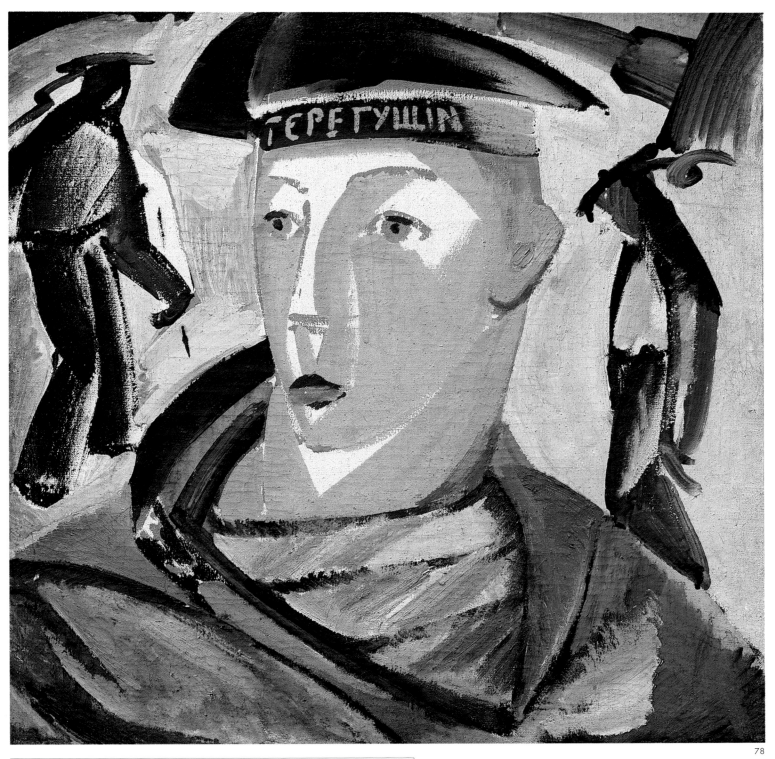

People's Commissariat for Education which is called IZO. The workers' revolution has helped the revolution in art. <...>
It has always seemed to me that museums workers are amazingly like moles who have a splendid understanding of how to get around underground, but do not see anything on the surface. For them, the present phenomenon of art is like the sun for a mole or an owl — exceedingly bright, and that is why they have always lowered their eyes to the ground before the building where active art was on display. In 1910, the Jack of Diamonds; in 1912, Donkey's Tail; in 1914, Streetcar B, Target; in 1915, The Last Futurist Exhibition 0.10, and others.[38] Those were the days when the sun reached the point of greatest brightness in that period.

The eminent names in the administration of museums and writing criticism could do nothing more than scream: 'This is abomination and desolation,' and that 'the Coming Lout' was there.[39] A. Benois and D. Merezhkovsky shouted this, and they're not savages but cultured people, 'connoisseurs of art.' Not one savage shouted to the sun: 'Disappear into the abyss of the sea because you blind my eyes and make my reason swim.'"

K. Malevich, *Muzei khudozhestvennoi kul'tury* [*Museum of Artistic Culture*], August 15, 1923. St. Petersburg, Central State Archive, fund 4340, part 1, No. 25, ff. 30–35

77
Vladimir Tatlin
Model. 1910s
Oil on canvas. 104.5 x 130.5 cm

78
Vladimir Tatlin
Sailor. 1911
Tempera on canvas. 71.5 x 71.5 cm

79

In the summer of 1922, the Museum of Artistic Culture received a telegram from the village of Santalovo in Novgorod Province: "Khlebnikov sick; immediate help required." The message had been sent by Piotr Miturich, who happened to be with his own family and the terminally ill poet in the Novgorod hinterlands. Pavel Mansurov recalled: "And since you mention the death of Khlebnikov, in 1922, before he passed away, I received instructions to travel to Santalovo, Novgorod Province, where he was laid up sick. With him was Miturich, who was also without a kopeck in his pocket and so could not render any material assistance. But when I was just supposed to set off as the youngest of all the members of the INKhUK Council,[40] a telegram arrived giving notice of Khlebnikov's death. And so the trip was cancelled. "[41]

Tatlin wrote to Miturich: "You know, as soon as we learned of Khlebnikov's death, we commemorated as well as we could the main things that have happened during all the time we have been together."[42]

For Tatlin, Velimir Khlebnikov, whose poetry he deeply admired, was a leading figure in contemporary literature and art. The influence of the poet's ideas on Tatlin's innovations has yet to be studied in full. The lines which Khlebnikov dedicated to him show that the poet too paid tribute to the temerity with which the artist struck forth on unexplored paths.

> Tatlin, secret-seer of blades,
> Stern singer of the screw,
> He of the sun-catchers' crew.
> A spidery dale of gossamer gear,
> He wove with hand dead sure
> Into iron shoes and shears.
> In a secret vision pincers
> Look, as he's shown,
> Blindmen of their speech outgrown
> So unheard of, beyond our ken,
> By his brush wrought, things of tin.[43]

Expressed here in poetic form is the impression created by Tatlin's new works, which staggered his contemporaries.

On May 9 this year a performance + lecture + exhibition of material constructions will be mounted at the Museum of Artistic Culture (9 St. Isaac's Square). The theme adopted is *Zangezi*, the piece that Khlebnikov produced shortly before his death. This is the crowning glory of Khlebnikov's work. His work on language and study of the laws of time merged in the play in the form of a superstory. N. Punin will give a paper on Khlebnikov's laws of time. The phonetician Yakubinsky will talk about his verbal creativity. The production of *Zangezi* will be in accordance with the principle: "The word is the unit of the buildings; the material is the unit of the organized volume." According to Khlebnikov's own definition, the superstory is the "architecture of stories," and the story is "the architecture of words." He regards the word as a plastic material. The properties of this material permit him to operate with them and

79

Velimir Khlebnikov in soldier's uniform. 1916

"In the name of preserving a correct literary perspective, I consider it my duty to put down in black and white both personally and, as I am sure, in the name of my friends, the poets Aseyev, Burliuk, Kruchonykh, Kamensky, and Pasternak, that we considered him — and still do, one of our poetic teachers, who is a splendid and most honorable knight in our poetic struggle."

V. Mayakovsky, "V.V. Khlebnikov," in V. Mayakovsky, *Sobraniye sochineniy* [*Collected Works*], vol. 12, p. 28, Moscow, 1922

80

Poster for the opera *Zangezi* based on Velimir Khlebnikov's poem *Zangezi* staged by Vladimir Tatlin in the Petrograd Museum of Artistic Culture. May 1923

"The small stone of equal-sized words serves as the unit. The superstory or the trans-story is comprised of independent excerpts, each with its special god, its special faith and special code. In response to the Moscow question: 'What is your faith?,' each answers independently of his neighbor. They have been granted the freedom of professing their faith. The structural unit, the stone of the superstory is the story of the first order. It resembles sculpture that is made from different-colored blocks of different kinds of stone — the body of white stone, the coat and garments, of sky blue stone, the eyes of black stone. The story is hewn from different-colored blocks of words having a different structure. Thus, we find a new kind of work in the domain of speech. A story is architecture consisting of words. The architecture built up of 'stories' is the superstory. The artist's block is not the word but the story of the first order."

Velimir Khlebnikov, "Vstupleniye" ["Introduction"], in *Zangezi*, Moscow, 1922, p. 1

"By his brush wrought, things of tin" are the "painted reliefs" and "counter-reliefs," which were relief and three-dimensional constructions executed using different materials. Tatlin first showed these works in 1914 and 1915 at exhibitions in Moscow and Petrograd.

At the time, the exhibition "The Union of New Tendencies in Art" was under way

80

in the museum. As soon as word of Khlebnikov's death arrived, Tatlin added to the exhibition a special display dedicated to the memory of the poet.

On the anniversary of Khlebnikov's death, Tatlin staged in the showing rooms of the Museum of Artistic Culture a dramatic poem that summed up the work of the poet on a "stellar" or "universe" language that was to unify mankind. This somewhat enigmatic work calls for mustering a great inner tension and spiritual effort in order to penetrate the complex world of ideas, images, symbols, and sounds with which the poem is filled. In it are alloyed the poet's conceptions regarding sound and word, the history of mankind, and space and time as "the measure of the world." In the deep

foundations of language, Khlebnikov thought, one can seize the immutable laws of time and space: "Space sound through the alphabet," and the speeches in *Zangezi* "are stellar songs in which the algebra of words is mixed with yards and hours."[44] The performance was given three times, on May 11, 13, and 30, 1923.

In the intermission between the first and second acts, the critic Nikolai Punin gave a talk on the laws of time in Khlebnikov's work and the linguist Lev Yakubinsky elucidated the linguistic structure of the poem. Little has been preserved of the performance — only three drawings by Tatlin, *Laughter* (depicting a character from *Zangezi*) and two sketches of the set, a pyramidal construction from the top of which Zangezi, a sage and prophet (played by Tatlin), harangued the crowd. The performances were played to a full house, calling forth both bewilderment and rapture, incomprehension and burning interest . Tatlin did everything possible to use scenographic means to reveal the ideas of *Zangezi* to the spectators. He wrote: "Parallel to the verbal construc-

build "national states of language." Khlebnikov's approach made it possible for me to work on the staging. We decided to carry out the material construction parallel to the verbal construction. This method will permit us to fuse into a single whole the works of two people of different specialities, thus making the work of Khlebnikov accessible to the masses. Khlebnikov takes sound as the main element. He has within him the impulse to generate words. The sound *ch*, say, gives rise to the words: *chasha* (cup), *cherep* (skull), *chulok* (sock), *chan* (vat). All these words convey the idea of a membrane, one body in the membrane of another. The sound *l* speaks of the diminishing of energy through the growth of the surface to which it is applied: *lodka* (boat), *lezhanka* (bunk), *ladon'* (palm), *list* (leaf), *lit'* (to pour), and so on. In one of the "decks of planes" which make up *Zangezi* there are a number of such prophetic sounds, like a song of "the Stellar Language":

> Where the swarm of green *Ha* for two,
> And *El* of the clothing while running,
> *Go* of the clouds above the games of people,
> *Ve* of the invisible fire of the crowds
> about us and *La* of work, and *Pe* of playing
> and singing.

So as to reveal the nature of these sounds, I have taken surfaces that are varied in material and treatment. The "song of the Stellar Language" and, in general, everything that Zangezi says, is like a ray slowly passing from the thinker above down to the uncomprehending crowd. This contact is established by means of a specially developed apparatus. In *Zangezi* there are places of great tension in the energy of verbal creativity. It was necessary to introduce machines which, through their movement, again create a parallel to the action and at the same time merge with it.

By virtue of its construction, *Zangezi* is such a diverse and difficult work to stage that the scenes cannot contain this pageant within themselves, being an enclosed space. In order to direct the attention of the spectator, the eye of the spotlight slips about from one place to another, introducing an element of order and continuity. The spotlight is also necessary to bring out the properties of the material.

The actors are young people: artists, students at the Academy of Arts, the Institute of Mining, and the University. This is deliberate: professional actors are trained in the traditions of old and contemporary theater. *Zangezi* is too new to be subordinated to any existing traditions whatsoever. So it is better for the revelation of Khlebnikov's creativity, as a revolutionary event, to mobilize young people who haven't been touched by the theater.

V. Tatlin, "*O Zangezi,*" *Zhizn' iskusstva* ["On *Zangezi,*" *The Life of Art*], 1923, No. 18, p. 15

81

tion, we have decided to introduce a material construction. This method will permit us to fuse into a single whole the works of two people of different specialities, thus making the work of Khlebnikov accessible to the masses."[45] Apart from the main structure atop which Zangezi held forth to those below, Tatlin created theatrical backdrops, or, to use his own terminology, "material backgrounds" and the "Iverni-

vyverni" machine (an expression from *Zangezi*) which brought these backgrounds into motion. The main element of the production was a "deck of planar surfaces," that is, boards which Tatlin painted in tempera and which expressed the sounds of a "Stellar Language." During the course of the play, they were paraded across the stage. Two spotlights guided the spectators eye focusing his attention on the main

At the time when Moscow is thus celebrating a great Suprematist festival, there lives quietly, nominally recognized but in fact far outside the sphere of wide influence, another master of the Moscow art world — V. Tatlin. There are no noticeable changes in the activity of this artist. The malicious dimwits interpret this fact as stagnation, decay, and death, if fate had granted these gentlemen a little bit more artistic feeling, they would understand what such a "stagnation" proclaims. Cézanne too stagnated in Arles, surpassed by the followers of Van Gogh; now we have discovered the meaning of this stagnation in Arles.

If you will permit me, I consider Tatlin to be the only creative force capable of moving art beyond the entrenchments of the old positional lines. Wherein lies this force? In a simplicity that is completely pure and organic. As a master, he is so developed internally that in him I do not find a single raw feeling or a single raw thought. He is a master from tip to toe, from the most involuntary reflex to the most conscious act. Striking, completely unparalleled mastery!

Tatlin's art, insofar as we are used to applying this concept to all our artistic past, is not art; it is, as he says himself, "an act of representation." Through this act of representation, Tatlin gave the world a new form. The new form is a kind of high relief which is the antipode of the past and has gone beyond all the limits of painting as such. It is clouds of arrows aimed at the future without circumspection.

N. Punin, "O novykh khudozhestvennykh gruppirovkakh. V Moskve (Pis'mo)," *Iskusstvo kommuny* ["On the New Artistic Groupings. In Moscow (A Letter)," *The Art of the Commune*], 1919, February 9 (excerpt)

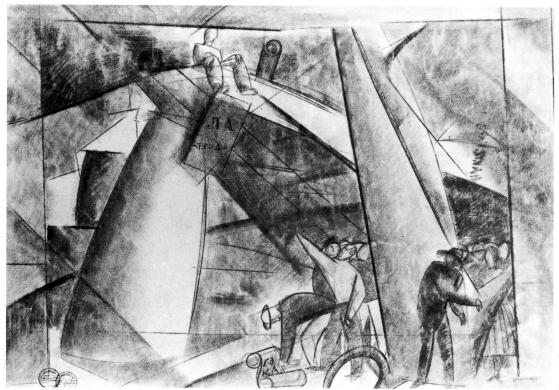

82

83

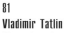

81

Vladimir Tatlin
Sketch of a costume for Richard Wagner's opera *The Flying Dutchman*. 1915–17
Charcoal on paper. 72.2 x 51 cm

82

Vladimir Tatlin
Sketch for the set of the opera *Zangezi* based on Velimir Khlebnikov's poem. 1923
Charcoal on paper. 55.8 x 76.3 cm

83

Vladimir Tatlin
Sketch for the set of the opera *Zangezi* based on Velimir Khlebnikov's poem. 1923
Charcoal on paper. 55.4 x 76.1 cm

conceptual points of the action taking place on stage.

The press carried only a few mentions of the play. Nikolai Punin observed presciently: "The time of Tatlin and Khelbnikov is somewhere still ahead of us. But when it comes many will be the times when people will remember these two evenings and beat their brains out trying to reconstruct how it actually was and it won't be only the stars who clap their hands in glee at the restoration experts."[46]

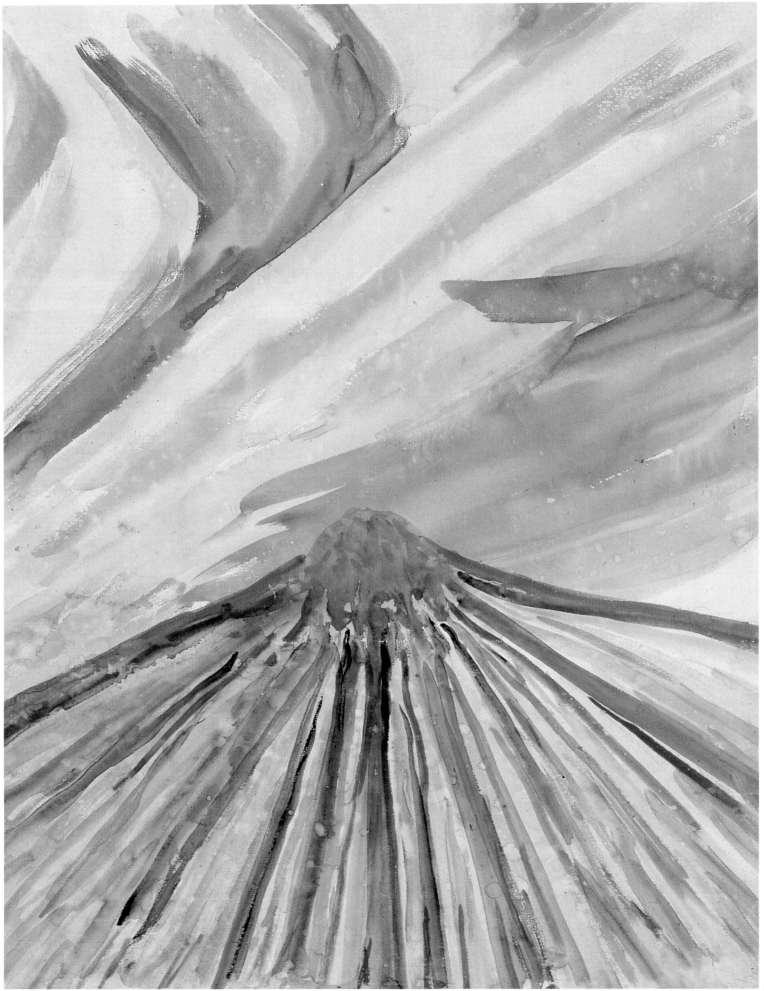

THE INSTITUTE OF ARTISTIC CULTURE

As early as 1921, research work began at the Museum of Artistic Culture. Malevich gave lectures on the themes "Light and Color" and "A New Proof in Art". Matiushin read a paper entitled "On the Artist's New Space", and Yermolayeva lectured on "The System of Cubism." The idea arose of creating a research center

Since 1912, an "exodus from Cubism" had been taking place in the Russian avant-garde. Whoever stuck with Cubism was squeezed of the main road of artistic development. The new tendencies were in need of a theoretical grounding, as was the case in France when Cubism was on the rise. Now that a research center had been

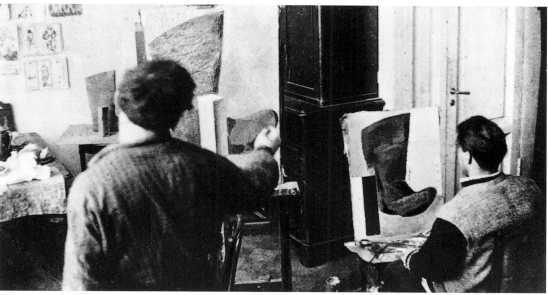

to study new problems in art. On June 9, 1923, at a museum conference in Petrograd, Pavel Filonov gave a lecture in which he set forth a proposal, in the name of "a group of leftist artists," to convert the museum into an Institute for the Study of Contemporary Artistic Culture.

But why should these creative figures also have to take upon themselves the task of art scholars? In order to answer this question, several points should be made.

Traditional criticism found itself bankrupt when faced with the questions raised by the new art. For two decades, it had scoffed at the Russian avant-garde movement, exaggerating the gulf between the public and the artists. Even the most enlightened critics, such as Alexander Benois, hampered the development of new artistic trends.

organized, the avant-garde artists considered that the development of plastic form had an inner logic that was free of anything arbitrary. They felt that there existed in the onward movement of art a natural and inevitable "world line." By studying the logic of the development of plastic structures, it would be possible not only to discern a strict regularity in the past but even to define a "vector" pointing to the future. And there was no inventing or fabricating this vector; one could only sweep aside all extraneous elements and "help" the "world line of development pass through" oneself.

There was yet another incentive for studying "artistic culture," which was less noticeable in the statements of the founders of the institute, but which was perhaps of the greatest importance. Each work of art was like a "little universe," or the materialized sum of the

84
Mikhail Matiushin
Haystack at Lakhta. 1921
Watercolor on paper. 53 x 41.5 cm

85
In a GINKhUK studio. Valentin Kurdov (left) and Yury Vasnetsov (right). 1926

Kasimir Malevich's Interview
with His Pupil V. Sterligov

The task of the interview is to reveal
the pupil's attitude to the main elements
of painting. To find out his gravitation
to this or that element. By periodically
repeating such interrogations, we obtain
a full picture of the struggle of the surplus
elements in the individual. We can assess
the (subconscious) affinity for this or that
surplus element. We can speed up the
development by removing other
influences or, *vice versa*, slow it down by
grafting on surplus elements that contrast
with the first. In the interrogation,
we consider and differentiate conscious
and subconscious solutions, affinities, and
gravitations.
On November 30, 1926, V. S. was
called to his workshop for a discussion.
The question was asked: "Does this work
exhibit something new and if so, what
exactly?"
V. S. answered that a relationship had
been revealed. A feeling which previously
had not entered into his consciousness
at all. Apart from the mechanical linking
together of two units (board to board,
nailed together) there existed a connec-
tion via the relations, which naturally
is the link with painting. Objects are not
painted separately; rather, all the attention
is directed at the relations between them,
i.e. it is not the object that is being painted
but the relation. It is not through objects
that the artist expresses himself but
through relations.
Two objects are understood as two picto-
rial forms, which are raw, and acquire life
only in relationships. They may intensify
or weaken each other and thereby act
on the whole.

L. Yudin, *Dnevnik [Diary]*, 1926. Yudin family
archive, St. Petersburg

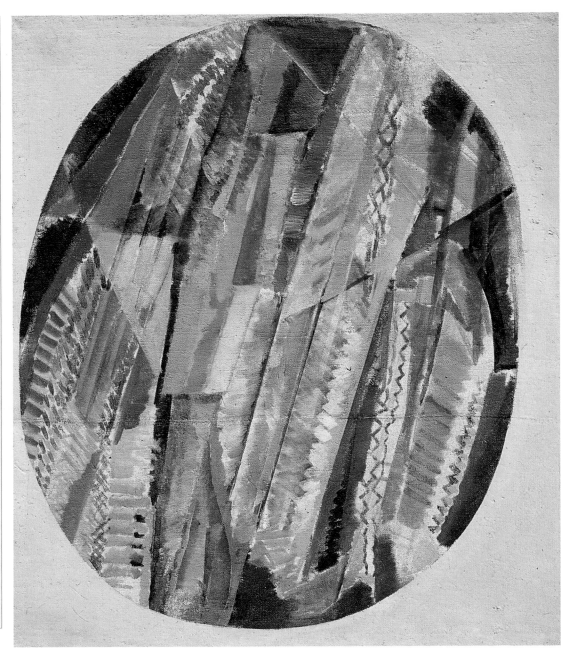

86

86
Valentin Kurdov
Chinese Lantern. 1926–27
Oil on canvas. 117 x 99 cm

interaction of the spiritual movement
of time and space. In the all-encompass-
ing nature of this model of the universe
lies the ability of art to outstrip and anti-
cipate science. That is why "a picture,"
as Pavel Mansurov observed, "is a hymn
to what has not appeared. There is
a dichotomy: the arts and the sciences.
Art is the first phase, which anticipates
the new form of technical and then
social relationships."[47] This prognostic
significance of the spiritual structures
and models embodied in works of art
did not escape the artists' notice

and they understood the necessity of
studying it not only for the needs of art
itself. The State Institute of Artistic
Culture (GINKhUK) opened in August
1923. This was the first research center
in Russia and in the world which studied
not past, but living, contemporary art
in its newest manifestations. The main
work at GINKhUK was the study of
post-Cubist phenomena in art. Malevich
was appointed director, with Punin
acting as his deputy and the sections
being headed by Tatlin, Matiushin, and
Mansurov.

In the Department of Painting Culture, also under the direction of Malevich, Yermolayeva was in charge of the Laboratory of Color and Yudin ran the Laboratory of Form. The department studied five systems of the newest art: Impressionism, Cézannism, Cubism,

master or time. Isn't this true? I did not listen to the fathers and I am not like them."[48] These words make it clear that Malevich considers Suprematism to be a step on the stairway upon which world art is ascending.

During his period in Vitebsk, the fever

87

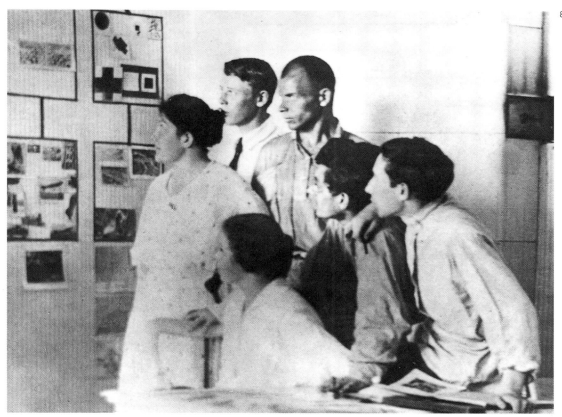

88

Futurism, and Suprematism, thereby developing the theory of the "surplus element" in painting — an attempt to explain the regular alternation of artistic forms. Apart from his creative gift as an artist, Kasimir Malevich was a natural researcher, striving to understand the reasons behind the birth of new forms in art and the logic of their development. The "black square" demanded of Malevich the application of great theoretical effort in order to demonstrate that Suprematism was not an isolated phenomenon, without roots, but the next step in the development of world artistic culture. In May 1916, defending Suprematism, the artist wrote to Alexander Benois: "And I am happy that the face of my square cannot blend with any other

for research reached such a peak that in December 1920 Malevich abandoned his canvas and paints, declaring: "I shall set forth what I see in the endless space of man's skull."[49]

Malevich's paradoxical assertion that the genuine painter suffers from "chromophobia" was the result of his researches into the nature of painting which he divided into three types:

1. Graphic coloring. Colored-in drawing, painting in the style of Holbein.
2. Painterly coloring. Based on the relationship of pure tones — Matisse, Petrov-Vodkin, and Malevich himself in his peasant cycles.
3. Painting proper. Color is blended, mixed as in the painting of Rembrandt, Konchalovsky, and the later Falk.

87, 88
Malevich at GINKhUK. 1925. Listening to his explanations (from left to right): standing, Vera Yermolayeva, Konstantin Rozhdestvensky, and Mikhail Gipsi (artist); seated, Anna Leporskaya, Pozemsky, and Lev Yudin

Marinetti and I spent the years of childhood and youth on the heights of Etna and our only companions were the demons that appeared through the smoke shaft of Etna. We were mystics at the time, but the demons tempted us the whole while with materialistic science and demonstrated that art should be materialistic. To be sure, I was somewhat intractable, but Marinetti immediately assimilated this concept and dashed off a manifesto extolling the smokestacks of the factories and all their production. From 1908, Futurism spread like a pestilent plague. <...> From Etna we could see the approaching threat of Futurism and how, not suspecting anything, Dionysus in his vineyards danced out his last cancan.

> K. Malevich, *Vsem, vsem, vsem, i druzyam, znakomym i rodstvennikam N. Radlova* [*To Everybody, Everybody, Everybody, and to Friends, Acquaintances, and Relatives of N. Radlov*], 1923. Manuscript Dept., Institute of Russian Literature, St. Petersburg, fund 172, No. 595, ff. 1–2

Kasimir Severinovich's works that I saw two days ago speak before the eyes. For the first time I understood that in his *Vanka* form is solved. Everything lies, of course, in the fact that K. S. taught us to work not with the impression of a form but with form itself. With real form. If Picasso wrote "esteem the object," then K. S. can say that he has great esteem for the logic of form. He will not agree to destroy this for anything. For him, this logic is the painter's highest reality. It is the origin of his organic, unbiased purity. K. S. doesn't simply shake the forms until they assume a more of less ingenious or piquant appearance (which often happens with us). He achieves solution of forms, for which he sacrifices all the trinkets.

> L. Yudin, *Dnevnik* [*Diary*]. Entry for October 21, 1934. Yudin family archive, St. Petersburg

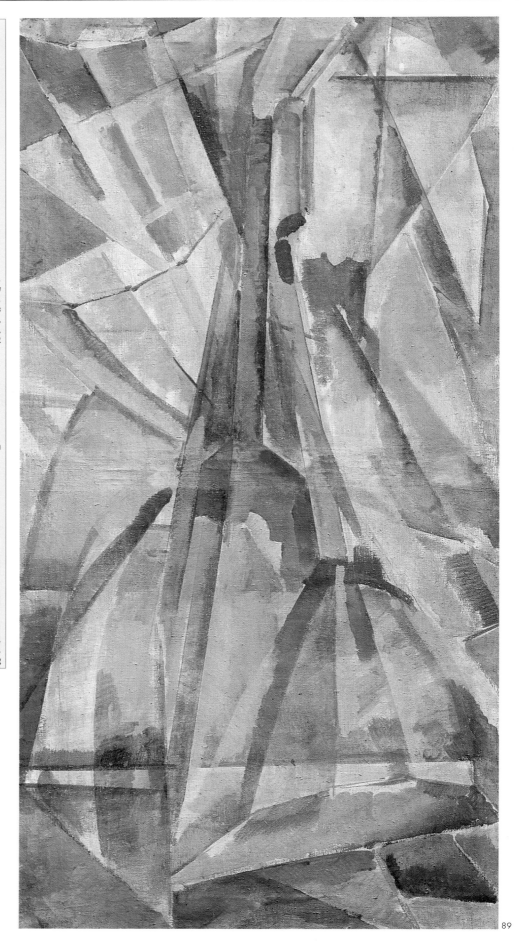

89
Valentin Kurdov
Balalaika. 1926
Oil on canvas. 125 × 65 cm

90

Nikolai Punin. 1926

"I was born into the family of an army doctor in Helsinki in 1888. In 1890, my parents brought me to Pavlovsk where I lived continuously until 1902. I received my elementary education in the local school and in 1899 I entered the Tsarskoye Selo Gymnasium. In 1902 I moved with my parents to Tsarskoye Selo where I lived until 1909. In 1907, I graduated from the Tsarskoye Selo Gymnasium taking a silver medal, and I entered the Law Faculty of Petrograd University. Subsequently I transferred to the Faculty of History and Philology, where I majored in history. For a number of years I attended courses on the history of the arts taught by professor Ainalov and I studied under him in the seminar. Having attended all the course lectures, I submitted my term paper on the theme 'Giotto's Landscape.' In 1913, while still a student, I was invited to work in the Department of Icons of the Russian Museum as a research assistant (academic registrar). I worked in this capacity until 1918 when the board of the museum elected me to the post of academic secretary of the Art Department. From 1918 to 1922, I was head of the Fine Arts Department of the People's Commissariat for Education. Since 1923, I have held the post of Head of the Art Section at the State Porcelain Factory. In July 1919, I was elected Professor of the former Academy of Arts, a position which I still hold. In January 1922, I was elected research assistant of the First Section of the Institute of the History of Arts. In October 1923, I was appointed freelance lecturer of the Department of Archaeology and the History of the Arts of the Department of Social Sciences at the University of Petrograd. The first of my published works appeared in the magazine *Apollon* in 1913."

N. Punin, *Avtobiografiya [Autobiography]*. Manuscript Dept., Russian Museum, St. Petersburg, fund 32, part 1, f. 160

But all three types were equally valid and of equal worth with regard to their authenticity and quality.

It is difficult to determine precisely when Malevich came up with the idea of the "surplus element" in painting, but, as he himself said, he already had the idea when he arrived in Vitebsk. Studying the alternation of trends in new art, Malevich came to the conclusion that a given module or "surplus" introduced into the structure of a constituted plastic system transforms it into a new artistic organism. It was this module that he named the "surplus element." In Vitebsk Malevich ran into young people who were enthralled with art and in whose works the most diverse influences of the newest currents in art were in active conflict. This was a marvelous field for conducting research. "Before me," recalls the artist, "there opened up the possibility of conducting various experiments in studying the effects of surplus elements on the pictorial perception of the nervous system of my subjects. In order to carry out this analysis, I began to adapt the institute which had been organized in Vitebsk. It afforded the possibility of carrying on the work at a great pace. Individuals who were infected with painting were divided by me into several states that were typical of it. As far as possible, these were arranged into more homogeneous groups representing this or that surplus element. I decided to try out in practice several of my theoretical conclusions concerning the effect of surplus elements."[50] Malevich continued these studies in GINKhUK.

In accordance with his theory of the surplus element, Malevich made the novice paint "prescribed still lifes," with a view to defining the artist's inclinations toward this or that system of painting. Having arrived at a "diagnosis," he worked with the young artist so as to give him or her the opportunity to develop individual, artistically unique elements. While deliberating over the works of Kurdov, Malevich once said: "It behoves us to seek out in Kurdov all the elements and to straighten them out, but not at all to make you into a Cubist, a Suprematist etc. We try to protect this unknown element [inherent in the individuality of the artist], to let him develop it in the future, and we try to get rid of what is alien." The analysis of works took place when Malevich made the rounds of the workshops. Among Kurdov's personal effects is a remarkable document, the minutes recording three such rounds (this is the source of Malevich's words quoted above). On October 12, 1926, Malevich and his assistants Yermolayeva, Yudin, Leporskaya, and Rozhdestvensky entered the studio where Kurdov was at work. On the easel stood a still life by Kurdov, which has not been preserved. It represented a compositional union of a pear, glass, wood, and fabric. Here is, in shortened form, an excerpt from the minutes — a unique dialog between Malevich and Kurdov. The notes were taken down by Leporskaya:

"*Malevich*: Why did you come to us?
Kurdov: I came to engage in scientific research.

Malevich: All works of painting have a flow of color which, to some degree, travels through the entire canvas, and that there is no distinctly expressed color. The color from the tube is mere paint,

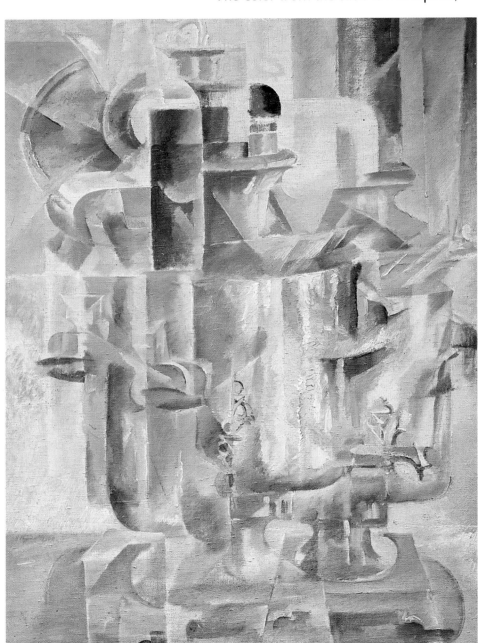

91

91
Valentin Kurdov
Copper Samovar. 1926–27
Oil on canvas. 76 x 56 cm

92
Yelena Guro
Woman in a Headscarf
(*The Scandinavian Princess*). 1910
Oil on canvas. 70 x 70 cm

but the painter always rubs the paint, mixes it, turns it into a tone. And on your canvas there is a combination of ocher and yellow, which you wish to fuse into one color. You have the characteristics of a painter. That is why Matisse is a combination of color harmonies where the color is not rubbed and each color asserts itself as vibrantly as possible.

Kurdov: But isn't it painting if the relationships of the painter's materials are expressed?
Malevich: Take a pear and paint it without mixing.
Kurdov: That's hard to do.
Malevich: You won't paint the pear because it is a painter's material and the approaches should be different. If you paint it with one color, that won't be painting as it was seen up to now, that everything is a painting, i.e. everything which is painted in a lifelike fashion, until we came up with a new term — we divorce painting from rendering in color, from tonality. A genuine painter (Konchalovsky) cannot bear color, and in this process, the more he fears color, the better his painting becomes (colorphobia). You in your canvas are striving to make a painting — in a pear. And there is still another characteristic of painting. There is no contour in your work — that is indeed the sign of a painter. In Kurdov's case it is necessary to exclude the elements — nearness to color and decorativeness which have a flat dimension and the covering of flat surfaces with one tone."

This is how the young artists mastered the "grammar of painting," the laws of plastic expressiveness. The intelligent guidance of Malevich helped many Leningrad artists find their "voice," their colors and forms, their unique artistic solutions. Malevich opened up before young masters the expressive primary elements of artistic form in order to teach them how to use these elements freely and consciously.

Malevich's study "Introduction to the Theory of the Surplus Element in Painting" was prepared for the collection of articles to be published by GINKhUK in 1925 but remained at the proof stage, since the collection did not appear. This work formed the basis of the artist's book *Die gegenstandlose Welt*, published by the Bauhaus in 1927.

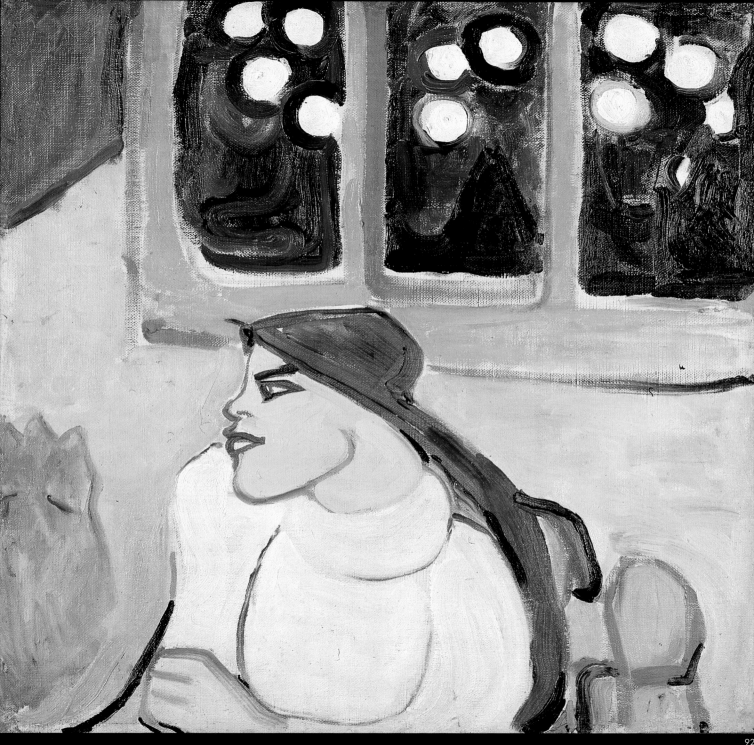

One of the founders of GINKhUK was Mikhail Matiushin, who ran the Department of Organic Culture. The questions studied by the department arose between 1910 and 1913 in the joint work of Matiushin and his wife Yelena Guro. Amidst a general passion for geometrical representation and Cubo-Futurism, a singular return to nature took place in the work of Matiushin and Guro. The barely noticeable rivulet developed in the 1920s into a wide stream. Matiushin and Guro did not pass by the new conceptions of space with which their comrades in the Union of Youth were carried away, but they interpreted them in a personal way. Their works suggested a new direction in painting, a synthesis of new spatial concepts right down to abstraction, and vibrant, natural sensations. Yelena Guro was "as much of a poet as an artist. She continually recorded her observations in parallel in word and drawing."[51] In her artistic activity, Guro sought harmonic correspondences in the slightest movements of the soul and the life of nature, in which for her there was nothing inert and dead.

At the height of a widespread enthusiasm for urbanism in poetry and Cubist geometrization in painting, Guro's return to nature was clearly ahead of its time. Like Filonov, but in her own way, she juxtaposed "the organic" and "the mechanical." Her poems and paintings are orientated toward primary, that is, natural, processes. Guro addresses the "saving earth" and strives to liken the creative process to the rhythms of living nature. "Try to breathe like the sighing of far-off pines, like the wind unfurling in agitation, like the universe breathes. Try to imitate the breathing of the earth and be like the fibers of the clouds."[52] In Guro's work, the movement toward nature had an inspired animation that was rare in its loftiness and purity. But in this spirituality there was no abstract schematic quality or symbolic polyvalent meaning. The most embracing images of cosmic grandeur in her poetry are always warmed by a keen and unmitigated sense of living nature: "And they tilted the sky's cup for all — and everybody drank and the sky did not diminish."[53] Guro achieved a high degree of generalization of color and form, whilst at the same time not losing the sharpness and immediacy of natural impressions. It is perhaps this very property which evokes the sense of keen spirituality in her painting. In her watercolors it seems as though the whole material substance of the colors has been trans-

Your grief and your loss will find a response in me; the figure of Yelena Genrikhovna is linked to me by many threads. I now recall her brave speech at the time of the last visit. In Yelena Genrikhovna's opinion, the excessively intense thought of one person can cause the death of another. She appeared unconcerned and, as it seemed, everything was close except her disease. My first impression was how strongly Yelena Genrikhovna had changed over that time. But it always seemed that she was under the sway of forces that do not control the majority of people and is alien to the majority. <...>
Her last works are strong by virtue of their lofty moral teaching, the strength and sincerity of the convictions that are expressed. Here the mantle of compassion falls on all the animal world and people deserve sympathy like heavenly camel colts,[54] like perishing young beasts "with golden fluff." With Russians, it is the good and proper judgement that limps more than the proper heart. <...>
Yel[ena] Genr[ikhovna] has a face that is as white as chalk, slightly mad black eyes like birch charcoal and quickly combed golden hair. Now she is waiting for meetings there where we shall be some day.

V. Khlebnikov, "Pis'mo M.V. Matiushinu 18/VI–1913," *Neizdannyie proizvedeniya* ['A Letter to M. Matiushin. June 18, 1913," *Unpublished Works*], Moscow, 1940, p. 365 (excerpt)

93
Yelena Guro. Early 1900s

Wherever you might stand, in the forest or in a field, always turn your soul toward what is emanating from the spot — listen to what is emanating and know the voices of the trees, the grass, and the ground. And you will hear dispersed love in the air and transported by the waves, by the clouds of heat and turned toward you, since things created love those who are attentive. And you will hear the touch of warmth on your cheeks, in your eyes, and on the back of your arms.

Ye. Guro, *Bedny rytsar'* [*The Poor Knight*], 1913. Manuscript Dept., Russian National Library, St. Petersburg, fund 116, No. 3, f. 36

There are times when mankind, piling experience upon experience, creates a conventional sign, into which its creativity flows and they begin to call this art ("art has been made"). But in the beginning was the simple reflection of an impression, repeated rhythmically, like a sound. This indeed was the uncomplicated, simple stride of life itself. Now, art in its steady movement and development has come to the point of fragmentation of its sign and is already being called "rightist," "centerist," and "leftist."
It is already "a cloven force."
ZORVED by virtue of the very act of vision (the field of vision is 360 degrees) stands up for the primordially active grounds of experience.
ZORVED signifies a physiological change of the former way of observation and entails a completely different way of representing what is seen.
ZORVED is the first to usher in observation and experience of the hitherto hidden background, all that space which has remained outside the human sphere owing to the insufficiency of experience. New findings have revealed the influence of space, of light, of color, and of form on the central areas of the brain through the occipital region. A number of experiments and observations made by the artists of ZORVED clearly establish the sensitivity to space of the main ocular zones located in the occipital part of the brain. Hereby, man is unexpectedly revealed the great power of spatial perceptions and since the most precious gift of man and the artist is to fathom space, this implies a new stride and rhythm of life that does not merge with any form and sign "of the right," or "of the left." So far, this is still "the most primitive life," which is accompanied by the greatest discoveries that have been wrenched loose and brought to the surface through the monstrous blast of the Russian Revolution...

M. Matiushin, "Ne iskusstvo, a zhizn'," *Zhizn' iskusstva* ["Not Art but Life," *The Life of Art*], 1923. No. 20, May 22

formed into color images that are shot through with vibrant light, softly glinting, smoke-wreathed, as if endowed with spirituality. The objects in Guro's canvases seem to be untouched by gravity, existing in a state of soaring buoyancy and weightlessness. Her colors are taken from nature, yet are spiritually lucid. We can gain some idea of Guro's palette and artistic aims from an entry in her diary: "I shall build a palace of shafts of light from heaven. Everyone coming there will receive bright, greenish, slightly rose-tinted or watery blue crystals of the sky. And there one will see fluffy, silver, and caressing garments."[55] The acute spirituality of Yelena Guro's work, the heightened intensity of her spiritual and moral explorations, made her a key figure of the Russian avantgarde, one who was admired even by those who could not share her convictions. The relationship of Mayakovsky the atheist to Guro was a moving one; the creative friendship which bound them together was cut short by the death of the poetess. A sense of spiritual want, an involuntary preoccupation with the central questions of existence, with which even materialists and atheists found themselves confronted, drew many poets and atheists to Yelena Guro and to her inner world. As it says in the Bible, "the devils also believe, and tremble" (Epistle of St. James, 2, 19). Opposition to the positivism of the nineteenth century stands out like a leitmotif in Russian art of the beginning of the century. Seekers after God — that was the position of many artists, writers, and philosophers of the time. All of them sought, but only a few succeeded in their quest. The searches often led up a blind alley. Vrubel searched for God but found a demon, albeit one who was cast down.
In that world of spiritual and moral ideas and experiences toward which many artists and poets painfully strove,

Guro lived with unconstrained ease, as if comfily at home. Any of her works, any diary entry springs fundamentally from the artist's one deep center of spiritual, moral, and religious notions and experiences. Few of those in Guro's entourage could guess that her art and

94

its orientation belonged to the future, and not even to a very immediate future. She herself said: "My pictures are the expression of a great spirit breaking forth through sickness."[56] "They are of great importance, but at the present moment of vast discord between spirit and matter they will not be understood and will be, as it were, 'prohibited' by the censors. My pictures have landed in the midst of an exclusively material throng, but there is no need to worry over this."[57] For many years, Yelena Guro's personality and her work were a spiritual and moral guiding point for the young artists grouped around Matiushin.

94
Mikhail Matiushin. About 1910

The moment of salvation is outside time and space. With the Cubists, perspective is taken away — the victory over time and space is like immortality. People have already appeared who see things (the world, beauty) with the eyes of angels and fit into a single instant space and time; they make possible salvation and bring immortality closer though they do not even suspect this.

Ye. Guro, *Dnevnik* [*Diary*], 1912. Manuscript Dept., Institute of Russian Literature, St. Petersburg, fund 631

Guro says: "Nature loves those who are attentive."
This means those who explore themselves, giving themselves over to nature and to her striking wonders.
She furthermore says: "For the seekers, there are unknown countries." But there are few seekers in nature and artists go with ready recipes and look at nature as at something "subservient to," and "within the jurisdiction of," the norms of art. Nature does not love such people and for them she is a closed book. They draw from that part of the whole which is also nature but is called "I". And which loves only "I" and all its manifestations.
Guro gave everything to nature, all her physical powers and her soul, and nature opened up its secrets and its love to her, as to no other. I know of no being who has lived more intensely in contact with nature and who has become more dissolved in it than Yelena Guro.

M. Matiushin, *Dnevniki* [*Diaries*]. Entry for December 1, 1928. Manuscript Dept., Institute of Russian Literature, St. Petersburg, fund 656, notebook 15

95

96

95

Yelena (at left) and Yekaterina Guro after graduating from high school. Mid-1890s

Both were participants of the literary association of Futurists called Hylaea. Yekaterina Guro published her stories under the pseudonym Ye. Nizen.
"I recall how Guro inspired me with the way she would invariably bare her soul in a natural setting as well as the constant intensity she applied to observation in the creative process. Thus was constituted a creatively fruitful environment of solid and friendly support. As a result of this communion, our achievements and new projects came into being."

M. Matiushin, *Tvorcheskiy put' khudozhnika* [The Creative Path of an Artist]. 1934. Manuscript Dept., Institute of Russian Literature, St. Petersburg, fund 656

96

Yelena Guro
The Morning of the Giant. 1910
Oil on canvas. 70 x 85 cm

97

Mikhail Matiushin
Composition on the Death of Yelena Guro. 1918
Watercolors on paper. 27 x 38.1 cm

97

In 1922, while summing up several points concerning his work, Matiushin declared: "I was the first to raise the banner of a return to nature and that is something that cannot be done by the leftists, the newcomers to art, who are struck dumb and mortified by the West."[58]

methods of nature's "creativity." "Nature tells us, don't imitate me when representing me. Create by yourselves in the same way. Learn to know my creativity."[59]

Matiushin developed the ideas of "expanded viewing" in painting, ideas

99

98
Mikhail Matiushin in the village Primorsky Khutor on the shore of the Gulf of Finland. Early 1920s

99
Mikhail Matiushin
Siverskaya: Landscape Viewed from All Sides. 1924.
Sheet from the *River* series
Watercolor on paper.
22.3 x 27.9 cm

No matter how far the artist moves away from figurativeness, from immediate representation, his canvases and watercolors always retain a living link with nature, his non-objectivity is filled with sensations of color and the shaping of forms, all of which spring from the observation of nature. Matiushin does not copy nature's forms but strives to follow her

which were embodied in his watercolors of the '20s and '30s.

The Impressionists and Pointillists studied the effectiveness of complementary colors, applied to the canvas separately. The resonance and purity of their pictures caused a revolution in world painting. Malevich introduced to the painter's palette two "non-colors" — black and white.

Since 1900, after my trip to Paris, I have done much work on theoretical artistic questions.

In the laboratories of the Research Department at the Museum of Artistic Culture, which grew into GINKhUK (the State Institute of Artistic Culture, 1923–27), I developed scientific research work in the area of the study of color, form, and space, begun in the workshop of "Spatial Realism" at the Academy of Arts from 1918.

I posed the question of centrally perceiving man, who consciously acts within his entire surroundings. In the future man will at any instant see, palpably feel, hear, and sense with the amplitude of the full surroundings. I have a presentiment of how the musical score of life, read by the intellect, will create what mankind has not yet found the boldness to dream of.

I set myself the task of studying the artist's perception in the conditions of the development and interaction of all the organs. I called my Research Department the "Department of Organic Culture."

M. Matiushin, "Nauka v iskusstve," in *Tvorchesky put' khudozhnika* ["Science in Art," in *The Creative Path of an Artist*], 1934. Manuscript Dept., Institute of Russian Literature, St. Petersburg, fund 656, f. 188

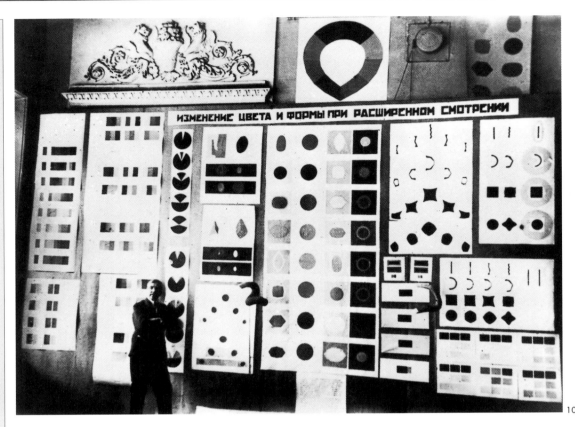

100

100

Mikhail Matiushin in 1930 at the exhibition of his group in the Leningrad House of the Arts. The research tables reveal the laws governing changes in color and form during "extended viewing."

101

In the rooms of the Museum of Artistic Culture. 1925. From left to right: Mikhail Matiushin and Maria, Xenia, and Boris Ender. 1925

Matiushin's school brought its own contribution to the system of painting. Studies have shown that two colors give rise to a third. Matiushin called this the "linkage-color" which arises between the color "medium" and the "fundamental" color. Developing and changing as in a fugue by Bach, evolving in a relation of interdependence, they enhance and enrich each other. The results of this work were published in Matiushin's *Spravochnik po tsvety* [*Handbook on Color*], which appeared in 1932. Matiushin's department also studied the interaction of color and form, of color and sound. Already in his early period, Matiushin experimented with the idea of communicating sounds through color. At the last exhibition of the Union of Youth (1913–14), he demonstrated two canvases, *The Chiming of Absolution* and *Red Chiming*, in which he "made an attempt to endow the audible with a visual form."[60] The latter picture was displayed at the exhibition of the Salon d'Automne in Paris (1914) and was lost in France.

101

Matiushin's department at GINKhUK was the place where many Leningrad artists learned their craft. Apart from the Enders' advanced group, the artists who worked there included Nikolai Kostrov, Yevgenia Magaril, Valida Delacroix, Olga Vaulina, and others. Matiushin valued the talented Ender

102

family very highly. Boris Ender developed into a real master, and his work has yet to be studied by scholars. Matiushin wrote of him that "Boris is very talented and much is open to him in painting."[61]

A large number of the Enders' works that were part of George Costakis' collection are now in the West and have been shown at exhibitions in a number of countries. They have opened up for the Western viewer a new side to the Russian avant-garde, showing a third path in non-objective art that was different from the Abstract Expressionism of Kandinsky and from the super-geometrization of Malevich. Matiushin's school of painting led non-objective art into the channel of natural qualities and values. The new movement began as a quiet spring amid the crashing waves of geometrization, but it proved viable, bringing forth remarkable fruit in the twenties. "The new truth," observed Matiushin, "is non-objective–objective. Objects do not pass out of the field of vision, but are simply transformed into a new image."[62] The influence of Matiushin's principles went far beyond the framework of the school and is perceptible in St. Petersburg painting up to the present day.

102
Mikhail Matiushin
Movement in Space. 1922 (?)
Oil on canvas. 124 x 168 cm

... The eye sees and feels the sun as a hemisphere. Has anyone ever imagined the sun from the other side: if gives you the creeps to think that it also shines and sends out beams on the other side. Your head spins, as if you were walking along a narrow path above an abyss.

We always know only the surface but we still do not know the center. To us, every three-dimensional object appears full, whole, impenetrable. We are so used to putting together on a whole plane what is perceived as terribly fragmented separate little pieces that we carry this over to the three-dimensional object.

But if we begin to analyze what a three-dimensional object is, we are convinced that almost every volume consists of planes that are filled with more or less solid mass. What is a house as a three-dimensional object other than the six planes of roof, walls, and floor, which separate the internal space from the air and ground.

If we imagine, as an instance of a three-dimensional form, a tree, then in the new understanding of volume, the growing tree exemplifies a victory over flatness, the eternal struggle with the law of gravity; the colossal energy of growth and movement in development and the constant,

103

Maria Ender
Attempt at a New Spatial Dimension. 1920
Oil on canvas. 67 x 67 cm

104

Boris Ender
Table of the graphic representation of speech sounds, from Alexander Tufanov's book *K zaumi* [*Towards Transsense*], 1924

The purpose of the table is to permit an association of speech sounds with respect to color and form. The consonants span the rainbow as viewed according to the principle that M. V. Matiushin has noticed in the organic world: from the middle of the constituent green there are simultaneous encounters with the yellow-curve and blue-straight at the ends and this is not on a continuum from one edge to the other edge. In each of the four stages there are liberations from the green (constituent) color or the encountering (constituent) form and sound.

In the first stage: t, d, p, b;
In the second stage: š, s, ž, z;
In the third stage: r, l, g, h;
In the fourth stage: v, f, m, n.

The diphthongs are located outside the rainbow. All the sounds are divided into black (swallowing) and white (shining) sounds.

The table can be reworked until it is unrecognizable or made according to some other principle.

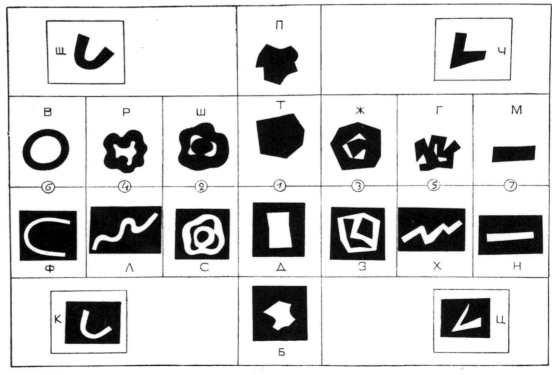

104

immutable return to the same flatness when the tension is relaxed. The spring of a three-dimensional object seems to come out of flatness, reaching the limit of tension and disappearing into the same flatness, imparting a marvelous force and life to everything.

Isn't that surprising flatness — the periphery of the earth — at the same time the most perfect volume?

The earth is not cut off from anywhere by a boundary and it moves along freely, not holding on to anything, and like a huge body it changes markedly, seeming to rock as it goes, slightly flattened out at the poles. The ebb and flow of its oceans continues like a ripple along the entire expanse of its surface. Its monstrous mountains move slowly, now growing, now receding.

So far, we have no conception of its center, but all its life on the surface demonstrates that it is the most alive, most perfect organism. Its spherical form is free in space. All this makes one think that the concept of volume begins with the earth. The entire stellar system is made up of such spherical masses and their mutual influence and contact are very complex and exceptionally interesting. Whoever has not experienced this, should look at the full moon. Strangely, and in a new way, you will see this convex sphere, illuminated by the sun from behind the earth. How can it hold itself in space and move while turning? To us, who are used to everything flat and to our three-dimensional objects that arise from and are constituted of planes, such a phenomenon seems unusual and miraculous.

When the earth turns toward the east, leaving the sun behind, we see the miracle of the passage of a large volume through a smaller one. The sun seems to set in the center of the earth and slowly sinks into it. The earth and the sun are only points (seeds) which create from their visible centers their own true body in the infinitely great space all around.

When the body of the sun passes through the body of the earth, it does not slip along the earth with its rays, but touches it and passes through with its solid and penetrating body.

The visible sky is not an empty space, but the most living body in the world — only we do not feel its solidity. The earth and the sun are only shining points of an enormous body. The earth's orbit is not the track of the movement of a body, but the body (skeleton) of the earth itself.

M. Matiushin, "Ob otnositel'nosti nashikh prostranstvennykh nabliudeniy," in *Tvorcheskiy put' khudozhnika* ["On the Relativity of Our Spatial Observations," in *The Creative Path of an Artist*], 1934. Manuscript Dept., Institute of Russian Literature, St. Petersburg, fund 656, ff. 146–147.

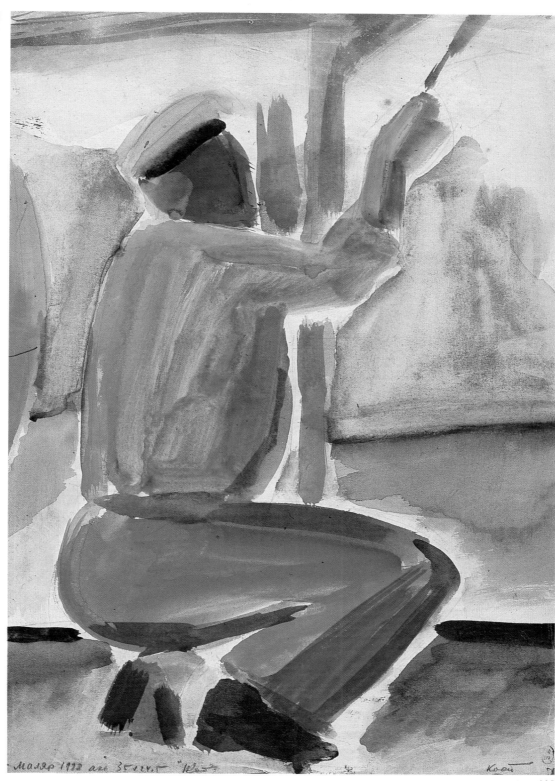

105

105
Nikolai Kostrov
Wall Painter. 1928
Watercolor on paper. 35.5 x 25 cm

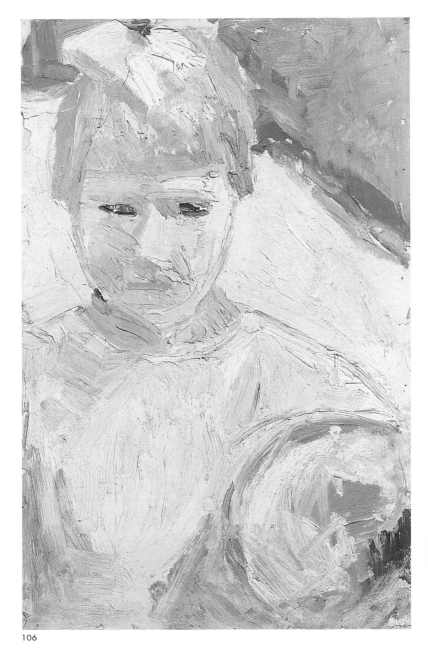

106
Nikolai Kostrov
Girl with a Ball. 1925
Oil on cardboard. 51 x 29 cm

Nikolai Kostrov
On the Bank. 1928
Watercolor on paper. 22.2 x 16.1 cm

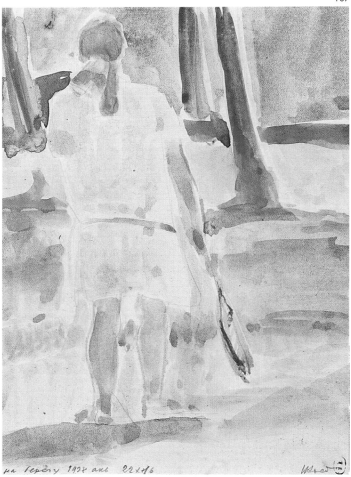

107

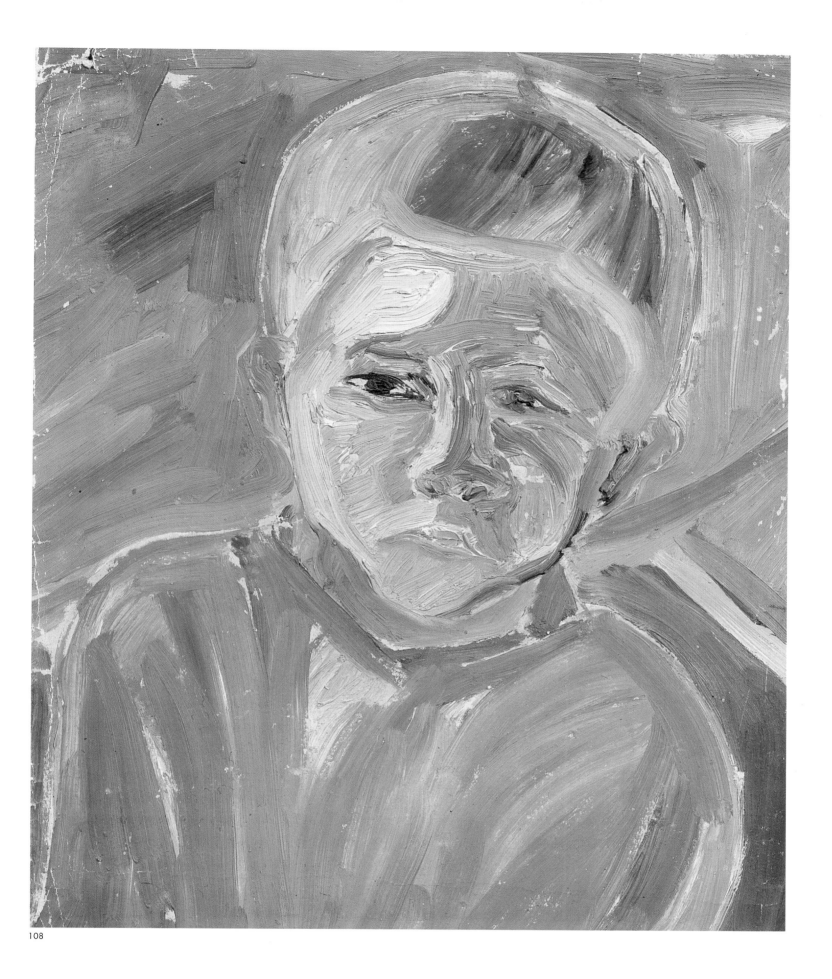

108
Yevgeniya Magaril
Portrait of a Boy. 1920s
Oil on cardboard. 32 x 26.5 cm

Many leading artists in Leningrad acquired their professional skills at GINKhUK. Among the students and postgraduates who passed through the departments of Malevich and Matiushin were Suetin and Chashnik, Leporskaya and Rozhdestvensky, Vasnetsov and Kurdov, Sterligov and Magaril, Yermolayeva and Kostrov, as well as Boris, Maria, and Xenia Ender. The works of many of these artists are included in this book.

109

109
At Yury Vasnetsov's (he is reclining) workshop for diploma students at the Academy of Arts in Leningrad. 1925. In the center — Valentin Kurdov, left — Dmitry Sannikov. On the easel is Vasnetsov's own diploma work *Bricklayer*

110
Yury Vasnetsov
Woman with a Mouse. 1932–34
Oil on plywood. 150 x 95 cm

The fate of that wonderful research institute and creative center was just as tragic as that of the German Bauhaus. GINKhUK provoked embittered spite among the artists of AKhRR (Association of Artists of Revolutionary Russia). As early as 1924, Malevich wrote: "The leftist thinkers in AKhRR envision a red Itinerants' movement. Surprising is the antagonism of the AKhRR adherents toward the non-objectivists. We are not enemies, for our paths are too different. The AKhRR artists are the narrators of everyday life, portrayers of events, whereas the artists of the Left are the very creators of this life, participants in revolutionary events. To at once create and describe the thing created is incompatible."[63]

In the summer of 1926, another exhibition opened at GINKhUK. By this time, the antagonism of which Malevich wrote had been exacerbated and the adherents of AKhRR had gained political strength. In the June 10, 1926, issue of *Leningradskaya Pravda* there appeared an article by the critic Grigory Sery entitled "State-Supported Monastery," which gave a crudely distorted description of the institute's activities and was written in the style of a political denunciation: "Having found shelter under the sign of a state institute, there exists a monastery, inhabited by a few fools-in-God, who, perhaps subconsciously, are engaged in overt counter-revolutionary preaching, making a laughing stock of our learned Soviet organs."[64]

Investigations were initiated and committees set up. During their sessions, distinguished specialists testified to the value of the research activity of the institute, but its fate was already decided. Appearing on June 16 at a general meeting of the institute's staff, Malevich declared: "Maybe we had better not continue these meetings, since tomorrow, thanks to Sery's article in *Leningradskaya Pravda*, there will be a commission which may bring to an end and terminate all cultural activities of GINKhUK, which is capable of greatly benefiting the study of art and the explication of its nature."[65] Thus the institute was liquidated.

But this was not enough. Malevich's opponents strove to settle their scores with the artist once and for all. At the exhibition, Filonov met Malevich, whose words he wrote down in his diary: "Then he began to complain to me about his fate and said that he had sat out three months in prison and undergone interrogation. The investigator asked him: 'What kind

This spring we had to withstand the savage attack of those AKhRR members again. (Maybe you know what kind of scarecrows they are? These are contemporary "Itinerants" whose task it is to express through "healthy realism" the revolutionary essence of the proletariat. At a stroke, however, they strike themselves out of the revolutionary march of art of the very same creative proletariat, paralyzing all new creative methods. Their exhibition is a sea of canvases utterly devoid of talent, lacking any naturalistic competence whatever and treating the most deliberately revolutionary themes.) Well, they were the ones who wanted to break off our work, who accused us of mysticism and idealism and who spread the poison in the press under the headline "State-Supported Monastery." But I hope that the energy which abounds in our group will not only emerge victorious in these ups and downs of the daily war, but will become the support of the groups of non-objective artists who are fanning out in all directions.

Vera Yermolayeva. Letter to Mikhail Larionov, July 17, 1926. Archive of A. Tomilina-Larionova, Paris

Don't worry about us. Don't teach us. Things are all right with us the way we are. Don't put stupid top hats on our heads and don't put us in the zoo. In our bazaars, your dead goods are not for sale; don't drone in our ears that we need your goods and factories. Now as always we make everything we need ourselves. In any field, we're cleverer than you are — in every craft, we are artists. Our folk art is the most magnificent thing, eternally ageless and true. Our fellow artists who have wound up in your urban paradise are dying of hunger and hanging themselves from ennui. In our history there has never been such shame: we canonize the most inspired as well as the wisest of us. They are our heart. We believe in them, honor them, and will pray to them forever. You are not an edict unto us. You live stupidly and evilly. Our green villages are better than the stench of your smoking cities. Don't rob us and we shall be rich. You annihilate us with wars. We have nothing to conquer; we have everything. Don't drive us into your factories; don't kill us, for we pity and love you. Come to us. But you are sick and we are afraid of you. There's nothing for us where you are. Your culture is evil; and your science in your hands does not promise us happiness. We wait for you, but we will not come to you.

P. Mansurov, *Mirskoye pis'mo k gorodu* [*A Secular Letter to the City*],[67] 1926, St. Petersburg, Central State Archive, fund 4340, part 1, No. 66, f. 27

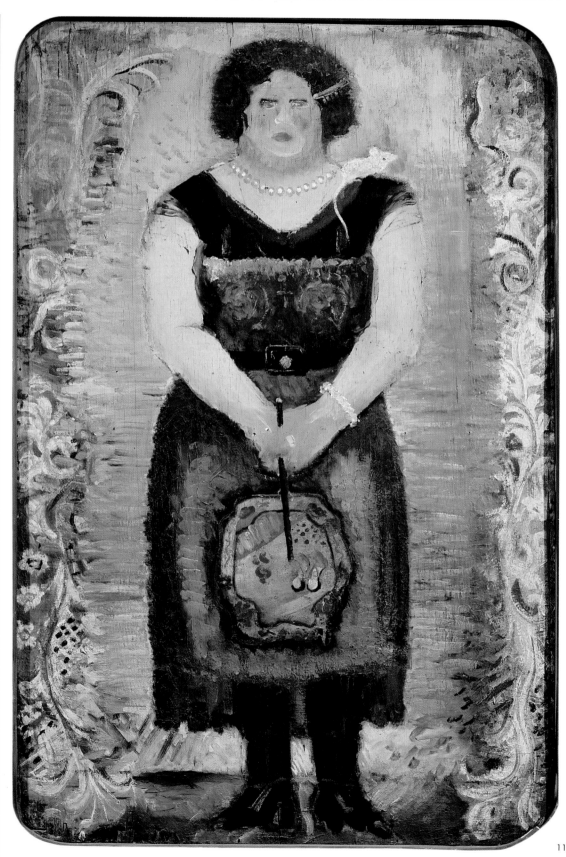

of Cézannism are you talking about? What kind of Cubism do you preach? The AKhRR members wanted to destroy me completely. They said, 'Destroy Malevich and the whole formalist movement will go down with him.' But then, they didn't destroy me. I remained alive. It's not so easy to wipe out Malevich."[66]

I know how dangerous it is for the artist himself to attempt to popularize his views.

As in the present case, such attempts always rest on inadequate scientific knowledge and seek to establish a completely original system that explains the entire complexity of the interrelationships of the artist with the environment which feeds and exploits him.

The special position of the artist at the present time compels him to combat in every way the ideas of administrators, politicians, and merchants, which have no real or even simply logical basis with respect to art; these people invoke their philosophy in support of all manner of approaches convenient for carrying on a discussion with the people.

The result of the prevailing political philosophy was the physical extinction of the artist, like the equally and completely destroyed artistic school. Being in the same position as other comrades and observing the whole unnaturalness of the relationships that have come into being, I attempt to explain to my enemies the reasons that compel us to live and work.

P. Mansurov, *Vmesto obyasneniya rabot*
[*Instead of Explaining Works*], 1926.
St. Petersburg, Central State Archive,
fund 4340, part 1, No. 66, f. 12

111

112

111
Yury Vasnetsov
Viatka. A Herd. 1924.
Sheet from the series *Viatka*
Colored pencils on paper. 35.9 x 40.5 cm

112
Yury Vasnetsov
Salmon. 1931. From the *Karelia* series
Graphite on paper. 25.7 x 43.8 cm

1. Long live utilitarianism (economy).
2. Technology is our freedom — the freedom of animals.
3. Down with the parasite of technology — "architecture."
4. Culture is the purity and lightness of form.
5. Beauty (health) is economy and the preciseness of calculation.
6. Down with religion, the family, aesthetics, and philosophy.
7. Down with those bloody parasites — the bourgeoisie.
8. Down with boundaries between peoples.
A precise slogan is the essence of ideology. I prefer a meeting to a newspaper polemic featuring cheats from "Russian art" or "the central union of 'leftist' tendencies" (head more to the left, then there's nothing else to talk about, spoiled dunces). I protest against the organization of Contest Committees for the erection of structures and headed by "the architects" Zholtovsky, Shchusev, and others, who are aesthetes and the most vicious enemies of the Proletariat and the Revolution; I take responsibility for my words and demand the organization of such committees (not, of course, consisting of "architects") on the basis of utilitarian economics, hygiene, and the healthy comfort of buildings which are truly necessary to the workers (for if we are going to punch the lords in the kisser, let's do it all along the line).

P. Mansurov, "Deklaratsiya," *Zhizn' iskusstva*
["Declaration," *The Life of Art*], 1923,
No. 20, May 22

113

113
Yury Vasnetsov
Fish on a Tray. 1934
Oil on canvas. 72 x 82 cm

114
Yury Vasnetsov
Viatka. Farmyard. 1925.
Sheet from the series *Viatka*
Graphite on paper. 30.7 x 36.7 cm

114

"The experimental section" of INKhUK, myself in other words, was preoccupied with the project of establishing the conditions of the birth of plastic forms. For each living creature in the world, along with the necessity of building what is needed, there is the parallel desire of making these constructions better, more beautiful, no matter whether they be a simple stick, nail, or hammer. The same applies to the insects, birds, and animals who build their nests and other kinds of dwellings. All of them too continuously show a care for their hygiene and attractiveness. Even fish of the same species and the same family have faces that are different from each other. There are not two identical flies of one and the same species. And in mechanics and physics, there are not two identical drops of water. This is my basis. I have not had any Cézannes or Rembrandts that I pushed myself away from. I was formed by things that have no relation to art. I turned them around myself. As for the future, I was ultimately turned around by the first aviation fleet when I was drafted into the army before my time, at the age of eighteen, after I had graduated from the School for the Promotion of the Arts. Later I was transferred to the Head Office of the Air Force as a draftsman and designer of hangars for the airplanes. My rapture at what I saw there turned me completely away from what I had studied at the school and in other places prior to my mobilization, I made the acquaintance of Matiushin, Malevich, and Tatlin after the October Revolution in 1917. I was, of course, delighted with Tatlin and Malevich, and Filonov I knew even before the Revolution, but his things were outside my delights. I loved him and his work for their devoutness. But all these four of my old comrades helped me to understand that I began to make "non-objective" things while I was still with the Head Office of the Air Force. And I also understood that they and I were berries from the same field. But I was still a little flower and they were already full-blown fruits, each in his own way."

Pavel Mansurov. Letter to Yevgeny Kovtun. Paris, May 24, 1971. Yevgeny Kovtun archive, St. Petersburg

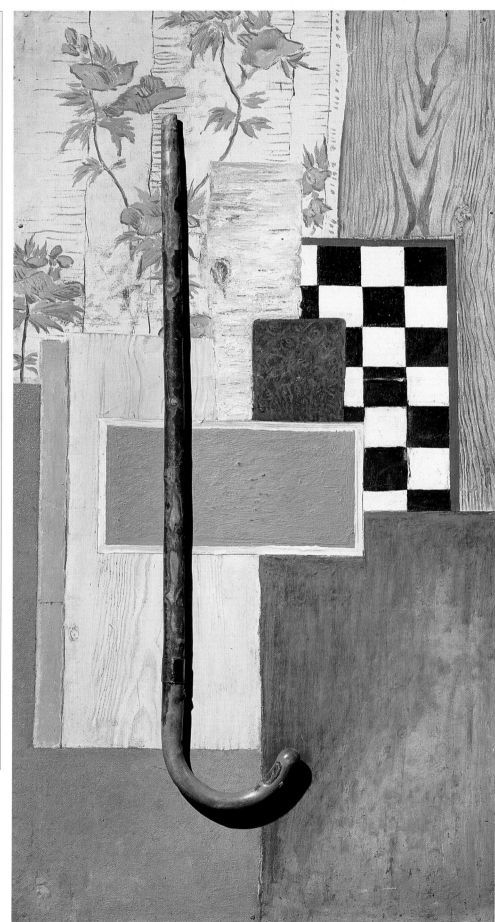

115
Yury Vasnetsov
Still Life with a Chessboard.
1926–28
Oil on plywood. 108 x 56 cm

MALEVICH'S SECOND PEASANT CYCLE

118

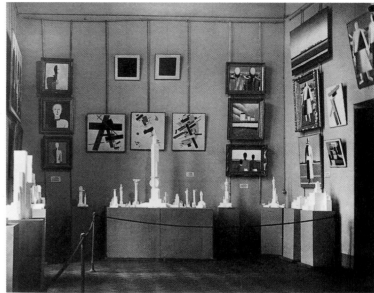

119

120

←
116
Kasimir Malevich. 1928

117
Kasimir Malevich
Peasant. 1928–32
Oil on canvas. 120 x 100 cm

118
A group of Russian Museum
staff looking at the "Art of the
Imperialist Era" exhibition in 1932

119
Kasimir Malevich's room at the
exhibition "Artists of the RSFSR
over the Last 15 Years (1917–32)"
in the Russian Museum,
Leningrad. 1932

120
Kasimir Malevich painting the
picture *Girl with a Pole* in 1933

After Malevich's trip to Berlin, where
a one-man exhibition of his works was
held in 1927, he eschewed non-objec-
tivity and created the so-called "second
peasant cycle." Malevich's painting,
whilst figurative once more, neverthe-
less bore the pronounced stamp of
Suprematism in the treatment of space
and form and in the feel for color.
These are works of surprising painterly
force and plastic expressiveness.
Fresh in conception, they represent
the last flight of the artist's creativity.
He painted monumentally solemn
figures of peasants — with white faces
and black beards — out in the fields,

"semi-images," as the painter himself
called them.
The artist Lev Yudin, Malevich's pupil,
made the following diary entry for
September 21, 1934, "This is the essence
of what K.S. [Kasimir Soverinovich]
said: 'Of the greatest importance
for the present times are non-objective
things and semi-images (like my peas-
ants). They have the sharpest
impact!'"[68] These peasant images clearly
express Malevich's philosophical posi-
tion, the sources of which can be dis-
cerned in the pre-revolutionary period.

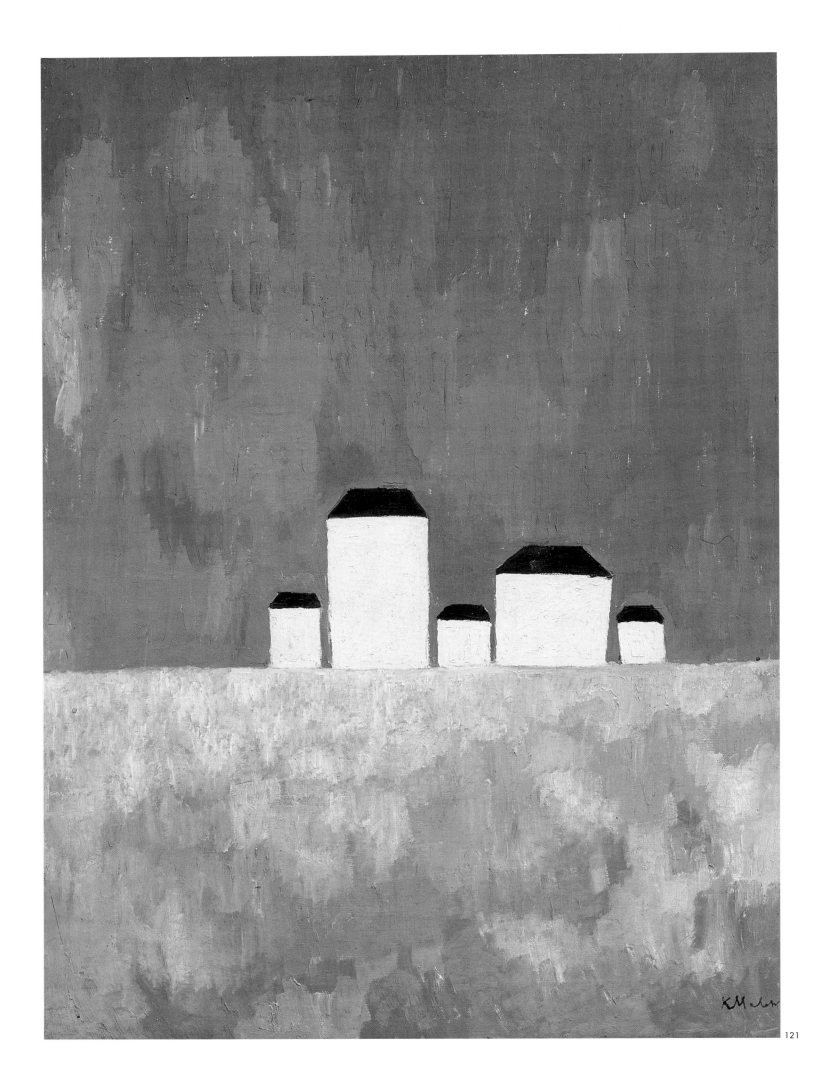

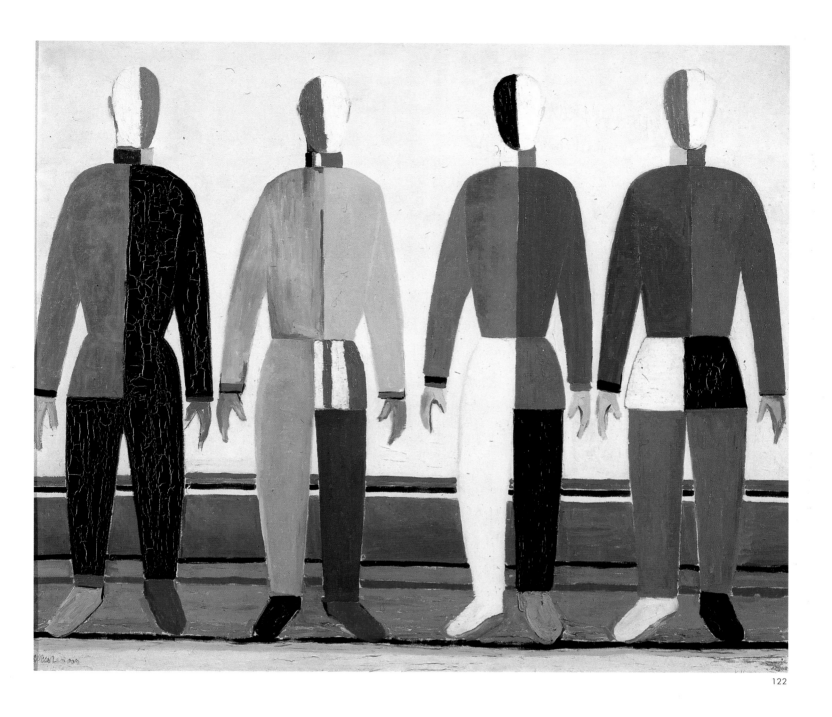

122

121
Kasimir Malevich
Landscape with Five Houses. 1928–32
Oil on canvas. 83 x 62 cm

122
Kasimir Malevich
*Athletes (Suprematism in the Contour
of Athletes).* 1928–32
Oil on canvas. 142 x 164 cm

After decades of positivism in Russian culture, there ensued a time of spiritual searching: we see a return to the Russian Orthodox tradition (Vladimir Solovyov, Pavel Florensky, Sergei Bulgakov, Nikolai Berdiayev), different forms of theosophy and anthroposophy (Yelena Blavatskaya, Andrei Bely, Nikolai Roerich, Wassily Kandinsky), variations of Oriental teachings whose roots are to be found in Tibet and India (Piotr Uspensky, Georgy Gurdzhiyev), God-seeking, God-constructing, and more. Nor did Malevich remain on the sidelines while these searches were going on. It is difficult to define his belief exactly, but it amounted to a theomachy in which God was supplanted by a human creator who reconstructed the world in accordance with his revelation-like views.

Among Malevich's early works is a triptych, executed in 1907, now in the Russian Museum. It consists of tempera sketches for frescoes. The central piece is a portrait of the young Malevich surrounded by haloed figures bowing before him. Concealed behind this self-deification, this substitution of a superman-creator for God, was a view of the world as a failed and imperfect creation that had to be redone. Malevich was not alone in holding this view. In 1906, an exhibition of the Leonardo da Vinci Society was organized in Moscow. In the preface to the exhibition program, the poet Victor Hofman wrote: "But art is not only the equal of the world — it surpasses the world in beauty. The world did not turn out right and God himself, in the form of the Devil, whistles derisively at the failure of his universe. Through art we correct the world, we create another and more perfect world. Herein lies our highest struggle with God."[69] Malevich could well have put his signature to these words. He saw all his work, especially his paintings produced during his Suprematist and post-Suprematist periods, as an "amendment" to Biblical Creation.

As we know, in the world He created, God laid down one restriction, one prohibition for Adam and Eve, the injunction against eating of the apple on the Tree of Knowledge of Good and Evil. But not wanting a forced obedience, He preserved for the first of humankind the possibility of choice, free will. It is here that Malevich perceived a flaw in the universe. "If God had constructed his system perfectly," he observed, "Adam would not have sinned. The entire error lies in the fact that a limit had been established within the system. A system with no limit has no defects."[70]

123

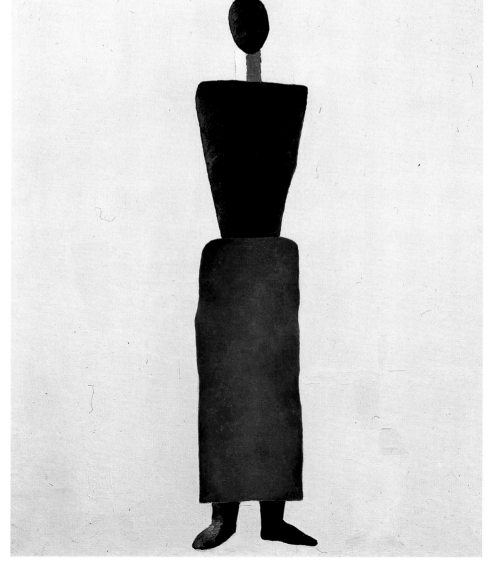

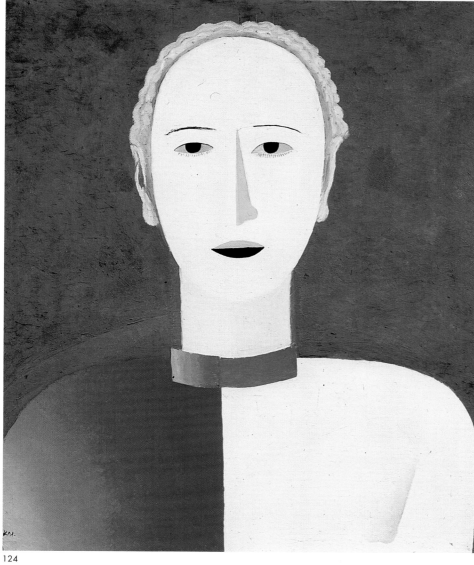

124

And Malevich gave the definition of such a system: "The perfection of the system lies in the fact that each and every unit, endowed with free movement and not experiencing pressure, can nevertheless not go beyond the limits of the system."[71] Precisely this kind of system, a kind of "Suprematist Universe," was what Malevich built throughout his life. Malevich's peasant cycle draws on the tradition of the Russian icon, but there is a profound difference between them. The icon painter recreated not a face, but a countenance, an illuminated, quintessential image of a man's face, a sort of super-personal image of a face. Ontological freedom, natural to man, preserved for him both countenance and individuality in the icon. In Malevich's works there is too little of a face to create a countenance and too much of a countenance to result a face. In the strictly deterministic world which he created, there could be no Fall from Grace, but there was no free will either and without it there could be no personality, no individuality. One must pay the price for a perfection organized without taking into account the category of freedom. Like Jacob in the Old Testament, Malevich struggled against God, but God defeated him. The correction to the Creation turned out to be a failure. Did Malevich feel this? Not only did he feel it, but certain changes took place in his work. From the 1920s and increasingly until the end of his life, elements of Christian symbolism appear and develop in the artist's works, above all, the image of the cross. He continued to paint peasants with white faces but sometimes performed on them a kind of baptismal ceremony, placing crosses on their forehead, arms, and legs, as is done at an actual baptism. The particular nature of Malevich's late canvases — non-objectivity dissolved in figurative elements — served as a starting point for many of his successors.

123
Kasimir Malevich
Suprematism. Figure of a Woman.
1928–32
Oil on canvas. 126 x 106 cm

124
Kasimir Malevich
Portrait of a Woman. About 1930
Oil on plywood. 58 x 49 cm

THE SCHOOL OF PETROV-VODKIN

Within the Russian avant-garde of the 1920s and 1930s there evolved several major artistic schools whose participants followed a set of unified principles worked out by a master and leader. We have already made the acquaintance of two of these, the schools of Malevich and Matiushin. Others were led by Petrov-Vodkin and Filonov. The creative work of Kuzma Petrov-Vodkin and his successors is one of the high points of Soviet art during that period.

As often happens, the creators of new artistic systems do not suffer lightly the ideas of other innovators. Malevich was constantly at loggerheads with Tatlin, Filonov rejected everybody, and they all jointly repudiated Petrov-Vodkin.

125

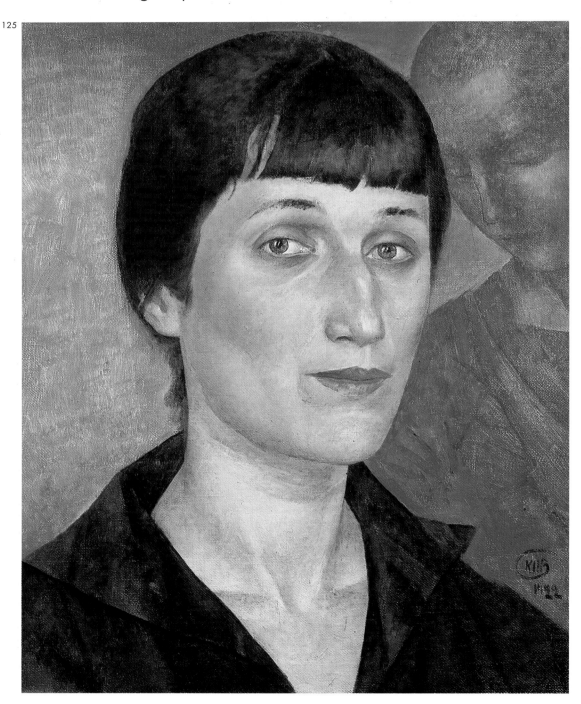

125
Kuzma Petrov-Vodkin
Portrait of Anna Akhmatova. 1922
Oil on canvas. 54.5 x 43.5 cm

Looking back from a distance of several decades, we can clearly see that all these artists, despite the various paths they followed, were moving in one direction. In this thesis on overcoming gravity and visual weightlesseness, Malevich was able to express the main principle of the new "spatial comprehension," which united them all. The Rayonism of Larionov, the Abstract Art of Kandinsky, the Suprematism of Malevich, and the Analytical Method of Filonov, despite their differences, were all systems founded on the principle of overcoming gravity. The structures which arose in their works were related to a world that was much larger and universal than the one in which gravity holds sway. To all of them, we can apply Petrov-Vodkin's concept of "planetary feeling." Petrov-Vodkin's theoretical notes speak of the enormous interest which he felt in these problems. "The struggle with the law of gravity. To overpower gravity means to sense a planetary feeling with one's whole organism. We destroy the perception of things through Euclid's geometry and the European perspective, placing them in a frontal position — 'up' and 'down.' The new way of looking is markedly an absence of vertical and horizontal lines."[72] In these theses lie the source of planetary feeling and of a concept of "spherical perspective," which are so keenly sensed in the pictures of Petrov-Vodkin. In the "tilted space" of his canvases, objects and human figures, having lost gravitational pull, appear ready to break loose from the earth's sphere. The spectator experiences his complicity with the enormous world of the Universe.

126
Kuzma Petrov-Vodkin
Morning Still Life. 1918
Oil on canvas. 66 x 88 cm

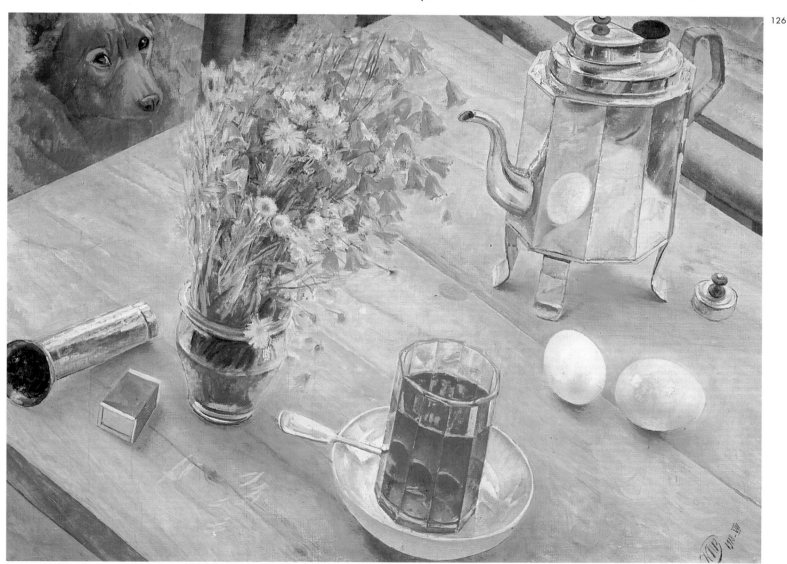

126

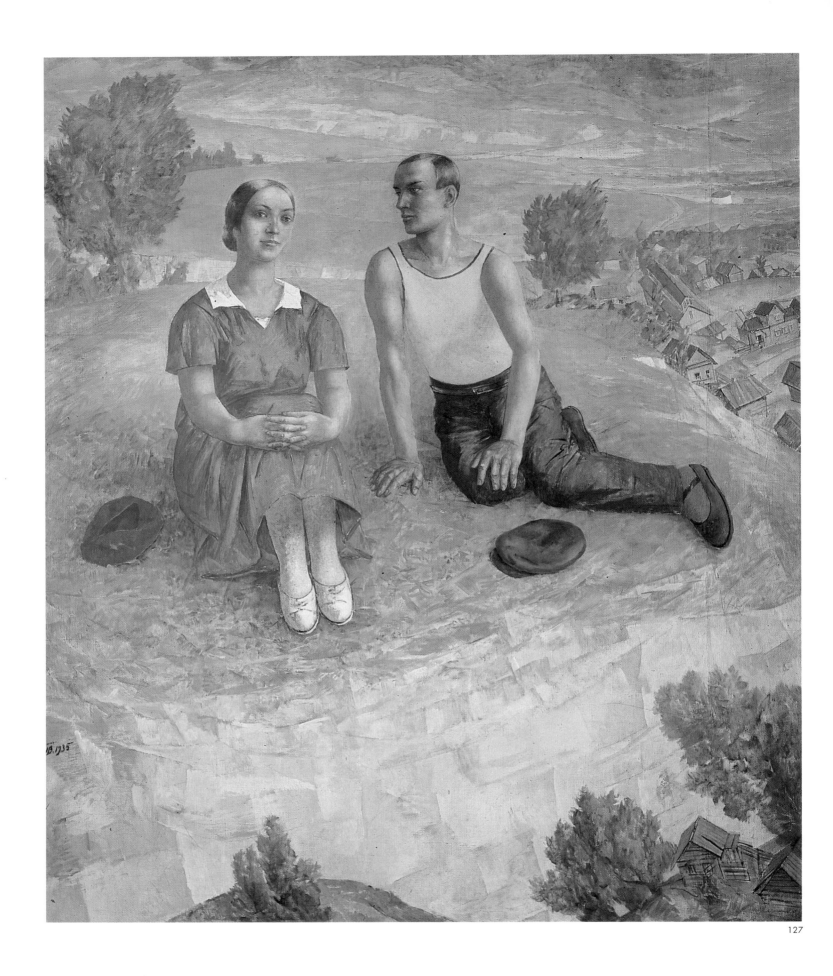

127
Kuzma Petrov-Vodkin
Spring. 1935
Oil on canvas. 186 x 159 cm

The 1910s saw the blossoming of Petrov-Vodkin's peculiar gift. All his life, the artist greatly admired the art of the early Italian Renaissance but it was at this time that he was attracted by the world of colors and forms of the recently "discovered" icon and old Russian fresco. It is impossible to understand the work of Petrov-Vodkin without their influence — especially that

as Malevich would put it, which is bounded by three relations — blue, red, and yellow — the primary, undiluted colors from which springs the entire coloristic richness of any master. In *Girls on the Volga* this principle stands out with particular directness and purity. But Petrov-Vodkin's famous "triad of color" does not imply any impoverishment of the painting, since each large, local

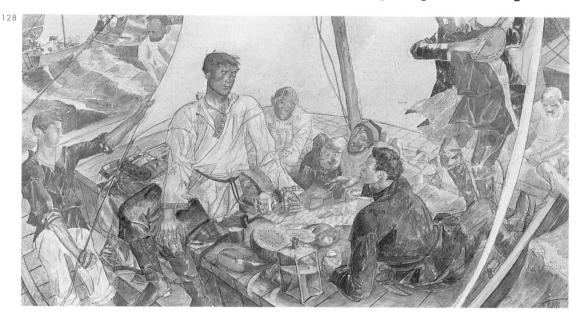

128

of the fresco — which was not direct but latent, yet profound and pervasive.
In the pre-revolutionary years, the artist painted pictures which were among the treasures of the new Russian painting: *Mother, Girls on the Volga, Morning, Bathing Women*, and others. Monumental in their rhythms and forms, they are at the same time intimately lyrical, a combination not often found. They are full of a singular music ringing with Russian sounds. Strikingly pronounced in these canvases is the artist's unique chromatic and spatial system.
Petrov-Vodkin's painting represents the antithesis of the lively and vibrating light and color of Impressionism. The similarity lies only in the fact that it too is built on the principle of complementary colors. In his pictures we do not find that primordial element of color, the "color dust," which can be seen, for example, in Larionov's work. This is the "artistic rendering in color,"

plane within it is full of tonal gradations. Petrov-Vodkin's painterly harmonies are deeply national in color and his canvases have that same "timbre" and the same blues, reds, and greens that we find in old Russian frescos. The artist long pondered over the particular national quality of color in the everyday life and art of different peoples and came to the conclusion that it is determined by the predominant color of the environment. Traveling through Central Asia and seeing the majolicas of the Samarkand minarets, he understood that "only here is the existing coloring of the turquoise" born of the sweltering gold of the desert as its complement. "This is the invocation as turquoise of the fiery spirit of the desert."[73] A red of a special timbre, which was dubbed "calico red," became the same kind of national, yet purely Russian color. This is the red of the shirts of Russian peasants, which provide a color complement to the cool green of the fields.

128
Kuzma Petrov-Vodkin
Stepan Razin. 1918.
Sketch for a panel
Watercolor on paper.
36.8 x 63.5 cm

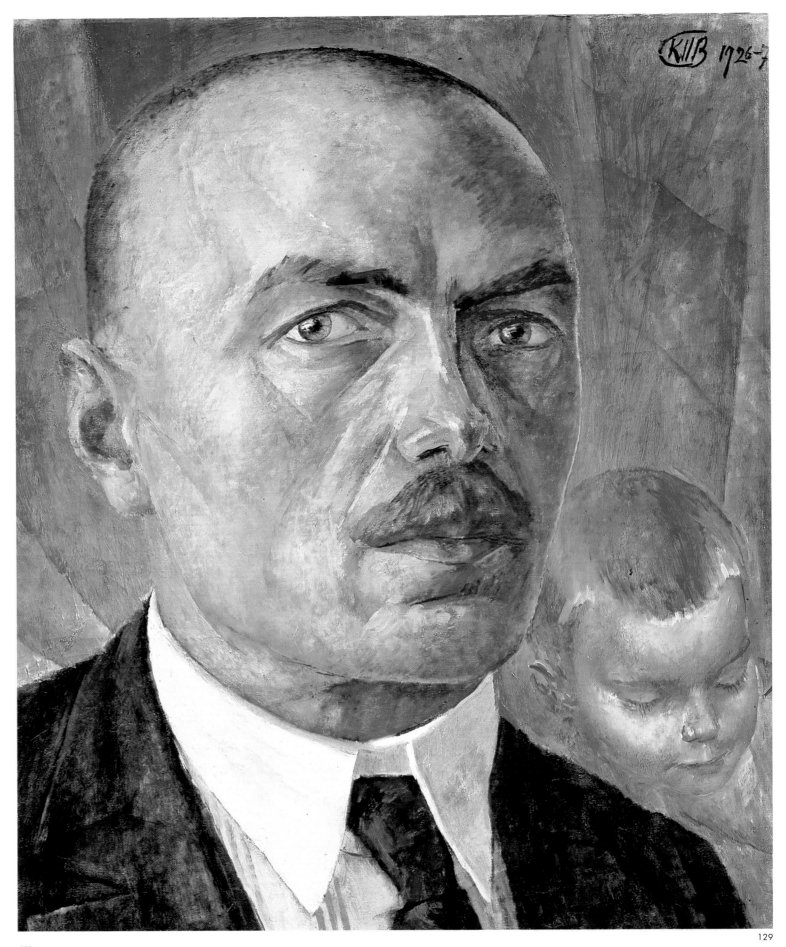

129

Kuzma Petrov-Vodkin
Self-Portrait. 1926–27
Oil on canvas. 82 x 65 cm

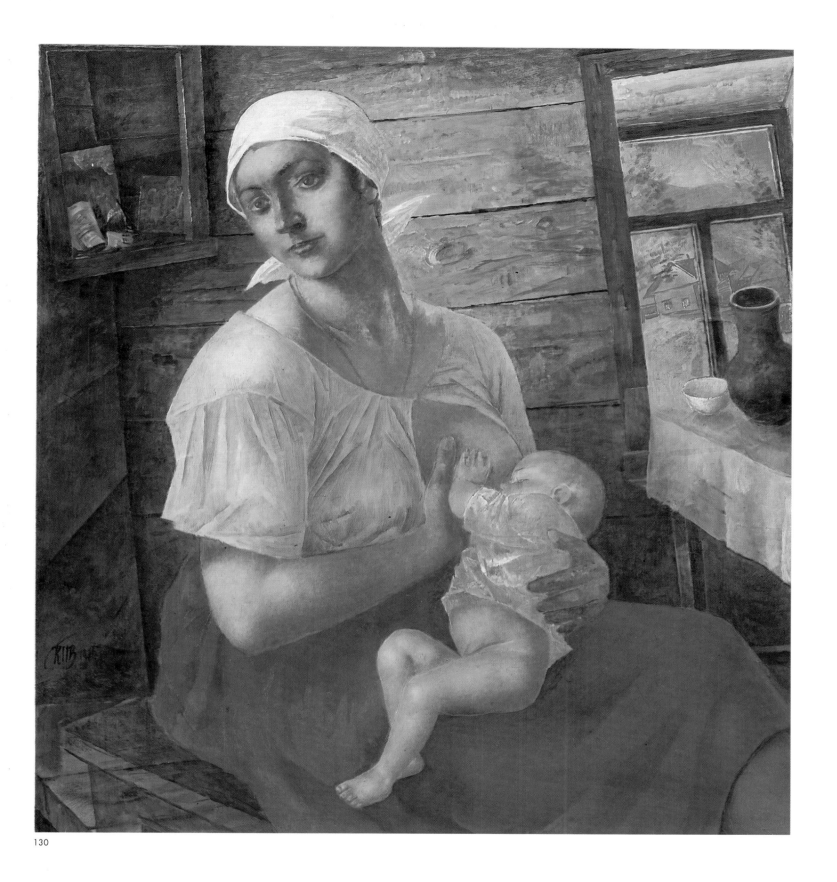

130

130
Kuzma Petrov-Vodkin
Mother. 1915
Oil on canvas. 107 x 98.5 cm

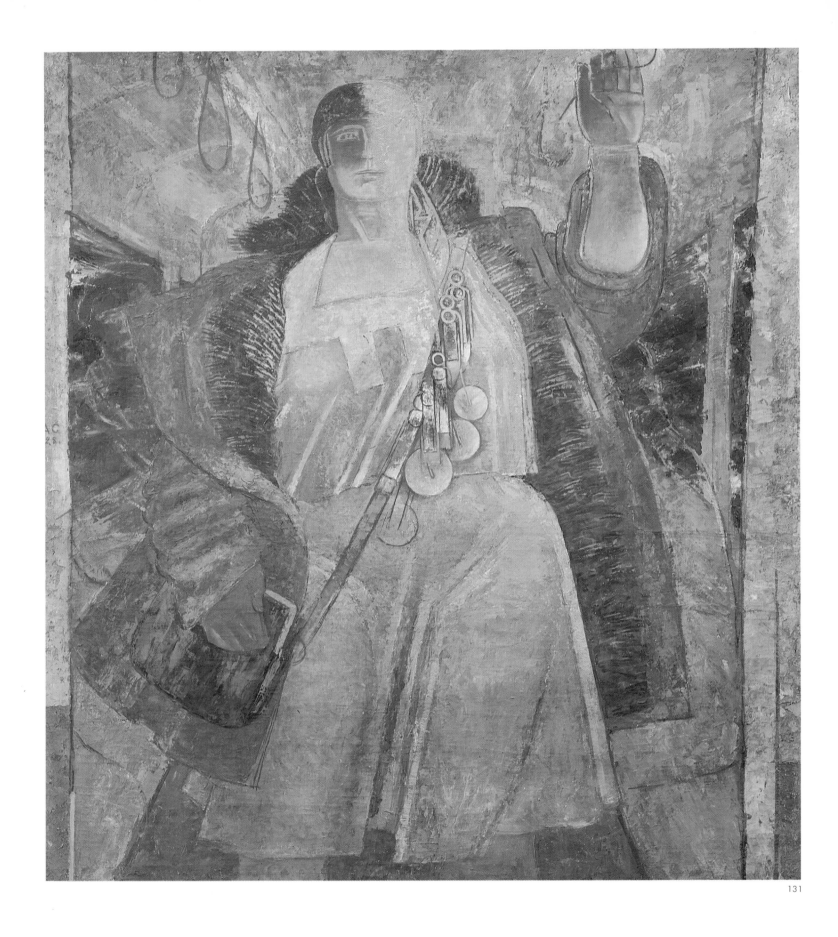

131
Alexander Samokhvalov
Conductress. 1928
Tempera on canvas. 130 x 127 cm

In the 1920s, Petrov-Vodkin taught in the transformed Academy of Arts and his workshop turned out true masters — Alexander Lappo-Danilevsky, Piotr Sokolov, an unusual artist who created paintings and graphics which were the artistic counterpart of the poetry of the Oberiuts (Union of Real Art). Yevgeniya Evenbach was remarkable among them.

In winter, the students worked in classrooms and in summer Petrov-Vodkin took them on sketching trips. They went to Pskov and Novgorod, and they

132

133

134

135

136

copied the frescos by Dionysius in the St. Therapont Monastery.

The teacher's bright individuality left its mark on the students' painting and yet a few decided to enter his studio. There is a view that Petrov-Vodkin's painting system had a pernicious influence on young artists, but this was true only for the weakest pupils. It helped the strong ones to find themselves.

Minei Kuks recalled the following episode. "In the winter of 1920, I arrived at the Academy and went into the glass-paned workshop where I ran into Piotr Ivanovich [Sokolov]. Under his arm he had a sketch book, a small box of paints — he carried them around in a suitcase — and an easel. He said angrily: 'Take the easel and follow me.' We went up a dark stairway into the main building and entered one of the studies. 'You left Petrov-Vodkin?'

'Yes. What Petrov-Vodkin does, nobody but himself needs to do. That art will end with him. Take Chupiatov. He took it to the absurd. There's nowhere left to go.'"[74]

Leonid Chupiatov, an orthodox "Vodkinite" during his student years, was nevertheless able to find his own artistic path. The canvas reproduced in this book gives only a brief glimpse of the originality of this master whose work has remained completely unstudied. His work is striking in terms of the depth and spiritual height of its content. He died in the siege of Leningrad having just finished his last canvas. *Intercession of the Virgin*, which is now in a private collection.

136
Yevgeniya Evenbakh
Nivkh Children after Fishing.
Mid-1930s
Watercolor on paper. 25.7 x 35.4 cm

137
Yevgeniya Evenbakh
Students. 1923
Oil on canvas. 160 x 132 cm

138

138
Leonid Chupiatov
Still Life: Apples and Lemon. 1923
Oil on canvas. 69.5 x 92 cm

139
Alexander Samokhvalov
Insomnia. 1921
Watercolor on paper. 37.5 x 29.4 cm

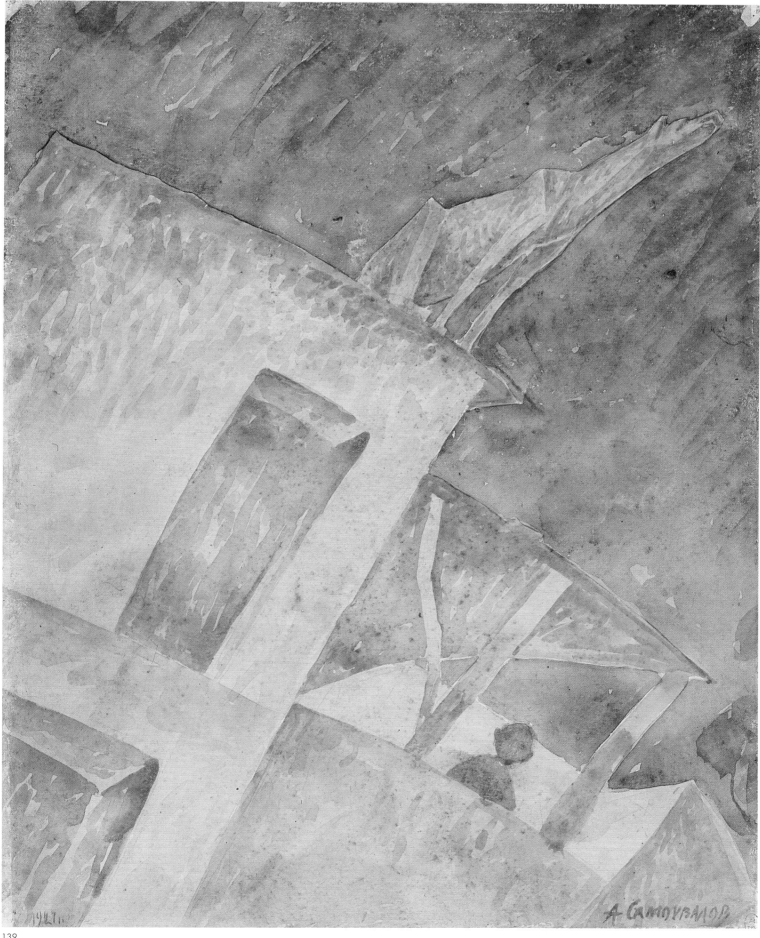

139

FILONOV AND THE MASTERS
OF ANALYTICAL ART

140
Pavel Filonov. 1917

141
Pavel Filonov
Man in the World. 1925–26
Oil on paper mounted on canvas.
107 x 71.5 cm

excluded from the country's artistic life. None of the leaders of the Russian avant-garde was subjected to such consistent persecution during his lifetime or was relegated to such utter silence after his death. All that remained was the "Filonov legend," which his pupils passed on by word of mouth.

He lived the life of an ascetic before the Revolution, subordinating everything to the tasks of creativity. He lived in dire poverty even after the Revolution, especially in the 1930s when he was practically reduced to the state of a beggar. Yet he never lost the ascetic fervor of creativity. In a diary entry for August 30, 1935, he wrote: "All this time, from the first days of June, I lived only on tea, sugar, and one kilogram of bread a day. Only once did I buy cauliflowers for fifty kopecks and there-after, saving on bread, I bought potatoes for forty kopecks, and 'sprouty potatoes.' About ten days before August 30, seeing that my money would not carry me through, spent the last of it on tea, sugar, *makhorka* [crude tobacco], and matches and, lacking money for bread, began to bake flat cakes from the white flour which I still had. On the 29th skimping the whole time on flour, I baked the last flat cake in the morning from the last handful of flour, preparing myself, according to the example of many people, many times, to live no one knows how long without eating."[75] Filonov perished in the very first months of the siege of Leningrad. His sister, Yevdokia Glebova, saved his works and preserved them during the long years when her brother's artwork was unrecognized. The artist never sold his pictures. "All his works," he wrote (referring to hiself in the third person), "both those that are already done and those which he planned, he decided to hand over to the state to be made into a Museum of Analytical Art." [76]

Pavel Nikolayevich Filonov came to the fore of Russian art on the eve of the First World War. From 1932, when his works were demonstrated for the last time in the Russian Museum at an exhibition dedicated to the 15th anniversary of the Revolution, Filonov's creative work was

While still a student at the Academy of Arts (which he was forced to leave), Filonov proved to be a black sheep. Many years later he reminisced: "From the very first day, I began to work in my own way. Tsionglinsky is the only one I can remember with respect and love: he didn't stand in my way; indeed, he greeted my works with unrestrained enthusiasm. More than once, when struck by my tenaciousness, he shouted to the whole class: 'Look! Look what he's doing! Those are the kind who turn out to be Cézannes, Van Goghs, Holbeins, and Leonardos!'"[77]
Filonov showed his works for the first time in 1910 at an exhibition of the Union of Youth.[78]

142
Pavel Filonov
Countenances. 1940
Oil on paper. 63.5 x 56 cm

142

Filonov's early works were the first completely conscious opposition to Cubism. The creative method of this Russian artist, who had begun to develop the principles of Analytical Art, went right against Cubist geometrization. In 1913, Filonov wrote an article entitled "Canon and Law."[79] In it he distinguishes two paths in the creation of a picture: "In revealing the construction of a form

143

143
Pavel Filonov
Colonial Policy. 1925–26
India ink with pen, watercolor,
and indelible pencil on paper.
15.3 x 12.4 cm

or picture, I can proceed according to my conception of this construction of form; i.e. in a preconceived manner, or by pointing out and revealing the law of its organic development; consequently, even the revelation of the construction of the form will be preconceived:

a canon, or organically, a law."[80] Here Filonov for the first time uses the attribute "organic," which is so important in his artistic conception. Cubism, as he saw it, was the voluntary decision to geometrize the object to be depicted. A "law," in contradistinction to a "canon," assumes another path — the building up of a form from the specific to the general: "Let things develop from the specific, totally developed and then you will see true generality such as you never even expected."[81]

In all these principles we can see the opposition of Filonov's method to Cubism. The Cubists' link with nature appeared to him to be insufficient and attenuated. To a geometrization that does not reflect even a small part of those properties and processes of nature which could be expressed plastically, he juxtaposed the principle of the organic growth (as a tree grows) of the artistic form which he realized in Analytic Art. "Organism" against "mechanism" is how we can define the essence of Filonov's theory.

The "principle of made pictures" is one of the fundamental notions of the analytic method: the artist "builds" his picture as nature "creates" larger structures from atoms and molecules. Filonov painted large canvases with a small brush. For him, each contact with the canvas, each point was "a unit of action," and this unit always acts simultaneously as form and color. The artist wrote: "With persistence and precision, I apply the crafted color to each atom so that it will eat its way therein, like heat penetrating a body, or so that it will be organically linked with form, as in nature the cellular tissue of a flower is linked with color."[82] For Filonov, the process of life was an example or model which the artist follows in creating a work of art. He wished to imitate not the forms created by nature but the methods by which nature "acts."

I repudiate all the "dark kingdom" of contemporary Russian art criticism, which puts science and proletarian life to shame: and I reject its everyday slogans: "Pull, don't push," "Divide and rule," which have parasitically reduced that same ideology of realistic emasculation to the state of refined rhetorical rubbish. The activity of the "Pillars" of Russian art criticism is historically fruitless, brutal, and so unscientific as to constitute a juggling with the facts (see N. Punin's articles in the book *Russkoye iskusstvo* [*Russian Art*], where right in front of everybody he carts stowaways and contraband goods along the high road of Russian Art). Just recall the battle of the Itinerants[83] against the old guard academicians and, *vice versa*, the caste persecution by the World of Art and Benois of the Itinerants, the provocation of both rightists and leftists by Benois and the World of Art, and the leftist campaign against the Naturalists. Remember, how they automatically buried such great men as Bruni, Surikov, Savitsky, and such like. Russian art and icon-painting were first scholasticized *en masse* by the Byzantine inoculation of form, color, and aesthetics. Then it was scholasticized by the Moscow Assembly of priests.[84] Then the Populist movement of the Itinerants was scholasticized by the World of Art and was finished off by Benois — and all in the name of the "two predicates of realism." Its latest, unvanquished, purely revolutionary breakthrough, dating from 1904, is "leftist art of all origins." But it too is forced to pull on the same scholastic harness and bit of the "canonism of form and color" according to the ritual of mere external protocol. It is constrained by the same Assembly — "the Responsible Ministry": Punin, Tatlin, Petrov-Vodkin, Malevich, Radlov, Matiushin, and the Guild of Daubers, i.e. the representatives and clerks of the Europeanized (in particular in the French style) tendencies of the same two-predicate realism. The deviant branch of French art in Russia (Hellenism), which is supported, via Suprem-Constructionism, by the very same routine of the two predicates, is called "the high road of Russian art." The station masters have been appointed and the slogan has been issued: "Production of non-objectiveness." But that act won't go on.

Filonov considered that the artists who were his contemporaries — both Cubists and Realists — interacted with nature in a narrow and one-sided manner, capturing only two of her properties — color and form, whereas each phenomenon has a countless number of properties. He declared the "reformation" of Picasso to be "scholastic formalism, and in essence devoid of revolutionary significance,"[85] since in Picasso's works, as in those of Repin, only the form and color "of the periphery of objects" is painted, plus or minus "the orthography of the school, people, tribe, or master."[86] Filonov's method seeks to draw into the sphere of creative expression the entire complexity of life in its visible and invisible manifestations: "Since I know, I analyze, I see, I feel by intuition that in any object there are not two predicates, form and color, but a whole world of seen and unseen phenomena, their emanations, reactions, inclusions, genesis, being, known or secret properties, which in turn sometimes have countless predicates — that is why I reject the dogma of contemporary Realism of two predicates, and all its orthodox leftist-rightist sects, for they are unscientific and dead — totally."[87]

Nikolai Zabolotsky, who was very strongly influenced by Filonov's work, wrote a poem entitled *Trees*, in which a flower reveals the multifaceted spectrum of its features or, according to Filonov, "of its predicates," both visible and invisible.

"*Bombeyev:*
Who are you, nodding your little head?
Who plays with the bug and ladybird?
Voices:
I am the sunny force of leaves.
I am the stomach of the flower.
I am the chandelier of the pistil.

145

144
Pavel Filonov
Goat. 1920s
Oil on paper. 80 x 62 cm

145
Pavel Filonov
Formula of Spring. 1928–29
Oil on canvas. 250 x 285 cm

Artist, you must think critically for your-self, see penetratingly, do, create, invent. You must have the maximum of inventive power, have an ideology on a world scale; a scientific perception and a sense of what this demands. See to it that the walls of exhibition galleries and the columns of the newspapers do not abound in carrion. Get going on the reassessment of values. The universal flowering is approaching and the age of made pictures is upon us.
<...> Greetings to the masters: Malevich, Mansurov, Chekhonin, and, for the relevance of their work daily life, to Andreyev,[88] Kuznetsov, the author of *The Shaman*, Khiger, and Shapiro. I define Russian art (in general) as an ex-ceptional variety of European art (in gene-ral) for its "generic" textural qualities: weight, the rawness of spontaneous un-biased texture, organic aesthetics. This is the indicator that the artist has achieved his results through intuition, not through a canon. Here the master's spirit dynamical-ly enters the material of the object, domi-nating the condition of representation, as a subconscious and conscious repudiation of the canon. The French school in gene-ral is realism of two predicates and specu-lative aesthetics. The Russian school in general is realism of two predicates, organ-ic aesthetics and an elemental, intuitive break with the canon. (Compare: Surikov, Savitsky, Courbet, Cézanne). This is the origin of the concept of the Russian contribution to universal leftist art as a chronological consistent development. Precisely for this reason, I repudiate the contemporary notion of a Russian high road and give my own: The Itinerants, Surikov, Savitsky, Jack of Diamonds,[89] Donkey's Tail,[90] my works, Rayonism,[91] Malevich, and the Burliuks. Cubo-Futurism, my works, and the thesis of pure, acting form and the shift of the cen-ter of gravity in art to Russia. Suprematism, Mansurov, my present (repeated) opposition to realism. I am the artist of universal flowering; consequently, I am proletarian. I term my principle naturalistic because of its purely scientific method of conceptualizing the object, which is able to see through things sufficiently exhaustively, to intuitively sense all its predicates to the point of sub- and superconscious calculations and to reveal the object in a solution that matches the perception of it. I am not establishing rules or a school (I absolutely reject them as an approach); I give as a basis a simple, purely scientific method by means of which each person, whether on the left or the right, can act in his own way...

P. Filonov, "Deklaratsiya Mirovogo Rastsveta," *Zhizn' iskusstva* ["Declaration of Universal Flowering," *The Life of Art*], 1923, No. 20, pp. 13–15

146

I am the delicate stem of the meek gilly-flower.
I am the tiny root of fate.
And I am the burdock of rest.
Altogether we are the image of the flower, its shoot, and the direction of its tendril."
Filonov was convinced that all these properties and phenomena, both visible and invisible, could be expressed in painting through plastic means. He developed the notion of the "seeing eye" and the "knowing eye." Under the sway of the first are the color and form of the object. On the basis of intuition, the "knowing eye" captures concealed processes and the artist paints them "with an invented form," i.e. non-objectively. This is why figur-ative representation is so often alloyed in his pictures with non-objective ele-ments. The poet Alexei Kruchonykh called Filonov the "eye-witness of the invisible."

146
Pavel Filonov
Rabble. 1923–24
India ink and graphite on paper.
17.7 x 10.7 cm

147
Pavel Filonov
Living Head. 1926
Oil on paper mounted on canvas.
105 x 72.5 cm

147

In 1919, Filonov participated in a vast exhibition which opened in the Winter Palace, showing twenty-two canvases. Two groups of images, a division which was already noticeable in the pre-revolutionary decades, run through these canvases and Filonov's entire work. One theme is that of the contemporary city, which Filonov, like Yelena Guro and Khlebnikov, perceived as being the source of evil, something that maimed man physically and spiritually. He was an opponent of urbanization and the "machine" civilization which Marinetti welcomed. The artist sympathized deeply with the victims of this city "machine" which pulverizes man, depriving him of his individuality. "Excellent Filonov, full of suffering, the little known singer of city suffering" — this is how Khlebnikov referred to him.[92]

The Feast of Kings, created in 1914, on the eve of the war, is a visual image of an evil world that crushes man and the humanity within him. The painting *Animals* (1925–26), shows monstrous anthropomorphic beasts roaming in the midst of desolate stone buildings.

The break with nature, which both Filonov and Khlebnikov rejected, wreaks vengeance by making man a spiritually wild beast. Khlebnikov wrote: "Man took the surface of the Earth away from the wise community of beasts and plants and became lonely; he had no one with whom to play tag and blindman's buff; at rest in a void with the darkness of non-existence all around, there were no games, no comrades. Who was he to have fun with? All around was an empty 'nothing.' Driven out of their bodies, the souls of the beasts threw themselves upon him and inhabited his steppes with their law. Beastly cities were built in the heart."[93]

To this inhuman contemporaneity, the poet and the artist opposed a humanistic Utopia of their own, one in which the future of mankind is perceived through images of primeval and primordial purity. In this world which has conquered enmity and violence, man and the animal world coexist in harmonious unity. "Behold the lion asleep on my knees," wrote Khlebnikov in his short futurological work *Utios iz budushchego* [*A Crag from the Future*].

At the exhibition of 1919, Filonov showed a cycle of pictures that he entitled *Introduction to Universal Flowering*. These are *The Holy Family*, *Three at Table*, *Flowers of Universal Flowering*, *Conqueror of the City*, and others. Here the artist developed his socio-artistic Utopia that heralded a fraternal, just life for man on earth. Victor Shklovsky, who visited the exhibition, wrote: "At the exhibition, Filonov looks like Mount Ararat. He is not a provincial Westerner. And if he is a provincial, then he is from a province which, having created a new form for itself, prepares a campaign to take over the spent, decrepit center. In his pictures one feels an enormous sweep, the enthusiasm of a great master... Filonov now has the strength of Russian, not imported, painting.[94]

148
Pavel Filonov
Animals. 1925–26
Oil on cardboard. 36 x 44 cm

148

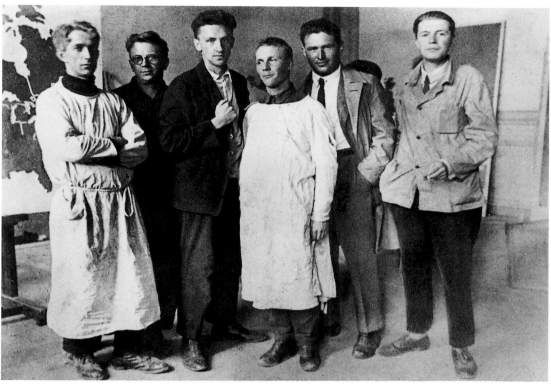

149

149

A group of Filonov's pupils at the Press House in 1927. From left to right: Eduard Tenisman, Vladimir Luppian, Vsevolod Sulimo-Samuillo, Mikhail Tsybasov, Yevgeny Kibrik, and Nikolai Yevgrafov

"At the end of 1926 and the beginning of 1927, the director of the Press House strove to implant and give a free field of action to all that was new in art. He commissioned Filonov's school, headed up by Pavel Nikolayevich, to decorate the rooms of the Press House with paintings. The Press House was located at the time in the former Shuvalov Mansion on the Fontanka."

T. Glebova, "Vospominaniya o P. N. Filonove," *Panorama iskusstv 11* ["Reminiscences of Pavel Filonov," *Panorama of the Arts 11*], Moscow, 1967, p. 115

→
150
Andrei Sashin
Sketch of a tavern servant's costume for Nikolai Gogol's comedy *Revizor* [*The Inspector General*]. 1927 Watercolor on paper. 47.7 x 36.2 cm

→
151
A poster by Pavel Filonov for a performance of Nikolai Gogol's *Revizor* [*The Inspector General*] at the Leningrad Press House, 1927. In composing the poster, Filonov used sketches by (clockwise, from above) Rebecca Leviton, Andrei Sashin, Arthur Liandsberg, and Nikolai Yevgrafov.

"The day of the opening of the Press House was to be a performance of *The Inspector General* with a set and costumes by Pavel Filonov's students. Five enormous painted backdrops on the background of which black booth-like cupboards were to move around. The costumes were of white cloth and were painted up like pictures. Poor Pavel Nikolayevich was so worn out from the sleepless nights he had spent that he slept through the entire performance propped up with his elbow on the armrest of his fourth row seat, with his wife, Yekaterina Serebriakova, seated next to him."

T. Glebova, "Vospominaniya o P. N. Filonove," *Panorama iskusstv 11* ["Reminiscences of Pavel Filonov", *Panorama of the Arts 11*], Moscow, 1967, p. 120

Filonov's painting attracted young artists like a magnet. Among the leaders of the Russian avant-garde, no other master had such a wide following. In 1925, from June to September, Filonov taught in one of the rooms of the Academy of Arts. His classes were attended by up to seventy pupils, many of whom, admittedly, did not stay long. By 1927, when the Masters of Analytical Art (MAI) was officially established, he was working with around forty artists. Among them were Pavel Kondratyev, Alisa Poret, Tatyana Glebova, Yury Khrzhanovsky, Alexander Sazhin, Mikhail Tsybasov, Boris Gurvich, Rebecca Leviton, Yevgeny Kibrik, Vsevolod Sulimo-Samuillo, Sophia Zaklikovskaya, Nikolai Yevgrafov, Innokenty Suvorov, Alevtina Mordvinova, and others. They constituted the core of "Filonov's school." In 1927, the first major public appearance of the Filonovites took place. The Leningrad Press House, headed by Nikolai Baskakov, organized an exhibition of the MAI collective and staged a presentation of Gogol's *The Inspector*

General, directed by Igor Terentyev with stage sets by Filonov's pupils. On the walls of the theater auditorium in the Press House hung large panels measuring up to five meters in height, painted by the Filonovites, and all united by the theme "The Downfall of Capitalism." Filonov, who was in charge of all the paintings, worked through the night helping the artists to complete the task. This period of work under the master's direction and in strict compliance with the principles of Analytical Art left an indelible impression on all the participants in the exhibition. Many years later, Tatyana Glebova reminisced: "The work in the Press House was our Academy. We were seized with enthusiasm and faith in the fact that our way was the correct and only way."[95]

ТЕАТР ДОМА ПЕЧАТИ

РЕВИЗОР

Гоголя

Художник: Мастера Аналитического Искусства–
Школа Филонова.
Композитор–**Владимир Кашницкий.**
Постановщик: **Игорь Терентьев.**

ЛЕНИНГРАД
Апрель 1927 г.

In 1929, the Russian Museum proposed to Filonov that he organize a one-man exhibition. Vera Anikiyeva, one of the museum staff, wrote a scholarly article and compiled a catalog which to the present day ranks as the only precise document covering this event. Right from the start, however, there were

while polemical articles appeared in the press; opinions were expressed for and against his work. Isaac Brodsky, an artist whose work was the anthithesis of Filonov's, wrote in one newspaper: "I consider — and this is not only my opinion — that Filonov is the greatest painter not only in our country but also in Europe

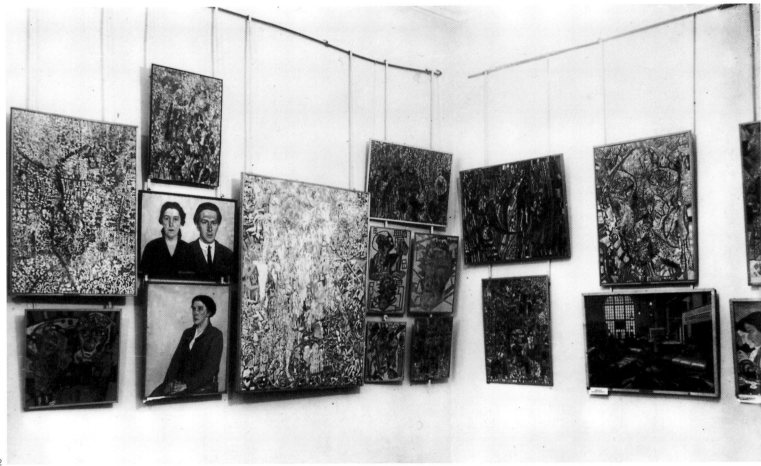

152

complications. Forces emerged which began to actively impede the opening of the exhibition. The catalog was reprinted: the introduction by Anikiyeva was expunged and was replaced with an article by Sergei Isakov, who expressed doubts about the value of Filonov's creative work. Filonov's opponents attempted to back up their position with the opinions of workers, who were invited to take part in closed discussions about the exhibition. Yet all the workers who expressed an opinion were in favor of opening the exhibition. For a whole year, Filonov's pictures hung in the rooms of the museum

and America. His artistic techniques — his use of color, his approach to the work, and his depth of thought — will beyond doubt make their mark on world painting, and our country will have earned the legitimate right to be proud of him."[96] But the exhibition never opened.

153
Nikolai Yevgrafov
Carnival. Variation. 1938–40
Oil on canvas. 117 x 88 cm

154
Nikolai Yevgrafov
The New Life. 1932
Oil on canvas. 124 x 87 cm

152
Filonov's room in the Russian Museum. The exhibition "Artists of the RSFSR over the Last 15 Years (1917–32)." 1932

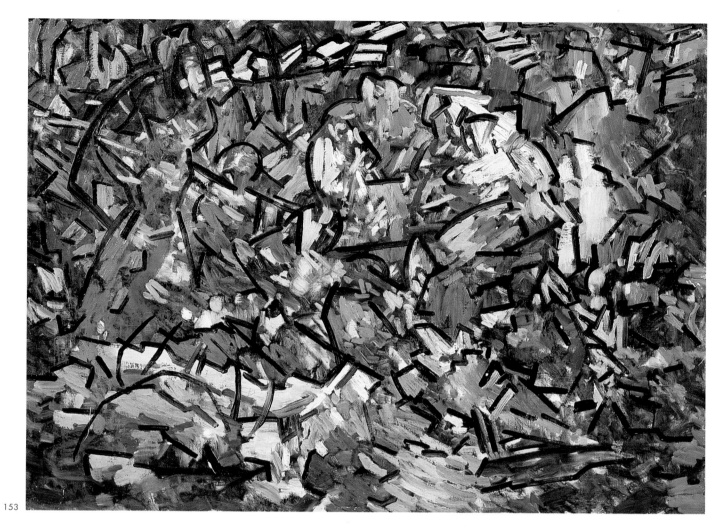

153

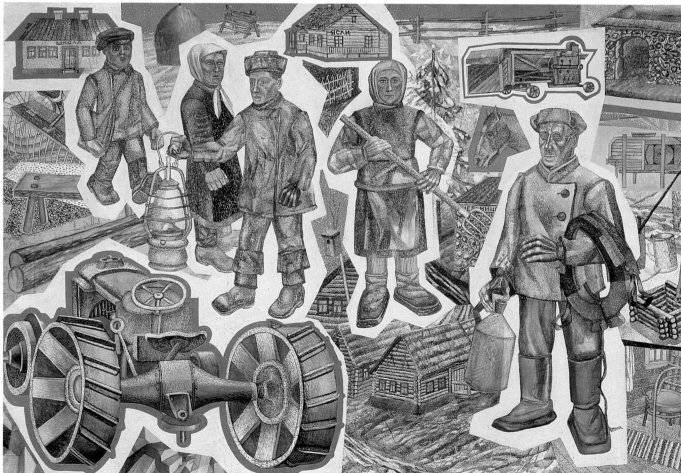

154

155

156

157

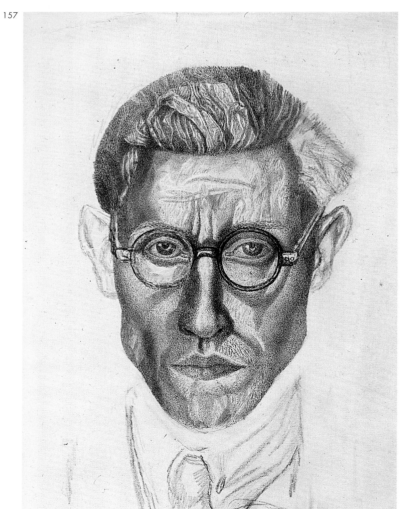

158

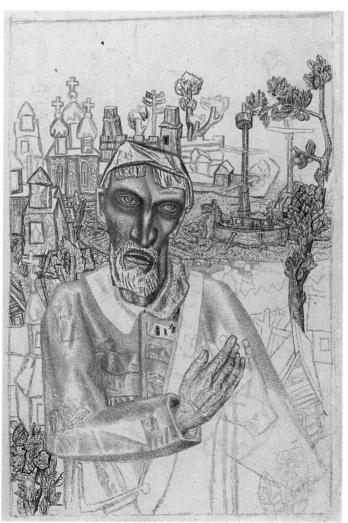

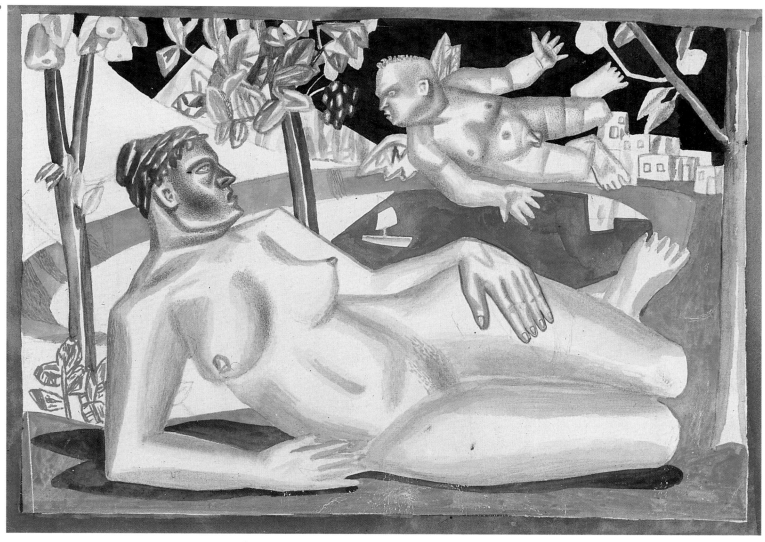

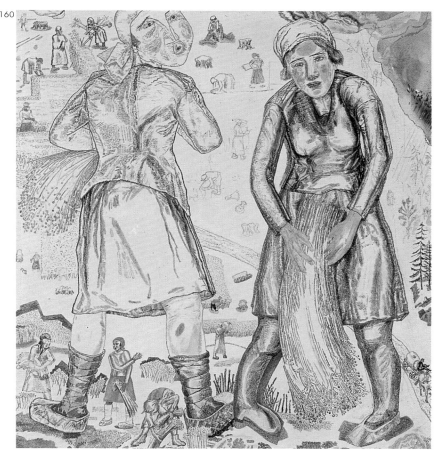

155
Vsevolod Sulimo-Samuillo. Late 1920s

156
Vsevolod Sulimo-Samuillo
Portrait of the Artist Mikhail Tsybasov. Late 1920s
Graphite, colored pencils, and watercolor on paper.
25 x 21.3 cm

157
Vsevolod Sulimo-Samuillo
Self-Portrait. Late 1920s
Graphite and watercolor on paper. 24.6 x 17.6 cm

158
Vsevolod Sulimo-Samuillo
Old Man. Late 1920s
Graphite, colored pencils, and watercolor
on paper. 26.3 x 17.2 cm

159
Vsevolod Sulimo-Samuillo
Venus and Cupid. Sketch for a panel
Watercolor and India ink on paper. 18.2 x 25 cm

160
Pavel Kondratyev
Collective Farm Women Harvesting Flax. 1920
Watercolor and graphite on paper. 36.3 x 33.4 cm

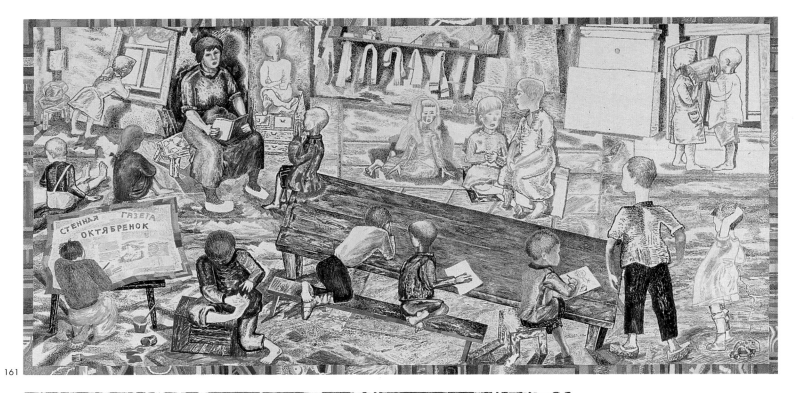

161

162

163

164

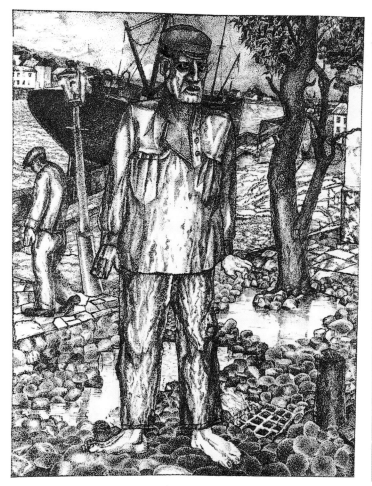

165

166

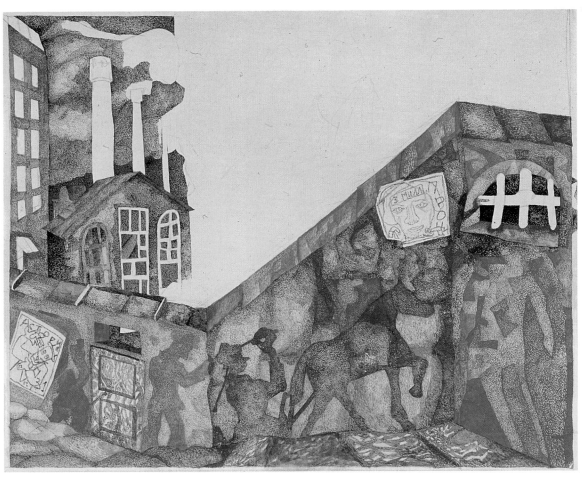

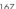

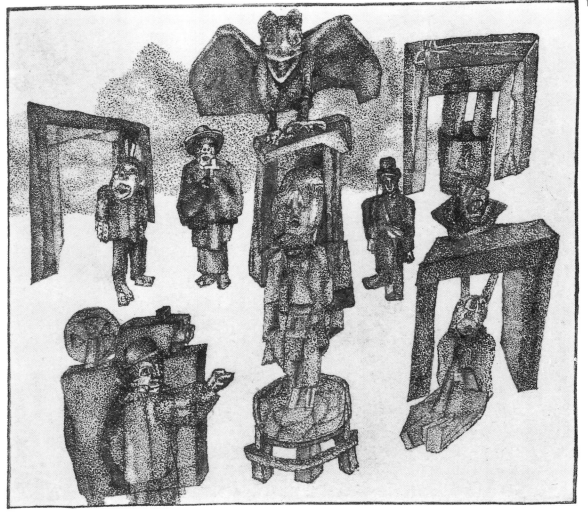

167
Boris Gurvich
Sketch for a mural. 1931
Watercolor and graphite
on paper. 17.3 x 20.3 cm

168
Boris Gurvich
*"Relax. I'm taking your
picture."* 1925
Brown ink on paper mounted
on cardboard. 17.3 x 20.3 cm

169
Valentina Markova
Self-Portrait. 1930 (?)
Oil on canvas. 104.5 x 68 cm

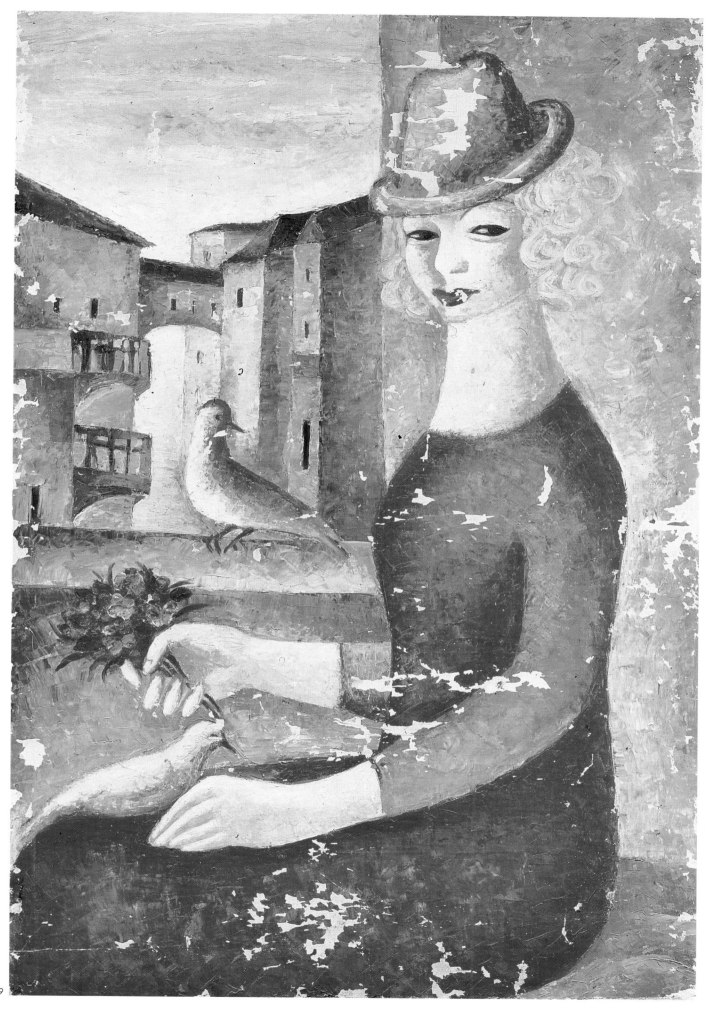

The second joint work of the MAI collective (Masters of Analytical Art) was an illustrated edition of the Finnish epic *Kalevala* executed under Filonov's direction. Working closely together on the drawings accompanying the Karelian-Finnish epic were thirty artists, among them Tatyana Glebova, Alisa Poret, Mikhail Tsybasov, Sophia Zaklikovskaya, and Pavel Zaltsman. Glebova recalled: "We all worked

illustrations to the *Kalevala*. The book's dust jacket was the collective work of the Filonovites. Here non-objective structures are interspersed with representations of beasts and birds, boats and people. Out of this complex fusion arises the image of Finland, indented with the blue of lakes, ringed by moss-covered granite ridges and coniferous forests. The reader gets a bird's-eye view of Suomi, both

170

171

at home and got together in the evening about twice a week to discuss what had been done, the main thing, of course, being to hear what Pavel Nikolayevich would say about our work."[97]

Filonov understood his role as an editor in quite a broad sense. He chose the subjects for illustration, determining the general character and stylistic features of the drawings, the handling of images, and sometimes he himself would take up the pen or watercolor brush to correct this or that drawing.

It is impossible to divide the works of Filonov and his successors into figurative and non-ovjective. Often the same canvas, in the same image, combined both principles. We also see this in the

in a visual and a conceptual sense. The *Kalevala* as a poetic approach, as a means of figurative thinking, proved to be akin to the principles of Analytical Art, with its alogism, its shift in spiritual and temporal connections, and the interpenetration of objects, violating habitual relationships. Here is how the *Kalevala* depicts all these transformations and shifts as the singing of the bard Väinämönen works its spell:

> The old Väinämöinen sang:
> the lakes rippled, the earth shook,
> the copper mountains trembled,
> the sturdy boulders rumbled,
> the cliffs flew in two,
> the rocks cracked upon the shores.
>
> *Kalevala*, 3, 295–300
> (Translated by Keith Bosley)

170
Tatyana Glebova and Alisa Poret. About 1930

171
Daniel Kharms and Alisa Poret. About 1929

The artists of Filonov's group and the Oberiut poets (Vvedensky, Kharms, Zabolotsky, and Oleinikov) were united by their tendency toward alogism and "transsense" poetics. Poret, Glebova, and Kondratyev often illustrated children's book by the Oberiut writers. Their frequent meetings took place in a relaxed atmosphere of jokes and witty sallies.

Zaklikovskaya's drawing *Kullervo the Serf* is completely subordinated to this logic of transformations and shifts — objects become transparent and interpenetrate one another

The *Kalevala* was published in December 1933, half of the print run of 10,000 being sold in Finland.

The Filonov school was hard. Filonov's strong personality and his adamant stands on artistic questions no doubt

there's nothing to be sorry about."[98] Those who passed through Filonov's school and did not "go to pieces," became eminent masters, each with his or her own personality. Many of Filonov's pupils who professed fidelity to his principles strayed far from the rigorous norms of the analytical method, yet the Filonovite fundamentals remained for them a fertile soil which nurtured their own highly original creative works.

172

173

stifled the young artists. Many, fearful of losing their individuality, dropped their studies half-way through.

Her first contact with Filonov's studio made a startling impression on Tatyana Glebova: "When I entered the studio, I was amazed: everywhere nailed to the walls were large sheets of paper with drawings that had been started; on the easels were recently begun canvases, all the work of pupils and all slavishly imitating the works of the master. I didn't find this at all to my liking... I was afraid of losing my individuality and that made me hesitate: should I stay there? But then I decided — if I do have true individuality, then it will be impossible to destroy it; if that's not the case,

172
Sophia Zaklikovskaya. Late 1920s

173
Three lady artists in Alisa Poret's apartment. From left to right: Olga Liashkova, Tatyana Glebova, and Alisa Poret. Late 1920s

174
Sophia Zaklikovskaya
*The Old and New Ways
of Life*. 1927
Oil on canvas. 282 x 121 cm

175
Sophia Zaklikovskaya
Kullervo the Serf. 1932.
Illustration to the Karelian-Finnish
epic *Kalevala*
Pen and India ink on paper.
20.2 x 17 cm

176
Alisa Poret
Bride. 1932. Illustration
to Chapters 30–35 of the
Karelian-Finnish epic *Kalevala*
Black watercolor on paper.
21 x 17.7 cm

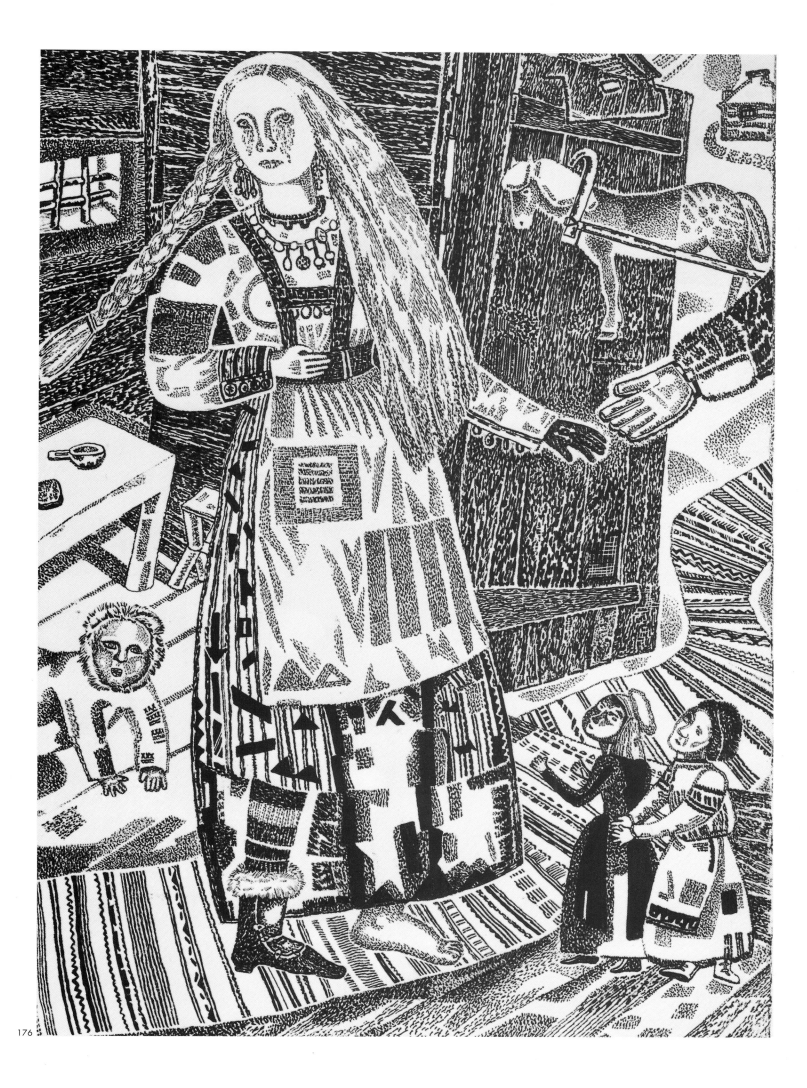

ARTISTIC GROUPINGS OF THE 1920s

Numerous groupings appeared on the Soviet art scene in the 1920s, from the distinctly realist Association of Artists of Revolutionary Russia to the groups which pursued non-objective approaches such as the Society of Young Artists or the Society of Easel Painters. The majority of them were short-lived, but others continued to exist right up to 1932 when all artistic societies were liquidated.

Among the most significant of these groupings were the Association of Artists of Revolutionary Russia (AKhRR), The Four Arts, the Society of Easel Painters (OST), October, and Thirteen. Much has been written about these associations and many of the artists who were part of them are the subject of monographs, but there were also other societies whose activities have not yet been studied.

178

177
Samuil Adlivankin
Competition of Young Model Builders. 1931
Sketch for a painting
Oil on canvas. 121 x 95 cm

178
Alexander Labas
Dirigible. 1931
Oil on canvas. 155.5 x 199 cm

179
Nikolai Sinezubov
Street in Spring. 1920
Oil on cardboard. 61 x 50.5 cm

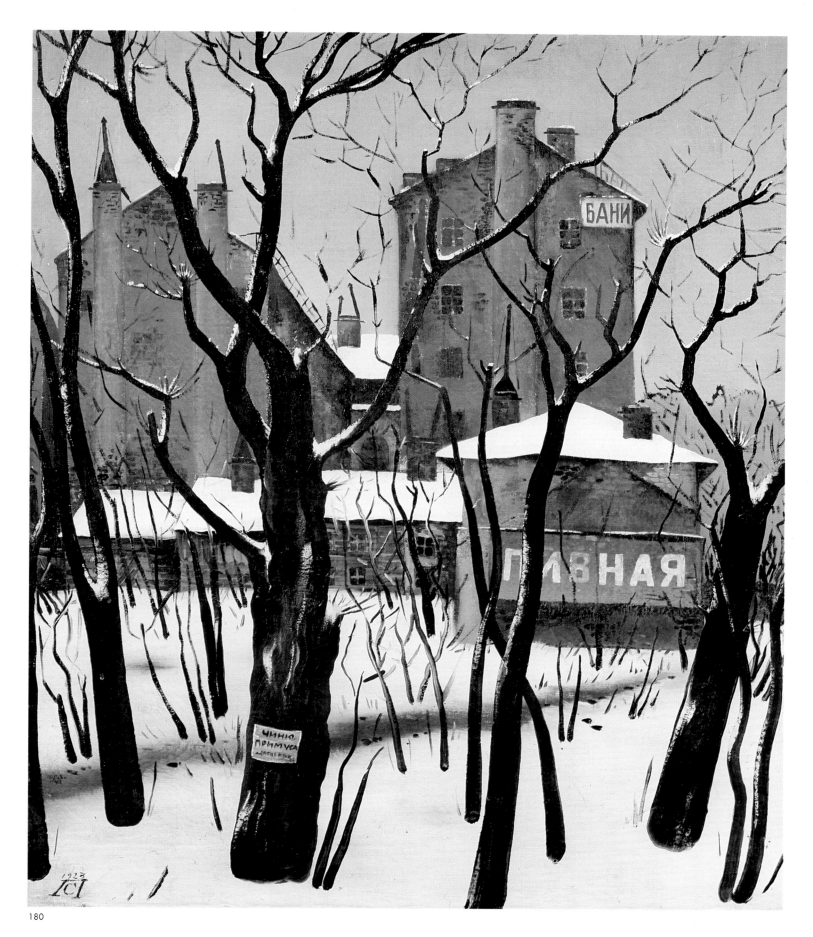

180

180
Semion Pavlov
*View of Vasilyevsky Island
in Petrograd.* 1923
Oil on canvas. 91 x 78 cm

The Four Arts society of artists
DECLARATION

The artist shows the spectator, above all, the artistic quality of his work. It is only in this quality that the artist's relation to the world surrounding him is expressed.

The growth of art and the development of a culture of art are in such a period that its specific element is characteristically to be found, with the greatest depth, in what is simple and close to human feelings.

In the conditions of Russian traditions, we consider that painterly realism corresponds best to the artistic culture of our times.

We consider the French school to be the most valuable in and of itself, since it most fully and diversely develops the basic properties of the art of painting.

On the tasks of the artist:

The content of our works is not characterized by subjects. This is why we do not name our pictures in any way. The choice of a subject characterizes the artistic tasks which occupy the artist. In this sense, the subject is only a pretext for the creative transformation of material into an artistic form. The spectator feels the confirmation of artistic truth in the transformation which the visual forms experience when the artist, having taken from life their significance for painting, builds a new form — a picture. This new form is important not in its resemblance to a living form but in its harmony with the material from which it is constructed. This material is the plane of the picture, and the color is paint, canvas, etc. The action of the artistic form on the spectator flows from the nature of the given kind of art, its characteristics, its elements (in music — one thing, in painting — another, in literature — yet another). The organization of these characteristics and the mastery of material for this purpose in the creation of the artist.

Vystavka kartin i skul'ptury. Katalog [Exhibition of Paintings and Sculpture. Catalog], Leningrad, 1928–1929, pp. 18

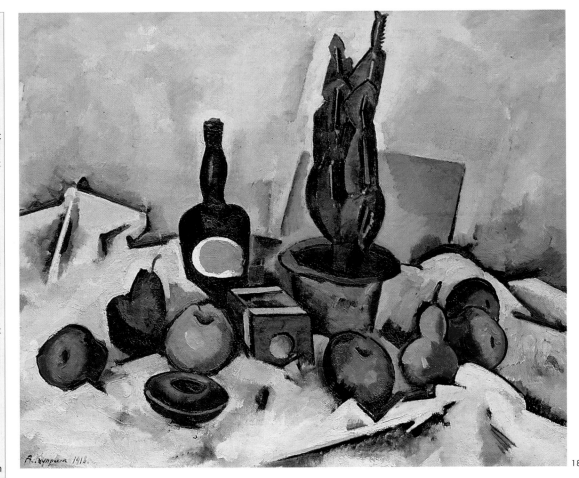

181

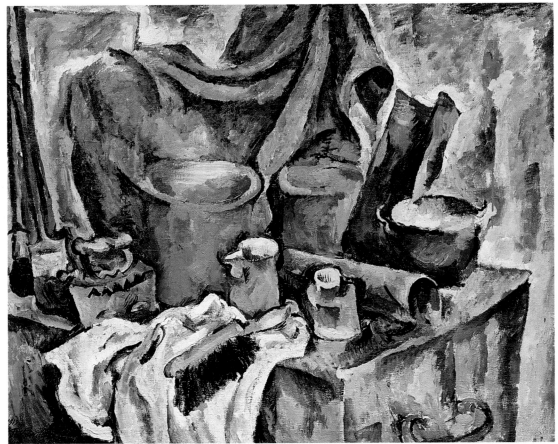

182

181

Alexander Kuprin
Still Life: Cactus and Fruits. 1918
Oil on canvas. 96.5 x 113 cm

182

Piotr Konchalovsky
Still Life: Trunk (Heroic). 1919
Oil on canvas. 143.5 x 174 cm

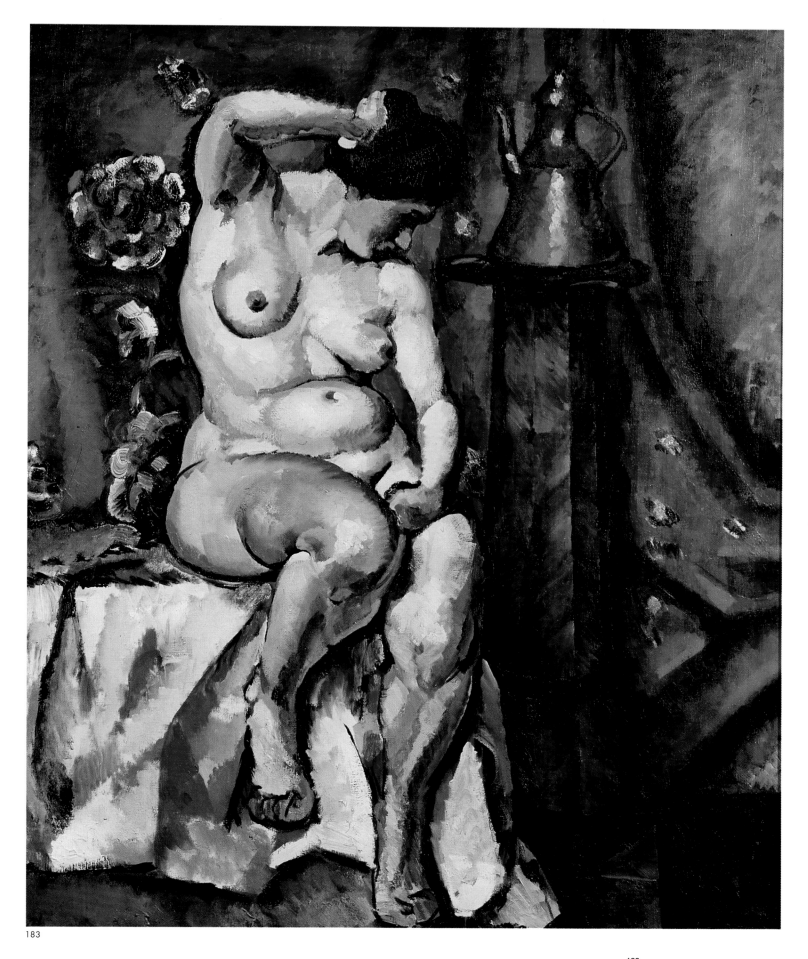

183

183
Ilya Mashkov
Artist's Model. 1920s
Oil on canvas. 140 x 115 cm

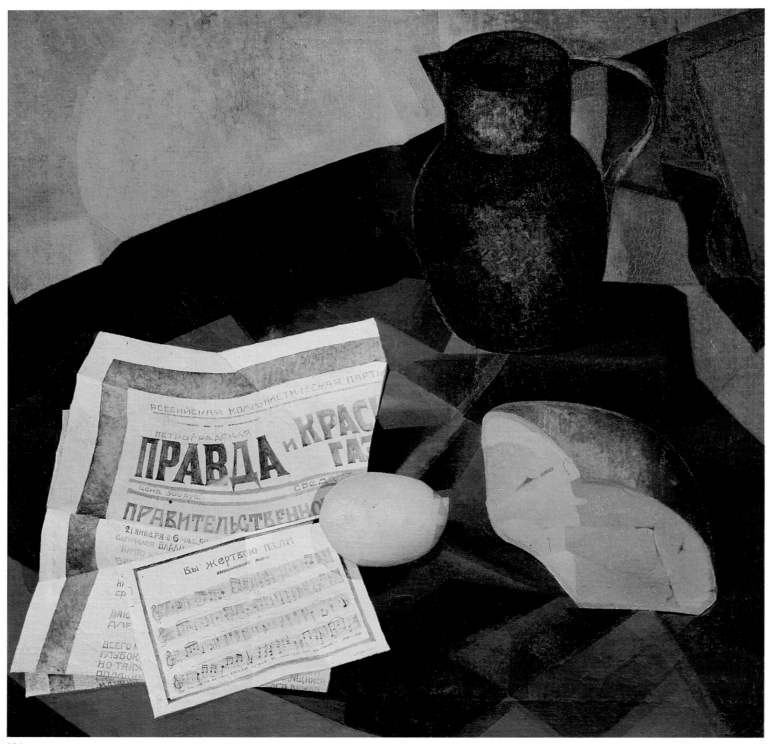

184

184
Vladimir Malagis
Still Life: Mourning. 1924
Oil on canvas. 74 x 74 cm

185
Alexander Osmiorkin
Portrait of E. T. Barkova. 1921
Oil on canvas. 125 x 96.5 cm

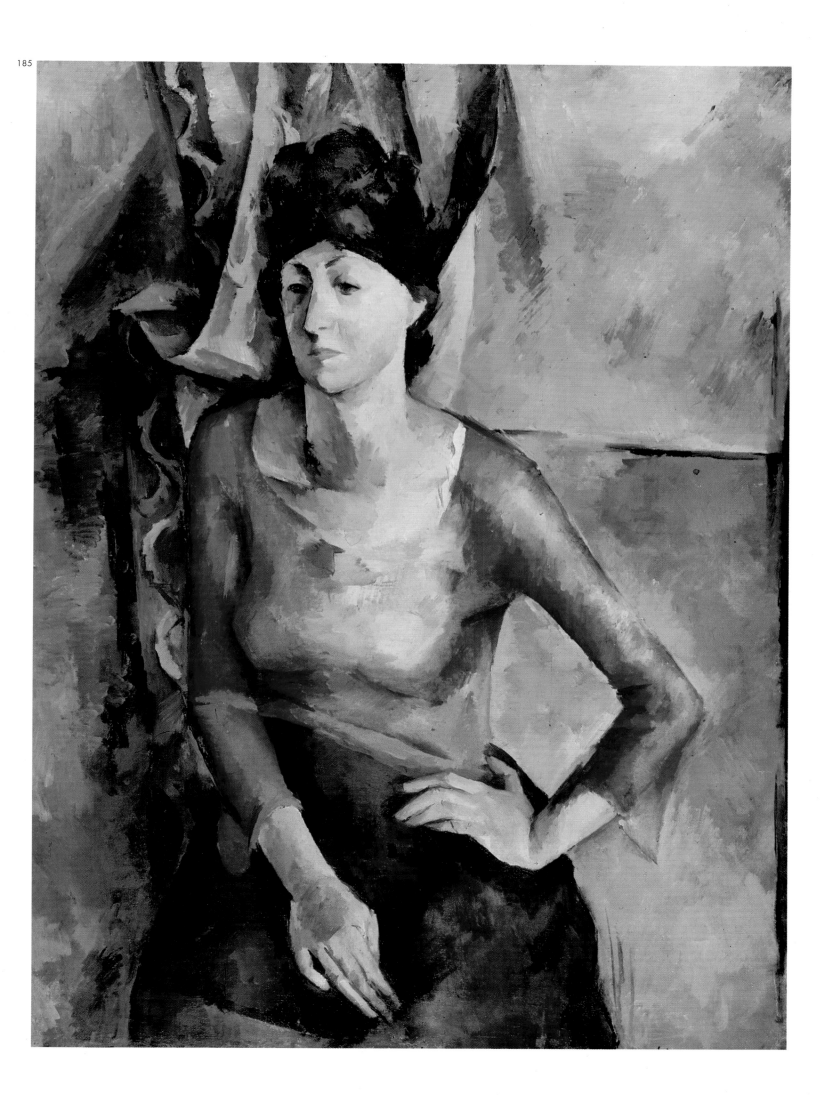

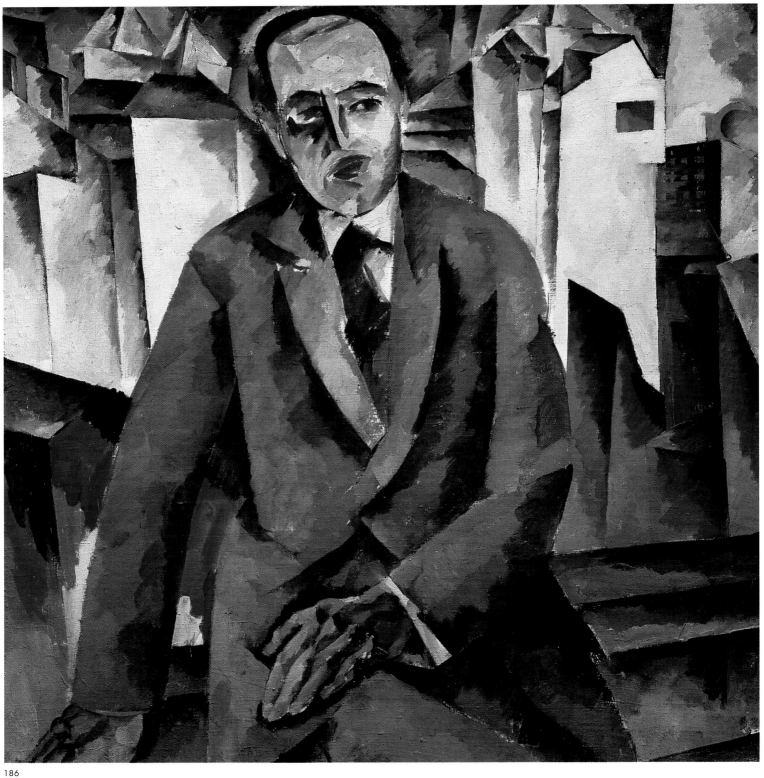

186

186
Aristarkh Lentulov
Portrait of Alexander Tairov. 1919–20
Oil on canvas. 104.7 x 99 cm

187
Alexander Kuprin
Boats on the Volga. 1921
Oil on canvas. 109 x 160 cm

188
Aristarkh Lentulov
Landscape with a Monastery. 1920
Oil on canvas. 104 x 140 cm

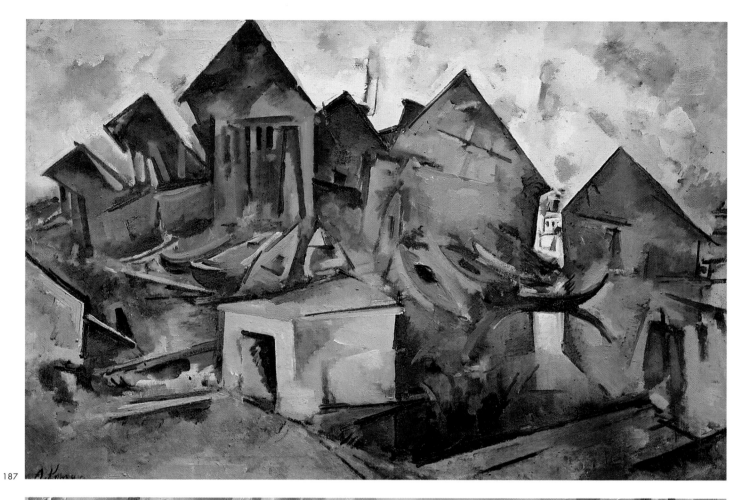

187

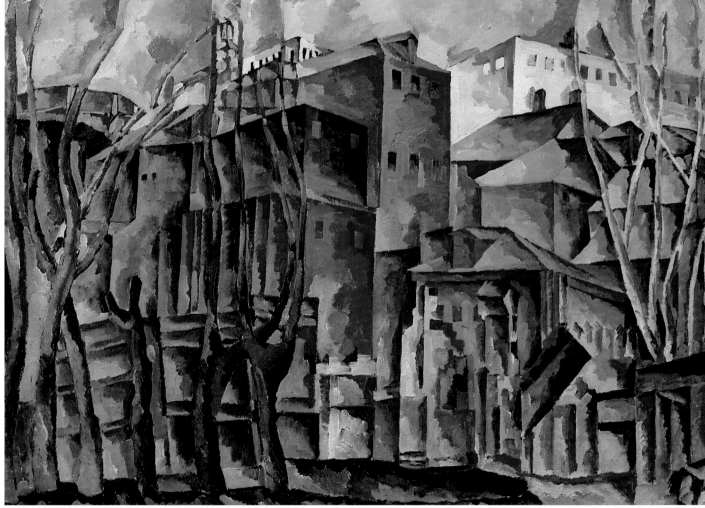

188

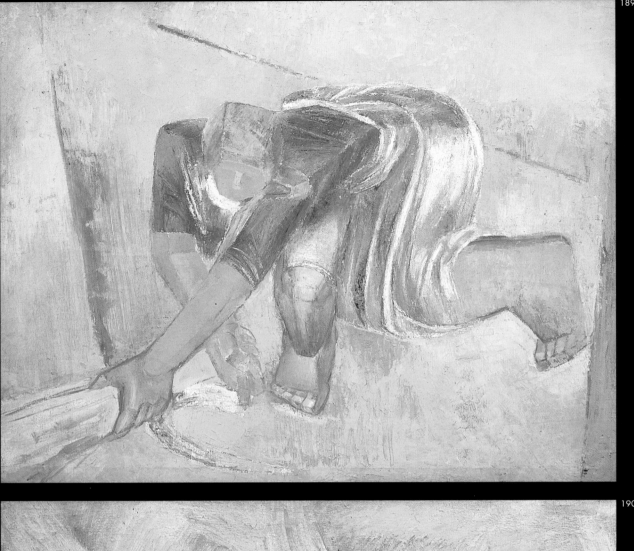

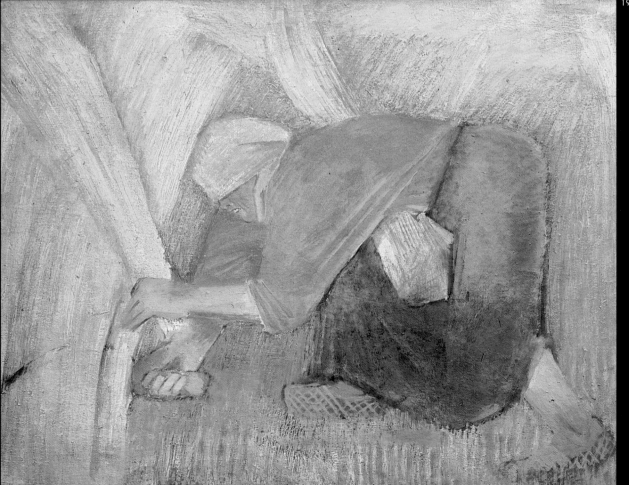

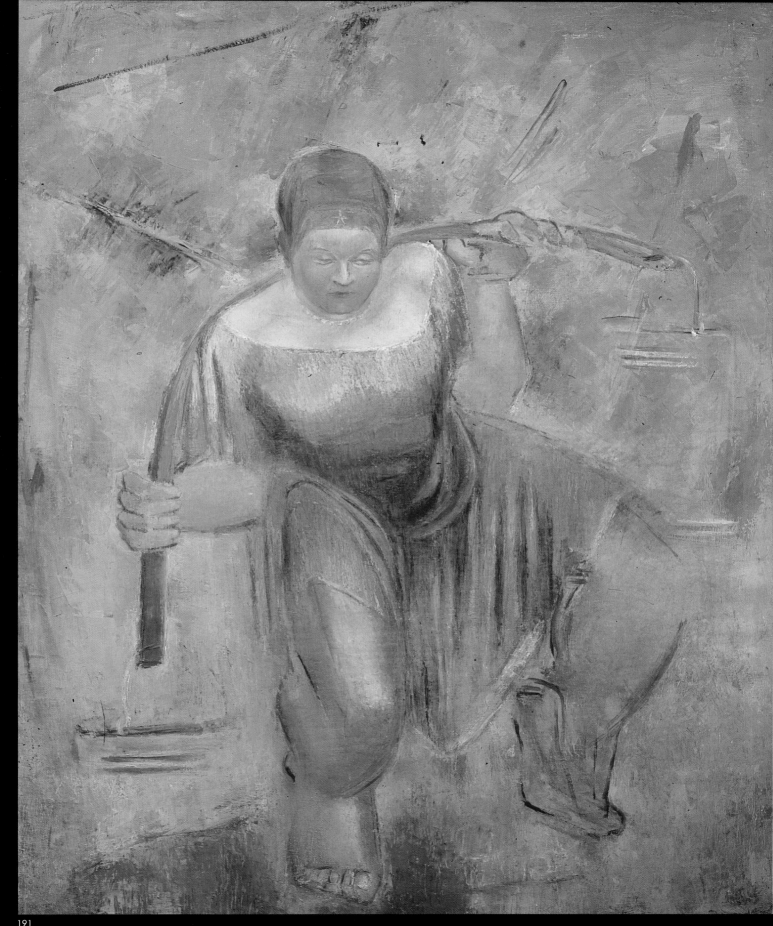

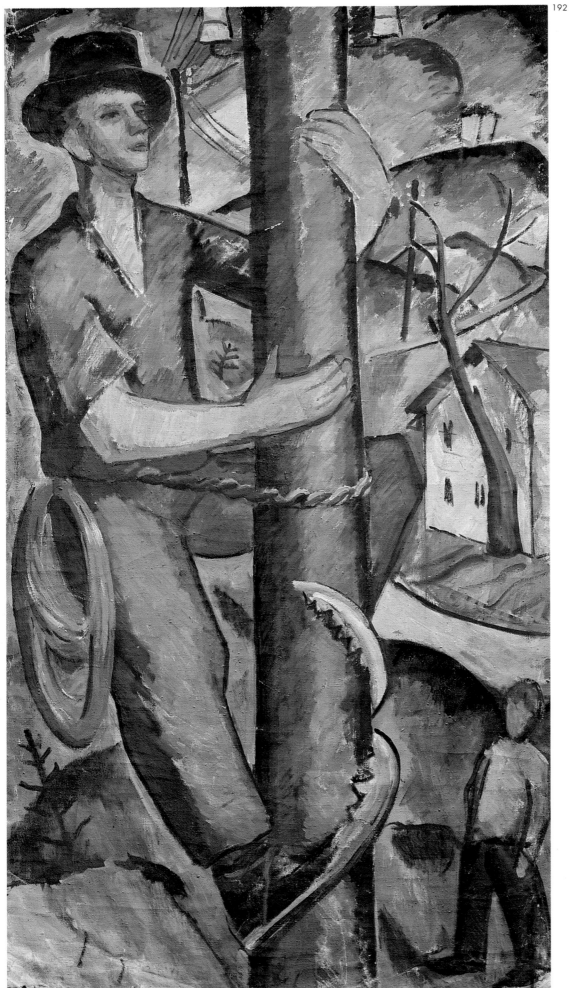

←
189
Viacheslav Pakulin
Woman Harvester. 1926–27
Oil on canvas. 152 x 187 cm

←
190
Alexei Pakhomov
Woman Harvester
(The Harvest). 1928
Oil on canvas. 85 x 106 cm

191
Viacheslav Pakulin
Woman with Pails. 1928 (?)
Oil on canvas. 187 x 151.5 cm

192
Alexander Rusakov
Fitter. 1928 (?)
Oil on canvas. 164 x 68 cm

193
Meyer Axelrod
Watering Place. 1931.
From the series *In the Steppe*
Watercolor, gouache, white, and
India ink on paper. 30.2 x 43.2 cm

194
Piotr Osolodkov
Sailors (October). 1928
India ink on paper. 47.5 x 55 cm

195
Piotr Osolodkov
Portrait of a Miner. 1933–34
Oil on canvas. 119 x 85.6 cm

193

194

The Circle of Artists Society
DECLARATION
(excerpts)

In contradistinction to the generally accepted principle of an exhibiting association which leaves its members complete freedom from responsibility in the manifestation of individual tendencies, the organizers of the Circle of Artists Society opposed the principle of a closely knit collective which carries out both the general artistic and ideological education of its members and the direction of their practical work. There shall be no cult of the individual, subjective experiences and tastes, retrospective stylization and dilettante quirks!

The Circle sets as its task the confirmation in our country of painting and sculpture as art and the professions of painter and sculptor as genuine professions.

This task calls for the unstinting work of each member of the society at his easel and for the firm direction of this work on the part of the entire collective and, finally, for the activity of the Circle as a social organization.

In the professional sense, this means the consideration and analysis of the entire artistic patrimony of the past and the utilization of the formal experience which, raising the figurative culture of the artist, contributes to the conceptualization of contemporary times in terms of painting and plastic form.

In the social sense, this is the linkage and cooperation with the wide strata of Soviet society.

Highly valuing the social role and significance of paintings, the Circle takes a negative attitude toward their utilization for the purpose of illustrating separate episodes and capturing different moments of everyday life, etc. Or to making them

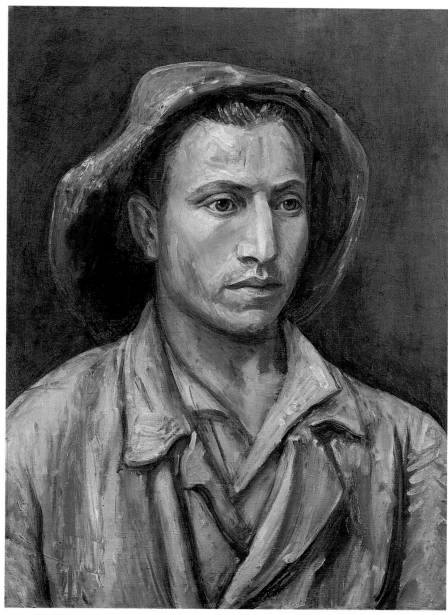

195

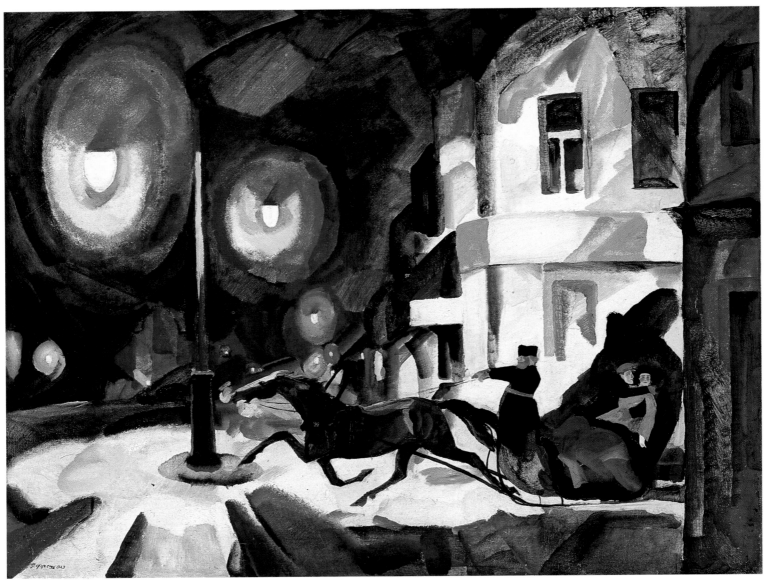

196

196
Rudolf Frenz
Nevsky Prospekt at Night:
Carriage Driver. 1923
Oil on canvas. 63.5 x 81 cm

subservient to narrow and transitory means of social propaganda. These tasks can be carried out more directly and more effectively by other forms of representing reality: photography, the movies, illustrations, posters, etc.

The Circle considers that the theme of a picture should also be significant, crystallized phenomena that are conditioned by the epoch and which could give it solidity in time, significance, and the monumental quality of forms.

The correct posing of the question concerning a theme and its formal solution should lead to the creation of a style of the epoch, i.e. to such a linkage of the formal elements as could become characteristic and uncontestably germane to our new social and political structure of life. Bearing in mind that the progressive world view of our epoch is scientific-Marxist and realistic, and that Realism as a method of the artistic perception of life has always been characteristic of the classes that are on the rise and in art has coincided with the professional maximum, the Circle sets the realistic method as the basis of its work. Having before it the experience of many centuries all the way down to the most recent achievements of French painting, the Circle expands the concept of Realism to the plane of professional actions: Realism in the correct relation to the material of color and canvas, to the laws of the visual perception of color and form, to the structure of the pictorial organism of the painting.

Relating what has been said to the domain of sculpture, we should add that the work within the forms of painting and sculpture performed on a supporting frame, as this work is understood by the Circle, and the very organizational structure of society, open the way to the solution of monumental tasks, as both the state and social initiative and the new construction demand this of the contemporary artist. Nevertheless, in their works, artists should not lower the quality and the tasks in favor of a false "intelligibility" bordering on a vulgarization but they should raise them up as much as possible and carry the spectator with them — these are the guidelines of the Circle in the atmosphere of our low artistic culture, both general and professional and in the midst of inferior hackwork and time-serving.

Vystavka kartin i skul'ptury. Katalog [Exhibition of Paintings and Sculpture. Catalog], Leningrad, 1928–1929, pp. 18–21

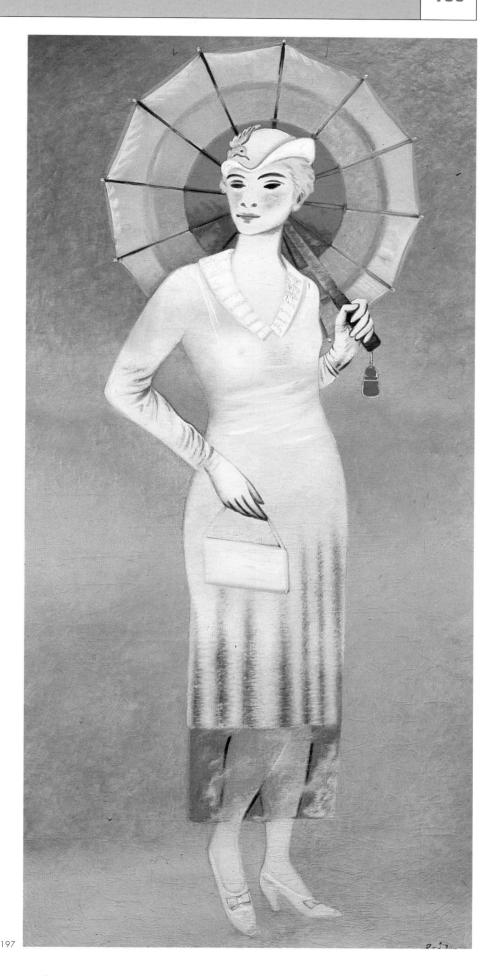

197

197

Kliment Redko
A Parisian Woman. 1931
Oil on canvas. 107 x 80.5 cm

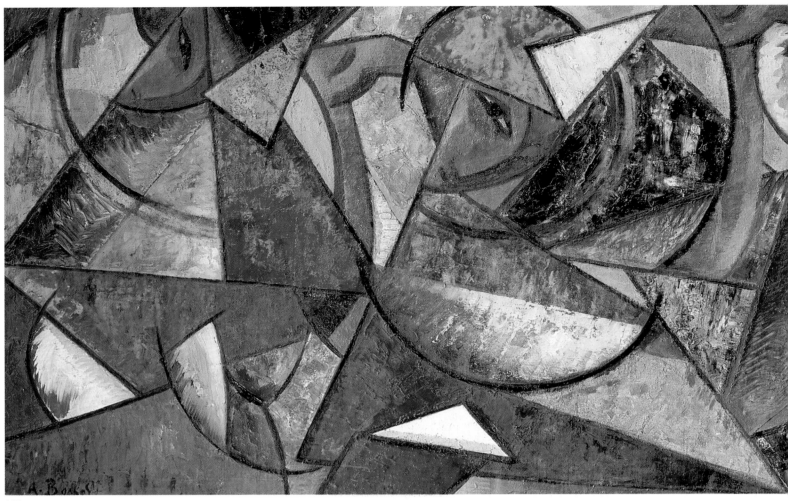

198

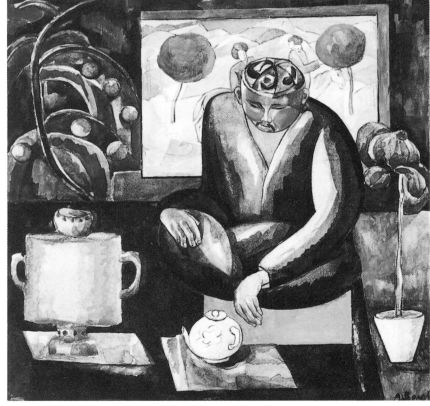

198
Alexander Volkov
Caravan. 1920s
Oil on canvas mounted on plywood.
70 x 150 cm

199
Alexander Volkov
Tea. 1926
Tempera, India ink, watercolor,
and lacquer on paper. 30 x 30.3 cm

200
Alexander Volkov
Autumn. 1926
Tempera, watercolor, India ink,
and lacquer on paper. 32 x 31.8 cm

201
Alexander Volkov
Hoeing Cotton. 1930
Oil on canvas. 118 x 208 cm

199

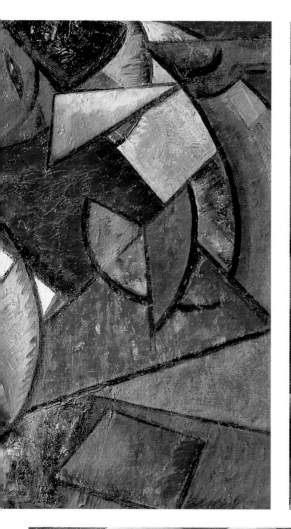

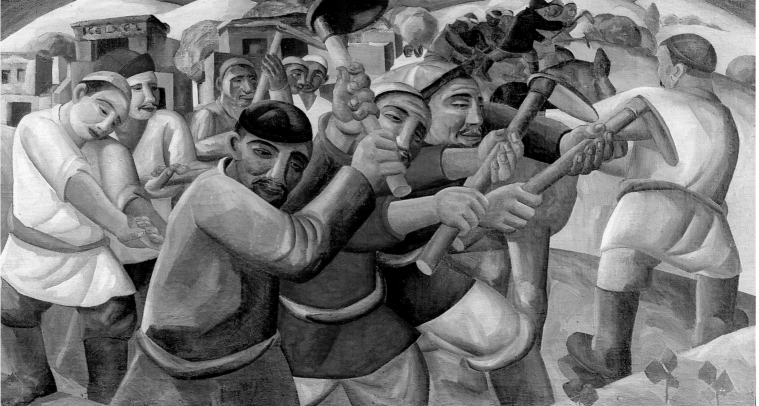

202

Vasily Kuptsov
The Airplane ANT-20 "Maxim Gorky." 1934
Oil on canvas. 110 x 121 cm

203
Grigory Bibikov
*The Stratosphere Balloon
"Osoaviakhim."* 1935
Oil on canvas. 238 x 156 cm

204
Alexander Labas
*In the Far East. Red Army
Man.* 1928
Oil on canvas. 98 x 78 cm

205
Alexander Drevin
Parachute Jump (blue version). 1932
Oil on canvas. 89 x 107 cm

203

204

205

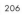

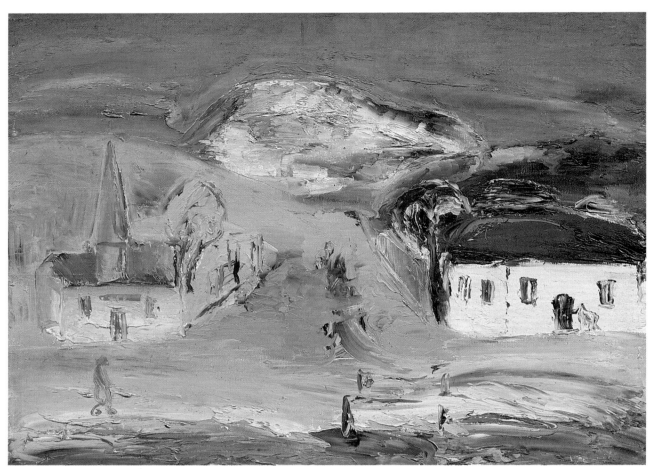

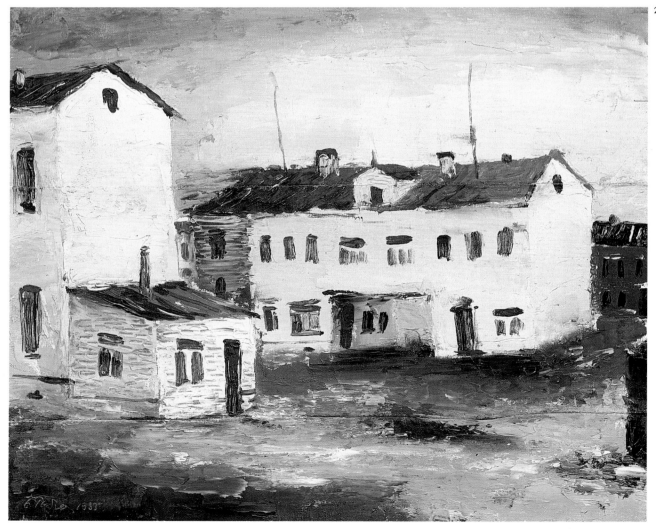

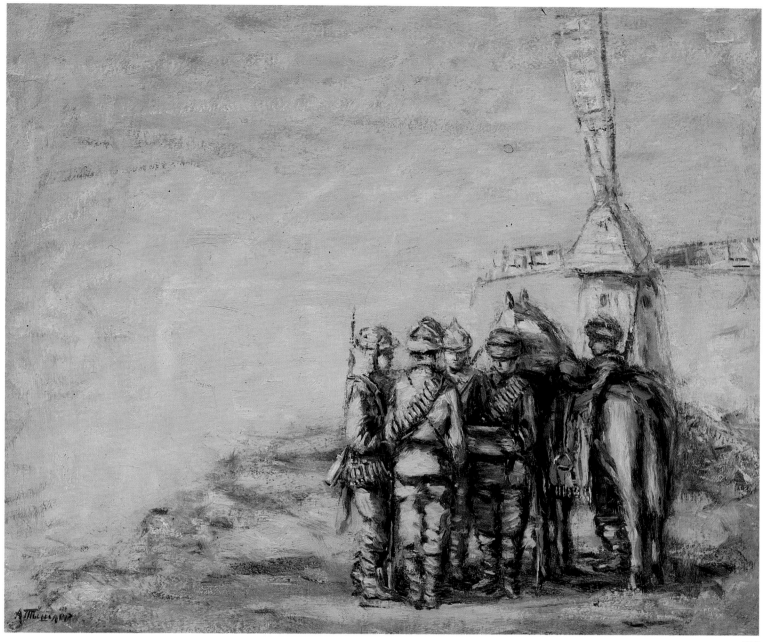

208

206
Boris Rybchenkov
Beyond the Butyrskaya Gate:
Yard with a Through Passage. 1933
Oil on canvas. 52.5 x 62.5 cm

207
Alexander Drevin
Village Soviet
(The First Village Councils). 1932
Oil on canvas. 62 x 84 cm

208
Alexander Tyshler
Young Red Army Recruits Reading
a Newspaper. 1936
Oil on canvas. 56 x 65 cm

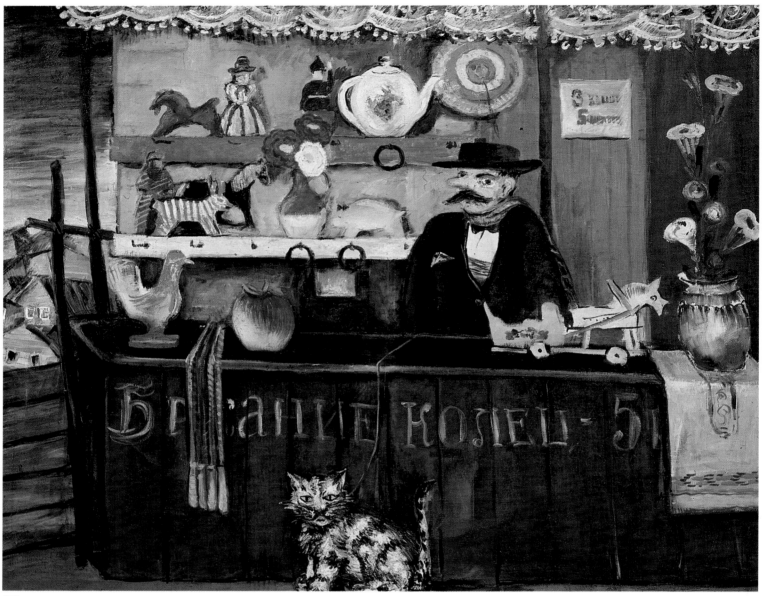

209

209
Yury Shchukin
Sideshow. 1933
Oil on canvas. 120 x 150 cm

210
Nikolai Dormidontov
Musicians. 1931–34
Oil on canvas. 76 x 60 cm

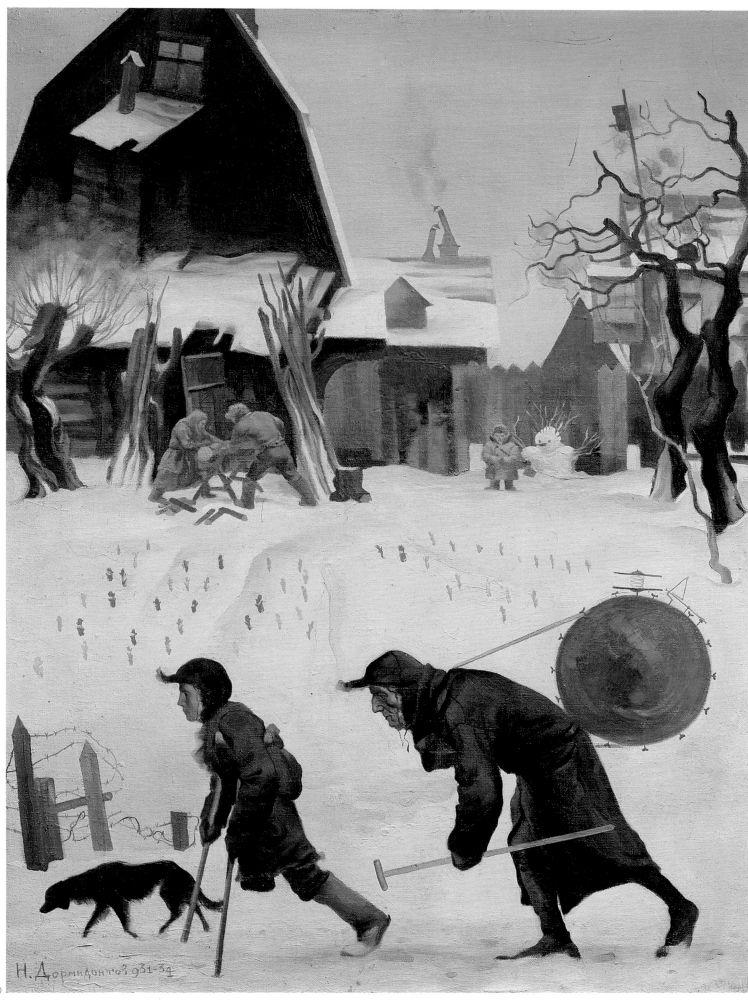

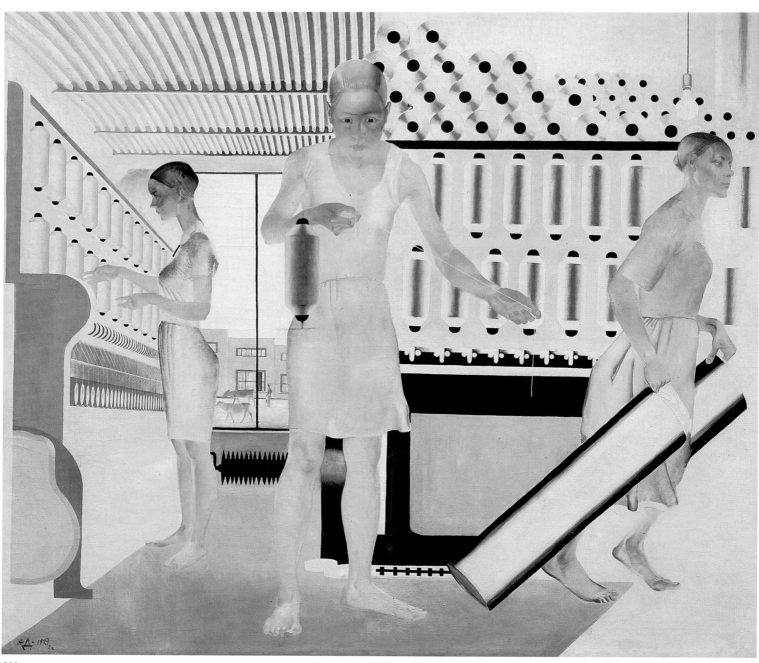

211

211
Alexander Deineka
Textile Makers. 1927
Oil on canvas. 171 x 195 cm

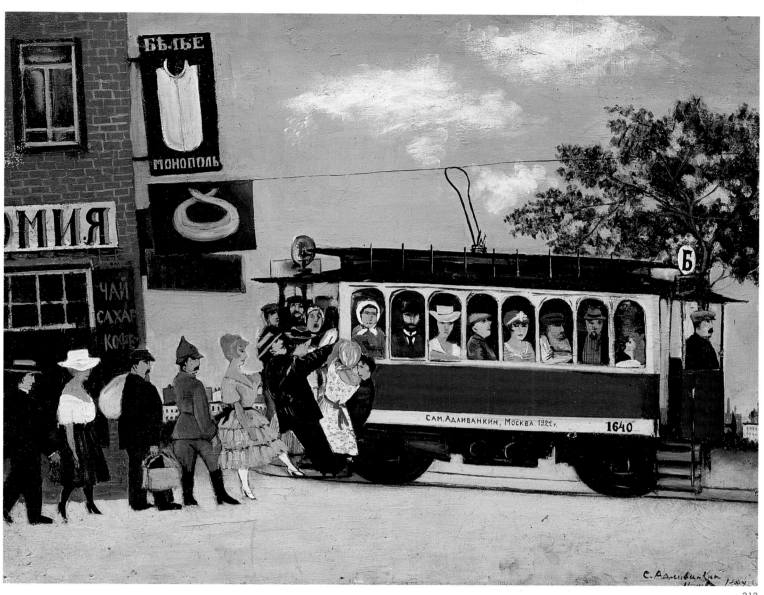

212

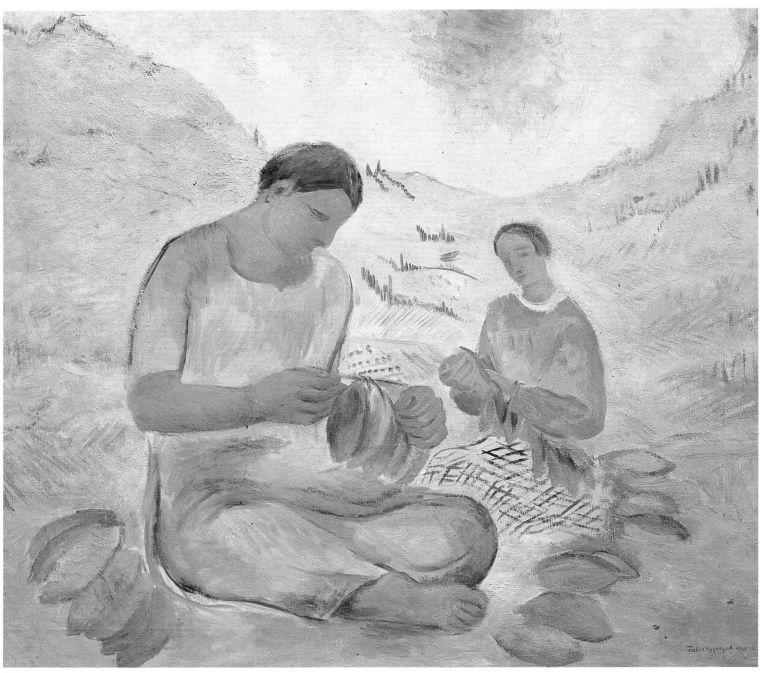

213

213
Pavel Kuznetsov
Tobacco Growers. 1925–26
Tempera on canvas. 97 x 106 cm

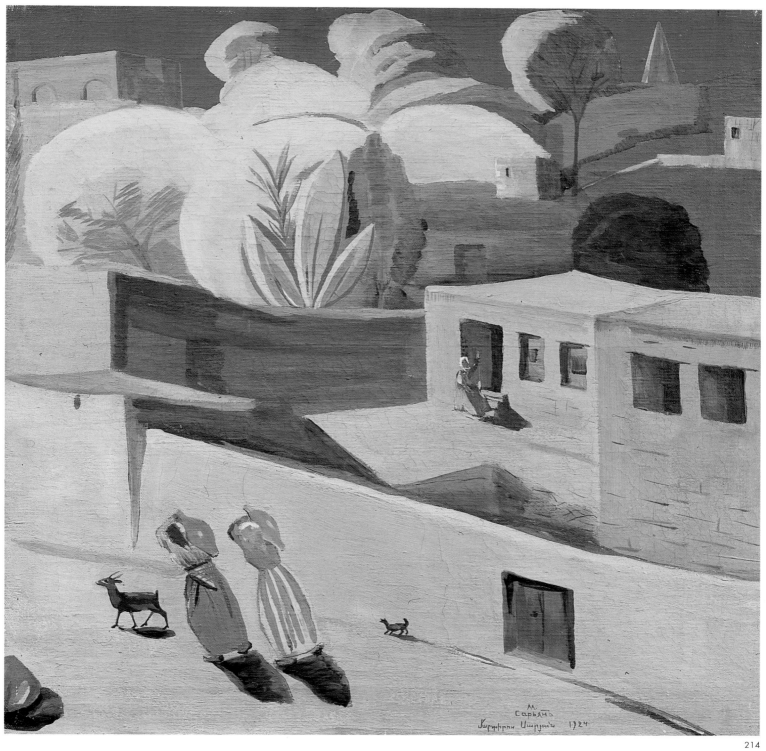

214

Martiros Saryan
Yerevan. 1924
Oil on canvas. 69 x 68 cm

→
215
David Shterenberg
Auntie Sasha. 1922–23
Oil on canvas. 130 x 98 cm

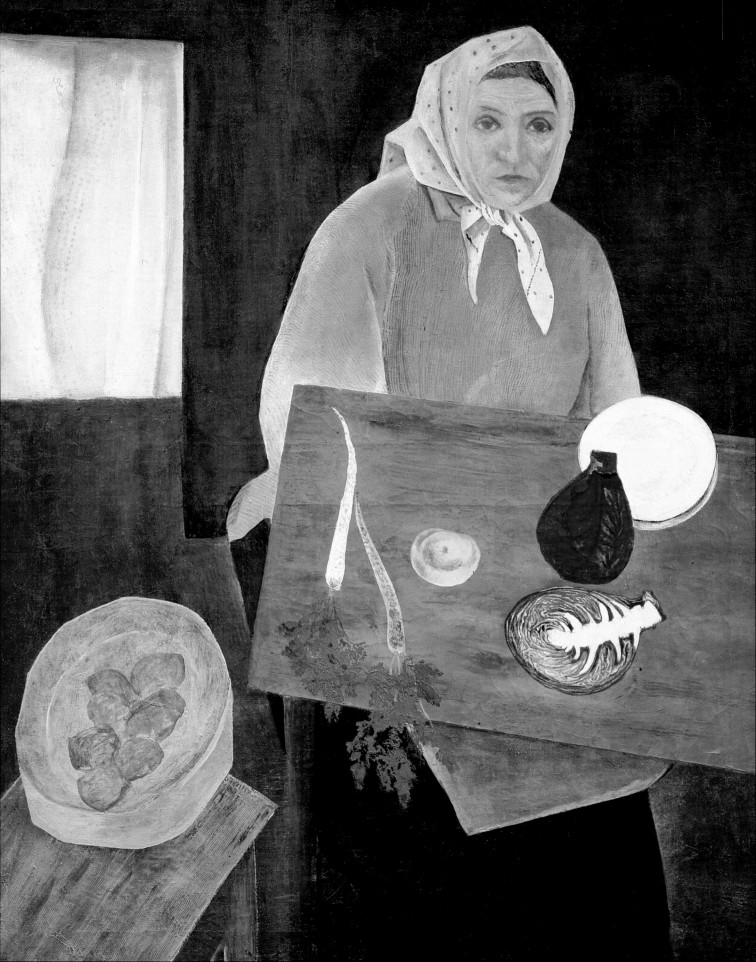

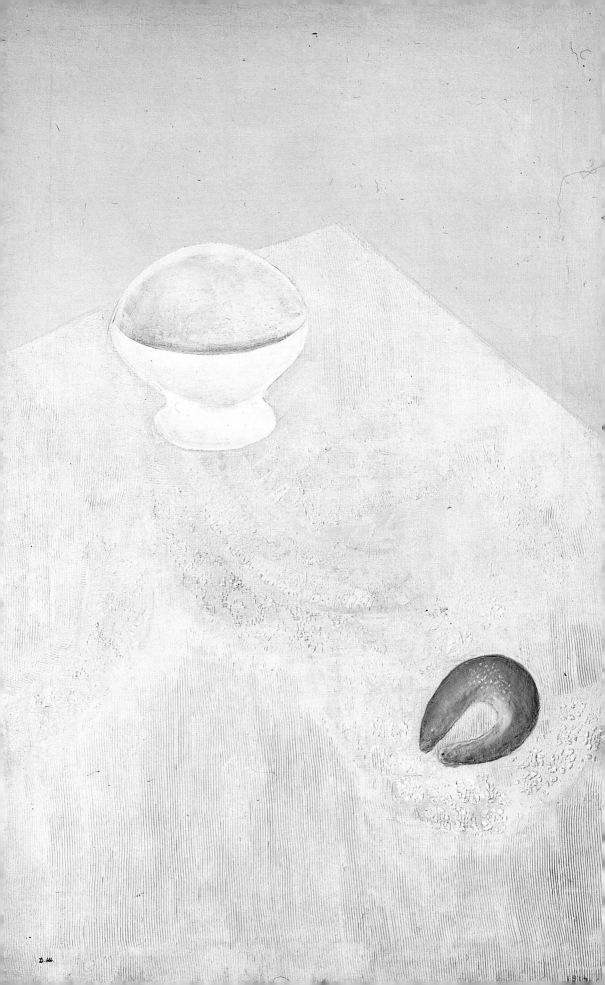

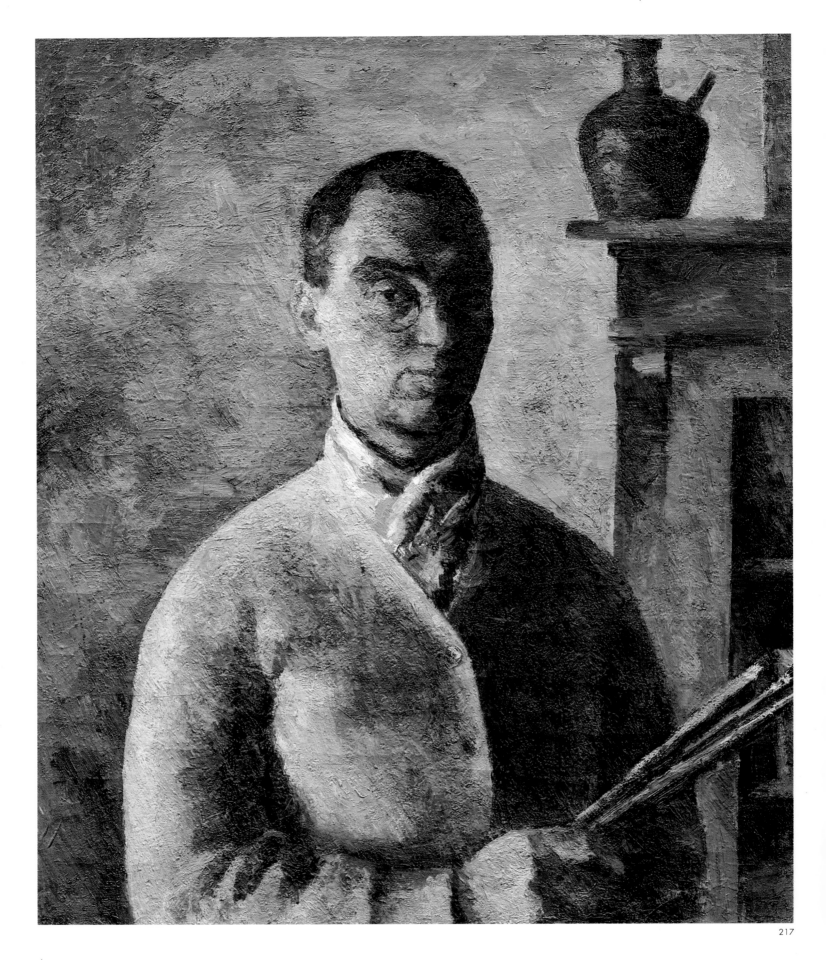

←
216
David Shterenberg
Table: Croissant. 1919
Oil on canvas. 89 x 53.5 cm

217
Robert Falk
Self-Portrait in Yellow. 1924
Oil on canvas. 100 x 83 cm

218

218
Robert Falk
French Landscape
(*Landscape at Aix*). 1932 (1934?)
Oil on canvas. 72.5 x 90 cm

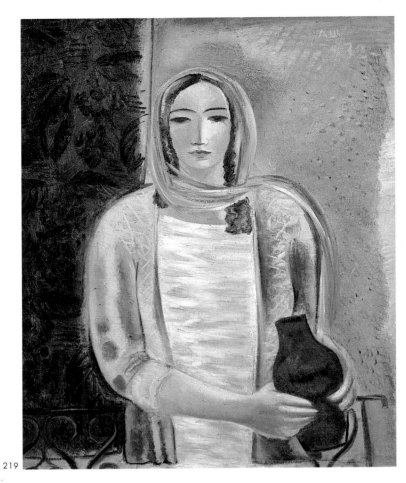

219

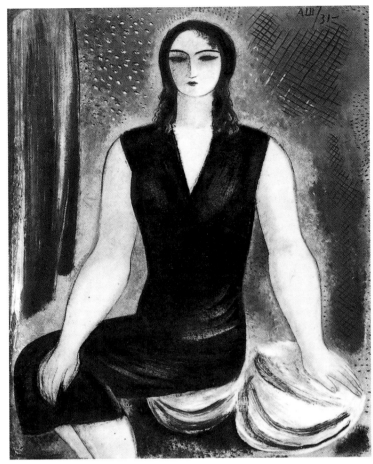

220

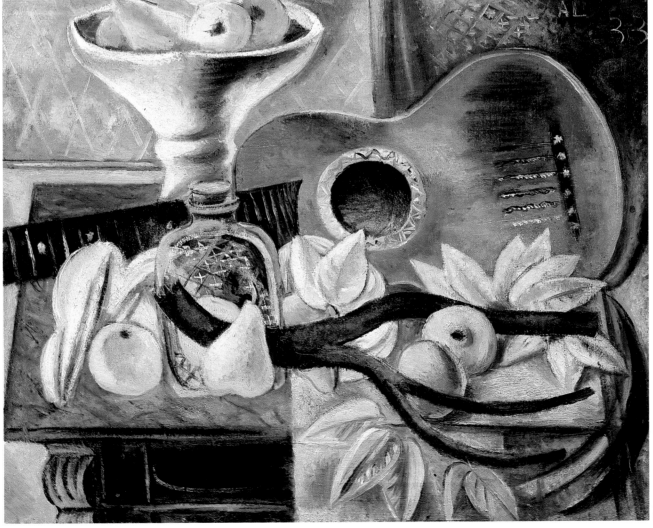

221

222

223

219
Alexander Shevchenko
Woman in Green. 1932
Oil on canvas. 117 x 95 cm

220
Alexander Shevchenko
Woman in Black. 1931
Colored monotype. 36.3 x 28 cm

221
Alexander Shevchenko
Still Life with a Guitar. 1933
Oil on canvas. 65.2 x 79.8 cm

222
Alexei Karev
The Neva River. 1934
Oil on canvas. 116 x 173 cm

223
Alexei Karev
Still Life: Cone on a White Background. 1921
Oil on canvas. 58 x 45 cm

224
Solomon Nikritin
Composition. 1930
Oil on canvas. 68 x 58 cm

→
225
Kliment Redko
Midnight Sun (Northern Lights). 1925
Oil on canvas. 107 x 80.5 cm

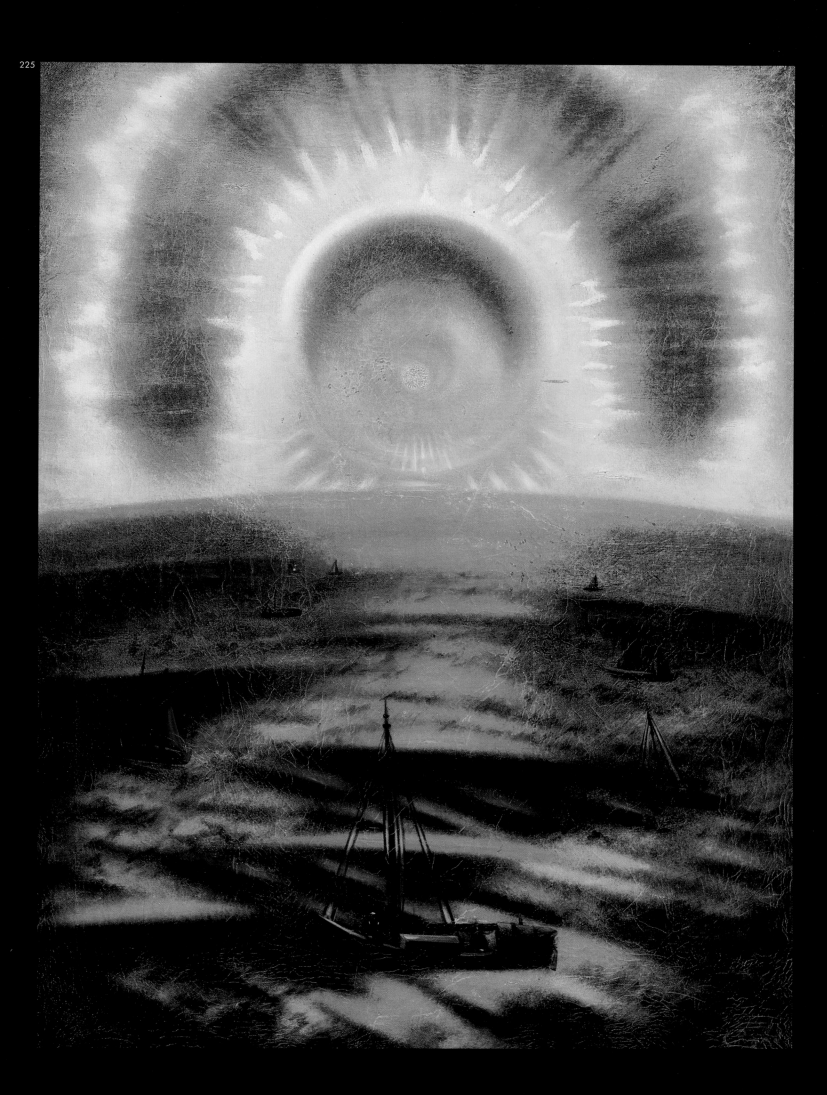

At the end of 1921, a union of artists and poets known as Art Is Life was formed in Moscow. It published two issues of the magazine *Makovets*, a title which subsequently became the name of the association

Makovets declared: "We do not do battle with anybody. We are not the creators of any newism. A time of bright creativity is beginning when unshakable values are needed, when art is undergoing a resurrec-

226

Vladimir Favorsky
Cover for the magazine *Makovets*
(No. 3, 1923, never published)
Xylograph. 18.2 x 17.5 cm

227

Cover of Pavel Florensky's book
Mnimosti v geometrii [*The Imaginary Quantities in Geometry*]. 1922
The cover of the present book is a woodcut by Vladimir Andreyevich Favorsky. As is characteristic of this artist in general, here too the engraving not only embellishes the book but is an integral part of its conceptual make-up. That's why this work of Favorsky's is art saturated with mathematical thought. An experiment like this may be the first in our times to represent a renaissance of the woodcut. Incidentally, here is a direction in art ahead of which lies a rich harvest in terms of the general synthetic cast of culture to come.

Pavel Florensky, *Mnimosti v geometrii*
[*The Imaginary Quantities in Geometry*],
Moscow, 1922, p. 58

itself. The organizers of the society and the participants in its exhibitions were Vasily Chekrygin, Nikolai Chernyshov, Vera Pestel, Sergei Romanovich, Lev Zhegin (Shekhtel), Alexander Shevchenko, and others. The magazine *Makovets* published articles by Chekrygin, Pavel Florensky, and Romanovich, as well as poems by Velimir Khlebnikov and Boris Pasternak. Although only two issues of the magazine were published before *Makovets* was closed down, it was a major landmark in the history of Russian art. *Makovets* came into being at the moment when Russian art was being swamped by a wave of all manner of "isms," when the very existence of easel painting was called into question. The manifesto published in

tion in its endless movement and demands only the simple wisdom of the inspired."[99] The realism of the Makovets group did not consist of an up-to-the-minute, calculated reaction to current events; rather, its representatives strove to find a profound meaning in life. They were the first who in those years turned to the national artistic tradition — the Russian fresco and icon. Florensky observed: "To Makovets devolves the task of acting as a collector of Russian culture."[100] The adherents of Makovets understood artistic creation as "spiritual doing." It was no accident that they selected the name "Makovets" for their magazine, for this was the name of the hill on which St. Sergius of Radonezh founded the Trinity Monastery .

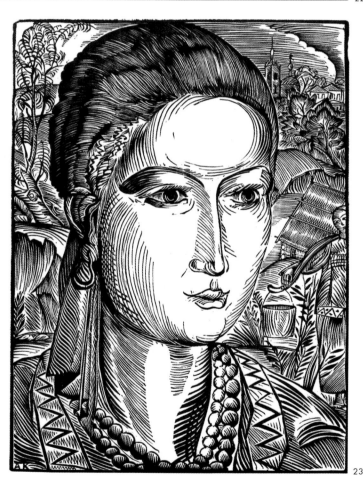

228
Vladimir Favorsky
Portrait of Fiodor
Dostoyevsky. 1929
Xylograph. 20.5 x 13.5 cm

229
Vladimir Favorsky
Sergiyev Posad. 1919
Xylograph. 13.6 x 15.3 cm

230
Alexei Kravchenko
Stradivarius in His
Workshop. 1926
Xylograph. 17.9 x 13.6 cm

231
Alexei Kravchenko
A Girl's Head. 1925
Xylograph. 25.3 x 17.9 cm

232
Vera Pestel
Auntie Pasha. 1919
Oil on canvas. 48 x 97 cm

There man burned up.
A. Fet

What I want to say is not new but has not been expressed in its naked form and has acquired the quality of something, which is not talked about. I want to rip the cover away from one of the bases of all art, rip away the mask from people who have dedicated themselves to it, and show them naked.

I shall talk about the tragedy of the personal life of every true artist, about the immutable law according to which creators pay for perfection in art through martyrdom in life.

Art is cruel and demands sacrifices.

It burns those who approach it and the closer they come, the more merciless it is. And it is only the unattentive gaze that does not understand the pain that is sometimes expressed by the artist's lips in difficult and thoroughly terrifying minutes. Art is as untamed as the elements and that is why it doesn't stand for half measures. Art is sexual and therefore does not subordinate itself to the calculation and analysis of reason.

Finally, art is passion and, like all passion, it is jealous, capricious, and all-engulfing. This is why the artist's soul is desolate and ill at ease. An eternal wanderer, he does not know long periods of rest and happiness, and the stronger the antipathy of his life to the surrounding feast, the more dramatic and seductive, the more aromatic and wonderful is his art. All his passion for life, the fascination with its magnificence, is in his works and herein lies his sacrifice to art. But those short moments of ecstasy that success grants him, that intoxication with creativity which gives him the courage to live are too insignificant, fortuitous and rare; but life and the world are always before his eyes and are also tempting and splendid, open to him in greater fullness, stronger blossoming out than they are to the rest of people. Yet to accommodate ordinariness with the high and iron limit is impossible. It is difficult to be cruel where children are playing; you must become like them in order not to appear an outsider, or else go away. Thus it is that the artist is either cruel or alone. He cannot make himself like everyone else or he doesn't dare to and he suffers, suffers seeing the small happiness of that odd world, of that other limit. He is not excited by the desire for a reward while alive or after death and there is no time to dream of such things. But does there exist a measure according to which one could reward, the ordeal that Gogol, Watteau or Edgar Poe suffered?

N. Sinezubov, "Sud'ba khudozhnika,"
["The Artist's Destiny"], *Makovets*, 1922,
No. 2, p. 31

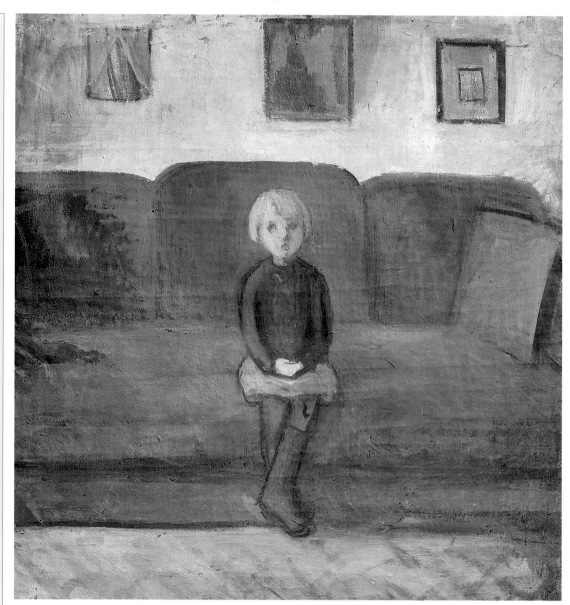

233

233
Vera Pestel
Little Girl on a Couch. 1922
Oil on canvas. 87 x 78 cm

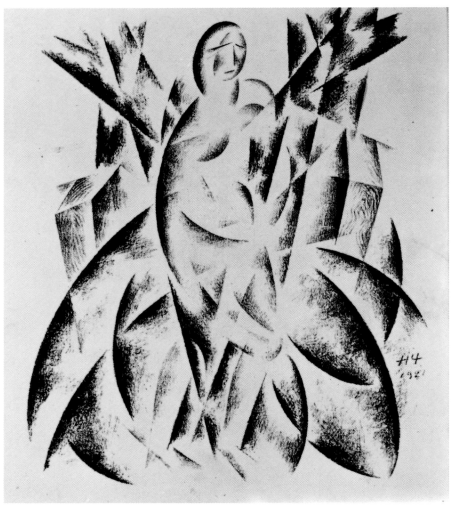

234

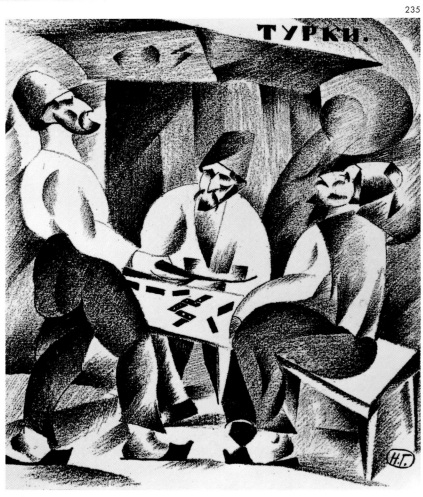

235

234
Nikolai Chernyshov
Nude Woman.
From the album *Lithographs*. 1921
Lighograph. 21.7 x 17.2 cm

235
Nikolai Grigoryev
Turks.
From the album *Lithographs*. 1921
Lithograph. 22.4 x 19.1 cm

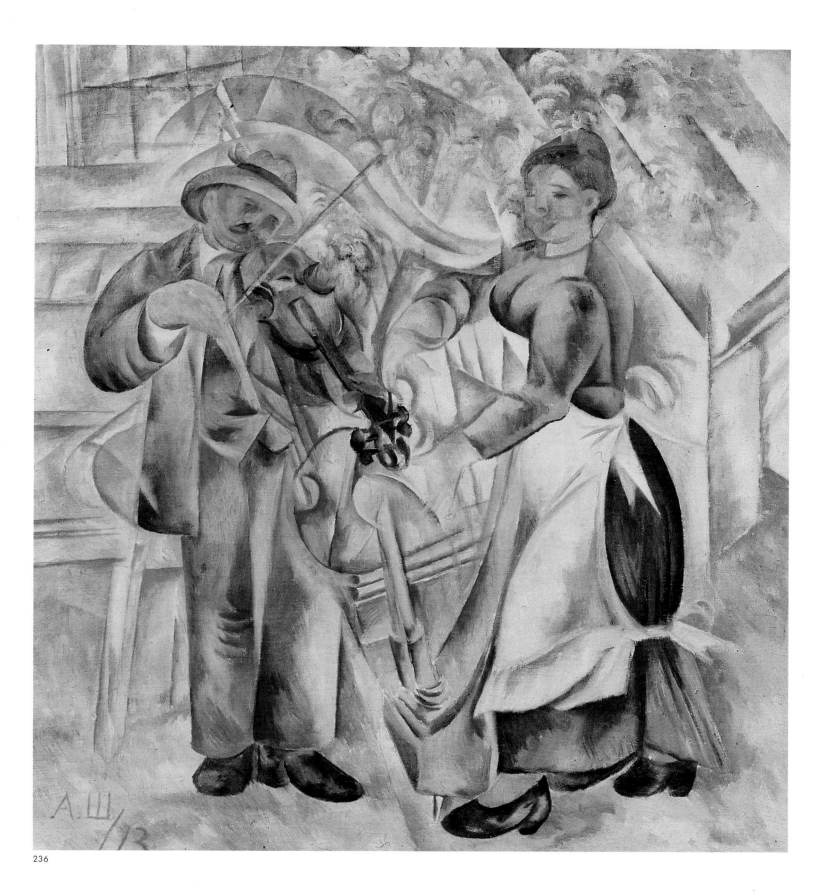

236

236
Alexander Shevchenko
Musicians. 1913
Oil on canvas. 114 x 104.5 cm

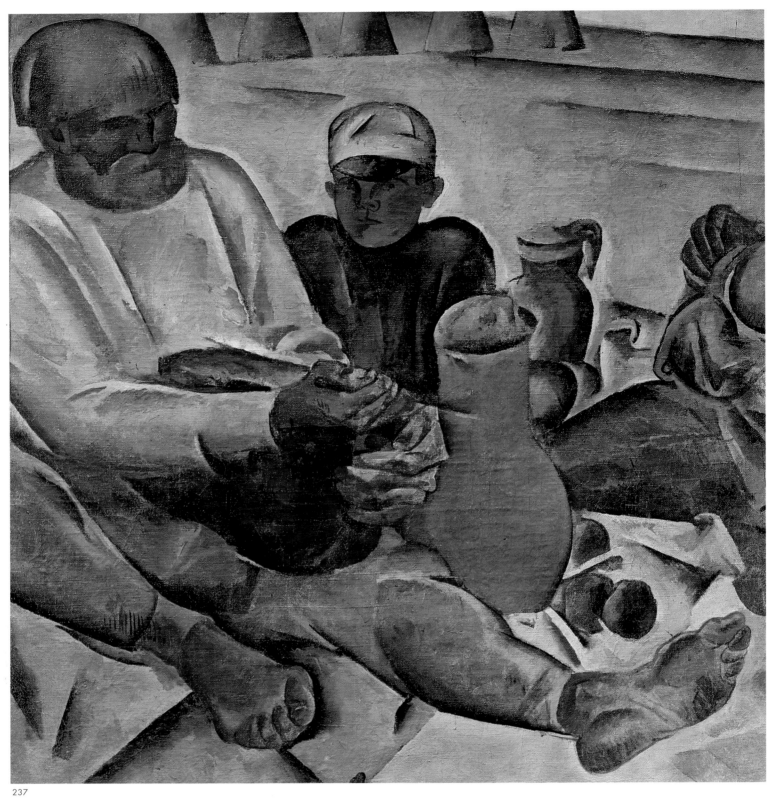

237

237
Sergei Gerasimov
Our Daily Bread. 1921
Oil on canvas. 83.5 x 83 cm

238
Sergei Gerasimov
Peasant Wearing a Cap. 1925
Oil on canvas. 81 x 61 cm

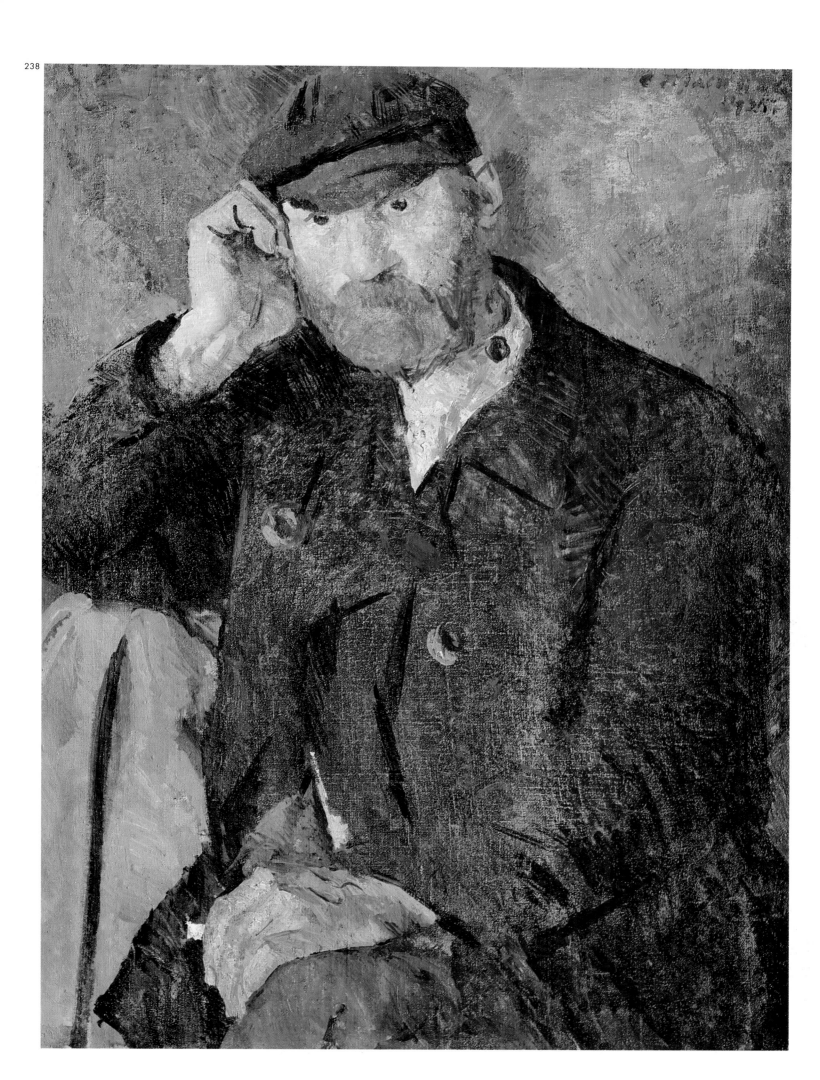

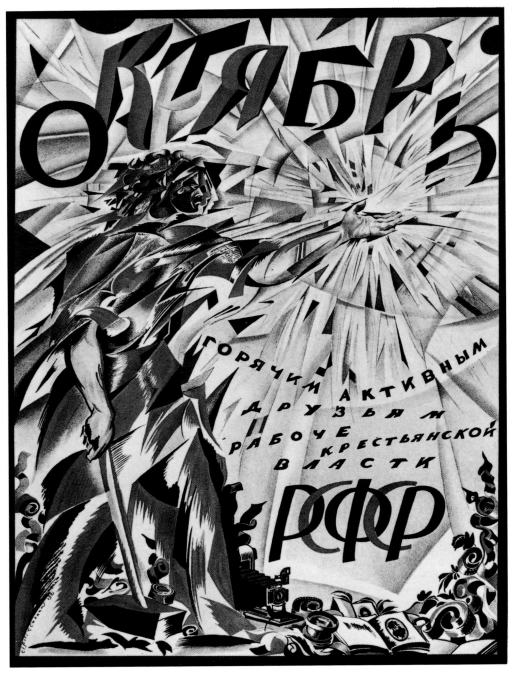

239
Sergei Chekhonin
Cover of the *Oktiabr* [*October*]
magazine. 1921
Typographical print on paper.
30.8 x 22.5 cm

240
Vladimir Konashevich
Illustration for *Oktiabr'skaya
knizhka dlia detei*
[*October Book for Children*]. 1927
India ink and watercolor on paper.
35.9 x 56.9 cm

241

241
Vladimir Konashevich
Winter in Pavlovsk. 1932
India ink with brush on paper.
79 x 54.5 cm

242
Dmitri Mitrokhin
Letter Carrier. 1929
Xylograph, tinted with watercolor.
12.6 x 7.7 cm

243
Dmitry Mitrokhin
The Central Park of Culture and Rest.
Flowers on the Bank of a Pond. 1937
Paper, engraved with a cutting tool.
13.2 x 15.9 cm

242

243

244

246

244
David Zagoskin
Basia, the Komsomol Girl. 1930
Brown watercolor and India ink
on paper. 61.2 x 44.5 cm

245
Nikolai Tyrsa
Portrait of Anna Akhmatova. 1928
Lampblack on paper.
36.5 x 22.7 cm

246
Cover of the magazine *Krasnaya
Panorama* [*The Red Panorama*]

247
Nathan Altman
Illustration to Nikolai Gogol's
short story *Nos*
[*The Nose*]. 1934
Gouache and scratching on
cardboard. 22.2 x 24.8 cm

248
The artist Viacheslav Pakulin
with his wife. Late 1920s

247

248

249
Georgy Vereisky
Young Artist. 1928
Italian pencil on paper. 60 x 42.6 cm

249

Nathan Altman

251

250
Nathan Altman
Artistic design of Nikolai Gogol's book
Peterburgskiye povesti [*St. Petersburg Tales*].
Frontispiece. 1934
Gouache, black chalk, and scratching
on cardboard. 32.5 x 24.8 cm

251
Arthur Fonvizin
At the Circus. 1931
Watercolor on paper. 42.4 x 35 cm

The most important master of the Makovets group was, without a doubt, Vasily Chekrygin, who is represented in this volume by his picture *Fate* and a number of masterfully executed graphic works which are profound and vibrant with feeling. In the last years of his life and work, Chekrygin was completely absorbed by the philosophy of Nikolai Fiodorov. The main tenet of Fiodorov's moral and philosophical teachings is that sons receive everything as a gift from theit fathers, even life itself. "We have nothing of our own, which is produced by us; instead, everything comes as a gift, or rather as a debt; our life is not ours at all; it is appropriated, alienable, mortal; we received life from our fathers, who are similarly indebted to their parents, and so forth. Birth is the transfer of a debt and not its payment."[101]

253

252
Vasily Chekrygin
Fate. 1922
Oil on canvas. 143 x 107.5 cm

253
Vasily Chekrygin
Composition. From the cycle
The Resurrection. 1922
Lead pencil on paper. 28 x 23 cm

The earth and all other conditions of life do not constitute our property; we are not landowners but the bonded servants of the earth in the exact same way as the earth depends on the sun, gravitates toward it and the sun in its turn is similarly dependent of some other body, etc. The regulation of this blind universal pull which is not only earthly and which conditions our mortality was meant to be the yoke of the human race. It follows from this that the resurrection is work that turns what we have received as a gift into our own, "cleansing debt." An unpaid debt entails punishment through slavery, through death. The payment of a debt is the returning of life to one's parents, i.e. the payment of a debt to one's creditors and thereby, freedom for oneself.

N. Fiodorov, *Sochineniya* [*Works*], Moscow, 1982, p. 163

Dear Mikhail Fiodorovich!
I wrote you about the situation your library is in, plus your pictures and drawings. I sent the letter through your cousin. But I decided to write again to make sure that everybody is informed in case the previous letters get lost. Your pictures and drawings are fully preserved in the State Repository. The artist Durnov is now the curator for them. He pays close attention to your works and drawings (according to Nikolai Mikhailovich.[102]) The repository is located in the Kuznetsov Mansion on Malaya Dmitrovka Street across from Pimenovsky Lane. Your publications, which are completely preserved, are in the same place. The pictures, drawings, and library were transported from your house by the artist Kirillov (you no doubt remember him from the Institute of Painting, Sculpture, and Architecture; a blond fellow who wears pince-nez). The library is located in the First Proletarian Museum on Malaya Dmitrovka Street in the Loewe Mansion, which contains wonderful things. They wanted to buy you and Natalia Sergeyevna from the repository to become part of the Tretyakov Gallery collections, but they were unable to do this, since there was nobody to talk to about the matter. You must send a power of attorney either to Grabar (it's best to send it to him, since he will then have a free choice, being the one who is in charge of these matters) or to me at the Pushkino address.

Vasily Chekrygin. Letter to Mikhail Larionov (excerpt). Pushkino, February 15 (N.S.), 1921. Archive of A. Tomilina-Larionova, Paris

1920 ah. 37.

254

254
Vasily Chekrygin
Multifigure Composition. 1920
Charcoal and lead pencil on paper.
28.8 x 21.8 cm

As Fiodorov saw it, the sons should return the debt to their fathers by resurrecting the past generations of fathers. Herein lies the "common cause" of the human race. This idea determined all the philosopher's remaining theses. The task of taking possession of cosmic space and planetary worlds followed on from the necessity of accomodating the resurrected generations. This common source also determined the purpose of art: "The highest task of art is not to represent, not to trace abstract thoughts (which amounts to the ghostly creation of mere likenesses, i.e. to illusion), but to show the way and — in artistic form and creative perception — to create a design for the cause itself, the very truest task of the human race."[103]

255

This grandiose "project" captured Chekrygin's imagination. Over a period of two or three years, he created a huge cycle of drawings which are to be perceived as a single work. This grandiose epic of the resurrection of generations past is related in images of great dramatic impact. Running through his drawings is a sharp sense of cosmic space, in which suns flare up and are extinguished while planets journey on. Chekrygin boldly sketched the destiny of mankind, and its inevitable venturing forth into outer space.

He executed his drawings with compressed charcoal, achieving endless tonal gradations. The plastic structure of his black-and-white drawings comes very close to painting.

A railway accident cut Chekrygin's life short at a moment when the artist stood at the peak of his creative powers.

255
Vasily Chekrygin
Composition. From the cycle
The Resurrection. 1922
Pressed charcoal on paper.
24.2 x 29.5 cm

256

256
Vasily Chekrygin
Composition. From the cycle
The Resurrection. 1922
Charcoal and lead pencil
on paper. 28.8 x 21.8 cm

In 1928 several artists who were close friends back in their days at GINKhUK formed the creative group "Painterly Plastic Realism," a name proposed by Yudin. Among the active members were Vera Yermolayeva, Lev Yudin, Konstantin Rozhdestvensky, Nikolai Suetin, Vladimir Sterligov, and Anna Leporskaya. Yudin defined the tasks of the group as follows: "What characterizes the new period? It is grounded in the aspiration of the individual to establish a sort of living, concrete equilibrium between himself and reality, based exclusively on the plastic means at his disposal."[104] Our book reproduces several works by the artists of this group of friends — graphic works by Yudin, Leporskaya's stern *Portrait of a Pskov Woman*, and gouaches by Yermolayeva. In these works, one hears the echo of Suprematism, but a Suprematism that is reinterpreted and integrated into the system of figurative painting. Yermolayeva's gouache *Woman with Child* is striking with its deep sense of color, and the clear plastic structure of the powerful forms. The invincible intuitive approach, characteristic of Yermo-

layeva, is introduced here into the austere channel of monumental form. Such of the artist's works as *Woman with Child, Fishermen* or *The Keg* can be called daring painting, which breaks with the usual canons. In these gouaches, Yermolayeva produced her own independent variant of the application of the color solutions generated by Suprematism to new figurative painting. From her trip to the Barents Sea in 1930, Yermolayeva brought back a cycle of landscape gouaches. These works clearly express an eternal, timeless element, the powerful movement of the ocean, and the mighty "Cubism" of the rocky crags. The entire cycle of northern gouaches is suffused with a perception of nature that is demiurgical in spirit. Nature's forms are expressed in the free and vigorous language of painting, creating a world which is bound henceforth to have a life of its own. In these works we can see how, to use Malevich's figurative expression, "Painting grows like a forest, a mountain, a stone."[105] This was the very essence of Vera Yermolayeva's conception of painterly plastic realism.

257

257
Vera Yermolayeva
Wine Glass and Apples. 1934
Black watercolor on paper.
14.5 x 21 cm

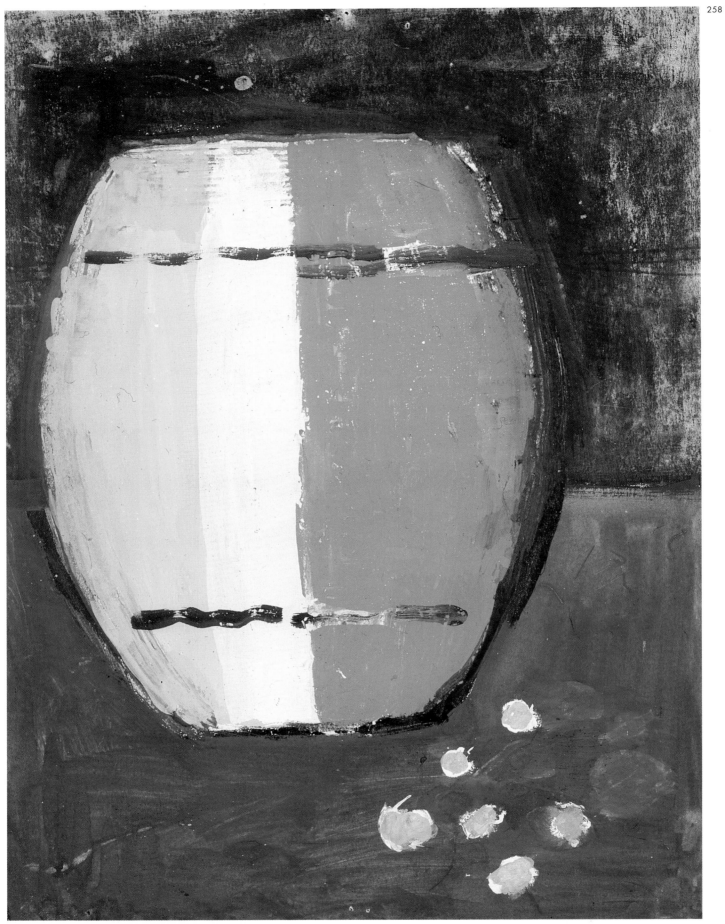

258
Vera Yermolayeva
Barrel. 1933
Gouache on paper. 29.3 x 22 cm

259
Vera Yermolayeva
Peasant Woman with Rake and Child. 1933 (?)
Gouache on paper. 29.5 x 22 cm

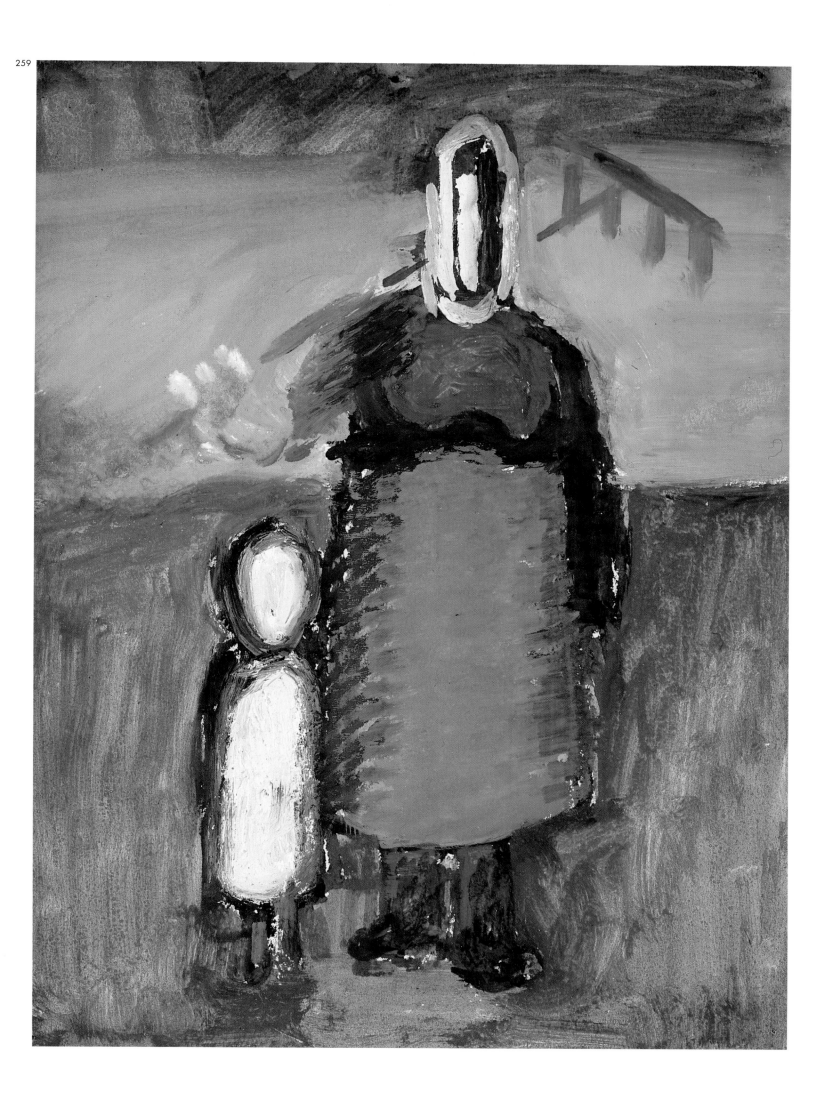

260

261

262

260
Vladimir Sterligov in
his studio. About 1930

261
Vera Yermolayeva
Self-Portrait. 1934
Black watercolor
and white on paper.
45 x 33.2 cm

262
Vera Yermolayeva
*The Barents Sea:
A Steamship*. 1928
Gouache on paper.
38.8 x 33.6 cm

263
Vera Yermolayeva
*Lucretius Points
to the Sun*. 1934
Illustration to the poem
On the Nature of Things
by Lucretius Carus
Tempera and graphite
on paper. 31.9 x 21.5 cm

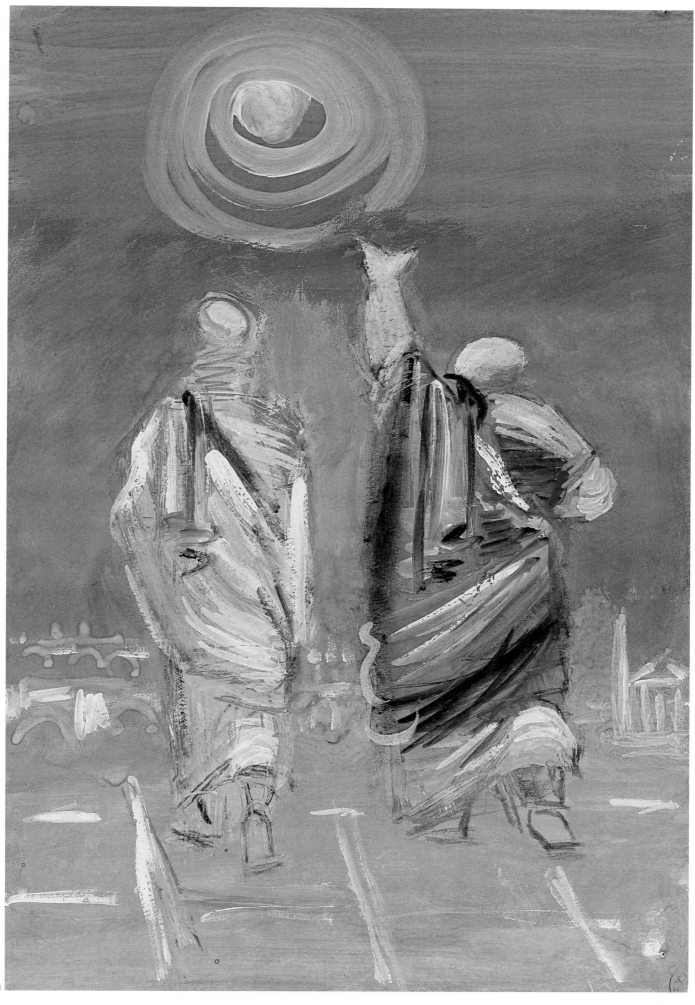

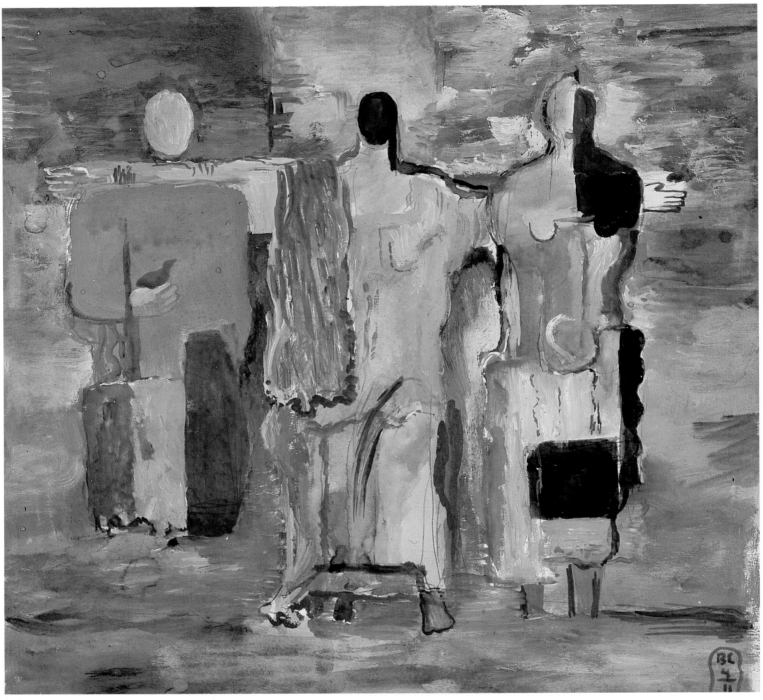

264

264
Vera Yermolayeva
Three Figures. 1928
Gouache and India ink on paper.
32.8 x 34 cm

265
Lev Yudin
Still Life: Coffee Pot, Pitcher, and Sugar Bowl. Between 1936 and 1939
Oil on canvas. 42 x 59 cm

266
Lev Yudin working on a paper sculpture. Early 1930s

267
Lev Yudin
Pear. 1926
Graphite, watercolor, and gouache on paper. 23 x 22.3 cm

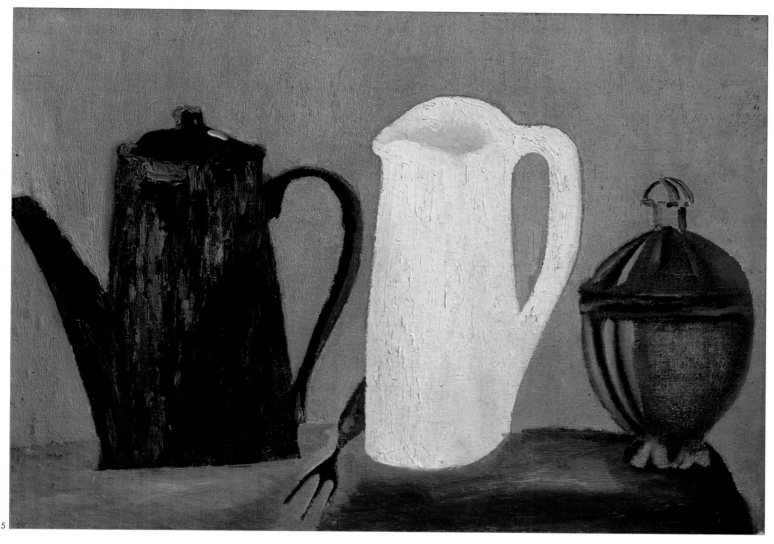

265

266

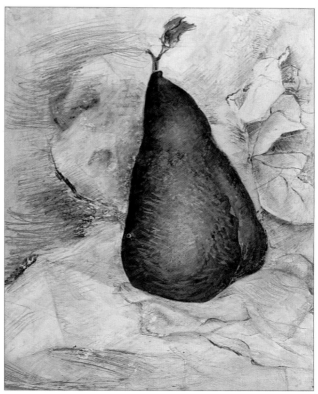

267

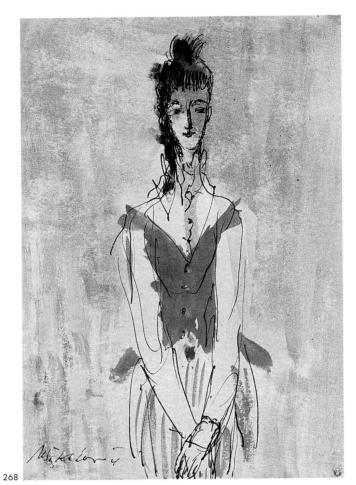

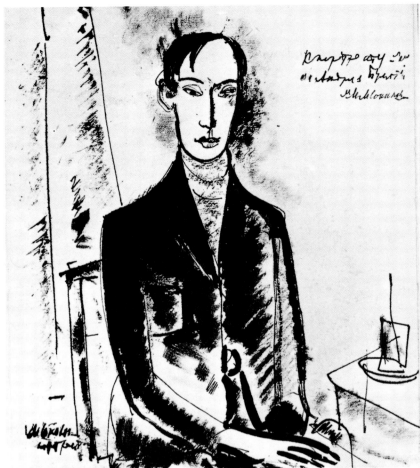

269
Mikhail Sokolov
Portrait of Andrei B. 1920s
India ink on paper.
19 x 15.6 cm

270
Mikhail Sokolov
Drawing from the series
Riders. 1935–37
India ink on paper.
20.3 x 28.2 cm

271
Pavel Basmanov
Landscape. 1933
Watercolor on paper.
20.3 x 22.5 cm

272
Pavel Basmanov
Sandy Hills: A Stroll. 1934
Watercolor on paper.
11.7 x 16.3 cm

268
Mikhail Sokolov
Sheet from the series *Ladies.* 1930s
Watercolor and pen and India ink
on paper. 28.5 x 19.4 cm

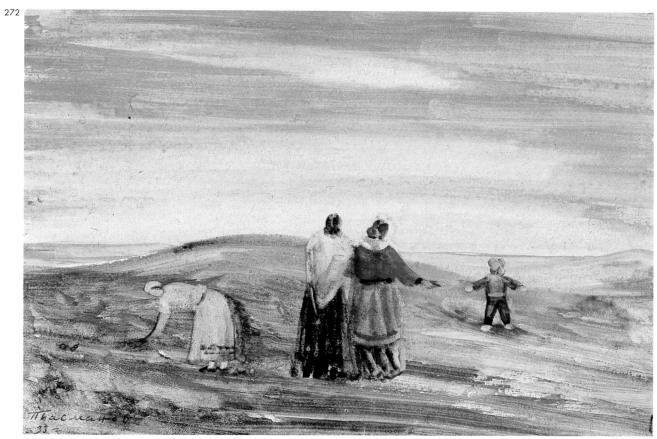

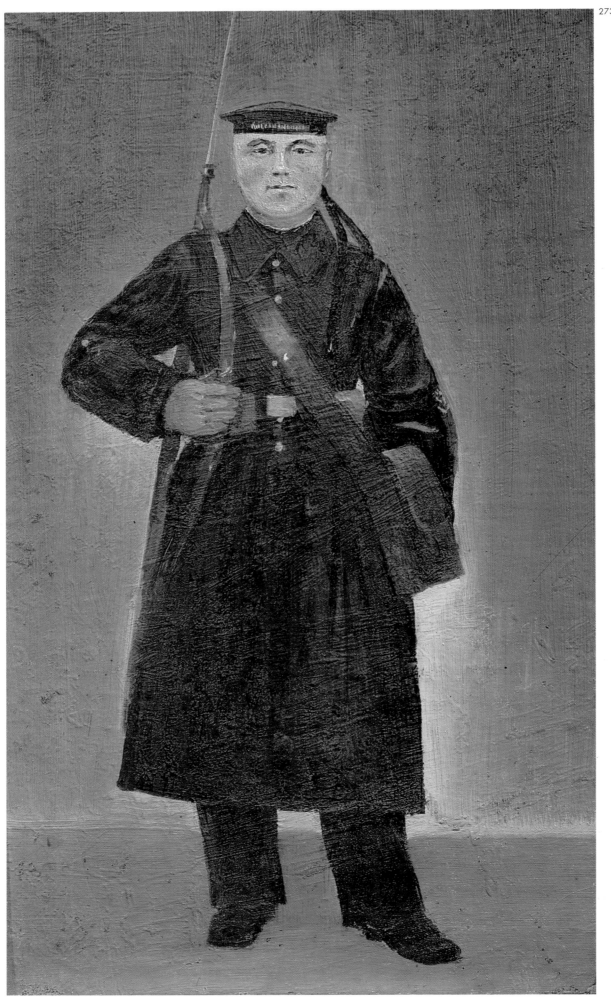

273
Boris Yermolayev
Red Navy Man.
Second half of the 1930s
Oil on canvas mounted on
cardboard. 25.5 x 17.5 cm

274
Boris Yermolayev
Family Portrait. 1930
Oil on canvas mounted
on cardboard. 31 x 41 cm

275
Mikhail Sokolov
Still Life with Fish. 1930s
Oil on canvas.
52.7 x 70.5 cm

→
276
Anna Leporskaya
Pskov Woman.
First half of the 1930s
Oil on canvas. 60 x 48 cm

→
277
Piotr Sokolov
*Portrait of
A. M. Smirnova*. 1920s
Oil on canvas. 64 x 51.5 cm

274

275

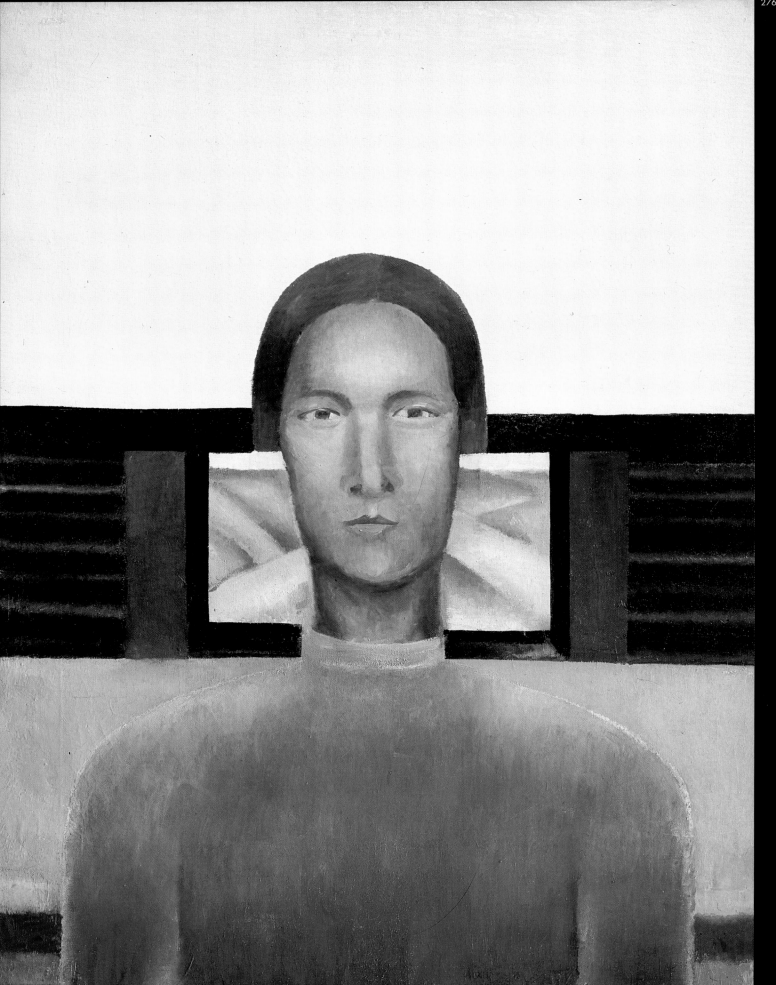

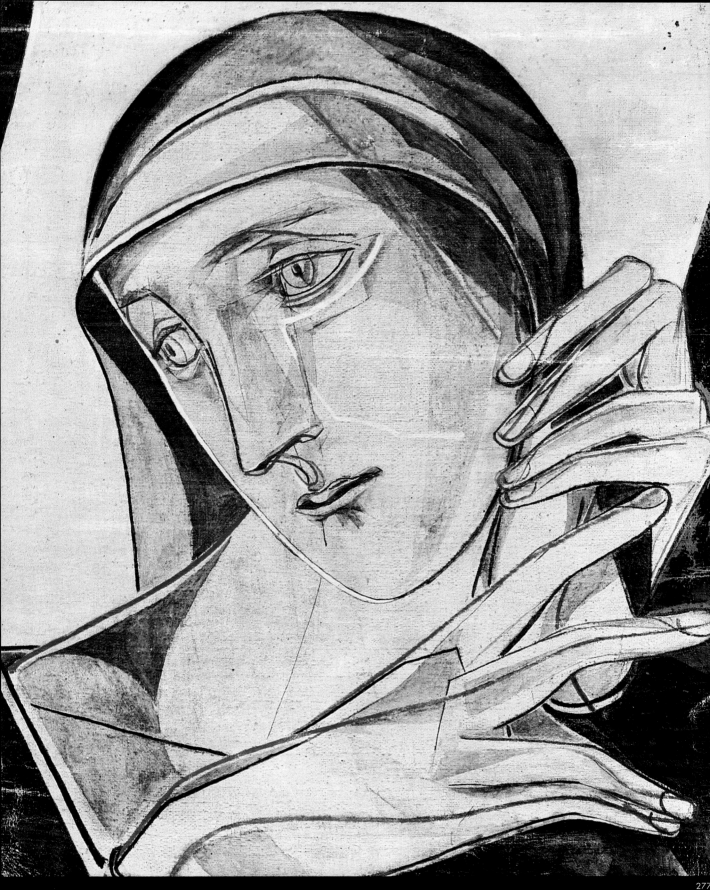

РЫНОК

Е. ШВАРЦ
РИСУНКИ
Е. ЭВЕНБАХ

РАДУГА
1925

LENINGRAD DETGIZ

In 1925 a children's literature section was formed in Leningrad as part of the State Publishing House under the directorship of Samuil Marshak. A large group of creative figures gathered around Marshak including the writers Boris Zhitkov, Vitaly Bianchi, Kornei Chukovsky, Charushin, and others — were splendid painters and graphic artists. Their work on the books, strengthened by their command of easel painting and drawing, constituted, as it were, the logical outcome of their varied artistic experience. Though they shared the same basic

279

280

278
Yevgenia Evenbakh
Illustration for Yevgeny Schwartz's book *Rynok* [*The Market*]. 1925
Gouache on paper. 27.6 x 21.8 cm

279
At Vladimir Lebedev's exhibition in the Russian Museum. 1928.
From left to right: Nikolai Punin, Vera Anikiyeva, Piotr Neradovsky, and Vladimir Lebedev

280
Vladimir Lebedev at his one-man show in the Russian Museum. 1928

→
281
Vera Yermolayeva
Cover for Nikolai Aseyev's book *Top-top-top*. 1925
Gouache and India ink on paper. 26.7 x 20.8 cm

→
282
Vera Yermolayeva
Illustration for Daniil Kharms's book *Ivan Ivanych Samovar*. 1930
Gouache on paper. 23.1 x 18.3 cm

Yevgeny Schwartz, Daniil Kharms, Alexander Vvedensky, Nikolai Zabolotsky, and others. They carefully and purposefully worked on the creation of a new children's literature.

The art department of Detgiz was headed by Vladimir Lebedev, who endeavored to give children's books a new look and form. He saw the book as being an integral artistic organism in which all elements are bound together as a structural unity. Lebedev's best books — *The Hunt, The Circus, Ice Cream* (the last co-authored with Marshak) — brilliantly expressed this constructional principle.

Children's books in the 1920s and 1930s were created not by publishing specialists, but by artists in the broad sense of the word. Lebedev and his closest comrades-in-arms at Detgiz — Vera Yermolayeva, Yevgeniya Evenbakh, Nikolai Tyrsa, Alexei Pakhomov, Nikolai Lapshin, Yury Vasnetsov, Valentin Kurdov, Yevgeny

approach, each of these masters developed his or her own style for the design of books. Whereas Lebedev's children's books were a brilliant expression of a structural graphic basis, at the other end of spectrum stood the works of Vasnetsov and Yermolayeva, who showed a preference for pictorial expressiveness. The creator of drawings for children should be not simply a good artist, but must possess special qualities. "It is very important," observed Lebedev, "for the artist who works on children's books to have the ability and know-how to again experience the keen inquisitiveness which he experienced in childhood. But if the artist deliberately tries to think like a child, nothing will turn out right and his drawing will be easily seen to be an artistic fake."[106] Vasnetsov's drawings reveal a characteristic trait, the ability to experience again and again that "keen interest" in everything, expressed in his work with such

281

282

intensity and purity that it seems as if the world is opening up before us for the first time. In this discovery of the world, there is always an element of surprise, a naivety, taking on faith everything he sees as children do. These traits are an intrinsic part of Vasnetsov's book *Boloto* [*The Bog*], which he created together with the writer Bianchi. In the artist's drawings, the secret, busy life of the bog is clearly seen, seeming to loom at the reader as if viewed under a magnifying glass. *The Bog*, which is justifiably considered to be Vasnetsov's first great success in this new field, showed the artist's love of intense chromatic solutions and resonant, highly colored illustrations.

On many of her books, Yermolayeva worked in close association with the Oberiut poets, Alexander Vvedensky, Nikolai Zabolotsky, and Nikolai Oleinikov. The inventiveness and humor which epitomize her vivid works were revealed with particular verve in the illustrations to Kharms's verses *Ivan Ivanych Samovar*. In the artist's rapidly alternating drawings or "frames," there unfolds the amusing tableau of a family having tea, the main role played by a pot-bellied but dignified samovar that slims down by the end of the ceremony. The simple, precise drawing highlights characteristic details of the verses and Yermolayeva achieves a stylistic equivalent to Kharms' verses with their playful rhythm and intonation:

> The samovar they tilted
> And the samovar they tipped
> But all that it emitted
> Was a puff, puff, puff.
> The samovar they tilted
> Like a cup, cup, cupboard
> But all that it delivered
> Was a drip, drip, drip.

Yermolayeva was extremely observant and she often transformed the most humdrum objects and occurrences into images for her children's books. The artist Vladimir Sterligov recalled: "There was a time in the 1920s when we were going down the stairs after leaving the Enders'

283

285

286

283
Alexei Pakhomov
Cover of Yevgeny Schwartz's
book *Vedro* [*The Pail*]. 1926
Watercolor and graphite
on paper. 26.5 x 20.8 cm

284
Alexei Pakhomov
Illustration for Yevgeny Schwartz's
book *Vedro* [*The Pail*]. 1926
Watercolor on paper.
24.6 x 19.5 cm

285
Vladimir Lebedev
Illustration for Vladimir
Lebedev's book *Okhota*
[*The Hunt*]. 1924
Lithograph. 23.7 x 18 cm

286
Yury Vasnetsov
Cover of Vitaly Bianchi's book
Boloto [*The Bog*]. 1931
Colored pencils, lithographic crayon,
on paper. 22.4 x 18.4 cm

287

**287
Vladimir Tambi**
Seaside (Blue) Town. 1930s. From
the series *The Towns of the Future*
Gouache on colored paper.
19.5 x 31.5 cm

apartment[107] where poets, writers, and
artists used to get together — Zabolotsky,
Matiushin, Kharms, and many others.
Vera Mikhailovna, leaning on crutches,[108]
was the last to come out and I was
in front of her. Suddenly she said to me:
'Just look how she's wiggling her little
whiskers, woof, woof.' In a small niche
by the door there was a little brush
for cleaning the lamp fixtures — that, and
nothing more. Everybody had passed by
it paying no notice, but Vera Mikhailovna
saw that the brush was a living thing.
Several years later I saw that brush
embodied in the person of a kind old man
in Kharms's book *Ivan Ivanych Samovar*
and I immediately recognized it. This is
how Vera Mikhailovna took from life and
made into artistic images things that
passed unnoticed by others."[109]
Quite often the initiative for a new book
came not from the writer but from the
artist. In summer 1928 Yermolayeva
made a journey around the Barents Sea
coast. The artist was struck by the

powerful motion of the ocean and the
mighty "cubism" of the rocky mountains.
Her whole cycle of northern gouaches is
imbued with a cosmic perception of na-
ture. Magnificent, formidable, and grand
images create an impression of inevitabi-
lity and invincibility in the motion of the
elements. All this is expressed in a free,
bold language, deploying a powerful plas-
ticity of forms. In these works one can
see how, to use Malevich's figurative
expression, "painting grows by forest, hill,
stone." Yermolayeva's gouaches caught
Vvedensky's imagination with their keen
breath of the North. They became the
impetus for one of the best books the
artist and the poet produced together —
The Fishermen.
The blossoming of the art of book pro-
duction in the 1920s and the early 1930s
was associated with the efforts of
Vladimir Favorsky in Moscow and with
Vladimir Lebedev's group of artists in
Leningrad. Their activity won wide inter-
national acclaim for Russian books.

кто лучше?

288
Alevtina Mordvinova
Back cover of the book
Who is Better? 1936
Coloured lithograph.
18.4 x 17.5 cm

289
Alevtina Mordvinova
Cover of the book
Who is Better? 1936
Colored lithograph on paper.
18.8 x 17.6 cm

290
Pavel Kondratyev
Cover of Olga Bergholz's
book *Stasia in the Palace*. 1930
Watercolor and pen and colored
ink on paper. 19.9 x 13.8 cm

291
Alexander Samokhvalov
Illustration for Alexander Samokhva-
lov's book *Deep Diving Station*. 1928
Gouache and pencil on paper.
28.7 x 21.5 cm

292, 293
Vera Yermolayeva
Cover for the book *Rybaki*
[*The Fishermen*]. 1929
Watercolor and tempera on paper.
22.3 x 18.9 cm

SCULPTURE

Among the sculptural works produced during the immediate post-revolutionary years, a special place is occupied by Piotr Bromirsky's monument to the eminent Russian painter Vasily Surikov. Bromirsky was considered an ingenious artist by his authoritative contemporaries such as Alexander Matveyev, Mikhail Larionov, and Vasily Chekrygin, but now he has been largely forgotten and his works are unknown even to specialists.

The monument to Surikov was created in accordance with the Plan for Monumental Propaganda, signed by Lenin in 1918. Originally, the idea was to erect it on the former Place of Execution on Moscow's Red Square. In the Russian Museum is a plaster of Paris model for the monument, consisting of the figure of an angel holding a sword and scales.

Like his older friend, Mikhail Vrubel, Bromirsky greatly valued the heritage of old Russian art and believed that the contemporary artist should take its traditions as a starting point. The painter Sergei Romanovich, a friend of Bromirsky, wrote: "When Bromirsky was confronted with the question of selecting the form of the monument, his predilection led him to the forms of old art, which he applied with a freedom that resulted from his understanding of these forms from the point of view of contemporary man. Bromirsky easily skirted the danger of formalization, which many artists who tried to find the connection with old art did not manage to avoid."[110]

The figure of the angel was to have been made of wrought iron. Contemporaries saw only the angel's head and a wing, all of which have now disappeared without trace. Instead, a different statue was erected on Red Square, Sergei Konionkov's wood sculptural group *Stepan Razin and His Rebels* (1917–18).

Cubist sculptural principles are prominently expressed in the works of Boris Koroliov, whose work is still almost unknown to the public. Koroliov studied with Alexandre Archipenko in Paris, but his form of Cubism (*Salome*, *Archaic Figure*) has a more genuine and manly character than the teacher's works, which bore the stamp of aestheticism. The work of Alexander Matveyev, an important figure in contemporary art, was oriented toward the traditions of the classical world. He had a large number of pupils and followers whose works are represented in this book.

In 1926, a Faculty of Northern Peoples was organized within the Yenukidze Oriental Institute in Leningrad. Among the students in this faculty were representatives of the Tungus, Evenk, Gold, and Itelmen peoples, as well as other small nationalities of Siberia and the Far East. The faculty organized drawing and sculpture workshops and in a short time achieved remarkable success. The artists, who come from essentially primitive societies, brought to art an astonishingly acute perception, spontaneity, and purity of vision. An exhibition of the works of Northern peoples was organized in the Russian Museum in May, 1929, and these works were then shown in Paris, to the delight of the spectators. Nikolai Punin wrote: "The Northern peoples, who have no conception of European art... manifest such a highly developed artistic culture and such keen feeling in understanding the contemporary tasks of art that all who visited the workshops... have formed a very definite opinion: these works are a major event in our artistic world, an event that will play a great role in the development of contemporary art."[114] Punin was not mistaken: the graphics of these peoples soon exercised an influence on Leningrad artists, expecially on the brilliant graphic artist Piotr Sokolov.

294
The sculptor Piotr Bromirsky (left) and the painter Sergei Romanovich. 1919
"When Bromirsky was confronted with the question of selecting the form for the monument, his predilection led him to the forms of old art, which he applied with a freedom that he possessed by virtue of his understanding of those forms from the point of view of contemporary man. Bromirsky easily skirted the danger of 'formalization,' which many artists who tried to find the connection with old art failed to avoid.
These fruitless attempts were continued through the efforts of Stelletsky, V. Vasnetsov, Nesterov, Roerich, and others. Vrubel, who was marked by a special destiny and linked by personal relations to P[iotr] I[gnatyevich], also attempted to unite the ancient tradition with a contemporary painting. However, he was not able to carry through the natural line from ancient Russian culture to the art of our times. All this was quite different for Piotr Ignatyevich Bromirsky. In the hands of this artist, ancient art appeared in a new and natural form for contemporary man, a form devoid of all marginal additive elements in his drawings, and sketches, which were sometimes rendered in two or three lines that were full of meaning. When examining his drawings for the Surikov monument, it is of course possible to see that the old tradition was the artist's starting point in his quest for this figure of Justice and Strength, but this was such a free movement, one that had its roots not only in all the best that has been created by Russian art but which we would not be mistaken in defining as the basis of the solutions that he found in world art as an integral phenomenon."
Sergei Romanovich, *Piotr Bromirsky*, 1950s. Romanovich family archive, Moscow

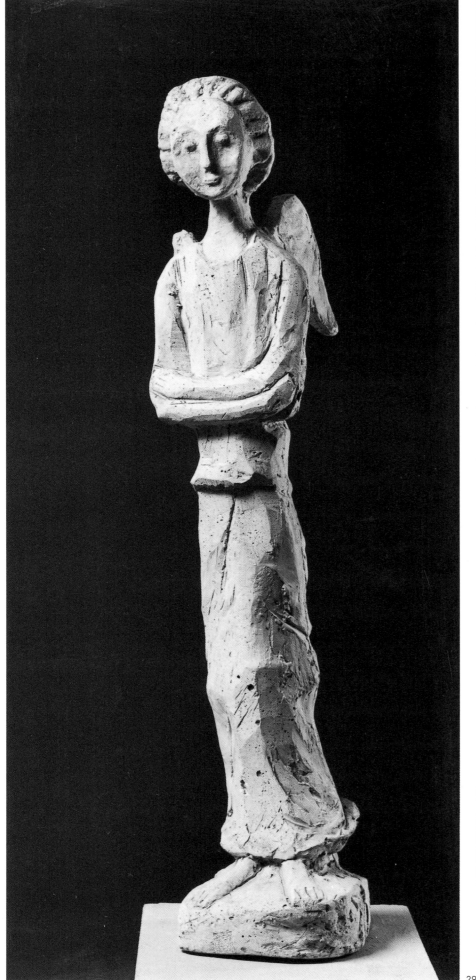

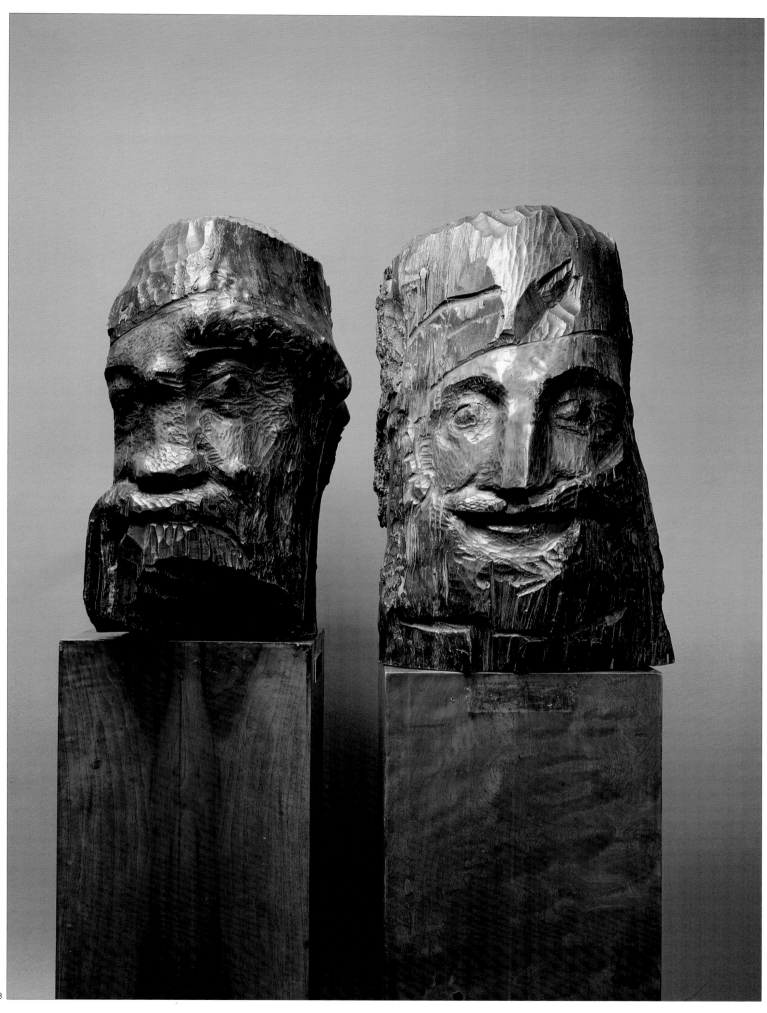

299

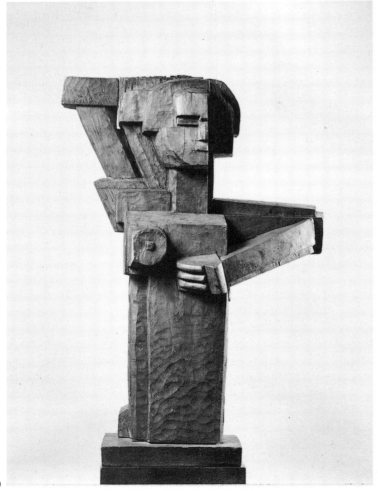

300

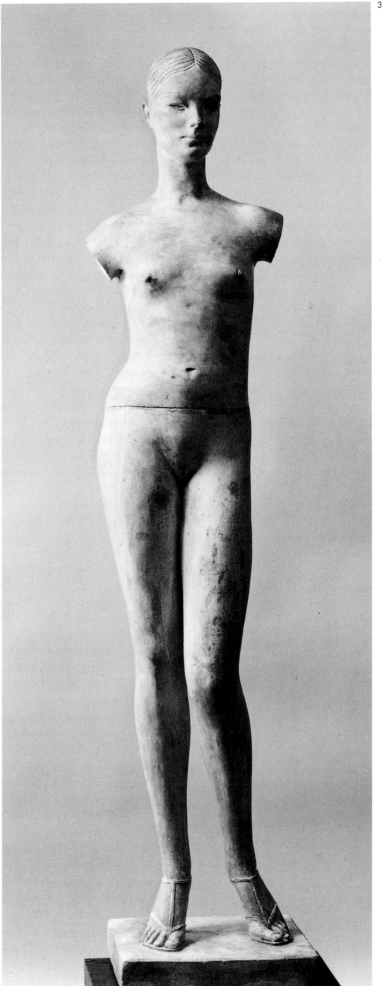

295
Piotr Bromirsky
Angel. Model for an unrealized
monument to Vasily Surikov.
1918–19
Plaster of Paris. 89 x 18 x 21 cm

296
Piotr Bromirsky
The Resurrection of Christ. 1918–19 (?)
India ink on paper. 31 x 21.5 cm

297
Piotr Bromirsky
Sketch for a monument
to Vasily Surikov. 1919
Charcoal on paper. 29 x 17.4 cm

298
Sergei Konionkov
*Stepan Razin and
One of His Rebels.* 1918–19
Tinted wood. 61 x 38 x 39 cm;
55 x 30 x 46 cm

299
Boris Koroliov
Figure of a Woman. 1920
Plaster of Paris. 60 x 17 x 22 cm

300
Boris Koroliov
Salome. 1922
Wood. 110 x 71 x 34.5 cm

301
Sarra Lebedeva
Shopwindow mannequin. 1936
Tinted plaster of Paris.
207 x 40 x 50 cm

302
Boris Koroliov
A Man. 1920
Plaster of Paris and iron.
64 x 22 x 23 cm

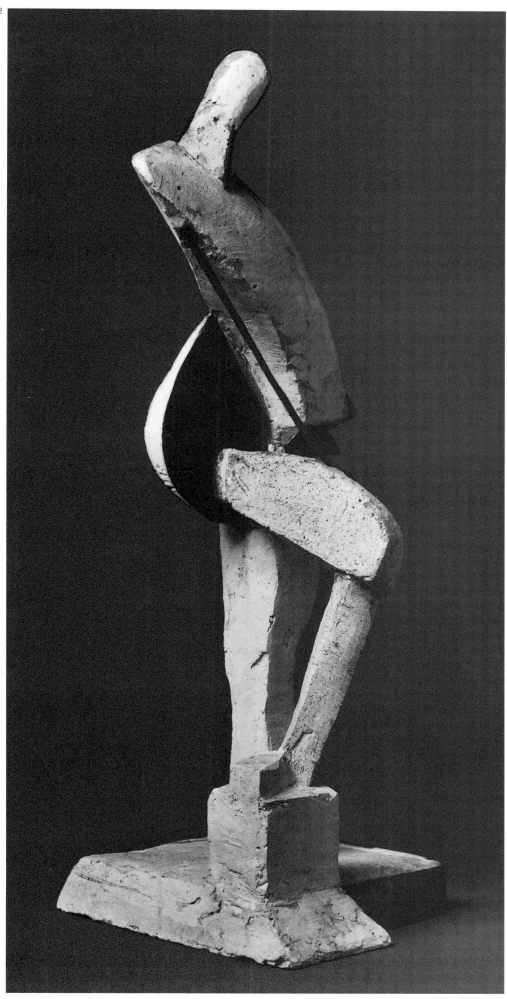

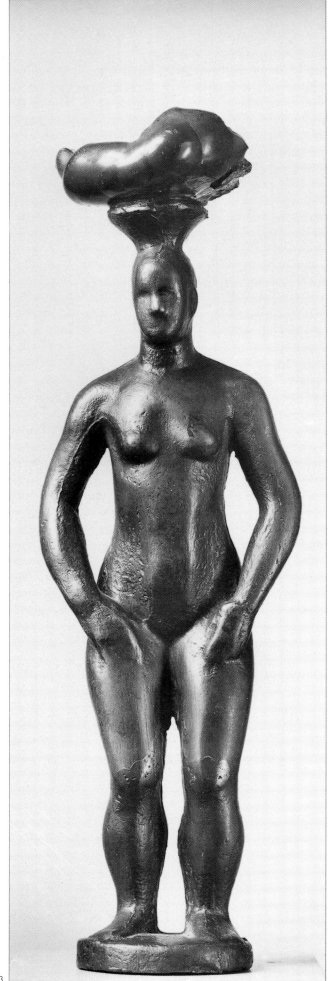

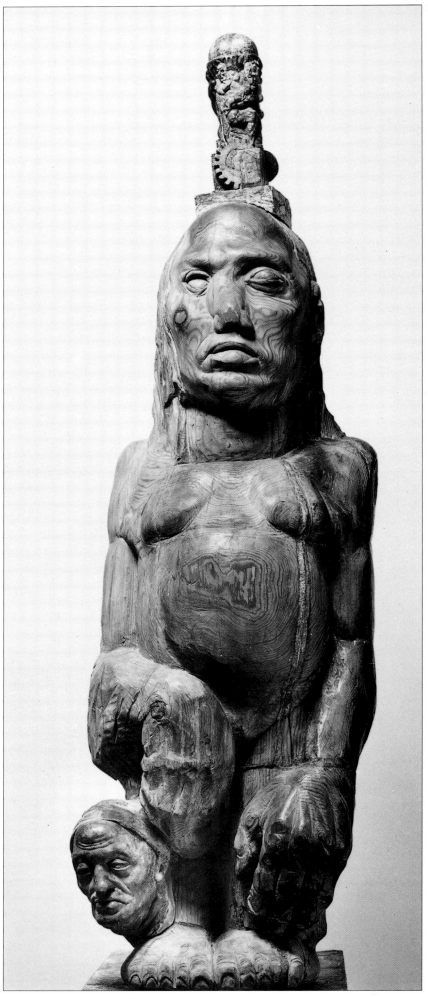

305

303
Alexander Matveyev
Flora. 1923–25
Cast iron and malachite. 27 x 8 x 6 cm

304
Innokenty Suvorov
Wisdom. 1928
Wood and painted plaster of Paris.
140 x 38 x 64 cm

305
Sarra Lebedeva
Robespierre. 1920. Propaganda relief
Painted plaster of Paris.
53 x 40 x 11 cm

307

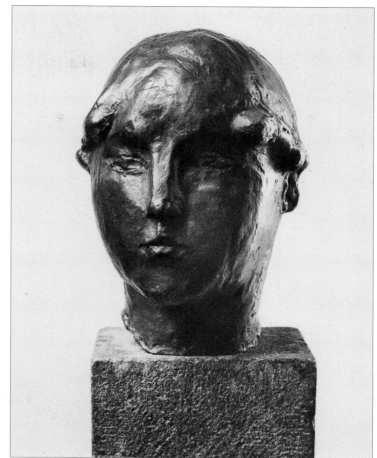

308

306
Sergei Bulakovsky
Girl with a Bird. 1929
Marble. 72 x 28 x 30 cm

307
Alexander Matveyev
Self-Portrait. 1939–41
Bronze. 44 x 25 x 30 cm

308
Boris Koroliov
Portrait of a Woman (Head). 1920
Bronze with a granite base. 24 x 18 x 22 cm;
15.5 x 16 cm; 5 x 15 cm

309
Nathan Altman
Anatoly Lunacharsky. Propaganda relief. 1920
Tinted plaster of Paris. 63.2 x 46 x 7 cm

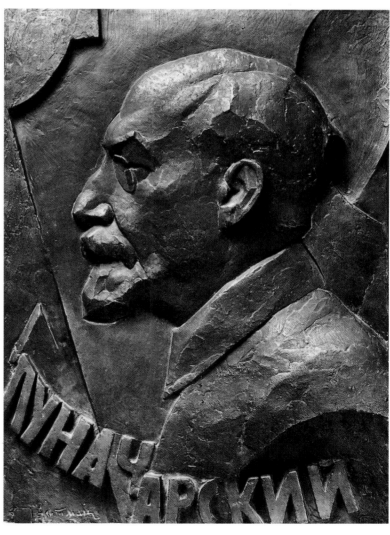

309

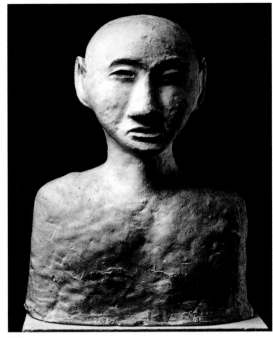

310

312

311

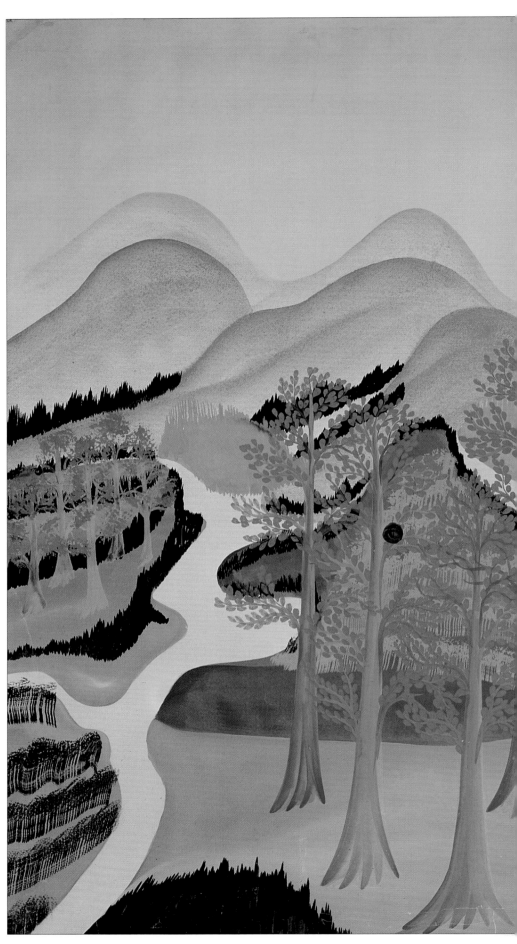

310
Bogdan Khodzher
Father's Portrait. 1928–29
Plaster of Paris. 47 x 35 x 20 cm

311
Prokopy Bekerov
Portrait of a Woman. 1928–29
Plaster of Paris. 35 x 31 x 10 cm; height 7 cm

312
Leonid Mess
Head of an Ostiak Man. 1931
Bronze. 64 x 34 x 34 cm

313
Konstantin Pankov
The Hunt. 1930s
Watercolor on paper. 62.5 x 87.5 cm

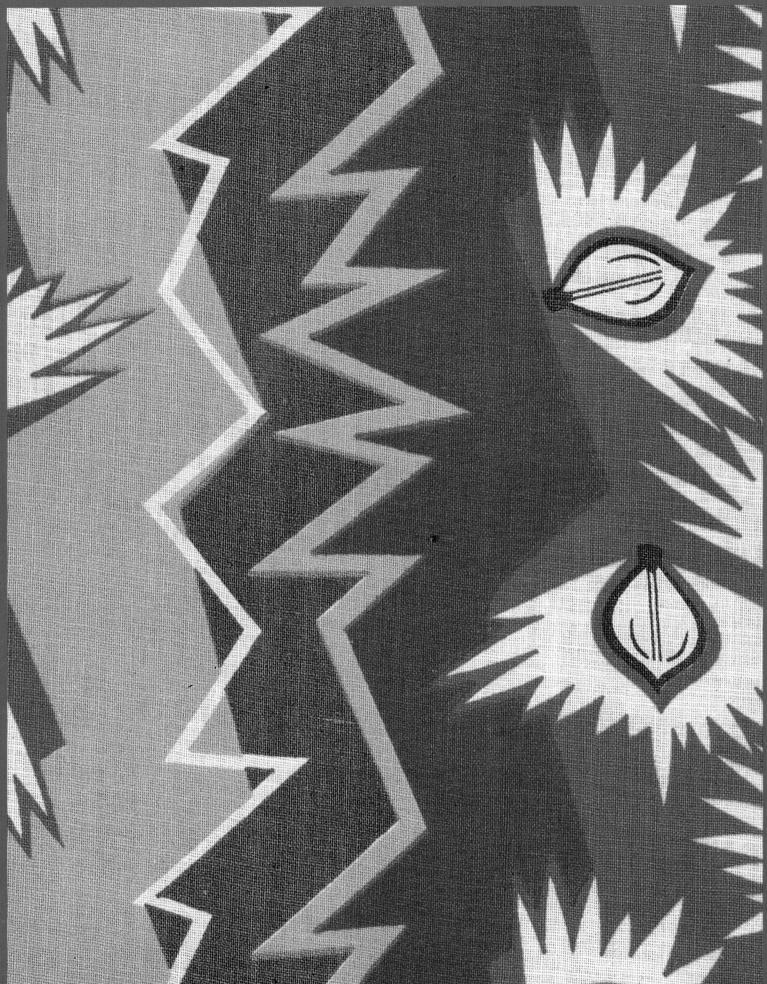

THE DECORATIVE INSTITUTE, PORCELAIN AND TEXTILE FACTORIES

The year 1918 saw the formation in Petrograd of an Institute of Decorative Art, with various production workshops for posters, stage designs, mass agitational art, and other applied arts. The institute was directed by the painter and theater artist Iosif Shkolnik. From time to time, leading masters such as Nathan Altman, Vladimir Kozlinsky, and artists of Matiushin's school worked in the institute.

Another new center of applied art was the Leningrad Porcelain Factory. It was perceived as a prototype for the industry of the future, an experimental laboratory, exemplary in terms of both art and science.

form of decoration to dishes (of the porcelain factory). The sales in Moscow are colossal. I'm terribly happy about this success. It refutes the disgusting remarks about the inability of Leftist art to become an integral part of life."[112]

Among the works reproduced in this book, we wish to draw attention to the Suprematist china of Kasimir Malevich, Nikolai Suetin, and Ilya Chashnik, as well as to the rare plate by Vladimir Tatlin known as *Tsarevich*, and to the decorative paintings on china by Sergei Chekhonin, Alexandra Shchekatikhina-Pototskaya, and Nikolai Lapshin.

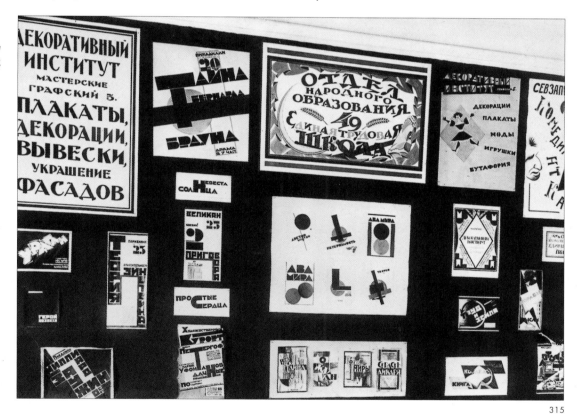

315

Malevich's successors, Nikolai Suetin, Ilya Chashnik, and later Anna Leporskaya came to work there. The china with decorative designs by them in accordance with the principles of Suprematism marked a genuine epoch in the factory's history. As early as 1923, Matiushin observed: "Malevich is having tremendous success. His student [N. Suetin] has applied the Suprematist

314
S. Strusevich
Fabric: *Lamps (for the Republics of Central Asia)*. 1928–30
Block-printed calico. 18 x 21 cm

315
Exhibition of the Decorative Institute. 1924
"The Decorative Institute was supposed to show the significance of the old form and the negative effect of the decorative phase in its development and, furthermore, it was to introduce the principle of Constructivism into manufactured articles, and if not able to influence the mass-produced form itself, then it was to address the so-called decorative elements, acting in the last case, like an antidote to one of the most potent poisons of the old art."

N. Punin, *Dekorativny institut. Vystavka* [*The Decorative Institute. Exhibition*], Petrograd, November, 1922, p. 7

→
316
Vladimir Tatlin
Dish: *Tsarevich*. 1922
China, with overglaze decoration. Diameter 23 cm

In the painted decoration of this plate, Tatlin returned to his theme of former years. In 1911, the St. Petersburg Union of Youth staged the folk drama *Tsar Maxemyan and His Disobedient Son, Adolf*. For the Moscow presentation of the drama, Tatlin did a large number of theatrical sketches.

→
317
Nikolai Suetin
Saucer: *Suprematism*. 1923
China, with underglaze and overglaze painted decoration. Diameter 31.5 cm

→
318
Alexandra Shchekatikhina-Pototskaya
Dish: *Sailor on the Town on May 1, 1921, Petrograd*. 1921
China, with overglaze painted and gilded decoration. Diameter 24.8 cm

→
319
Alexandra Shekatikhina-Pototskaya
Tray: *Snow-White*. 1922
China, with cobalt underglaze coating and overglaze painted and gilded decoration. Diameter 35 cm

→
320
Bosilka Radonich
Plate: *Equality*. 1920
China, with overglaze painted decoration. Diameter 21.5 cm

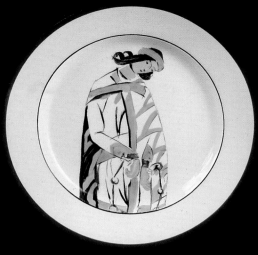

316

317

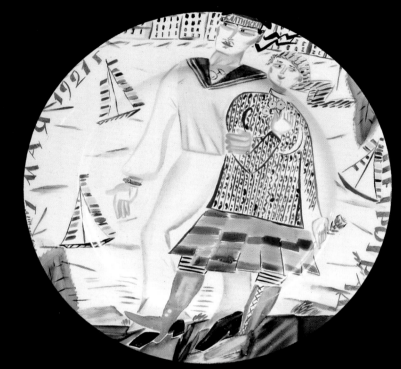

318

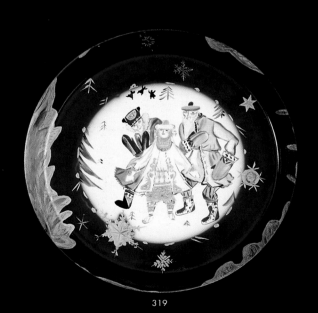

319

320

321

322

323

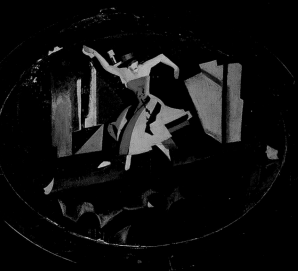

324

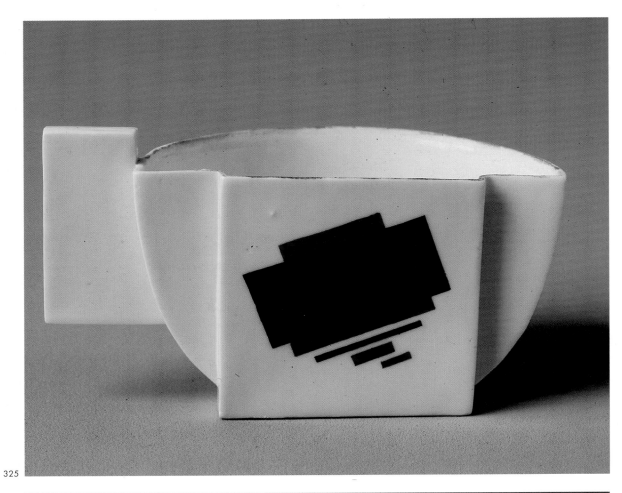

325

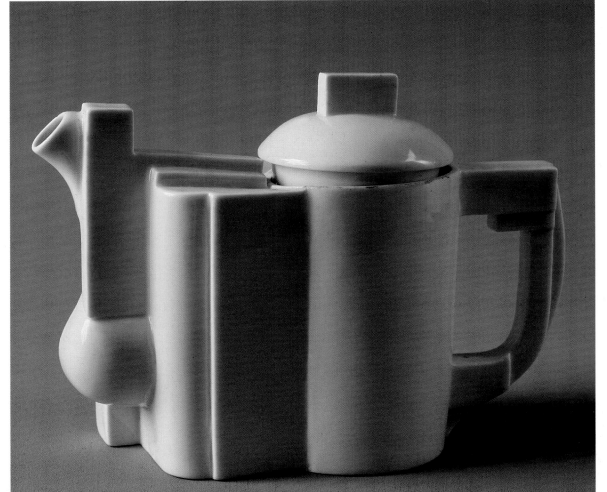

326

←
321
Sergei Chekhonin
Tray: *RSFSR*. 1921
China, with overglaze
painted and gilded
decoration.
33.2 x 27.5 cm (oval)

←
322
Nikolai Lapshin
Tray: *25. X. 17 (25th of
October 25, 1917)*. 1922–24
Wood, painted in oils and
bronze color.
Diameter 40 cm

←
323
Nathan Altman
Plate: *The Earth
for the Workers*. 1919
China, with overglaze
painted decoration.
Diameter 24.7 cm

←
324
Rudolf Frenz
Tray: *Tango*. 1922–24
Wood, painted in oils.
53 x 42 cm (oval)

325
Kasimir Malevich [design],
Ilya Chashnik [decoration]
Teacup: *Suprematism*. 1923
China, with overglaze
decoration. 7.2 x 12 x 6 cm

326
Kasimir Malevich
Teapot. 1923
China. 16 x 22.2 x 8.8 cm

327
Unknown artist
Fabric. Late 1920s –
early 1930s
Block-printed calico

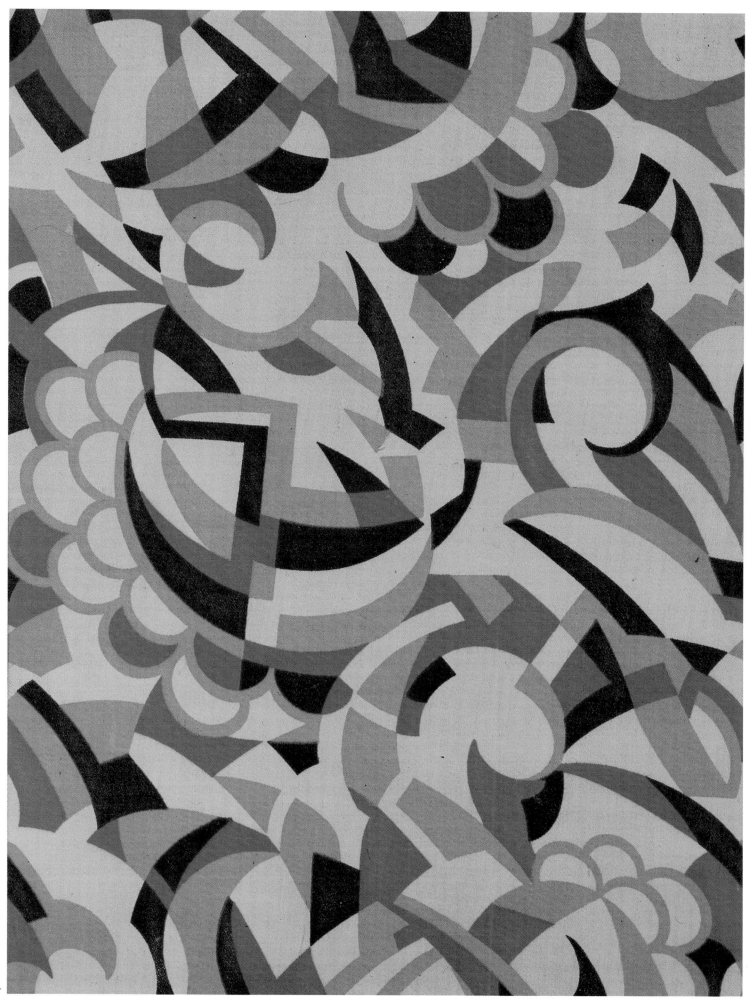

328

329

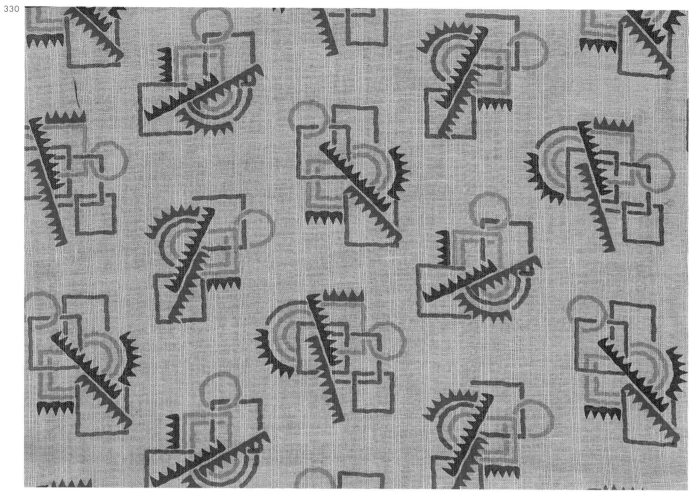

332
Panel for a cupboard. 1921.
The Decorative Institute

333
Natalia Danko
Statuette: *Sportswoman*.
Early 1930s
China with overglaze painted
decoration. Height 17.6 cm

334
Natalia Danko and Yelena Danko
Anna Akhmatova. Statuette. 1924
(decorative painting of 1937)
China, with overglaze painted
and gilded decoration.
Height 22.2 cm

335
Alexandra Shekatikhina-Pototskaya
Cup with saucer: *Red
Countenance*. 1922
China, with overglaze painted
and gilded decoration.
10.3 x 12.2 x 9.5 cm; diameter
of the saucer 17.1 cm

336
Unknown artists
Three boxes. 1924
Oil on wood. 76 x 13.2 cm;
9.9 x 13 cm; 8 x 12.4 cm

337
Mikhail Mokh
Tea-service: *Metal*. 1930
China, with overglaze, painted,
gilded, and cirrated decoration
Tray — diameter 34.5 cm
Teapot — 13.8 x 18 x 12.2 cm
Milk pitcher — 13.9 x 10.3 x 8 cm
Sugar dish with cover —
10.4 x 13.5 x 10.5 cm
Two tea cups with saucers —
5.5 x 11 x 9.4 cm (each),
diameter of each saucer 15 cm

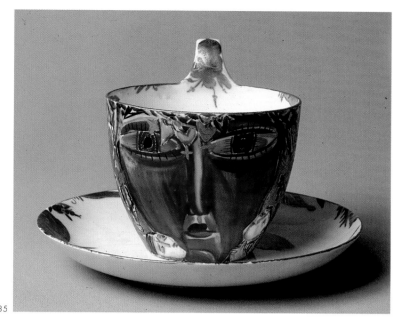

335

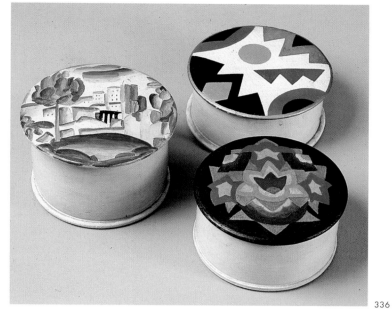

336

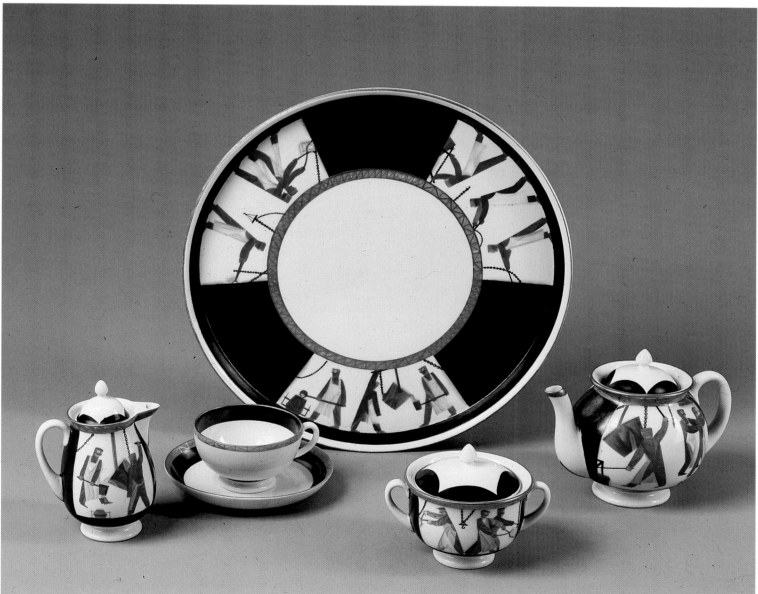

337

THE ARRESTED MOVEMENT

For several decades now, there has been consistent world-wide interest in the Russian avant-garde. This is to be explained in many respects by the fate of Russian art in the 1920s and 1930s. At the beginning of the twentieth century, Russian art securely occupied a leading position in the eyes of the world. It brought forth new ideas and solutions to plastic problems which led artists to previously unseen horizons. Picasso, who met with no obstacles, did everything he could and wanted to do. The cause of the Russian artists remained incomplete. The mercurial movement was abruptly broken off; the beginnings abandoned in mid-stream. The great potential of these unrealized causes and unresolved problems is what attracts artists, researchers, and avid art enthusiasts. World art may well have gone along another route if the Russian avant-garde had not met with misfortune.

Several generations grew up, and for many years encountered only a distorted picture of the art of the 1920s and 1930s from the exhibition rooms and museums of Moscow and Leningrad. This picture omitted the greatest contemporary masters, Larionov and Kandinsky, Malevich and Tatlin, Filonov and Chagall, Matuishin and Chekrygin, Goncharova and Rozanova. Not only individual names, but entire schools, trends, and artistic organizations were absent: the Masters of Analytical Art, the Vitebsk UNOVIS, Matiushin's school, the Suprematists, the Leningrad GINKhUK, and many more. There was an obvious striving to force the grand diversity of art along a straight and narrow path. The living, dynamically developing art was stopped in its tracks. The 1930s inflicted a particularly deep loss on our art. A number of artists (how many, we still do not know), such as Vera Yermolayeva and Piotr Sokolov, departed forever. Others were for a long time forcibly torn away from their calling. Still others — and they constituted the majority — did not stand up to pressure and abjectly gave in, being reduced to utter nothingness as original artists. How many personal exhibitions we have seen over the past years that had a brilliant beginning and ended up — in the 1930s and 1940s — so depressingly.

Yet there remained steadfast masters who were dedicated to their cause and continued to work according to their conscience, not counting on exhibitions and recognition or material success. Pushed off, as it seemed, onto the side of the road of art, these artists proved to be, as we now can see, in its center. They preserved the honor and dignity of contemporary Russian art. It is they who, forgotten and unsung, form a significant part of the masters included in this book, which constitutes the first attempt to show the authentic history of Soviet figurative art of the 1920s and 1930s.

338
Vera Yermolayeva
Illustration to the poem *On the Nature of Things* by Lucretius Carus. 1934
Gouache on paper. 29.2 x 22.2 cm

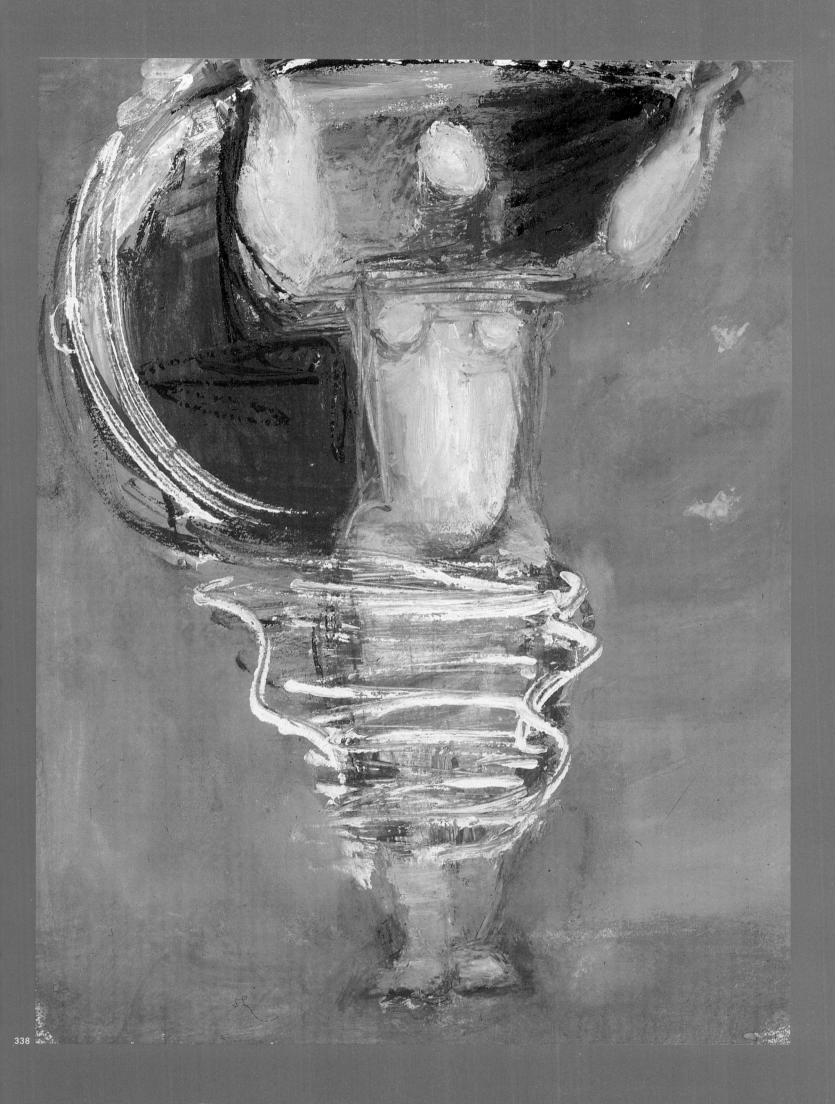

1 P. Filonov, *Intimnaya masterskaya zhivopistsev i riso-val'shchikov "Sdelanniye kartiny"* [*The Intimate Workshop of Painters and Draftsmen "Made Pictures"*], St. Petersburg, 1914.

2 P. Filonov, "Kanon i zakon" ["Canon and Law"]. Manuscript Dept., Institute of Russian Literature, St. Petersburg, fund 656.

3 N. Berdiayev, "Picasso," *Sofiya* ["Picasso," *Sophia*], 1914, No. 3, p. 62.

4 M. Matiushin, "Tvorchestvo Pavla Filonova," in *Yezhegodnik Rukopisnogo otdela Pushkinskogo doma na 1977 god* ["The Work of Pavel Filonov," in *Yearbook of the Manuscript Department of the Pushkin House for 1977*], Leningrad, 1979, pp. 233–234.

5 Mikhail Le Dantu. Letter to Olga Liashkova, 1917. Manuscript Dept., Russian Museum, fund 135, No. 3, f. 2.

6 N. Punin, *Tatlin (protiv kubizma)* [Tatlin (*Against Cubism*)], Petrograd, 1921, p. 7.

7 A. Gleizes, J. Metzinger, *O kubizme* [*On Cubism*], St. Petersburg, 1913, p. 14.

8 Kasimir Malevich. Letter to Mikhail Matiushin, June 1916, published in *Yezhegodnik Rukopisnogo otdela Pushkinskogo doma na 1974 god* [*Yearbook of the Manuscript Department of the Pushkin House for 1974*], Leningrad, 1975, p. 192.

9 K. Malevich, *Bog ne skinut. Iskusstvo, tserkov', fabrika* [*God is Not Cast Down. Art, the Church, the Factory*], Vitebsk, 1922, p. 7.

10 This is the subheading of K. Malevich's pamphlet *Ot kubizma k suprematizmu* [*From Cubism to Suprematism*], Petrograd, 1915.

11 V. Shklovsky, "Prostranstvo v iskusstve i suprema-tisty," *Zhizh' iskusstva* ["Space in Art and the Suprematists," *The Life of Art*], 1919, No. 196–197.

12 *Izobrazitel'noye iskusstvo* [*Fine Art*], 1919, No. 1, p. 28.

13 *Mayakovskomu* [*To Mayakovsky*], Leningrad, 1940, p. 90.

14 V. Shklovsky, "Sluchay na proizvodstve," *Stroika* ["An Incident in Production," *Building*], 1931, No. 11.

15 A. Smirnov, "Retsenziya," *Tvorchestvo* ["Review," *Creativity*], Kharkov, 1919, No. 4, p. 24.

16 N. Punun, "V Moskve (pis'mo)," *Iskusstvo kommuny* ["In Moscow (A Letter)," *The Art of the Commune*], 1919, February 9.

17 "Reliefs of a higher type" are three-dimensional non-objective constructions made of various materials.

18 V. Tatlin, "Otvechayu na 'Pis'mo k futuristam,'" *Anarkhiya* ["I Answer the' Letter to the Futurists,'" *Anarchy*], 1918, March 29.

19 N. Punin, *Iskusstvo i revolyutsiya* [*Art and the Revolution*]. Unpublished memoirs. 1930s. Punin family archive, St. Petersburg.

20 Wassily Kandinsky. Letter to Nikolai Kulbin, March 28, 1912, published in *Pamyatniki kul'tury. Noviye otkrytiya* [*Cultural Monuments: New Discoveries*], Leningrad, 1981, p. 408.

21 *Ibid.*, p. 401.

22 *Kandinsky. Tekst khudozhnika* [*Kandinsky. Text by the Artist*], Moscow, 1918, p. 28.

23 Nikolai Fiodorovich Fiodorov (1828 –1903), Librarian of the Rumiantsev Museum in Moscow, a philosopher whose original conception was highly esteemed by Leo Tolstoy, Fiodor Dostoyevsky, and Vladimir Solovyov. It was only after Fiodorov's death that his works were published by his followers under the title *Filosofiya obshchego dela* [*The Philosophy of the Common Cause*], vol. 1, Verny, 1906; vol. 2, Moscow, 1913.

24 N. Fiodorov, *Filosofiya obshchego dela* [*The Philosophy of the Common Cause*], vol. 1, Verny, 1906, p. 293.

25 *Op. cit.*, vol. 2, p. 350.

26 *Op. cit.*, vol. 1, p. 293.

27 *Op. cit.*, vol. 2, p. 254.

28 *Op. cit.*, vol. 2, p. 350.

29 *Iskusstvo kommuny* [*The Art of the Commune*], 1918, No. 3.

30 A. Efros, *Profili* [*Profiles*], Moscow, 1930, p. 201.

31 L. Yudin, *Dnevnik* [*Diary*]. November 12, 1922. Yudin family archive, St. Petersburg.

32 "Working Plan of the UNOVIS Council," *UNOVIS Almanac*, No. 1, Vitebsk, 1920. Manuscript Dept., Tretyakov Gallery, Moscow, fund 76, No. 9.

33 S. Dymshits-Tolstaya, *Vospominaniya* [*Memoirs*]. Manuscript Dept., Russian Museum, St. Petersburg, fund 100, No. 249, f. 67.

34 Minutes of UNOVIS meetings. Manuscript Dept., Russian Museum, St. Petersburg, fund 55, f. 7.

35 *Ibid.*, ff. 7, 8.

36 "Russkaya vystavka v Berline. Iz besedy s D. P. Shterenbergom," *Zrelishcha* ["Russian Exhibition in Berlin. From a Conversation with D. P. Shterenberg," *Spectacle*], 1923, No. 19.

37 *Zhizn' iskusstva* [*The Life of Art*], 1922, No. 1.

38 Kasimir Malevich lists the most important exhibitions of Russian Futurists.

39 "The Coming Lout" was the name of an article by Dmitry Merezhkovsky (1862–1941).

40 At that time the Institute of Artistic Culture was being set up on the basis of the Museum of Artistic Culture.

41 Pavel Mansurov. Letter to Yevgeny Kovtun, November 4, 1970. Ye. Kovtun collection, St. Petersburg.

42 Cited in V. Tatlin, Moscow, 1977, p. 7.

43 V. Khlebnikov, *Niezdannieye proizvedeniya* [*Unpublished Works*], Moscow, 1940, p. 170.

44 V. Khlebnikov, *Zangezi*, Moscow, 1920, pp. 6, 7.

45 V. Tatlin, "O Zangezi," *Zhizn' iskusstva* ["On Zangezi," *The Life of Art*], 1923, No. 18, p. 15.

46 N. Punin, "Zangezi," *Zhizn' iskusstva* [*The Life of Art*], 1923, No. 20, p. 12.

47 Pavel Mansurov. Letter to Yevgeny Kovtun, August 3, 1970. Ye. Kovtun collection, St. Petersburg.

48 Kasimir Malevich. Letter to Alexander Benois, May 1916, Manuscript Dept., Russian Museum, St. Petersburg, fund 137. No. 1.186, f. 1.

49 K. Malevich, *Suprematism. 34 risunka* [*Suprematism. 34 Drawings*], Vitebsk, 1920, p. 4.

50 K. Malevich, *Vvedeniye v teoriyu pribavochnogo ele-menta v zhivopisi* [*Introduction to the Theory of the Surplus Element in Painting*], 1925. Proofs of an unpublished article. Ye Kovtun collection, St. Petersburg.

51 M. Matiushin, *Tvorcheskiy put' khudozhnika* [*The Creative Path of an Artist*], 1934, Manuscript Dept., Institute of Russian Literature, St. Petersburg, fund 656.

52 Ye. Guro, *Bednyi rytsar'* [*The Poor Knight*], 1913. Manuscript Dept., Russian National Library, St. Petersburg, fund 1116, No. 3, f. 48.

53 *Ibid.*, f. 72.

54 The title of a work by Yelena Guro.

55 Ye. Guro, *Dnevnik* [*Diary*]. Entry for June 5, 1911. Manuscript Dept., Russian National Library, St. Petersburg, fund 1116.

56 Yelena Guro suffered from leukemia, which she died from in the spring of 1913 in the Finnish village of Uusikirkko.

57 M. Matiushin, *Dnevniki* [*Diaries*]. Notebook No. 2. Entry for April 16, 1923. Manuscript Dept., Institute of Russian Literature, St. Petersburg, fund 656.

58 *Ibid.*

59 *Ibid*

60 M. Matiushin, *Tvorcheskiy put' khudozhnika* [*The Creative Path of an Artist*], 1934, Manuscript Dept., Institute of Russian Literature, St. Petersburg, fund 656.

61 M. Matiushin, *Dnevniki* [*Diaries*]. Notebook No. 2. Entry for April 14, 1923. Manuscript Dept., Institute of Russian Literature, St. Petersburg, fund 656.

62 *Ibid*

63 K. Malevich, "Khudozhniki ob AKhRR," *Zhizn' iskusstva* ["Artists on the Association of Artists of Revolutionary Russia," *The Life of Art*], 1924, No. 6.

64 *Leningradskaya Pravda* [*Leningrad Truth*], June 10, 1926.

65 K. Malevich, *O teoriyi pribavochnogo elementa v zhivopisi* [*On the Theory of the Surplus Element in Painting*], Paper given at a general meeting of the staff of GINKhUK. June 16, 1926. Central State Archive, St. Petersburg, fund 2555, No. 1018, f. 160.

66 P. Filonov, *Dnevnik* [*Diary*]. Entry for November 4, 1932, Manuscript Dept., Russian Museum, St. Petersburg, fund 156, No. 30. f. 51.

67 Mansurov hung his manifestos on the walls of the room where his works were displayed at the last exhibition of GINKhUK in the summer of 1926.

68 L. Yudin, *Dnevnik* [*Diary*]. Yudin family archive, St. Petersburg.

69 *Obshchestvo imeni Leonardo da Vinci. Katalog vystavki molodykh khudozhnikov* [*Leonardo da Vinci Society. Catalog of the Exhibition of Young Artists*], Moscow, 1906, p. 7.

70 K. Malevich, *Bog ne skinut... [God Is Not Cast Down...*], p. 2.

71 *Ibid.*, p. 4.

72 Manuscript Dept., Russian Museum, St. Petersburg, fund 105, No. 15, f. 28.

73 K. Petrov-Vodkin, *Khlynovsk. Prostranstvo Evklida. Samarkandia* [*Khlynovsk. Euclidian Space. Samarkandia*], Leningrad, 1970, p. 581.

74 Short-hand report of a meeting in commemoration of Piotr Sokolov, June 13, 1971. Archive of the St. Petersburg Branch of the Russian Federation Union of Artists.

75 P. Filonov, *Dnevnik* [*Diary*]. Entry for August 30, 1935. Manuscript Dept., Russian Museum, St. Petersburg, fund 156, No. 31, ff. 88 and 88v.

76 P. Filonov, *Vystavka Filonova v Russkom Muzeye vsio eshcho ne otkryta* [*The Filonov Exhibition at the Russian Museum Still Hasn't Opened*], 1931. Central State Archives

of Literature and Art, Moscow, fund 2348, part 1, No. 23, ff. 1–5.

77 P. Filonov, *Dnevnik* [*Diary*]. Entry for May 30, 1936. Manuscript Dept., Russian Museum, St. Petersburg, fund 656, No. 31, ff. 39 and 39v.

78 Filonov was among the founding members of the Union of Youth (1910–14) and was a regular participant in its exhibitions.

79 The article survives in Mikhail Matiushin's version.

80 P. Filonov, "Kanon i zakon" ["Canon and Law"].

81 Pavel Filonov. Letter to Vera Sholpo, June 1928. Published in *Yezhegodnik Rukopisnogo otdela Pushkinskogo doma na 1977 g.* [*Yearbook of the Manuscript Department of the Pushkin House for 1977*], Leningrad, 1979, p. 231.

82 P. Filonov, "Ideologiya analiticheskogo iskusstva," in *Filonov. Katalog vystavky* ["The Ideology of Analytical Art," in *Filonov: Exhibition Catalog*], the Russian Museum, Leningrad, 1930, p. 42.

83 The Itinerants was the name applied to members of the Society for Itinerant Exhibitions (1870–1923), an association of realist artists.

84 Filonov is referring to the Stoglavyi Sobor (1551), an assembly of clergymen who made a number of fundamental decisions including the enacting of a strict code of rules regulating the creative work of icon painters.

85 P. Filonov, "Deklaratsiya mirovogo rastsveta," *Zhizn' iskusstva* ["The Declaration of Universal Flowering," *The Life of Art*], 1923, No. 20, p. 13.

86 Pavel Filonov. Letter to Vera Sholpo, June 1928. *Op. cit.*, p. 229.

87 P. Filonov, *Deklaratsiya mirovogo rastsveta* [*The Declaration of Universal Flowering*], p. 13.

88 The portrait of the artist Andrei Andreyev by Iosif Gurvich was reproduced in Filonov's declaration in the magazine *Zhizn' iskusstva* [*The Life of Art*] (1923, No. 20).

89 Jack of Diamonds was an association of Moscow painters, founded in 1911 by Piotr Konchalovsky, Aristarkh Lentulov, Ilya Mashkov, Robert Falk, etc.

90 Donkey's Tail was an artistic association set up in Moscow in 1912 by Mikhail Larionov; its members included Natalia Goncharova, Kasimir Malevich, Mikhail Le Dantu, and Alexander Shevchenko.

91 Rayonism was a non-figurative trend in painting, launched by Mikhail Larionov in 1912.

92 V. Khlebnikov, *Tvoreniya* [*Creative Works*], Moscow, 1986, p. 618.

93 V. Khlebnikov, *Poemy. dramy, proza* [*Poems. Drama. Prose*], Moscow, 1986, pp. 324–325.

94 V. Shklovsky, "Svobodnaya vystavka vo Dvortse iskusstv," *Zhizn' iskusstva* ["Free Exhibition at the Palace of the Arts," *The Life of Art*], 1919, No. 149–150.

95 T. Glebova, "Vospominaniya o P. N. Filonove," *Panorama iskusstv 11* ["Reminiscences of P. N. Filonov", *Panorama of the Arts 11*], Moscow, 1967.

96 I. Brodsky, "Pis'mo v redaktsiyu," *Krasnaya gazeta* ["Letter to the Editors," *Red Paper*] (Evening edition), November 25, 1930.

97 T. Glebova, *Op. cit.*

98 *Ibid.*

99 "Nash prolog" ["Our Prolog"], Makovets, 1922, No. 1, p. 4.

100 Cited in *Sovetskoye iskusstvoznaniye '79* [*Soviet Art Research '79*], No. 2, Moscow, 1980, p. 380.

101 N. Fiodorov, *Filosofiya obshchego dela* [*The Philosophy of the Common Cause*], vol. 1, Verny, 1906, p. 93.

102 Nikolai Mikhailovich Kirillov, a painter.

103 N. Fiodorov, *Op. cit.*, vol. 2, Moscow, 1913, p. 153.

104 L. Yudin, *Dnevnik* [*Diary*]. Entry for June 28, 1929. Yudin family archive, St. Petersburg.

105 K. Malevich, *Ot Cézanna do suprematizma* [*Form Cézanne to Suprematism*], Moscow, 1920, p. 8.

106 *Literaturnyi sovremennik* [*The Literary Contemporary*], 1933. No. 12, p. 204.

107 The apartment at 10 Pesochnaya Street where Mikhail Matiushin's pupils lived — the Ender brothers and sisters.

108 Vera Yermolayeva walked on crutches as a result of increasing paralysis of her legs after a fall from a horse in childhood.

109 Evening in commemoration of Vera Yermolayeva. May 18, 1972. Shorthand notes. Archive of the St. Petersburg Branch of the Russian Federation Union of Artists.

110 Sergei Romanovich and Piotr Bromirsky. 1950s. Romanovich family archive, Moscow

111 N. Punin, "Iskusstvo primitiva i sovremennyi risunok," in *Iskusstvo narodnostei Sibiri* ["The Art of the Primitive and the Contemporary Drawing," in *Art of the Peoples of Siberia*], Leningrad, 1930, p. 20.

112 M. Matiushin, *Dnevniki* [*Diaries*]. Notebook No. 2. Entry for April 14, 1923. Manuscript Dept., Institute of Russian Literature, St. Petersburg, fund 656.

APPENDIX

Association of Artists of Revolutionary Russia (AKhRR), in 1921 renamed the Association of Artists of the Revolution (AKhR) (1922–32), Moscow and Leningrad. More than 30 branches in other cities.

The Association brought together artists who set art the task of continuing the democratic traditions of the Itinerants (Wanderers).

The declaration of AKhRR states: "It is our civic duty before humanity to capture, through artistic and documentary means, this supreme moment in history, capturing its revolutionary gusto. We shall portray today's events: the life of the Red Army, the life of workers, the peasantry, revolutionary activists, and the heroes of labor" (*Bor'ba za realizm v izobrazitel'nom iskusstve 1920-kh godov. Materialy, dokumenty, vospominaniya* [*The Struggle for Realism in the Fine Arts of the 1920s. Materials, Documents, Reminiscences*], Moscow, 1962, p. 120).

The first chairman of AKhRR was Pavel Radimov, who was also the last chairman of the Itinerants. In 1924, a publishing section was organized under the directorship of Victor Perelman and the "Production Office" (director Alexei Volter); in 1925, an information bureau and the central office of AKhRR were set up. The members of the association included: Nikolai Andreyev (sculptor), Abram Arkhipov, Mikhail Avilov, Vasily Baksheyev, Witold Bialynitsky-Birulia, Fiodor Bogorodsky, Isaac Brodsky, Yefim Cheptsov, Vladimir Domogatsky (sculptor), Nikolai Dormidontov, Ivan Drozdov, Alexander Gerasimov, Ilya Ginzburg (sculptor), Mitrofan Grekov, Alexander Grigoryev, Vladimir Grinberg, Boris Ioganson, Nikolai Ionin, Nikolai Kasatkin, Yevgeny Katsman, Piotr Kotov, Boris Kustodiev, Sergei Luppov, Sergei Maliutin, Matvei Manizer (sculptor), Sergei Merkurov (sculptor), Vasily N. Meshkov, Vasily V. Meshkov, Fiodor Modorov, Semion Pavlov, Victor Perelman, Pavel Radimov, Serafima Riangina, Georgy Riazhsky, Arkady Rylov, Georgy Savitsky, Ivan Shadr (sculptor), Piotr Shukhmin, Piotr Sokolov-Skalia, Vasily Svarog, Nikolai Terpsikhorov, Ivan Vladimirov, Boris Yakovlev, Vasily Yakovlev, Konstantin Yuon, etc. The membership varied between eighty and three hundred members and exhibitors.

The first exhibition was held in 1922 ("I vystavka AKhRR v pol'zu golodayushchikh Povolzhya" ["The 1st Exhibition of AKhRR for the Benefit of the Starving People of the Volga Region"]).

Circle of Artists (1925–32). Leningrad

"The Circle arose as a consequence of the fact that not one of the existing artistic associations, in terms of its social, artistic, and ideological purposes, satisfied many of the young artists who had matured politically and professionally in the atmosphere of the revolutionary years and strove to express their new understanding of life and their new feeling in painted plastic images that were appropriate to the epoch" ("Pervaya deklaratsiya obshchestva," in *Sovetskoye iskusstvo za 15 let* ["The First Declaration of the Society," in *Fifteen Years of Soviet Art*], Moscow–Leningrad, 1933, p. 322). The original membership of the society was comprised principally of the graduates of VKhUTEIN for 1925 and the pupils of Alexei Karev, Alexander Savinov, Kuzma Petrov-Vodkin, and Alexander Matveyev. The chairman was Viacheslav Pakulin and the members included Lev Britanishsky, Sergei Chugunov, Vladimir Denisov, Maria Fedoricheva, Tatyana Gernet, Boris Kapliansky (sculptor), Vasily Kuptsov, Vladimir Malagis, Abram Malakhin (sculptor), Leonid Mess (sculptor), Naum Mogilevsky (sculptor), Piotr Osolodkov, Alexei Pakhomov, Viacheslav Pakulin, Alexei Pochtenny, Alexander Rusakov, Alexander Samokhvalov, Mikhail Sutskever (sculptor), Nikolai Svinenko, Georgy Traugot, Alexander Vedernikov, Mikhail Verbov, Lev Volstein, David Zagoskin, Alexander Zaitsev, etc., a total of over forty. In 1929 many of the artists switched from the Circle to AKhR and October (organized in 1930).

The first exhibition was held in 1927 in the Russian Museum in Leningrad.

The Four Arts (1925–32). Leningrad and Moscow

An association of painters, graphic artists, sculptors, and architects who espoused different creative views and ranged from former participants of the Blue Rose and World of Art movements to Kasimir Malevich, Ivan Kliun, and El Lissitzky.

"It was necessary to integrate the plastic arts in to life, to enable them to make a useful contribution to the overall building up process, uplifting and ennobling man, communicating to him the joy of an aesthetic perception of his surroundings. To carry out this task, we felt that what was needed was a complex of all four plastic arts: painting, sculpture, graphic art, and architecture" (Ye. Bebutova, P. Kuznetsov, "Obshchestvo khydozhnikov 4 iskusstva'" in *Bor'ba za realizm v izobrazitel'nom iskusstve 1920-kh godov. Materialy, dokumenty, vospominaniya* ["The Four Arts Society of Artists," in *The Struggle for Realism in the Fine Arts of the 1920s. Materials, Documents, Reminiscences*], Moscow, 1962, p. 233).

The chairman of the society was Pavel Kuznetsov.

The members included: Meyer Axelrod, Yelena Bebutova, Vladimir Bekhteyev, Lev Bruni, Iosif Chaikov (sculptor), Vladimir Favorsky, Anna Glagoleva, Lado Gudiashvili, Konstantin Istomin (secretary of the society), Alexei Karev, Ivan Kliun, Alexei Kravchenko, Pavel Kuznetsov, Piotr Lvov, Alexander Matveyev (sculptor), Piotr Neradovsky, Ignaty Nivinsky, Kuzma Petrov-Vodkin, Martiros Saryan, Vladimir Shchuko (architect), Alexei Shchusev (architect), Nina Simonovich-Yefimova, Nikolai Ulyanov, Piotr Utkin, etc. During the entire period of its activity, the society comprised more than seventy members. The first exhibition was held in 1925 at the State Museum of Fine Arts in Moscow.

Makovets (1921–25). Moscow

The group was originally known as the Union of Artists and Poets "Art Is Life." The creative work of the members was marked by a striving to lend meaning to the new reality through romantic pictorial forms.

The association was formed around the magazine *Makovets* published by the Union of Artists and Poets "Art Is Life" (organized in 1920). The contributors to the magazine (two issues were published in 1922) were Pavel Antokolsky, Nikolai Aseyev, Konstantin Bolshakov, Pavel Florensky, Velimir Khlebnikov, Anfian Reshetov, Boris Pasternak, and others.

The members of the association were: Victor Bart, Vasily Chekrygin, Nikolai Chernyshov, Arthur Fonvizin, Sergei Gerasimov, Konstantin Istomin, Vera Pestel, Mikhail Rodionov, Sergei Romanovich, Vadim Ryndin, Nikolai Sinezubov, Alexander Shevchenko, Anton Yastrzhemsky, Lev Zhegin, etc. Works by

Piotr Bromirsky, who died in 1920, were also displayed at the Makovets exhibition. During its existence, Makovets united twenty artists within its ranks. In 1927, some of its members organized the society Way of Painting, and others went over to the societies The Four Arts and the Society of Moscow Artists. The first exhibition was held in 1922 at the Museum of Fine Arts in Moscow (*Vystavka kartin Soyuza Khudozhnikov i poetov "Iskusstvo — zhizn'"* [*Exhibition of the Paintings of the Union of Artists and Poets "Art Is Life"*], Catalog, Moscow, 1922).

The Masters of Analytical Art (MAI) (1925–32). Leningrad

The union of Pavel Filonov's pupils. It formed in 1925 and existed officially until 1925, but Filonov continued to give lessons in his studio until his death in 1941. About 70 artists were members of the MAI in different years. The core of the society was made up of Tatyana Glebova, Boris Gurvich, Yury Khrzhanovsky, Yevgeny Kibrik, Pavel Kondratyev, Rebecca Leviton, Alevtina Mordvinova, Alisa Poret, Andrei Sashin, Vsevolod Sulimo-Samuillo, Innokenty Suvorov, Mikhail Tsybasov, Nikolai Yevgrafov, and Sophia Zaklikovskaya.

Filonov elucidated the main principles of analytical art, the methods of working and teaching, in a letter to Vera Sholpo and in his manuscript *The Ideology of Analytical Art and the Principle of Madeness* (published in *Yezhegodnik rukopisnogo otdela Pushkinskogo doma na 1977 g.* [*The Annual of the Manuscript Department of the Pushkin House for 1977*], Leningrad, 1979.

In "A Short Explanation of Our Exhibition of Works" written for one of the MAI exhibitions, Filonov declared:

"The masters of analytical art perceive any phenomenon in the world in terms of its inner significance, striving as far as it is possible to the maximum mastery, utmost study, and cognition of the object, not being satisfied with painting an object's 'façade,' its 'countenance,' without its sides and back, hollow inside as has been done in fine art up to now since in art the accepted time-hallowed thing is to be absorbed with the color and form of the surface of an object without penetrating inside, as any researcher in any science does. It is not only the face of a watch, but its mechanism

and motion that matters. The inner data of any object define its facial, outward significance with its form and color."

The group's exhibition took place in 1927 in the Press House in Leningrad. At the same time Nikolai Gogol's play *Inspector General* was staged there with set designs by members of the MAI.

Monolith (1918–22). Moscow

A group of sculptors (attached to the Fine Arts Department of Narkompros) which was formed to organize a competition for the monument celebrating "Labor Liberated." The founding member and chairman of the group was Boris Koroliov. The members of the group were: Alexei Babichev, A. Blazhiyevich, Sergei Konionkov, Boris Koroliov, Nadezhda Krandiyevskaya, Alexander Kudinov, Vera Mukhina, Vera Popova, Maria Strakhovskaya, Boris Ternovets, and Alexander Zlatovratsky. The exhibitions of the designs of the monument *To Labor Liberated* submitted for the competition was held in 1920 in Moscow.

Moscow Painters (1924–26). Moscow

"... Considering its struggle in the past for a new culture in art, its professional experience and the full seriousness and responsibility of the problems brought forth by the Revolution within the domain of the fine arts, the Jack of Diamonds group has united and will continue to unite around itself all kindred forces and has organized a society of painters and sculptors, Moscow Painters. This new society sets as its task a true synthesis of contemporary content and contemporary realistic form and considers that it is only in this direction that art can move forward and not backward" (*Bor'ba za realism v izobrazitel'nom iskusstve 1920-kh godov. Materialy, dokumenty, vospominaniya* [*The Struggle for Realism in the Fine Arts of the 1920s. Materials, Documents, Reminiscencies*], Moscow, 1962).

The members of the group were: Mikhail Avetov, Ivan Chekmazov, Alexander Drevin, Robert Falk, Vera Favorskaya, German Fiodorov, Igor Grabar, Piotr Konchalovsky, Boris Koroliov (sculptor), Alexander Kuprin, Aristarkh Lentulov, Ilya Mashkov, Alexander Osmiorkin, Vasily Rozhdestvensky, Nadezhda Udaltsova, etc., a total of forty artists.

In 1926 the group was completely merged with AKhRR. In 1927 the majority of the artists of the Moscow Painters association left AKhRR and founded the Society of Moscow Artists. The first exhibition was held in 1925 in Moscow (see *Moskovskiye zhivopistsy. Katalog vystavki* [*Moscow Painters. Exhibition Catalog*], Moscow, 1925).

New Society of Painters (1921–24). Moscow

"Our group grew up organically. It was not a theory or a manifesto that united us, but a community of feeling. Although we share common feelings, we proceed along our own thoroughly individual paths. Each of us has his own penchant, his own style. This is why we are not trend setters and not a school." ("Programma-platforma 'Nash put','" in *Sovetskoye iskusstvo za 15 let* ["The Program 'Our War,'" in *Fifteen Years of Soviet Art*], Moscow–Leningrad, 1933, p. 312).

In creative terms, the works of members of the New Society of Painters were often of a satirical and grotesque cast and were stylistically based on the popular *lubok* prints and the painting of the French primitivist Henri Rousseau. The themes tended toward an exposure of philistinism and the everyday reality of the New Economic Policy period. The members of the society were: Samuil Adlivankin, Alexander Gluskin, Amshei Niurenberg, Mikhail Perutsky, Nikolai Popov, Georgy Riazhsky, etc. In 1924 the majority of the artists went over to the Existence society. One exhibition was held in 1922 in Moscow.

October (with the Young October society attached to it) 1930–32. Moscow–Leningrad

The society took shape in the late 1920s. In 1930 it comprised more than 100 members including painters, sculptors, industrial artists, and art historians.

Art critics noted the predominance of a propagandistic trend in the work of October artists and the group's affinity with the program of the LEF (Left Front) union. The October artists played a very prominent role in the development of Soviet poster, art in industrial design and architecture.

The society's declaration was published in 1929, and later a revised version appeared.

The society included a national section (program published 1929) and a photographic section (program published 1930). In 1931 some of its members joined the Russian Association of Proletarian Artists. The founding members of the society were Alexander Deineka, Sergei Eisenstein, Alexei Gan, Moisei Ginzburg, Paul Irbit, Gustav Klutsis, Alfred Kurella, Ivan Matsa, Dmitry Moor, Pavel Novitsky, Diego Rivera, Sergei Senkin, Solomon Telingater, Alexander Vesnin, Victor Vesnin, Béla Uitz, Vasily Yolkin, etc. Other members and participants in its exhibitions included Semion Chuikov, Valentina Kulagina, El Lissitzky, Leonid Mess (sculptor), Alexei Pakhomov, Alexander Rodchenko, Alexander Samokhvalov, and Varvara Stepanova. The first exhibition was held in Moscow in 1930.

Society of Easel Painters (OST, 1925–32). Moscow

The society was founded by a group of graduates of VKhUTEMAS under the direction of David Shterenberg. The members of the group upheld the value of forms of art realized on the easel, but considered that it was necessary to develop a new representational language that would be characterized by the simplicity, dynamic composition, and the clarity of drawing. The main themes were industrialization, sport, and urban life. The society played an important role in developing easel and monumental painting, book illustration and design, the poster, and the art of stage design.

The platform of the society was based on the premise that "in the epoch of building socialism, the active forces of art should be participants in the building process and one of the factors in the cultural revolution in the reorganization and design of a new everyday environment along with the creation of a new socialist culture" ("Platforma OST," in Bor'ba za realizm v izobrazitel'nom iskusstve 1920-kh godov. Materialy, dokumenty, vospominaniya ["Platform of the Society of Easel Painters," in The Struggle for Realism in the Fine Arts of the 1920s. Materials, Documents, Reminiscences], Moscow, 1962, p. 211).

The chairman was David Shterenberg. The member included Georgy Berendhoff, Alexander Deineka, Nikolai Denisovsky, Victor Ellonen, Andrei Goncharov, Ivan Kliun, Alexander Kozlov, Nikolai

Kupreyanov, Alexander Labas, Sergei Luchishkin, Yelena Melnikova, Yury Merkulov, Yury Pimenov, Alexander Tyshler, Piotr Vilyams, etc., over thirty members in all. In 1931, a schism took place in the society and half of its membership left to set up Izobrigada, with others going over to October (created in 1930). The first exhibition was held in 1925 in Moscow (Katalog pervoi vystavki. Obshchestvo stankovistov [Catalog of the First Exhibition: Society of Easel Painters], Moscow, 1925).

Society of Moscow Artists (1927–32). Moscow

The society mainly included former members of the Jack of Diamonds and the participants of the associations Moscow Painters, Existence, and Makovets. On a creative level, the society continued the principles of Cézannism in painting and gave preference to landscape and still life. In the declaration of the Society of Moscow Painters we find the statement: "Painting is not contemplation, not a static 'repetition' of everyday life, not a passively naturalistic reflection of reality, and not a means of only knowing that reality; rather, it is a powerful tool for exercising a creative influence on the world, a tool for the active reconstruction of life" (Bor'ba za realizm v izobrazitel'nom iskusstve 1920-kh godov. Materialy, dokumenty, vospominaniya [The Struggle for Realism in the Fine Arts of the 1920s. Materials, Documents, Reminiscences], Moscow, 1962, p. 224). The chairman of the Society of Moscow Artists was Aristarkh Lentulov.

The members of the society were: Nikolai Chernyshov, Alexander Drevin, Robert Falk, German Fiodorov, Arthur Fonvizin, Sergei Gerasimov, Igor Grabar, Nikolai Grigoryev, Boris Koroliov (sculptor), Nikolai Krymov, Alexander Kuprin, Aristarkh Lentulov, Ilya Mashkov, Alexander Osmiorkin, Vasily Rozhdestvensky, Georgy Rubliov, Nadezhda Udaltsova, Konstantin Zefirov, etc., a total of seventy full and candidate members. The first exhibition was held in 1928 in Moscow.

Society of Russian Sculptors (1925–32). Moscow

The society brought together sculptors representing different trends who had previously belonged to the Moscow Professional Union of Sculptors.

"... The first and main objective which stood before the basic group or the Society of Russian Sculptors was to reinforce the independent position of sculpture among all the fine arts. To accomplish this, it was necessary, first, to unite all those who engaged in sculpture as an art and who set themselves serious artistic tasks, separating them from the mass of hack artists who appeared thanks to the increased demand from the government for monumental decorations serving propagandistic aims. Secondly, it was necessary to undertake the organization of independent sculpture exhibitions, which would present the wide masses all the creative accomplishments of contemporary sculptors no matter what their persuasion" ("Otchiot o deyatel'nosti ORSa za 1926–27 gg.," in Sovetskoye iskusstvo za 15 let ["Report on the Activities of the Society of Russian Sculptors for 1926–27," in Fifteen Years of Soviet Art], Moscow–Leningrad, 1933, p. 327).

Isidor Frikh-Khar, Ivan Rakhmanov, Marina Ryndziunskaya, and Alexander Zlatovratsky comprised the core of the society. The member and exhibitors were: Nathan Altman, Nikolai Andreyev, Viacheslav Andreyev, Iosif Chaikov, Vladimir Domogatsky, Victor Ellonen, Stepan Erzia, Anna Golubkina, Lev Kardashev, Grigory Kepinov, Sergei Konionkov, Boris Koroliov, Nadezhda Krandiyevskaya, Yulia Kun, Sarra Lebedeva, Alexander Matveyev, Vera Mukhina, Yekaterina Muromtseva, Yekaterina Nikiforova, Nina Niss-Goldman, Yevgeny Oranovsky, Beatrisa Sandomirskaya, Ivan Shadr, Yelena Shishkina, Ilya Slonim, Maria Strakhovskaya, Dmitry Tsaplin, Vasily Vatagin, Ivan Yefimov, Sergei Yevangulov, Alexei Zelensky, etc. The first exhibition was held in 1926 in Moscow (Gosudarstvennaya vystavka sovremennoi skul'ptury. Katalog [State Exhibition of Contemporary Sculpture. Catalog]. Moscow, 1926).

Society of Young Artists (1919–22). Moscow

The society was organized by a group of students of the First Free Art Studios, principally by the pupils of Aristarkh Lentulov, Georgy Yakulov, and Alexander Rodchenko. The members produced easel painting, spatial compositions, and sculptures, as well as stencils for posters, badges, the decoration of streets and

squares, stage designs and organized travel-ing exhibitions in villages. The members of the society were: Nikolai Denisovsky, Karl Ioganson, Vasily Komardenkov, Aristarkh Lentulov, Konstantin Medunetsky, Nikolai Prusakov, Alexander Rodchenko, Georgy Stenberg, Vladimir Stenberg, Sergei Svetlov, Georgy Yakulov, Alexander Zamoshkin, etc., a total about twenty members.
The first exhibition was held in 1919 in Moscow.

Thirteen (1929–31). Moscow

The title of the group reflects the number of participants in its first exhibition.
The group united mainly graphic artists dealing with questions of imagery and style in the field of drawing. They sought to implement their own principles of life draw-ing, to convey "the tempo of the creation of a drawing, reflecting the pulsation of life itself, its rhythm."
The leading role in the development of the group's program and in the organization of its exhibitions was played by two artists, Nikolai Kuzmin and Vladimir Milashevsky. The first exhibition took place in 1929.
The participants in the first exhibition were: Daniil Daran, Olga Gildebrandt, Nadezhda Kashina, Nina Kashina, Nikolai Kuzmin, Tatyana Lebedeva (Mavrina), Vladimir Milashevsky, Mikhail Nedbailo, Sergei Rastorguyev, Boris Rybchenkov, Yury Yurkun, Valentin Yustitsky, and Lev Zevin.

The Union of Youth (1910–14). St. Petersburg/Petrograd

The society brought together artists (Cézannists, Cubists, Futurists, and Non-Objectivists) and writers. Members of the Jack of Diamonds and Donkey's Tail parti-cipated in their exhibitions. In the creative work of the artists affiliated with the Union of Youth, a great deal of attention was paid to developing the formal principles of painting. "Only contemporary art has fully brought forth the serious import of such principles as dynamism, three-dimensional visual impact, and balance in painting and the principles of heaviness and weightless-ness, linear and planar displacement, and rhythm in the sense that they are a regular division of space, planning, planar and sur-face dimensions, texture, the relationship of colors, and many other things" (O. Rozanova, "Osnovy Novogo

Tvorchestva i prichiny yego neponimaniya," *Soyuz molodiozhi* ["The Basic Principles of the New Creativity and the Causes of Its Not Being Understood," *The Union of Youth*], book 3, St. Petersburg, 1913, p. 20).
In 1913, the Union of Youth was expanded to include a literary section known as Hylaea, among whose members were David Burliuk, Nikolai Burliuk, Yelena Guro, Vasily Kamensky, Velimir Khlebnikov, Alexei Kruchonykh, and Vladimir Mayakovsky. The society published the magazine *Soyuz Molodiozhi* [*The Union of Youth*] and staged the opera *Victory over the Sun* (music by Mikhail Matiushin, libret-to by Alexei Kruchonykh, prolog by Velimir Khlebnikov, set desigh by Kasimir Malevich) and the tragedy *Vladimir Mayakovsky* (stage design by Pavel Filonov and Iosif Shkolnik).
The chairman of the society was Levky Zheverzheyev.
The members of the society were Yury Annenkov, Varvara Bubnova, David Burliuk, Vladimir Burliuk, Marc Chagall, Pavel Filonov, Ivan Kliun, Nadezhda Lermontova, Kasimir Malevich, Mikhail Matiushin, Vladimir Matvei, Alexei Morgunov, Ivan Puni, Olga Rozanova, Eduard Spandikov, Vladimir Tatlin, etc.
The first exhibition was held in St. Petersburg in 1910.

The Way of Painting (1926–30). Moscow

Organized by some participants of Makovets, which had fallen apart, the new society preserved the fundamental artistic principles of Makovets. Its pictoral solu-tions tended toward an intimate idiom and lyricism; its favorite genres were portrait, landscape, and interiors. "We are searching for an art that is realistic both in form and subject. In the balance between form and content or even in the complete inse-parability of these concepts we see the way to the realization of such an art" ("Programma gruppy," *Tvorchestvo* ["Program of the Group," *Creativity*], 1975, No. 6, p. 16).
The group's organizer was Lev Zhegin.
The members of the group were Tatyana Alexandrova, P. P. Babichev, Vsevolod Dmitriyev, S. S. Grib, Vasily Gubin, V. A. Koroteyev, G. V. Kostiukhin, Ivan Nikolayevtsev, Vera Pestel, G. V. Sashenkov, and Lev Zhegin.

The first exhibition was held in 1927 in Moscow (*Katalog pervoi vystavky kartin i risunkov "Put' zhivopisi"* [*Catalog of the First Exhibition of Paintings and Drawings "The Way of Painting"*], Moscow, 1927).

World of Art (1898–1904, 1910–24). St. Petersburg and Moscow

The society was formed on the basis of a club of young students who were artists and art lovers under the direction of Alexander Benois and Sergei Diaghilev.
The members studied and assimilated the art of the 18th and 19th centuries, Rococo, and the Russian "Empire" style. Stylistically, the creative work of the members of the World of Art was close to European Art Nouveau, and their idiom often recalls the poetics of Symbolism and Neo-Romanticism. The society played a major role in the development of the theater, music, architecture, and the applied arts. Of particular significance was their work in theatrical decor and graphics, both book design and illustration and independent works.
"The object of the society is to aid the development of Russian art and to make it easier for its members to sell their artis-tic productions" (*Ustav obshchestva "Mir iskusstva"* [*Regulations of the World of Art Association*], Petrograd, 1914, p. 3).
The members of the association were: Léon Bakst, Alexander Benois, Ivan Bilibin, Sergei Chekhonin, Mstislav Dobuzhinsky, Ivan Fomin (architect), Alexander Golovin, Natalia Goncharova, Piotr Konchalovsky, Yelizaveta Kruglikova, Boris Kustodiev, Pavel Kuznetsov, Yevgeny Lanceray, Ilya Mashkov, Alexander Matveyev (sculptor), Dmitry Mitrokhin, Georgy Narbut, Anna Ostroumova-Lebedeva, Kuzma Petrov-Vodkin, Nikolai Roerich, Martiros Saryan, Zinaida Serebriakova, Vladimir Shchuko (architect), Alexei Shchusev (architect), Konstantin Somov, Dmitry Stelletsky, Sergei Sudeikin, Alexander Tamanov (architect), Nikolai Ulyanov, Piotr Utkin, Alexander Yakovlev, Sergei Yaremich, etc.
The first exhibition was held in 1899 in the offices of the St. Petersburg illustrated artistic magazine *Mir iskusstva* [*World of Art*], which gave its name to the association.

Adlivankin, Samuil Yakovlevich
1897 Tatarsk (Mogiliov Province) – 1966
Moscow
Painter and graphic artist. Author of portraits, landscapes, genre pictures, and monumental decorative works. Illustrator of books and magazines. Poster designer. Cinema artist. Studied at the Odessa Art College (1912–17) under Kiriak Kostandi and in the Free State Art Studios in Moscow (1918–19) with Vladimir Tatlin. Founding member of the New Society of Painters (1921–22). Participant in exhibitions from 1916, including the New Society of Painters (from 1922). He lived and worked in Tatarsk and Odessa (1897–1917), Samara (1919–21), and Moscow (1918–19, from 1921).

Altman, Nathan Isayevich
1889 Vinnitsa – 1970 Leningrad
Painter, graphic artist, stage designer, and sculptor. Studied at the Odessa Art College (1903–07) under Kiriak Kostandi, Gennady Ladyzhensky, and Luigi Iorini. From 1910 to 1912, attended the Free Russian Academy (the M. Vasilyeva Academy) in Paris. From 1906, participant in exhibitions of the Society of Southern Russian Artists, the Union of Youth, 0.10, the World of Art, Jack of Diamonds, and other groups. From 1918 to 1920, taught at the Petrograd Free Art Studios. Took part in the realization of Lenin's Plan for Monumental Propaganda and in the festive decoration of Petrograd for the first anniversary of the October Revolution. From 1928 to 1935, lived and worked in Paris. Created designs for decorative plates produced by the Porcelain Factory in Petrograd.

Annenkov, Yury Pavlovich
1889 Petropavlovsk-on-Kamchatka – 1974 Paris
Painter and graphic artist. From 1908 to 1909 studied in St. Petersburg in Savely Zaidenberg's studio; from 1909 to 1910, in the studio school of Yan Tsionglinsky; from 1909 to 1911, studied at the Baron Stieglitz Central School of Technical Drawing in St. Petersburg; from 1911 to 1912, in Paris under Maurice Denis and Félix Vallotton. In 1913, worked in Switzerland and began to work in the theater. Participated in exhibitions from 1916 (?). Member of the World of Art (1922) and OST (1926) associations and participant in their exhibitions. Contributed to various exhibitions abroad. From 1924, lived in Germany and France.

Axelrod, Meyer [Mark] Moiseyevich
1902 Molodechno – 1969 Moscow
Painter, graphic artist, and stage designer. Served as a draftsman in the Office of Com-

munications of the Red Army on the western front in Minsk and Smolensk (1919–20). In Smolensk, attended the fine arts studio of Proletkult directed by Vladimir Shtranikh. Studied in Moscow at VKhUTEMAS–VKhUTEIN (1921–28) with Pavel Pavlinov, Vladimir Favorsky, and Sergei Gerasimov. Participated in exhibitions from 1926. Member of The Four Arts and the Society of Easel Painters. Taught at VKhUTEIN in Moscow (1928–30) and at the Moscow Textile Institute (1931–32). From 1921, lived and worked in Moscow.

Baranov-Rossiné [Baranov], Vladimir [Leib] Davidovich
(showed his works under the name Daniel Rossiné between 1907 and 1913 and from 1925)
1888 Kherson – 1942 France (in a Nazi concentration camp)
Painter, graphic artist, sculptor, and musician. Creator of portraits, landscapes, and Cubo-Futuristic and abstract compositions. Studied at the Odessa Art College (1902), at the Academy of Arts in St. Petersburg (1903–07), and a private academy in Paris (1907–10). Member of the following associations and participant in their exhibitions: Stefanos (1907–08), Moscow; the Stefanos Wreath (1909), St. Petersburg, and the World of Art (1918); he also participated in the Salon des Indépendants (1913 and from 1925), and the Salon d'Automne (1913) in Paris. Took part in the design of decorations for mass festivities (1918). His creative experiments were directed at the study of a synthesis of the different types of art. Evolved the theory of a music of colors, and constructed an "orthophonic piano," which he demonstrated in concerts at the Bolshoi Theater and Vsevolod Meyerhold's theater in Moscow (1923). In 1918, directed the workshop of the Petrograd Free Art Studios and was member of the Collegium for Art Affairs of the People's Commissariat for Education. Lived and worked in St. Petersburg/Petrograd/Leningrad (1903–07, 1914–15?, 1918–25), Paris (1907–13, from 1925), and Norway (1915–17).

Basmanov, Pavel Ivanovich
1906 village of Batalovo (Altai Territory) – 1993 St. Petersburg
Watercolorist and graphic artist. Studied in the Altai Art Workshops (1920–22) and at the Industrial Arts College in Petrograd/Leningrad (1922–27) under Mikhail Avilov and Vladimir Levitsky. Lived in Leningrad/St. Petersburg. Participant in exhibitions from 1935. From 1928 worked for publishing houses.

Bekerov, Prokopy
Born 1914
Sculptor. From 1928 to 1929 studied at the Faculty of Northern Peoples within the Yenukidze Oriental Institute in Leningrad. In November 1928, an experimental sculpture workshop (directed by Leonid Mess) was organized at the faculty, and in May 1929, an exhibition of the students of this workshop was held at the Russian Museum in Leningrad. After this date there is no further information on Bekerov's life.

Bibikov, Grigory Nikolayevich
1903 Poltava – 1976 Leningrad
Painter, graphic artist, and stage designer. Studied at the Omsk Industrial Arts College (1920–25), at VKhUTEIN–Repin Institute in Leningrad (1925–30) under Kuzma Petrov-Vodkin, Alexander Savinov, and Dmitry Kiplik. Participated in exhibitions from 1920. Lived and worked in Leningrad from 1925.

Bromirsky, Piotr Ignatyevich
1886 Ustilug (Volyn Province) – 1920 Moscow
Sculptor and graphic artist. Studied at the Vladimiro-Volynsk City School and the Moscow Institute of Painting, Sculpture, and Architecture (1906–10) under Paolo Troubetzkoy. In 1910, visited Italy. Worked in Savva Mamontov's pottery workshop at Abramtsevo. Participated in exhibitions from 1905. Took part in the realization of Lenin's Plan for Monumental Propaganda (preliminary design of a monument to Vasily Surikov, 1919).

Bruni, Lev Alexandrovich
1894 Malaya Vishera – 1948 Moscow
Painter and graphic artist. Studied in St. Petersburg in the Maria Tenisheva School (1904–08), the Higher Art School within the Academy of Arts in St. Petersburg (1909–12) under Franz Rubo, and Nikolai Samokish (1911), in the workshop of Yan Tsionglinsky, and in Paris at the Académie Julian (1912) under Jean-Paul Laurens. Participated in exhibitions from 1915. Member of the associations World of Art, Makovets, and The Four Arts. Taught at the Petrograd Free Art Studios–VKhUTEMAS (1920–21), at VKhUTEMAS–the Surikov Institute in Moscow (1923–38), the Moscow Textile Institute (1930–31), and the Workshop of Monumental Painting of the USSR Academy of Architecture (1935–48). From 1923, lived in Moscow.

Bulakovsky, Sergei Fiodorovich
1880 Odessa – 1937 Kratovo
(Moscow Region)
Sculptor and graphic artist. He studied sculpture in Odessa (1893–1902) under Boris Eduards, at the Milan Academy of Fine Arts (1906-09) under the sculptor Eugenio Pellini, in Paris at the Académie des Beaux-Arts. Worked in the studio of Antonin Mercié (1909), Joseph Bernard, and at the Académie de la Grande Chaumière under Emile-Antoine Bourdelle (1910–11). Member of the AKhRR (from 1925), and the Society of Russian Sculptors (from 1926). Participant in exhibitions from 1907. Organizer and active member of the Russian Art Academy in Paris (1911–14). In 1917, returned to Russia and from 1922 lived in Moscow. Taught at VKhUTEMAS–VKhUTEIN in Moscow (1924, 1926–30).

Burliuk, David Davidovich
1882 Semirotovshchina Khutor (now Kharkov Region) – 1967 Long Island, New York, USA
Painter, graphic artist, stage designer, poet, writer, and art critic. Creator of portraits, landscapes, still lifes, genre pictures, and non-objective compositions, illustrator of books and magazines. Studied at the art colleges in Kazan (1898–99, 1901) and Odessa (1899–1900, 1909), and the Royal Academy in Munich (1902–03) under Wilhelm Dietz, the Académie Fernand Cormon in Paris (1904), and the Moscow Institute of Painting, Sculpture, and Architecture (1910–14). Participant in exhibitions from 1906. One of the organizers of the Jack of Diamonds association (1910). Member of the following associations and participant in their exhibitions: Union of Russian Artists (1906–07), Society of Southern Russian Artists (1906–07), Jack of Diamonds (1912–16), and World of Art (1915). In 1911, participated in the first exhibition of the Blaue Reiter in Munich. In 1910, published the manifesto *In Defense of the New Art*. In 1912, composed the manifesto *A Slap in the Face of Public Taste*. Organizer of the group of Futurists known as Hylaea (1910–13). From 1915, published *The First Futurist Magazine*. In 1918, together with Vasily Kamensky and Vladimir Mayakovsky, published the *Futurists' Gazette* in Moscow. During the years 1930–66, he published, together with his wife Marusia, the magazine *Color and Rhyme*. Lived and worked in Kazan, Odessa, Munich, Paris, St. Petersburg/ Petrograd, and Moscow (1907), in the Urals (1915–17), Japan (1920–22), and the USA (Long Island, New York) (from 1922). Visited the USSR in 1956 and 1965.

Chaikov, Iosif Moiseyevich
1888 Kiev – 1979 Moscow
Sculptor. Studied in Paris at the Ecole des Arts Décoratifs (1910–12) and the Ecole des Beaux-Arts (1912–13). Participant in exhibitions from 1912. Participated in realizing Lenin's Plan for Monumental Propaganda. Member of the Society of Russian Sculptors (from 1926) and The Four Arts. Taught at VKhUTEMAS–VKhUTEIN in Moscow (1923–32). Worked as a sculptor at the Kalinin Pottery Factory in Konakovo (1934).

Chashnik, Ilya Grigoryevich
1902 Vitebsk – 1929 Leningrad
Painter and designer; also worked in the decorative arts. Studied in the studio of Yury Pen in Vitebsk, at the Free State Art Studios in Moscow (1920), and at the Vitebsk Practical Art Institute (1920–22) under Kasimir Malevich. Member of UNOVIS. In 1922, moved to Petrograd together with Malevich. Member of GINKhUK (1923). Worked at the Porcelain Factory in Petrograd (1922–24) and at the State Institute of Art History in Leningrad (from 1926) and directed the Studio of Fine Arts of Working Youth (from 1927). Participated in the following exhibitions: UNOVIS–Vitebsk and Moscow, "The International Exhibition of Decorative Art" in Paris (1925), the exhibition in Monzo–Milan (1927, honorary diploma), and "The Artists of the Russian Federation over 15 Years" (1932).

Chekhonin, Sergei Vasilyevich
1878 Lukoshino Station (Novgorod Province) – 1936 Lerrach, Switzerland (now Germany)
Graphic artist and stage designer; also worked in the decorative arts. Studied at the Drawing School of the Society for the Promotion of the Arts in St. Petersburg (1896–97) and the Maria Tenisheva School (1897–1900) under Ilya Repin. Member of the World of Art (from 1912) and took part in its exhibitions. Worked at the pottery workshop of the art patron Savva Mamontov in Abramtsevo (1902–09) and directed the School of Decorative Enamel Painting in Rostov Yaroslavsky (1913–15). Art director of the Porcelain Factory in Petrograd/Leningrad (1918–23, 1925–27). From 1928, lived and worked abroad.

Chekrygin, Vasily Nikolayevich
1897 Zhizdra (Kaluga Province) – 1922 Mamontovka (Moscow Region)
Painter and graphic artist. Studied at the School of Icon Painting of the Kiev Monastery of the Caves (1906–10) and the Moscow

Institute of Painting, Sculpture, and Architecture (1910–14). Participant in exhibitions from 1910. Participated in "The Exhibition of Pictures. Futurists, Rayonists, and Primitivists (No. 4)" (1914). Founding member of Makovets (1922). Visited Germany, Austria, England, and France (1913–14). In 1915–16, served in the army. In 1917–18, Member of the Commission for the Preservation of Articles of Artistic Value in Moscow. In 1919–20, served in the Red Army. In 1920, appointed artist of the Children's Theater in Moscow and was on the staff of the Poster Section of the Fine Arts Department of the People's Commissariat for Education. Lived and worked in Moscow from 1910.

Chernyshov, Nikolai Mikhailovich
1885 village of Nikolskoye (Tambov Province) – 1973 Moscow
Painter, graphic artist, and art historian. In 1900, attended Sunday and evening classes at the Stroganov School in Moscow. Studied at the Moscow Institute of Painting, Sculpture, and Architecture (1901–11) under Valentin Serov, Abram Arkhipov, Sergei and Konstantin Korovin, at the Académie Julian in Paris (1910), and at the Higher Art Institute within the Academy of Arts in St. Petersburg/Petrograd (1911–15). Participant in exhibitions from 1906. In 1918, took part in designing decorations for revolutionary festivities in Moscow. Member of Makovets. Corresponding member of the Academy of Artistic Sciences. Taught at VKhUTEMAS–VKhUTEIN (1920–30) and the Moscow Institute of Fine Arts (1936–40). From 1935 to 1948, worked at the Studio of Monumental Painting within the USSR Academy of Architecture.

Chupiatov, Leonid Terentyevich
1890 St. Petersburg – 1941 Leningrad
Painter, graphic artist, and stage designer. Studied at the Drawing School of the Society for the Promotion of the Arts in St. Petersburg (1909–10) and in the studio of Yan Tsionglinsky (1909–12, 1912–16, in the group of Tsionglinsky's pupils, without a teacher). From 1916 to 1918, studied in the same group with Kuzma Petrov-Vodkin as his instructor. Worked in the studio of Mikhail Bernstein (1916), and in the Petrograd Free Art Studios–the Academy of Fine Arts (1918–19, 1920–21) under Petrov-Vodkin. From 1921 to 1925, worked in the Scientific Research Department of the Academy of Arts–VKhUTEMAS in Petrograd/Leningrad. Participant in exhibitions from 1916. Member of the following associations and participant

in their exhibitions: World of Art (1916–18), the Society of Individualist Artists (1922), Fire-Color (1924), the Society of Artists (1925–27, 1929), the Association of Contemporary Artists of the Ukraine (1928). Taught at VKhUTEMAS in Leningrad (1926), the Kiev Art Institute (1926–28), and VKhUTEIN–the Repin Institute in Leningrad (1929–33), as assistant to professor Dmitry Kiplik at the Faculty of the Techniques and Technology of Painting. Lived and worked in Novgorod (1890?–1909, 1919–20), Kiev (1926–28), and St. Petersburg/Petrograd/Leningrad (1909–19, 1920–26, from 1929).

Danko [Danko-Alexeyenko], Natalia Yakovlevna
1892 Tiflis – 1942 Irbit (Sverdlovsk Region)
From 1900 to 1902, studied at the Stroganov Central School in Moscow. From 1906 to 1908, studied in Vilnius at the City Art Studio of August Yanzen. From 1909, worked in the studios of Maria Dillon and Leonil Shervud in St. Petersburg. From 1909, worked in the sculpture workshop of Vasily Kuznetsov. From 1914, sculptor at the Porcelain Factory in Petrograd. From 1919, headed the factory's sculpture workshop.

Danko, Yelena Yakovlevna
1898 village of Parafiyevka (Chernigov Province) – 1942 on the road from Yaroslavl to Irbit
Porcelain painter. In 1915, studied at the School of Drawing under Alexander Murashko in Kiev and from 1915 to 1918, at the School of Ilya Mashkov, Ivan Rerberg, and Alexander Manganari in Moscow. In 1924–25, studied at VKhUTEIN in Leningrad. Participant in exhibitions from 1919. In 1919–20, an actress who wrote scripts for the puppet theater directed by Liubov Shaporina-Yakovleva. In 1923, member of the literary collegium of the Theater of Young Spectators in Petrograd. From 1918 to 1942, worked, with occasional intervals, as an artist at the Porcelain Factory in Petrograd/Leningrad.

Deineka, Alexander Alexandrovich
1899 Kursk – 1969 Moscow
Painter, graphic artist, and sculptor. Studied at the Kharkov Fine Arts College (1915–17) under R. M. Pestrikov, in the Polygraphic Faculty at VKhUTEMAS in Moscow (1921–25) under Vladimir Favorsky and Ignaty Nivinsky. Participated in the "First Discussion Exhibition of the Associations of Active Revolutionary Art" in the Group of Three with Andrei Goncharov and Yury Pimenov (from 1924). Founding member and participant in exhibitions of the Society of

Easel Painters (1925–28), member of October and participant in its exhibitions (1928–30), and member of the Russian Association of Proletarian Artists (1931–32). Lived and worked in Kursk, Kharkov, and Moscow (from 1920).

Dobuzhinsky, Mstislav Valerianovich
1875 Novgorod – 1957 New York
Graphic artist, painter, and stage designer. Studied at the Drawing School of the Society for the Promotion of the Arts in St. Petersburg (1885–87), in the Faculty of Law of the University of St. Petersburg (1895–99), in the schools of Anton Ažbe and Simon Hollósy in Munich (1899–1901). Participant in exhibitions from 1902. Member of the World of Art (1902–24) and Union of Russian Artists (1904–09). Taught at the studio school of Yelizaveta Zvantseva (1906–10) and the school of Maria Gagarina in St. Petersburg (from 1911), the People's School of the Fine Arts in Vitebsk (1918–19), the St. Petersburg Free Art Studios–VKhUTEMAS–VKhUTEIN (1918–23), and the Fine Arts School in Kaunas (1929–39). Collaborated on the periodicals *Mir iskusstva* [*World of Art*], *Zhupel* [*Bugbear*], *Adskaya Pochta* [*Hell's Mail*], *Plamia* [*Flame*], and others. Set designer for performances of the Moscow Art Theater. From 1925, lived abroad.

Dormidontov, Nikolai Ivanovich
1898 St. Petersburg – 1962 Leningrad
Painter and graphic artist. Studied in St. Petersburg/Petrograd at the Drawing School of the Society for the Promotion of the Arts (1914–18) under Ivan Bilibin and Arkady Rylov, as well as in the Petrograd Free Art Studios–VKhUTEMAS (1918–22) under Dmitry Kardovsky, Kuzma Petrov-Vodkin, and Vasily Shukhayev. Participant in exhibitions from 1922. Member of the AKhRR (1922–32) and the association Sixteen (1923–27). Lived and worked in St. Petersburg/Petrograd/Leningrad.

Drevin [Drevin, Dreviņš], Alexander Davidovich
1889 Venden (Lifland Province) – 1938 (died in the GULAG)
Painter and graphic artist. Studied at the Riga Fine Arts School (1908–13) under Wilhelm Purvit. Participant in exhibitions from 1911. Member of the following associations and participant in their exhibitions: the Green Flower (1913, Riga), World of Art (1922, Moscow), Moscow Painters (1925), AKhRR (1926), Society of Moscow Artists (1928), and Thirteen (1931), From 1918 to 1920, worked in the Fine Arts Department of the

People's Commissariat for Education and was a member of the Association of Extreme Innovators in Painting. Taught at the Free State Art Studios–VKhUTEIN in Moscow (1920–30). Lived and worked in Riga (1895–1914), Smolensk Province (1906–07), and Moscow (from 1914).

Ender, Maria Vladimirovna
1897 St. Petersburg – 1942 Leningrad
Painter, graphic artist, and designer. Author of articles and papers dedicated in the Department of Literature to the study of color in painting. Studied at the Women's Pedagogical Institute in Petrograd (1915–18) and at the Petrograd Free Art Studios (1918–22) under Mikhail Matiushin. Worked in the Department of Organic Culture of the Museum of Artistic Culture and at GINKhUK in Leningrad (1923–27) under the direction of Matiushin. In 1927, appointed to the staff of the Institute of Art History. Participant in exhibitions from 1922. Taught at VKhUTEIN–Repin Institute (1929–32), the Institute of Civil Aviation (1930), the Institute of Municipal Engineering, and the Industrial Arts College (1930) in Leningrad.

Evenbakh, Yevgeniya Konstantinovna
1889 Kremenchug – 1981 Leningrad
Painter and graphic artist. Studied at the Drawing School of the Society for the Promotion of the Arts in St. Petersburg/Petrograd (1910–17, with intervals), at the Higher Bestuzhev Courses, at the University of Petrograd (1917–24) and at the Petrograd Free Art Studios–VKhUTEIN (1918–23) under Kuzma Petrov-Vodkin. Participant in exhibitions from 1928. Worked in the Detgiz Publishing House for children's literature. From 1930, worked on the creation of writing systems for the peoples of the Far North. Collected material on the cultural history of the peoples of the Far East. Taught at the Department of Peoples of the North at the Herzen Pedagogical Institute in Leningrad (1948–52). She lived and worked in St. Petersburg/Petrograd/Leningrad.

Exter, Alexandra Alexandrovna
1882 Belostok (Grodno Province) – 1949 Fontainet-aux-Roses near Paris
Painter, graphic artist, theater and cinema designer, and designer. Studied at the Kiev Art Institute (1901–03, 1906–07). From 1908, regularly traveled to Paris where she attended La Grande Chaumière (1909), and the studio of C. Delval. In Paris she made the acquaintance of Picasso, Braque, Apollinaire, and the Italian Futurists Marinetti and Papini.

Participant in exhibitions from 1908. Member of the following associations and participant in their exhibitions: New Society of Artists (1908–09, St. Petersburg), Link (1908), Wreath-Stephanos (1909), Triangle (1910), Izdebsky Salon (1909–10, 1911; Odessa, Riga), Ring (1909–10, 1911; Kiev, St. Petersburg), Union of Youth (1910, Riga; 1913–14, St. Petersburg), the International Futurist Exhibition (1914, Rome), Jack of Diamonds (1910–17), Tramway V (1915), The Store (1916), 5 x 5 = 25 (1921), and also exhibited in the Salon des Indépendants in Paris (1914). In 1921, joined the Constructivists. In 1918, taught at the Children's Art School in Odessa; from 1918 to 1920, at her own studio of decorative art in Kiev; and in 1921–22, at VKhUTEMAS in Moscow. In 1923, began work on set and costume designs for the film *Aelita*. From 1925 to 1930, taught at the Academy of Contemporary Art of Fernand Léger in Paris. Lived and worked in Kiev, Odessa, St. Petersburg, Moscow, and Paris (from 1908 periodically and continuously from 1924).

Falk, Robert Rafailovich
1886 Moscow – 1958 Moscow
Painter, graphic artist, and theater designer. Studied at the studios of Konstantin Yuon and Ivan Dudin and of Ilya Mashkov in Moscow (1903–04), at the Moscow School of Painting, Sculpture, and Architecture (1905–10) under Konstantin Korovin and Valentin Serov. Participant in exhibitions from 1906. A founder of the Jack of Diamonds (1910–17), member of the following societies and participant in their exhibitions: the World of Art (1911–17, 1921, 1922), Moscow Painters (1925), Society of Moscow Artists (1925–28), and AKhRR (1925–28). Sent to Paris (1928–38). During the war lived and worked in Samarkand (1941–44). Taught at the First Free State Art Workshops–VKhUTEIN in Moscow (from 1918).

Favorsky, Vladimir Andreyevich
1886 Moscow – 1964 Moscow
Graphic artist, stage designer, and art theorist. Studied in Moscow at the school of Konstantin Yuon (1903–04), the school of Simon Hollósy in Munich (1906–07), the Section of Art History of the Philological Faculty at Moscow University (1907–12). Participant in exhibitions from 1911. Served in the Red Army (1919–21). Taught at VKhUTEMAS, the Polygraphical Institute (1930–34), the Surikov Institute (1934–48), and the Institute of Applied Art (1943–48)

in Moscow. Member of Makovets (1922) and The Four Arts (1925–29). Lived and worked in Moscow.

Filonov, Pavel Nikolayevich
1883 Moscow – 1941 Leningrad
Painter, graphic artist, stage designer, and poet. Studied in St. Petersburg at the Studios of Artistic and Utilitarian Painting (1897–1901), the School of Painting and Drawing of Lev Dmitriyev-Kavkazsky (1903–08), Drawing School of the Society for the Promotion of the Arts (1893–1901), and the Higher Art School within the Academy of Arts (1908–10) under Gugo Zaleman, Vasily Savinsky, Yan Tsionglinsky, Ivan Tvorozhnikov, and Grigory Miasoyedov. Participant in exhibitions from 1910. One of the founding members of the Union of Youth (1910). Member of the following associations and participant in their exhibitions: the Non-Party Society of Artists (1913), the Union of Youth (1910–14, 1917–19), and Society of Artists (1921–22, 1924). He organized the Masters of Analytical Art group (1925–32); it existed unofficially up to 1941). In 1914, organized a studio of artists known as Made Pictures and published a manifesto, the second version of which was completed in 1923 (*The Declaration of Universal Flowering*). In 1913, participated in designing stage sets for the production of the tragedy *Vladimir Mayakovsky* and wrote a number of poems collected in the book *Incantation to Universal Growth* (1914–15).
From 1916 to 1918, was at the front in Bessarabia (Moldavia) with the Second Marines of the Baltic Division. From the beginning of the Revolution he was chairman of the Divisional Committee for the Baltic Division and chairman of the Executive Committee of the city of Sulin, of the Soldiers' Congress in Izmail, and of the Executive Committee of the Danube region in Izmail as well as chairman of the Military Revolutionary Committee. In 1923, he joined the staff of the Department of General Ideology at the Museum of Artistic Culture and worked on the statutes of the Institute of Artistic Culture. In 1925, organized the Masters of Analytical Art group in Leningrad. Traveled to Palestine through Constantinople (between 1905 and 1907), France, and Italy (1911–12), along the Volga, and to the Caucasus (1905, 1911?). Lived and worked in Moscow and St. Petersburg/Petrograd/Leningrad.

Fonvizin (Von Wiesen, Vonwiesen, Arthur Vladimirovich
1882 Riga – 1975 Moscow
Graphic artist. Studied at the Moscow Institute of Painting, Sculpture, and

Architecture (1901–07) under P. I. Klodt and Vasily Baksheyev as well as in Munich (1904–06) in the studio of Geiman and Gardner. Participant in exhibitions from 1904 onward. Member of the following associations and participant in their exhibitions: World of Art (1913), Blue Rose (1907), Jack of Diamonds (1910), Makovets (1921–24), the Society of Moscow Artists (1928). Taught at the Studio of Fine Arts of the Tambov Proletkult (1918–22) and at the Art College in Nizhni Novgorod (1923–24). Lived in Moscow from 1927.

Frenz, Rudolf Rudolfovich
1888 St. Petersburg – 1956 Leningrad
Painter, graphic artist, and author of dioramas. Studied at the Petrograd Free Art Studios and at the Academy of Arts (1910–18, with intervals) under Nikolai Samokish. Participant in exhibitions from 1915. Member of the Society of Artists (1922–25) and AKhRR (1924). Lived and worked in St. Petersburg/Petrograd/Leningrad.

Gerasimov, Sergei Vasilyevich
1885 Mozhaisk – 1964 Moscow
Painter and graphic artist; author of articles on art. Studied at the Stroganov School in Moscow (1901–07) under Konstantin Korovin, Sergei Ivanov, and Stanislav-Witold Noakovsky and at the Moscow Institute of Painting, Sculpture, and Architecture (1907–11) under Abram Arkhipov, Sergei Ivanov, and Konstantin Korovin; trained in lithography under Sergei Goloushev. Participant in exhibitions from 1906. Member of the societies Moscow Salon (1911–20), World of Art (1921), Makovets (1922–25), Society of Moscow Artists (1926–29), and AKhR (1930–32). Taught at the School of Fine Arts at the typolithography of the Sytin Partnership (1912–14), the State School of Printing of the Fine Arts Department of the People's Commissariat for Education, which operated at the First Model Printer's Shop (1918–23), VKhUTEMAS–VKhUTEIN (1920–29), the Polygraphic Institute (1930–36), the Surikov Institute (1936–50), and the Stroganov School in Moscow (1950–64). Professor and doctor of art studies. Lived and worked in Moscow from 1901.

Gorbovets, Zinovy Isaakovich
1897 Zvenigorodka (Kiev Province) – 1979 Moscow
Graphic artist and painter. Studied at the Chernigov Art College (1916–19) and VKhUTEIN in Moscow (1929–31) under

Pavel Pavlinov and Vladimir Favorsky. From 1923 to 1924, lived in Minsk; from 1924 to 1929, in Vitebsk, teaching in schools and at the Art College. Participant in exhibitions from 1927. From 1929 lived and worked in Moscow.

Grigoryev, Boris Dmitriyevich
1886 Moscow – 1939 Cannes (France)
Painter and graphic artist. Studied at the Stroganov School in Moscow (1903–07) under Dmitry Shcherbinovsky and the Higher Art School at the Academy of Arts in St. Petersburg (1907–13) under Alexander Kiseliov and Dmitry Kardovsky. Participated in the exhibition "The Impressionists" (1909, St. Petersburg), the permanent exhibition of contemporary art (1913, the Office of Nadezhda Dobychina, St. Petersburg), and other exhibitions in Russia and abroad. Member of the World of Art (1913–18) and of the 1st Professional Union of Artists in Petrograd (1918), participant in the "First State Free Exhibition of Works of Art" (1919, Petrograd). Taught at the Stroganov School in Moscow (1918). From 1919, lived abroad, in France and the USA.

Grigoryev, Nikolai Mikhailovich
1880 Kotelnich (Viatka Province) – 1943 Moscow
Graphic artist and painter. Studied at the art school in Kazan under Nikolai Feshin, at the Moscow School of Painting, Sculpture and Architecture (1909–14) under Abram Arkhipov, Leonid Pasternak, and Konstantin Korovin. Member of Makovets (1922), Society of Moscow Artists (1927–32). Taught in the preparatory section of VKhUTEMAS–VKhUTEIN, Moscow, at the Architectural-Construction Institute and in the Department of Artistic Fabric Design at the Moscow Textile Institute. Lived and worked in Moscow.

Grishchenko, Alexei Vasilyevich
1883 Krolevets (Chernigov Province) – 1977 Paris
Painter, graphic artist, and art historian. Studied in the philological faculties of the universities of St. Petersburg, Kiev, and Moscow (1905–12). Practised painting in the workshop of Sergei Svetoslavsky in Kiev (1905), and in the studios of Konstantin Yuon and Ilya Mashkov in Moscow (1910–11). Participant in exhibitions from 1909. Member of the following associations and participant in their exhibitions: New Society of Artists (1910), Moscow Salon (1911), Jack of Diamonds (1912), Union of Youth (1913–14), Exhibition of Paintings of Leftist Tendencies (1915),

World of Art (1917), and Free Creation (1918), and participant in the 12th state exhibition "Color Dynamics and Tectonic Primitivism" (1919), at which he read a manifesto together with Alexander Shevchenko. Lived and worked in Kiev, St. Petersburg, Moscow, and Constantinople (1920–22), Venice and Paris (from 1923).

Gurvich, Boris Isaakovich
1905 St. Petersburg – 1985 Leningrad
Graphic artist, painter, and stage designer. Studied at VKhUTEIN in Petrograd/Leningrad (1921–26) under Kuzma Petrov-Vodkin, Kasimir Malevich, and Mstislav Dobuzhinsky. Participant in exhibitions from 1928. Member of the Masters of Analytical Art, participated in their exhibition in the Leningrad Press House. Designed the Soviet pavilion for the Paris World Fair in 1937. During the years 1930 to 1950, designed sets for theaters in the Ukraine and Leningrad. Lived and worked in Leningrad.

Guro, Yelena Genrikhovna
1877 St. Petersburg – 1913 Uusikirkko (Finland, now Russia)
Poet, painter, and graphic artist. Studied at the Drawing School of the Society for the Promotion of the Arts in St. Petersburg, at the studio-school of Yan Tsionglinsky (1903–05), where she made the acquaintance of Mikhail Matiushin, whom she married, and the studio-school of Yelizaveta Zvantseva (1906–07) under Léon Bakst. Participant in exhibitions from 1908. Member of the Impressionists group organized by Nikolai Kulbin. Founding member of the Union of Youth (from 1910) and a member of the Cubo-Futurist literary union Hylaea. Author of the collections of poetry *Sharmanka* [*Barrel Organ*] (1909), *Osenniy son* [*Autumn Dream*] (1912), and *Nebesniye verbliuzhata* [*Little Sky Camels*] (1914). Lived and worked in St. Petersburg and in Finland.

Kandinsky, Wassily (Vasily Vasilyevich)
1866 Moscow – 1944 Neuilly-sur-Seine (France)
Painter, graphic artist, and stage designer; author of theoretical essays. Studied in the Law Faculty of Moscow University (1886–92), at the school of Anton Ažbe in Munich (1897–99) and in the studio of Franz von Stuck at the Munich Academy. Founding member and chairman of the Phalanx group (1901–04, Munich), the New Association of Artists (1909, Munich). Founding member and participant in the exhibitions of the Blaue Reiter (1911–13, 1912, Munich, Berlin) and

the Blue Four (1924, Weimar); with Paul Klee, Alexei Jawlensky, and Lyonel Feininger. In 1920, created his first abstract works. In 1912, published the work *Concerning the Spiritual in Art*. Participant in exhibitions from 1901 (?), including Jack of Diamonds (from 1910), Donkey's Tail (1912), World of Art (1921), and state exhibitions in Moscow. In 1918, worked in the International Office of the Fine Arts Department of the People's Commissariat for Education. Active in the reorganization of museums in Russia (1919), appointed director of the Museum of Painting Culture in Moscow (1920). Member of GINKhUK (1921 (?), vice president of the Russian Academy of Artistic Sciences. In 1921, directed by the People's Commissariat for Education to teach at the Bauhaus: professor at the Bauhaus in Weimar and Dessau (1921–33). Lived and worked in Moscow (1866–69, 1886–97, 1903, 1910, 1915, 1917?–21), Italy (1869–71), Odessa (1871–86, 1903, 1905, 1910, 1915), St. Petersburg (1910), Munich (1897–1904, 1908–10, 1911–14), Rapallo (1905–06), Sèvres (1906–07), Berlin (1907–08, 1921?), Merano, Goldach, Zürich (1914), Stockholm (1915–16), Weimar and Dessau (1921–33), and France (1933–44).

Karev, Alexei Yeremeyevich
1879 village of Shilovka (Serdobsky District, Saratov Province) – 1942 Leningrad
Painter and graphic artist. Studied at the Bogoliubov Drawing School in Saratov (1896–98) under Vasily Konovalov, Seliverstov Art College in Penza (1898–1901) under Konstantin Savitsky and in the Kiev Art College (1901–02). In St. Petersburg worked in the Free Comrades' Workshop (1903–07). Participant in exhibitions from 1908. Member of the following associations and participant in their exhibitions: Wreath (1908, St. Petersburg), Golden Fleece (1908–09), World of Art (1911–24), Union of Youth (1917–19), and The Four Arts (from 1926). Lived and worked in Saratov (1895–98, 1919–21), Penza (1898–1901), Kiev (1901–02), and St. Petersburg/Petrograd/Leningrad (1903–19, 1922–42).

Khodasevich, Valentina Mikhailovna
1894 Moscow – 1970 Moscow
Painter, graphic artist, and stage designer. Studied at the school of Ivan Rerberg in Moscow, the studio of Haberman in Munich (1910–11) and at the Académie Vitti in Paris (1911–12) under Kees van Dongen. Worked in a studio under the direction of Vladimir Tatlin in Moscow (1912). Participant in exhibitions from 1912, including the Exhibition of Paintings of Leftist Tendencies (1915), the

Artistic Salon and Jack of Diamonds (1917). From 1913, lived in St. Petersburg. In 1919, began to work in the theater. From 1922, lived in Germany. Designed sets for theater performances in Milan and Rome. In 1927, worked on the design of the mass celebration for the Tenth Anniversary of the October Revolution. In 1928, stayed with Maxim Gorky in Sorrento.

Khodzher, Bogdan
Born 1910
Sculptor. From 1928 to 1929, studied in the Faculty of Northern Peoples at the Yenukidze Oriental Institute. In November 1928, an experimental sculpture studio was organized at the faculty (under the direction of Leonid Mess). In May 1929, an exhibition of the work of students from this studio was organized at the Russian Museum in Leningrad, including Khodzher's sculptures. Nothing is known of the sculptor's later life.

Kliun (Kliunkov), Ivan Vasilyevich
1873 village of Bolshiye Gorki (Vladimir Province) – 1943 Moscow
Painter, graphic artist, and sculptor; author of essays on art. In the 1890s, studied at the Drawing Schools of the Society for the Promotion of the Arts in Warsaw and Kiev. In the early 1900s, studied in the private workshops of Ivan Rerberg, Vladimir Fisher, and Ilya Mashkov in Moscow. Pupil and follower of Kasimir Malevich. In 1913, began to work on sculpture. From 1917 to 1921, headed the Central Exhibition Office of the Fine Arts Department of the People's Commissariat for Education. From 1918 to 1921, member of the Institute of Art in Moscow. From 1918 to 1921, taught at VKhUTEMAS in Moscow. Participant in exhibitions from 1910. Contributed to the exhibitions of the Union of Youth (1913–14), Tramway V (1915), 0.10 (1915–16), Shop (1916), Jack of Diamonds (from 1916), World of Art (1917), The Four Arts, and others.

Koltsov, Nikolai Alexeyevich
1907 Grozny – 1942 Zhikhorevo (Leningrad Region)
Sculptor. Studied in Moscow at VKhUTEIN (1926–30) under Vera Mukhina, Iosif Chaikov, and Ivan Yefimov (sculpture), under Vladimir Favorsky (theory of composition), and Pavel Pavlinov and Nikolai Radlov (drawing); also studied at the Repin Institute in Leningrad (1933–36) under Alexander Matveyev. Upon graduation, was sent to the Porcelain Factory in Leningrad (1937–39). Participant in exhibitions from 1938.

Konashevich, Vladimir Mikhailovich
1888 Novocherkassk – 1963 Leningrad
Graphic artist. Studied at the Moscow Institute of Painting, Sculpture, and Architecture (1908–14) under Sergei Maliutin, Konstantin Korovin, and Leonid Pasternak. Taught at VKhUTEMAS–VKhUTEIN in Petrograd/Leningrad (1921–30) and the Repin Institute (1944–48). Participant in exhibitions from 1915.

Konchalovsky, Piotr Petrovich
1876 Slaviansk – 1956 Moscow
Painter, graphic artist, and stage designer. Studied in Kharkov at the Drawing School of Maria Rayevskaya-Ivanova, at the evening classes of the Stroganov School in Moscow under Sukhov, in Paris at the Académie Julian (1897–98) under Jean-Paul Laurens, Jean-Joseph Benjamin Constant; at the Higher Art Institute within the Academy of Arts in St. Petersburg (1898–1905) under Ivan Tvorozhnikov, Vasily Savinsky, and Gugo Zaleman, and in the studio of Pavel Kovalevsky. Participant in exhibitions from 1908. One of the founding members and chairman of the Jack of Diamonds (1910). Participated in exhibitions of the Golden Fleece (1900s) and was a member of the Union of Youth (1911), World of Art (1911–12, 1917, 1921–22), Existence (1926–27), and AKhRR (1928). Lived and worked in Moscow.

Kondratyev, Pavel Mikhailovich
1902 Saratov – 1985 Leningrad
Painter, and graphic artist. Studied at the Academy of Arts–VKhUTEMAS–VKhUTEIN in Petrograd/Leningrad (1921–25) under Alexander Savinov, Alexei Karev, Mikhail Matiushin, and Arkady Rylov. Member of Pavel Filonov's Masters of Analytical Art group (1927–29). Participant in exhibitions from 1927. Worked in publishing houses and designed decorations for national festivals. Lived and worked in Petrograd/Leningrad from 1921.

Konionkov, Sergei Timofeyevich
1874 village of Karakovichi (Yelnia District, Smolensk Province) – 1971 Moscow
Sculptor. Studied at the Moscow Institute of Painting, Sculpture, and Architecture (1892–96) under Sergei Ivanov and Sergei Volnukhin and at the Academy of Arts in St. Petersburg (1899–1902) under Vladimir Beklemishev. Participant in exhibitions from 1899. Member of the New Society of Artists (from 1908), the Union of Russian Artists (from 1909), and the World of Art (from

1917). Had showings at exhibitions of the Society of Russian Sculptors (from 1926). Full member of the Academy of Arts (from 1916). Taught at the Free Art Workshops, VKhUTEMAS, and the Proletkult Studio in Moscow (1918–22). Participated in realizing Lenin's Plan for Monumental Propaganda. In 1924, when engaged as one of the participants and organizers of an exhibition of fine arts arranged under the auspices of the Soviet Government, traveled to America, where remained until 1954.

Koroliov, Boris Danilovich
1885 Moscow – 1965 Abramtsevo (Moscow Region)
Sculptor. Studied at the Faculty of Physics and Mathematics of Moscow University (1902–05); expelled for participating in revolutionary activities. Studied at private schools in Moscow: drawing under Ivan Rerberg on the art courses at the Bess Gymnasium (1907), and under Vasily Meshkov and Ilya Mashkov (1908–10) in the sculpture workshop of Maria Blok; at the Moscow Institute of Painting, Sculpture, and Architecture (1910–14) under Sergei Volnukhin. Participant in exhibitions from 1919. Member of the Monolith organization of sculptors (1920–21), Society of Russian Sculptors (from 1927), Association of Russian Artists (after 1928), and Society of Moscow Artists (from 1929).
Taught at the Free Art Studios–VKhUTEMAS in Moscow (1918–24). Participated in realizing Lenin's Plan for Monumental Propaganda.

Kostrov, Nikolai Ivanovich
1901 village of Vasilyevskoye (Viatka Province) – 1996 St. Petersburg
Painter and graphic artist. Studied in the Faculty of History and Philosophy of Kazan University (1920–21), at VKhUTEIN in Petrograd/Leningrad (1923–26) under Alexander Savinov and Mikhail Matiushin. Served with the Baltic Fleet (1926–28). Participant in exhibitions from 1931. Worked in the Experimental Lithographic Workshop of the Leningrad Branch of the RSFSR Union of Artists (from 1939). Taught at the Repin Institute in Leningrad (1932–33). Lived and worked in Leningrad from 1923.

Kozlinsky, Vladimir Ivanovich
1891 Kronstadt – 1967 Moscow
Graphic artist, stage and cinema designer. Studied in St. Petersburg at the Drawing School of the Society for the Promotion of the Arts, at the studio school of Yelizaveta

Zvantseva (1907) under Léon Bakst and Mstislav Dobuzhinsky, in the studio of Dmitry Kardovsky and in the Higher Art School at the Academy of Arts (1911–17) under Vasily Mathé. Member of the Union of Youth from 1918. Participant in exhibitions from 1909. Taught at the Petrograd Free Art Studios–the Academy of Arts (1918–21). In 1920–21, headed the Petrograd branch of ROSTA. Lived in Moscow from the middle of the 1920s.

Kravchenko, Alexei Ilyich
1889 Pokrovskaya Sloboda (Saratov Province) – 1940 Nikolina Gora (Moscow Region)
Painter and graphic artist. Studied at the Moscow Institute of Painting, Sculpture, and Architecture (1904–10) under Valentin Serov and Konstantin Korovin, and at the school of Simon Hollósy in Munich (1906–07). Participant in exhibitions from 1906. Member of the Moscow Society of Artists (after 1913), and The Four Arts society (from 1925). From 1918 to 1921 lived in Saratov, where he was director of the Saratov Faculty of Art Studios. From 1921, lived in Moscow. In 1925, received the Grand Prix at the International Exhibition of Decorative Art in Paris.

Kupreyanov, Nikolai Nikolayevich
1894 Wlotclawek (Poland) – 1933 near Moscow
Graphic artist. Studied in St. Petersburg at the school of Maria Tenisheva (1912), as well as in the studios of Dmitry Kardovsky (1912–14) and Kuzma Petrov-Vodkin (1915–16). Concurrently, studied law at St. Petersburg University (1912–16). Participated in exhibitions from 1912. From 1922, lived in Moscow. Member of The Four Arts and the Society of Easel Painters (1926–28). Taught at the Higher Institute of Photography and Photographic Technology in St. Petersburg (1918–21), and at VKhUTEMAS–VKhUTEIN in Moscow (1922–33).

Kuprin, Alexander Vasilyevich
1880 Borisoglebsk (Tambov Province) – 1916 Moscow
Painted and graphic artist. Studied at the Voronezh School of Painting and Drawing (1896), the school of painting and drawing of Lew Dmitriyev-Kavkazsky in St. Petersburg (1902–04), the school of Konstantin Yuon in Moscow (1904–05), and the Moscow Institute of Painting, Sculpture, and Architecture (1906–10) under Konstantin Korovin, Nikolai Kasatkin, Leonid Pasternak, and Abram Arkhipov. Participant in exhibitions from 1908. Founding member of the Jack of Diamonds (1910), member of the World of Art (1917,

1921), Existence (1926–27), and the Society of Moscow Artists (1928–29). Engaged in pedagogical work as an assistant to Korovin at the Free Art Studios–VKhUTEMAS in Moscow (1918–19), 1922–25) and taught at the art studios in Nizhni Novgorod and Sormovo (1920–22), at the Moscow Textile Institute (1928–32), and the Stroganov School (1946–52). Lived and worked in Moscow from 1904.

Kuptsov, Vasily Vasilyevich
1899 Pskov – 1935 Leningrad
Painter and graphic artist. Studied at the Van der Flit School of Industrial Arts in Pskov (1913–18), the Petrograd Free Art Studios–VKhUTEIN (1921–26), and in the studio of Pavel Filonov (from 1925?). Participant in exhibitions from 1921. Member of the Circle of Artists (1927–30). Lived and worked in Pskov and Petrograd/Leningrad.

Kurdov, Valentin Ivanovich
1905 village of Mikhailovskoye (Perm Province) – 1989 Leningrad
Graphic artist and painter. Studied at the Perm Art College (1918–19), the Free Art Workshops in Perm (1921), the Practical Art Institute in Sverdlovsk (1922), VKhUTEIN in Petrograd/Leningrad (1923–26) under Alexei Karev and Alexander Savinov, and GINKhUK in Leningrad (1926–27) under Kasimir Malevich. Participant in exhibitions from 1932. Worked in the Children's Department of the State Publishing House under the direction of Vladimir Lebedev. One of the organizers and active creators of the Fighting Pencil posters (from 1939). From this date also worked in the experimental lithographic workshop of the Leningrad Branch of the RSFSR Union of Artists. Lived and worked in Perograd/Leningrad since 1923.

Kuznetsov, Pavel Varfolomeyevich
1878 Saratov – 1968 Moscow
Painter, graphic artist, and stage designer. Trained in the studio of the Saratov Society of Art Lovers (1891–96) under Vasily Konovalov, and Gektor Salvini-Baracchi and also at the Moscow Institute of Painting, Sculpture, and Architecture (1897–1904) under Abram Arkhipov, Nikolai Kasatkin, Konstantin Korovin, Leonid Pasternak, and Valentin Serov. Studied at the Académie Colarossi and other studios in Paris (1906). One of the organizers of the Scarlet Rose exhibition (1904, Saratov); initiator of the Blue Rose exhibition (1907). Participant in exhibitions from 1901, including those of the World of Art (1902, 1911–22), and the Golden Fleece. Chairman of The Four Arts (1925–31).

Taught at the Institute of Painting, Sculpture, and Architecture–VKhUTEMAS–VKhUTEIN (1918–30), the Institute of Advanced Studies in the Arts (1939–41), and the Stroganov School (1945–48). Lived and worked in Moscow from 1897.

Labas, Alexander Arkadyevich
1900 Smolensk – 1983 Moscow
Painter, graphic artist, and stage designer. Studied at the art studio of Vitaly Mushketov in Smolensk (from 1908), the Stroganov School in Moscow (from 1912) under Dmitry Shcherbinovsky, Fiodor Fedorovsky, and Stanislav-Witold Noakovsky, in the studios of Ivan Rerberg (1915) and Ilya Mashkov (1916), and at the Free Art Studios in Moscow (1917), then volunteered for service in the Red Army (he was with the Third Army on the Eastern Front). Completed his studies at VKhUTEMAS in Moscow under David Shterenberg after being demobilized (1922–24). Participant in exhibitions from 1921 (Yekaterinburg/Sverdlovsk). Member of the Projectionists group, who in 1922 organized an exhibition in the Museum of Painting in Moscow. One of the founding members of the Society of Easel Painters (1925), participating in its exhibitions (1925–32). Taught at the Yekaterinburg Art Institute (1920–21), at VKhUTEMAS in Moscow (after 1924), and at the Krupskaya Moscow Communist Academy (1926). Lived and worked in Smolensk (1900–10), Riga (1910–12), Moscow (from 1912), and Tashkent (1942–45?).

Lappo-Danilevsky, Alexander Alexandrovich
1898 St. Petersburg – 1920 near Kharkov
Graphic artist and painter. Studied in the private studio of Mikhail Bernstein in St. Petersburg (after 1913), where he designed decorations for artistic parties. In 1917, after graduating from the gymnasium, traveled around the Crimea and lived in Bakhchisarai, where he made the acquaintance of Nathan Altman. Thereafter traveled in Finland. Joined the Studio of Young Artists, attached to the Council of the Petrograd Free Art Studios. Editor of the magazine *Ultramarine*. On the basis of the results of the exhibition at the Studio of Young Artists, he was admitted without an examination to the studio of Kuzma Petrov-Vodkin (spring 1918). In 1919, traveled to Odessa and from there to Kherson and Kharkov. On the return journey to Petrograd, he died of typhus.

Lebedev, Vladimir Vasilyevich
1891 St. Petersburg – 1967 Leningrad
Painter and graphic artist. Studied in

St. Petersburg at the studio of Franz Rubo (1910–11), attended courses at the Higher Art Institute within the Academy of Arts in St. Petersburg and at the same time attended the studio of Mikhail Bernstein (1912–16). Participant in exhibitions from 1909. Taught at the Petrograd Free Art Studios (1918–21). Contributed to the magazines *Satirikon*, *Argus*, and others. Worked in the poster section of the Petrograd branch of ROSTA (1920–22). Art editor of Detgiz (the Children's Section of the State Publishing House) in Petrograd (1922–23). Worked for the TASS Windows on the *Krasnoarmeyets* [*Red Army Man*] magazine, and at the Military Publishing House. Lived and worked in St. Petersburg/Petrograd/Leningrad.

Lebedeva, Sarra Dmitriyevna
1892 St. Petersburg – 1967 Moscow
Sculptress and graphic artist. Studied in St. Petersburg at the Drawing School of the Society for the Promotion of the Arts (1906). Before the First World War, made a number of trips to Europe and traveled around Italy. Studied painting and drawing at the studio of Mikhail Bernstein in St. Petersburg (1910–14), where she also studied sculpture under Leonid Shervud. Participant in exhibitions from 1918. In the first years of the Revolution, worked for the ROSTA Windows and participated in realizing Lenin's Plan for Monumental Propaganda in Petrograd. Taught at the Free Art Studios in Moscow (1919–20). Member of the Society of Russian Sculptors from 1926. Lived and worked in Moscow from 1925.

Lentulov, Aristarkh Vasilyevich
1882 village of Vorona (Penza Province) – 1943 Moscow
Painter and stage designer. Studied at the Seliverstov Art School in Penza (1898–1905) under Ivan Selezniov and Nikolai Pimonenko (1898–1900; 1905–06) and in the studio of Dmitry Kardovsky in St. Petersburg (1906–07). Worked independently at the Académie La Palette in Paris under Henri Le Fauconnier and Jean Metzinger. Participant in exhibitions from 1907, including those of the World of Art (1911–12, 1921–22), the Exhibition of Paintings of Leftist Tendencies (1915), and Contemporary Painting (1916). Founding member of the Jack of Diamonds group (1910–16), member of the Association of Artists of Revolutionary Russia (1926–27), chairman of the Association of Moscow Artists (1929–32). Taught at the Free Art Studios–Surikov Institute in Moscow (from 1917). Worked on the staff

of the Institute of Artistic Culture in Moscow (1919). Lived and worked in Moscow from 1909.

Leporskaya, Anna Alexandrovna
1900 Chernigov – 1982 Leningrad
Painter, graphic artist, and designer. Studied at the Pskov Art College (1918–22) under Alexei Radakov, Alisa Brusketti-Mitrokhina, and Andrei Taran, and VKhUTEIN in Petrograd (1922–25) under Kuzma Petrov-Vodkin, Alexander Savinov, and Victor Sinaisky. Studied and worked at GINKhUK in Leningrad, in the Formal Theoretical Section under the direction of Kasimir Malevich (1925–27). Participant in exhibitions from 1927. From 1942, worked at the Porcelain Factory in Leningrad. Lived and worked in Chernigov (1900–18?), Pskov (1918–22), and Petrograd/Leningrad (from 1922).

Lisitsky (El Lissitzky), Lazar Markovich
1890 village of Pochinok (near Smolensk) – 1941 Moscow
Architect and graphic artist. Studied in the Faculty of Architecture of the Higher Polytechnical School in Darmstadt, Germany (1909–14) and at the Riga Polytechnical Institute, which was evacuated to Moscow (1915–16). Participant in exhibitions from 1916. Lived in Vitebsk in 1919–20. Member of the UNOVIS group at the Vitebsk Practical Art Institute. Lived in Germany (1921–23), Switzerland (1924–25), and Moscow (from 1925). Created the first banner of the All-Russian Central Executive Committee (1918); together with Ilya Ehrenburg, founded the magazine *Veshch'* [*Thing*] (1920, Berlin), and together with Stam, the magazine *ABC* (1925, Switzerland). Created books designs (from 1916) and posters (1920) and was seriously involved in photography (1924). Member of the Moscow Association of New Architects (ASNOVA). Designed pavilions at the International Exhibitions in Dresden (1925) and Hanover (1927). Chief artist for the Soviet pavilions at the international fairs in Cologne (1928), Stuttgart (1929), Dresden, and Leipzig (1930). Taught at the Vitebsk Practical Art Institute (1919–20) and VKhUTEMAS in Moscow (from 1921, professor) and was a member of INKhUK (from 1921).

Magaril, Yevgeniya Markovna
1902 Vitebsk – 1987 Leningrad
Painter and graphic artist. Studied at the Vitebsk Practical Art Institute (1919–22) under Kasimir Malevich and Vera Yermolayeva. In 1925, graduated from VKhUTEIN in Leningrad where she studied under Mikhail Matiushin. Member of UNOVIS.

Worked as a teacher of drawing in a secondary school until 1941. During the Second World War evacuated to Biysk. Lived and worked in Leningrad.

Malagis, Vladimir Ilyich
1902 Griva (Kurland Province) – 1974 Leningrad
Painter and grahic artist. Studied at the Drawing School of the Society for the Promotion of the Arts in Petrograd (1919) under Vasily Navozov, Vladimir Plotnikov, Nikolai Khimona, and Alfred Eberling, at the Petrograd Free Art Studios–VKhUTEIN (1918–24) under Arkady Rylov, Alexander Savinov, Kuzma Petrov-Vodkin, Grigory Bobrovsky, and Vasily Savinsky and on the advanced art courses at the Leningrad Institute of Painting, Sculpture, and Architecture (1932–33) under Yevgeny Lanceray. Participant in exhibitions from 1925. Member of the associations Circle of Artists (1926–29), and October (after 1930). Made creative trips to Pskov Region (1931), to Nevel and Novgorod (late 1930s – early 1940s); other important trips were to Kalinin Region (1949) and the Ukraine (early 1950s). Taught at the Repin Institute (1945–48) in the studio of Mikhail Avilov. Lived and worked in Petrograd/Leningrad from 1916.

Malevich, Kasimir Severinovich
1878 Kiev – 1935 Leningrad
Painter, graphic artist, stage designer, designer, and art theorist; creator of landscapes, portraits, still lifes, genre and thematic pictures, Cubo-Futurist and non-objective compositions, three-dimensional "architectonic" constructions and projects known by the name Planit; also illustrator of books and magazines, poster designer. Took part in the design of mass festivities and worked in the area of decorative applied art; author of theoretical studies and a number of essays on art.
Studied at the art school in Kiev (1895–96), the Moscow Institute of Painting, Sculpture, and Architecture (1904–10), and attended the school of Ivan Rerberg in Moscow (1905–10). Participant in exhibitions from 1898. Member of the following associations and participant in their exhibitions: Moscow Association of Artists (1907), Jack of Diamonds (1910, 1914, 1917), Donkey's Tail (1912), Union of Youth (1913), 0.10 (1915–16, where he first showed his *Black Square*), Target (1913), Tramway V (1915), Shop (1915), World of Art (1917). Organizer and participant in UNOVIS exhibitions in Vitebsk (1920–22), and the review exhibi-

tions of UNOVIS in Moscow (1920–21). In 1913, created designs and costumes for the opera *Victory over the Sun* (music by Mikhail Matiushin, libretto by Alexei Kruchonykh, prolog by Velimir Khlebnikov) in which the basic elements of what was to become Suprematism could be discerned. In 1915, wrote the program brochure entitled *From Cubism and Futurism to Suprematism* (*New Realism in Painting*). In the same year sent his works to the exhibition of the Salon des Indépendants in Paris. Produced designs for Mayakovsky's play *Misteriya-Buff* (1918). Participated in the tenth "Non-objective Creative Work and Suprematism" and sixteenth (his one-man show) state exhibitions (1919). In June 1919, wrote the brochure *Concerning New Systems in Art*. From 1918 to 1919, member of the Collegium for Art Affairs of the People's Commissariat for Education, member of the Commission on the Preservation of Monuments, member of the International Office, and member of the Museum Commission.
Taught at the Free Art Studios in Moscow (1918–19), and the Petrograd Free Art Studios (1918–19). Taught in and directed the Free Studios in Vitebsk (1919–22). During the years 1923 to 1926, director of the Museum of Artistic Culture of GINKhUK in Petrograd/Leningrad, heading the Formal and Theoretical Section. In 1927–28, on the staff of the Institute of Art History in Leningrad. In 1929, transferred, together with his colleagues, to the Russian Museum, where he was given an office to pursue his work. Engaged in pedagogical work at the Kiev Art Institute (1929–30). Taught a course on the theory and practice of painting at the House of the Arts in Leningrad (1930). In 1927, accompanied his one-man show which toured in Poland and Germany. In 1927, his book entitled *Bespredmetny mir* [*The Non-Objective World*] was published in the Bauhaus series. Lived and worked in Kiev, Konotop (mid-1890s), Kursk (to 1902), Moscow (1902–19, from 1922), Vitebsk (1919–22), and Petrograd/Leningrad (1923–35).

Markova, Valentina Petrovna
1906 Yegoryevsk (Barnaul District) – 1941 (?) Leningrad
Painter, graphic artist, and stage designer; also worked in the area of applied art. Studied at the Technical Art Workshops in Barnaul (1920–22). Participant in exhibitions from 1923 (?). In 1923–24, traveled on army manoeuvres whilst working as a military artist for the newspaper *Krasnoarmeiskaya zvezda* [*Red Army Star*] (Siberia). From 1925, worked

as an artist for the newspaper *Pravda Vostoka* [*Truth of the East*] (Tashkent) and at the Uzbek State Publishing House. Lived and worked in Barnaul (1907–23), Novosibirsk (1923–25), Tashkent (1925–37), and Leningrad (from 1937).

Mashkov, Ilya Ivanovich
1881 Mikhailovskaya Stanitsa (now Uriupinsk District, Volgograd Region) – 1944 Moscow
Painter. Studied at the Moscow Institute of Painting, Sculpture, and Architecture (1900–04, 1907, 1908) under Konstantin Korovin, Valentin Serov, and Apollinary Vasnetsov. Participant in exhibitions from 1909. Founding member and secretary of the Jack of Diamonds (1910–14), member of the World of Art (after 1916), Moscow Painters (1925), AKhRR–AKhR (1925–30, 1932), and the Society of Moscow Artists (1928). Founded and directed an artistic studio in Moscow. Taught at the Second Free State Art Studios–VKhUTEIN in Moscow (1919–29). Lived and worked in Moscow from 1900.

Matiushin, Mikhail Vasilyevich
1861 Nizhni Novgorod – 1934 Leningrad
Painter, graphic artist, composer and musician, art theorist; creator of landscapes and non-objective compositions. Studied the qualities of color in painting. Taught at the Moscow Conservatory (1876–81) and was a violinist with the Imperial Opera from 1881 to 1913. Studied at the Drawing School within the Society for the Promotion of the Arts in St. Petersburg (1894–98) under Mstislav Dobuzhinsky and Léon Bakst as well as at the studio of Yan Tsionglinsky (1902–05). Attended the studio school of Yelizaveta Zvantseva (1906–08). In 1909, met Dr. Nikolai Kulbin, and in 1910, became close to the Futurist poets and artists. Also participated in the publication of the poetry anthology entitled *Sadok sudei* [*A Trap for Judges*]. Participated in exhibitions from 1908. One of the organizers of the Union of Youth (1910). Member of the following associations and participant in their exhibitions: Triangle (1910) and Union of Youth (1910–14); organizer of the group ZORVED (Vision and Knowing) (1919–26). In 1913, composed the opera *Victory over the Sun* (prolog by Velimir Khlebnikov, libretto by Alexei Kruchonykh, stage design by Kasimir Malevich). Composed music to plays written by his wife, Yelena Guro. Published the Russian translation of the book *O kubizme* [*On Cubism*] by Albert Gleizes and Jean Metzinger. Taught a class for violinists and lectured on the history of music in a number of schools (in the

1910s) and also at the Petrograd Free Art Studios–VKhUTEIN (1918–26). Head of the workshop of Spatial Realism and then of the Section of Organic Culture of GINKhUK in Petrograd/Leningrad (1923–27). Lived and worked in Nizhni Novgorod and Moscow (1861–81), Finland (1913), and St. Petersburg/Petrograd/Leningrad (after 1881).

Matveyev, Alexander Terentyevich
1878 Saratov – 1960 Moscow
Sculptor. Studied in Saratov at the Bogoliubov School of Drawing (1896–98) under Vasily Konovalov (a pupil of Pavel Chistiakov) and Gektor Salvini-Baracchi, as well as at the Moscow Institute of Painting, Sculpture, and Architecture (1899–1902) under Sergei Ivanov and Paolo Troubetzkoy. Participated in Exhibition from 1903. Worked in Savva Mamontov's ceramic factory "Abramtsevo" (1901–05) and studied drawing in private studios in Paris (1906). Member of the World of Art, The Four Arts (1925), and the Society of Russian Sculptors (1926). Taught at the Petrograd Free Art Studios, and the Repin Institute in Petrograd/Leningrad (1918–48).

Medunetsky, Konstantin [Kasimir] Konstantinovich
1899 Moscow – 1935 Moscow
Painter, graphic artist, stage designer, and designer; creator of non-objective compositions and spatial constructions; poster artist. Studied at the Stroganov School in Moscow (from 1914). Participant in exhibitions from 1919. Member of the following associations and participant in their exhibitions: the Society of Young Artists (1919–23?), the First Discussion Exhibition of the Associations of Active Revolutionary Art (in the group of "Constructivists") (1924). In 1922, together with the brothers Vladimir and Georgy Stenberg, organized the exhibition "Constructivists" in the Poets' Café in Moscow. In 1924, together with the Stenbergs created designs for Ostrovsky's play *Thunderstorm*, produced by Alexander Tairov. Member of INKhUK in Moscow (1920). Lived and worked in Moscow.

Mess, Leonid Abramovich
1907 Odessa – 1993 Zelenogorsk, near St. Petersburg
Sculptor. Studied in Petrograd at the Industrial Arts College (1921–22) under Vsevolod Lishev and at VKhUTEIN (1922–26) under Alexander Matveyev. Member of the Leningrad Association of Proletarian Artists and the societies Circle of Artists, and October. Directed the Experimental Sculpture Workshop at the Faculty of

Northern Peoples at the Yenukidze Oriental Institute in Leningrad (1928, 1934–41). Participant in exhibitions from 1928.

Mitrokhin, Dmitry Isidorovich
1883 Eisk – 1973 Moscow
Graphic artist. Studied at the Moscow Institute of Painting, Sculpture, and Architecture (1902–04) under Apollinary Vasnetsov and Alexei Stepanov, at the Stroganov School in Moscow (1904–05) under Stanislav-Witold Noakovsky, Sergei Yaguzhinsky, and in Paris (1905–06) under Théophile Steinlen and Eugène Grasset. Participant in exhibitions from 1902. Member of the World of Art (from 1916). Curator of the Section of Drawings and Engravings at the Russian Museum in Petrograd (1918–23). Taught in Petrograd at the Higher School of Photography and Photographic Technology (1919–23) and at VKhUTEMAS–VKhUTEIN in Leningrad (1924–31). Lived and worked in Moscow from 1944.

Miturich, Piotr Vasilyevich
1887 St. Petersburg – 1956 Moscow
Graphic artist and designer; creator of draft designs for floating and flying machines. Studied at the Kiev Art College (1906–09) and at the Higher Art School within the Academy of Arts in St. Petersburg/Petrograd (1908–16) under Nikolai Samokish. Worked in free studio "At the Tower" with Vladimir Favorsky and Konstantin Zefirov. Participant in exhibitions from 1915. Member of the World of Art and The Four Arts. Taught at VKhUTEMAS–VKhUTEIN in Moscow (1923–30) and at the Institute of Advanced Study for Painters and Graphic Artists (1930–37). Lived and worked in Moscow from 1922.

Mokh, Mikhail Nikolayevich
1911 Brest-Litovsk – 1978 Leningrad
Porcelain designer and restorer. In 1929, graduated from the Art School in Pavlovsk near Leningrad and in the same year began work as a painter of china at the Porcelain Factory in Leningrad. From 1941 to 1953, a restorer at the Hermitage Museum, and from 1953 to 1978, an artist at the Porcelain Factory in Leningrad. During his last years, worked on a contract basis.

Morgunov, Alexei Alexeyevich
1884 Moscow – 1935 Moscow
Painter. Studied at the Stroganov School in Moscow (1910s) under Sergei Ivanov and Konstantin Korovin. After 1913, came under the influence of Kasimir Malevich. Participant in exhibitions from 1907. Member of the following associations and participant in their exhibitions: Moscow Association of Artists (1907), Donkey's Tail (1912), Target (1913), Tramway V (1915), The Store (1916), and Society of Moscow Artists (1927–32). Member of the Moscow Collegium of Fine Arts of the People's Commissariat for Education (1918). Taught at the Free State Art Workshops–VKhUTEMAS in Moscow (1918–1920s). Lived and worked in Moscow.

Mordvinova, Alevtina Yevgenyevna
1900 village of Orlov Gai (Samara Province) – 1980 Leningrad
Painter and graphic artist. Studied at VKhUTEMAS–VKhUTEIN in Petrograd/Leningrad (1921–26) under Kuzma Petrov-Vodkin, Mstislav Dobuzhinsky, and Alexei Karev. Member of the Masters of Analytical Art group (from 1925). In 1927, participated in the exhibition of the Masters of Analytical Art at the Leningrad Press House. Later worked in drawing and lithography. Employed in the Children's Section of the State Publishing House under the direction of Vladimir Lebedev. Lived and worked in Petrograd/Leningrad from 1921.

Mukhina, Vera Ignatyevna
1889 Riga – 1953 Moscow
Sculptor and stage designer; also worked in the decorative arts. Studied in Moscow at the school of Konstantin Yuon (1909–11) and studied drawing in the school of Ilya Mashkov (1911), sculpture at the studio of Nina Sinitsyna (1911–12); in Paris she studied in the academies of Filippo Colarossi, La Palette, and La Grande Chaumière, in the studio of Emile-Antoine Bourdelle, the Académie des Beaux-Arts (1912–14). Participant in exhibitions from 1920. Member of the Monolith group of sculptors (1919–21), the Society of Russian Sculptors (from 1926), and The Four Arts (1925). Participated in the realization of Lenin's Plan for Monumental Propaganda. Taught at VKhUTEIN in Moscow (1926–30).

Nikritin, Solomon Borisovich
1898 Chernigov – 1965 Moscow
Painter, graphic artist, stage designer, and designer. Carried out experimental studies in the use and properties of color. Graduate of the Kiev Art College (1909–14). Studied at the decorative art studio of Alexandra Exter in Kiev (1918–20), with Leonid Pasternak and Alexander Yakovlev in Moscow and Petrograd (1914–17), and at VKhUTEMAS in Moscow (1920–22). Participant in exhibitions from 1922. One of the organizers of the Projection Theater, which in 1923 staged a production of *Tragedy A.O.U.* Organizer (together with Klement Redko, Mikhail Plaksin, Alexander Tyshler, and Sergei Luchishkin) of the Projectionists group and of Electro-organism, an exhibition held in 1922 in the Museum of Artistic Culture in Moscow. In 1923, joined the Method group. In 1924, participated in the First Discussion Exhibition of the Association of Active Revolutionary Art (with the Projectionists group), at which he came forth with a declaration. In 1922, chairman of the Scientific and Artistic Council of the Museum of Painting Culture in Moscow. In the early 1930s, became chief artist at the State Polytechnical Museum. From 1936 to 1941, chief artist of the All-Russian Agricultural Exhibition in Moscow. Lived and worked in Chernigov (from 1898), Kiev (1910–14, 1917–20) and Moscow (from 1920).

Osmiorkin, Alexander Alexandrovich
1892 Yelizavetgrad (Kherson Province) – 1953 Moscow
Painter, graphic artist, and stage designer. Took part in decorating Agit trains. Studied at the Drawing School of the Society for the Promotion of the Arts in St. Petersburg (1910), the Kiev Art Institute (1911–13) under Grigory Diadchenko, Ivan Makushenko, and Nikolai Pimonenko and in Moscow at the studio of Ilya Mashkov (1913–15). Participant in exhibitions from 1913. Member of the associations Jack of Diamonds (he showed his work at their exhibitions from 1913), the World of Art (from 1916), the Union of Russian Artists (1918), Moscow Painters (1925), and Existence (1926). Organized the Wing group (1927) and was founding member and secretary of the Society of Moscow Artists (1927–29). Taught in Moscow at the First and Second Free State Art Studios–VKhUTEMAS–VKhUTEIN (1918–30), at the Higher School of Military Camouflage in Kuntsevo (1919–20), at the Repin Institute in Leningrad and the Surikov Institute in Moscow (1932–47), (1937–48). Lived and worked in Moscow (from 1913).

Osolodkov, Piotr Alexeyevich
1898 Rybinsk – 1942 Leningrad
Painter and graphic artist. Studied at the Vrubel First Siberian Technical School of Applied Art (1920–24) and concurrently worked at the Fine Arts Studio of the 5th Red Army in Omsk. Further studies included VKhUTEIN in Leningrad (1924–29) under

Osip Braz and Alexander Savinov; work as a doctoral student at the Repin Institute in Leningrad (1932–34), where he took advanced courses (1934–36). Participant in exhibitions from 1927. Member of the Circle of Artists and participant in its exhibitions (1926–32). Lived and worked in St. Petersburg/Petrograd/Leningrad (1898–1917, from 1924) and Omsk (1917–24).

Pakhomov, Alexei Fiodorovich
1900 village of Varlamovo (Vologda Province) – 1973 Leningrad
Painter and graphic artist. Studied in Petrograd at the Baron Stieglitz Central School of Technical Drawing (1915–18) under Vasily Shukhayev and Sergei Chekhonin, and the Petrograd Free Art Studios–VKhUTEIN (1919–25) under Nikolai Tyrsa, Alexei Karev, and Alexander Savinov. Participant in exhibitions from 1923. Member of the Circle of Artists (1926–32). Published articles in the magazines *Noviy Robinzon* [*The New Robinson*] and *Zhizn' iskusstva* [*The Life of Art*] (from 1923). Worked as an artistic illustrator in the Department of Children's Literature of Ogiz and from 1925 at Detgiz and Detizdat (publishers of children's literature). Directed the drawing workshop of the Repin Institute in Leningrad (1948–73). Lived and worked in Petrograd/Leningrad from 1915.

Pakulin, Viacheslav Vladimirovich
1900 Rybinsk – 1951 Leningrad
Painter, graphic artist, and stage designer. Studied at the Baron Stieglitz Central School of Technical Drawing (1916–17, 1919?, 1920–22), and the Free Art Studios–VKhUTEIN in Petrograd/Leningrad (1922–25) under Alexei Karev, Vladimir Lebedev, and Alexander Savinov. While pursuing these studies, he also took courses leading to a degree in stage production organized in 1918 by Vsevolod Meyerhold. Participant in exhibitions from 1922. Member of the following associations and participant in their exhibitions: the Union of New Tendencies (after 1922), Circle of Artists (1926–32, founding member and chairman). From October 1919 to 1920, served in the Red Army. From 1922, worked as a designer at the Decorative Institute in Petrograd. From 1925 to 1929, member of the Board of the Fine Arts Section of the Leningrad Union of Workers' Art and from 1932, member of the directorate of the Leningrad Branch of the RSFSR Union of Artists. In 1917–18, lived in Rybinsk, where he participated in social work. Lived and worked in Petrograd/Leningrad from 1916 (?).

Palmov, Viktor Nikandrovich
1888 Samara – 1929 Kiev
Painter and graphic artist. Graduated from the Penza Art College (1910). Studied at the Moscow Institute of Painting, Sculpture, and Architecture (1910–14). Participant in exhibitions from 1919 (?). Member of the following associations and participant in their exhibitions: Society of Young Artists (?) (1919–20), Green Cat and Creativity (1919–23) in Chita, The Call (1924) in Zagorsk, the Association of the Revolutionary Art of the Ukraine (1927) in Kiev, the Union of Contemporary Artists of the Ukraine (1928), the Association of the Red Ukraine (1929), and the Association of Independent Ukrainian Artists (1932). Taught at the Chita School of Applied Art (1919?–23) and was at the same time member of the Fine Arts Department of the People's Commissariat for Education of the Far Eastern Republic. In 1920, together with David Burliuk, traveled to Japan, where he participated in the first exhibition of Russian artists. In the 1920s, lived in the Ukraine. From 1925 to 1929, taught at the Kiev Art Institute.

Pankov, Konstantin Alexeyevich
1910 Sarapul – 1942 killed in battle
Painter and graphic artist. Studied at the Experimental Sculpture Workshop under Alexei Uspensky and Leonid Mess. The workshop was organized within the Faculty of the Northern Peoples of the Yenukidze Oriental Institute in Leningrad.

Pavlov, Semion Andreyevich
1893 St. Petersburg – 1941 Leningrad
Painter and graphic artist. Studied at the Drawing School of the Society for the Promotion of the Arts in St. Petersburg, the Petrograd Free Artistic Workshops–VKhUTEMAS in Petrograd (1917–22) under Dmitry Kardovsky, Kuzma Petrov-Vodkin, and Vasily Shukhayev. Member of the Community of Artists (1922–27), Sixteen (1923–24), and one of the founding members of the Leningrad Branch of AKhRR–AKhR (from 1924). Participated in exhibitions from 1918. From 1932 taught at VKhUTEIN in Leningrad. Lived and worked in Petrograd/Leningrad.

Pestel, Vera Yefremovna
1887 Moscow – 1952 Moscow
Painter and graphic artist; also worked in the field of applied art. In the 1900s attended the private studio of Faliz, studied at the Stroganov School in Moscow (1904–06), the studio of Konstantin Yuon (1906–07), and

under Karoi Kiss, a pupil of Simon Hollósy (1909–11). Worked in the free studio "At the Tower" (together with Vladimir Favorsky, Piotr Miturich, and Konstantin Zefirov (1912). In 1930, whilst in Paris with Nadezhda Udaltsova, did drawings in free studios. Participant in exhibitions from 1916. Member of the following associations and participant in their exhibitions: The Store (1916), World of Art (1917, Petrograd), Makovets (1922–26), the L'Araignée (Spider) group (1925, Paris), and the Way of Painting. Lived and worked in Moscow.

Petrov-Vodkin, Kuzma Sergeyevich
1878 Khvalynsk – 1939 Leningrad
Painter, graphic artist, stage designer, and art theorist. Studied in the Fiodor Burov classes of painting and drawing in Samara (1894–95), at the Baron Stieglitz Central School of Technical Drawing in St. Petersburg (1895–97), at the Moscow School of Painting, Sculpture, and Architecture (1897–1904) under Abram Arkhipov, Nikolai Kasatkin, and Valentin Serov, in the Ažbe studio in Munich (1901), and in private academies in Paris, including Académie Colarossi (1905–08). Participant in exhibitions from 1908. Took part in the exhibitions of the Golden Fleece (1900s), Union of Russian Artists (1909–10), Fire-Color (1924), AKhRR (1928). Member of the following unions: World of Art (1910–22), Union of Artists Attached to the House of Arts (1920–21), The Four Arts (1925–28). Visited Warsaw, Prague, Leipzig, and Munich (1901), Turkey and Italy (1905). Working tours to North Africa (1907), Central Asia (1921), and Paris (1924–25). Taught at the Zvantseva school (from 1910), the Higher Art School of the St. Petersburg Academy of Arts–Repin Institute (1918–32). Lived and worked in St. Petersburg/Petrograd/Leningrad from 1908.

Plastov, Arkady Alexandrovich
1893 village of Prislonikha (Simbirsk Province) – 1972 Prislonikha (Ulyanovsk Region)
Painter and graphic artist. Studied at the Simbirsk Theological Seminary (1908–12), where Dmitry Arkhangelsky taught drawing and painting. Attended courses at the Stroganov School in Moscow (1912–14). Studied painting on the advice of Fiodor Fedorovsky. Studied in the Sculpture Section at the Moscow Institute of Painting, Sculpture, and Architecture (1914–17) under Sergei Volnukhin, and attended the painting studios where instruction was given by Apollinary Vasnetsov, Alexander Korin, Leonid Pasternak, and Alexei Stepanov.

Participant in exhibitions from 1921. Lived and worked in Prislonikha (1917–25) and Moscow (from 1925).

Poret, Alisa Ivanovna
1902 – 1984 Moscow
Painter and graphic artist; also worked in applied art. Studied at the Drawing School of the Society for the Promotion of the Arts in Petrograd (1920–21) and VKhUTEMAS–VKhUTEIN in Petrograd/Leningrad (1921–25) under Kuzma Petrov-Vodkin. Member of the Masters of Analytical Art group and worked in the Children's Department of the State Publishing House under the direction of Vladimir Lebedev. From 1944 lived in Moscow.

Puni, Ivan Albertovich [Jean Pougny]
1894 Kuokkala (now Repino, near St. Petersburg) – 1956 Paris
Painter, graphic artist, and stage designer. Studied under Ilya Repin, then in the military school in St. Petersburg (1900–08) and in Paris in various studios including the Académie Julian (1909–10). Participant in exhibitions from 1912. Member of the following associations and participant in their exhibitions: Union of Youth (1912–13), Jack of Diamonds (1916–17), The Four Arts (1928). One of the organizers of Tramway V (1915) and 0.10 (1915–16) and a participant in their exhibitions; exhibited at the Salon des Indépendants (Paris) in 1913 and 1914. In 1918 taught at the Petrograd Free Art Studios and in 1919 at VKhUTEMAS in Vitebsk under the direction of Marc Chagall. Lived and worked in Kuokkala, St. Petersburg/Petrograd (1894–1909, 1912–19), Finland (1919–20), Vitebsk (1919), Berlin (1920–23), and Paris (from 1923).

Radonich, Bosilka Stepanovna
Born 1884 Bessarabia – ?
In the 1920s, she worked as an artist painting porcelain at the Porcelain Factory in Leningrad.

Redko, Kliment Nikolayevich
1897 Kholm (Helm, Poland) – 1956 Moscow
Painter and graphic artist. Studied at the School of Icon Painting in the Kiev Monastery of the Caves (1910) and at the Drawing School of the Society for the Promotion of the Arts in Petrograd (1914–15) under Arkady Rylov, Alexander Vakhrameyev, and Nikolai Roerich. In 1915, volunteered for duty on the front, where he became a pilot. Between 1918 and 1920, came under the influence of Suprematism. Studied at the Kiev

Art College (1918) and worked in the Decorative Art Studios in Kiev (1918–20, with Solomon Nikritin). He made the acquaintance of Mikhail Boichuk. Studied at the Free State Art Studios–VKhUTEMAS in Moscow (1920–21) under Wassily Kandinsky. Participant in exhibitions from 1922. One of the organizers of the Projectionists group (creator of the "Electro-organism" trend, 1922), and participant in this group's exhibition at the Museum of Painting Culture in Moscow (1922). Participated in the First Discussion Exhibition of the Association of Active Revolutionary Art (1924, with the group known as The Method). From 1927 to 1935, was on a creative assignment in France. Lived and worked in Kiev, St. Petersburg, Paris, and Moscow.

Rodchenko, Alexander Mikhailovich
1891 St. Petersburg – 1956 Moscow
Painter, graphic artist, designer, photographer, stage and cinema designer, and architect. Studied at the School of Art run by Nikolai Feshin and Grigory Medvedev in Kazan (1910–14) and at the Stroganov School in Moscow (1914–17). Participant in exhibitions from 1913. Member of the following associations and participant in their exhibitions: The Store (1916), the Society of Young Artists (1920–21), 5 x 5=25 (1921). Organizer of and participant in the exhibition of the Third Comintern Congress (1920) and member of the October group (1930). In 1917, together with Vladimir Tatlin and Georgy Yakulov, worked on the interior design of the Café Pittoresque. In 1917–18, he was secretary of the Leftist Federation, a professional union of artists, member of the Fine Arts Department of the People's Commissariat for Education (head of the Museum Office and member of the Acquisitions Commission and later director of the Museum of Painting Culture in Moscow). In 1918, taught the theory of painting at the studio school of Moscow Proletkult and was a member of the presidium of the Board of the Union of Painters. In 1920, one of the organizers of the Union of Workers' Art and a member of the presidium of the Fine Arts Section of the Union of Workers' Art. From 1920 to 1924, member of the initiative group for the creation of INKhUK and organized the working group of Constructivists within the institute (1920–30). Professor at VKhUTEMAS–VKhUTEIN in Moscow, and in 1921 became director of the fine arts studio in the Sverdlov Club at the School of the All-Russian Central Executive Committee. From 1922, actively participated in the magazines *Kino–fot* [Cinema–Photo],

LEF, Ogoniok [Light], and others. From 1927 to 1935, member of the commission for exhibitions within the All-Russian Society of Cultural Connections. In 1928, became member of the Council of the Association of Portrait Photographers at the Press House. In 1929–30, worked in the Revolutionary Front of the Arts Group headed by Vladimir Mayakovsky. In 1932, lectured on a photography course at the Moscow Polygraphic Institute. In 1925, visited Paris. Lived and worked in Kazan (1910?–14), Moscow (1914–41, 1941–56), Ochera, and Perm (1941–42).

Rusakov, Alexander Isaakovich
1898 Sevsk (Orel Province) – 1952 Leningrad
Painter. Studied under the artist Mikhail Ignatyev, attended the studio school of Yelizaveta Zvantseva in St. Petersburg (1910s), and studied at the Petrograd Free Art Studios–VKhUTEIN (1918–24) under Nikolai Dubovskoi, Dmitry Kardovsky, and Osip Braz. Participant in exhibitions from 1925. Member of the foolowing associations and participant in their exhibitions: Society of Artists (1925–27), Circle of Artists (1926–32; founding member). Lived and worked in St. Petersburg/Petrograd/Leningrad.

Rybchenkov, Boris Fiodorovich
Born 1899 Smolensk
Painter and graphic artist. Studied at the Kiev Art Institute (1915–18) under Anna Prakhova-Kruger, and Nikolai Strunnikov, the Free Art Studios in Petrograd (1920–21) under Nathan Altman and Alexander Matveyev, and VKhUTEMAS in Moscow (1921–25) under Liubov Popova, Alexander Drevin, and Alexander Shevchenko. Directed the fine arts studio of Proletkult in Smolensk (1919), taught drawing at general education schools, and worked with amateur artists. Member of the ROST Society of Artists (after 1928). Worked for the Windows of Satire of the Western Front ROSTA and designed decorations for propaganda trains. Subsequently participated in exhibitions in the USSR and abroad. Since 1921, has lived in Moscow.

Samokhvalov, Alexander Nikolayevich
1894 Bezhetsk – 1971 Leningrad
Peinter, graphic artist, stage designer, and sculptor; author of architectural projects; also worked in applied art.
Studied in the Faculty of Architecture at the Higher Art Institute within the Academy of Arts in Petrograd (1914–17) under Valentin Beliayev and Gugo Zaleman, and at the

Faculty of Painting of the Petrograd Free Art Studios–VKhUTEIN (1920–23) under Kuzma Petrov-Vodkin, Dmitry Kardovsky, and Arkady Rylov. Participant in exhibitions from 1917. Member of the following associations and participant in their exhibitions: the World of Art (1917), Society of Artists (1922), Union of New Tendencies (1922), Fire-Color (1924), Circle of Artists (1926–29), October (after 1930). In 1921, traveled to Central Asia. In 1924–25, made a trip to the village of Navolok near Novgorod and thereafter participated in restoration works at the St George Cathedral in Staraya Ladoga. Lived and worked in Petrograd/Leningrad from 1914.

Saryan, Martiros Sergeyevich
1880 Nakhichevan-on-Don – 1972 Yerevan
Painter, graphic artist, and stage designer. Studied at the Moscow Institute of Painting, Sculpture, and Architecture (1897–1904) under Konstantin Korovin and Valentin Serov. Participant in exhibitions from 1907, including those of the Blue Rose (1907) and World of Art (1913–15). Member of the Union of Russian Artists (1910–11) and The Four Arts society (1925–29). Lived and worked in Yerevan from 1921.

Sashin, Andrei Timofeyevich
1896 – 1965
Painter, graphic artist, and stage designer. Member of the Masters of Analytical Art group. In 1927, participated in the exhibition of the Masters of Analytical Art in the Leningrad Press House. Author of costume designs for Gogol's *The Inspector General*, which was staged in the Press House.

Shchekatikhina-Pototskaya, Alexandra Vasilyevna
1892 Alexandrovsk – 1967 Leningrad
From 1908 to 1915, studied under Nikolai Roerich and Ivan Bilibin at the Drawing School of the Society for the Promotion of the Arts in St. Petersburg/Petrograd. In 1913, worked in Paris in the studios of Maurice Denis, Félix Vallotton, and Paul Cérusier. From 1912 to 1920, worked as a stage designer. From 1915, participated in exhibitions of the World of Art. Between 1918 and 1923, artist at the Porcelain Factory in Petrograd. In 1923, traveled extensively in Egypt, Syria, and Palestine. From 1925 to 1936, lived in Paris, where she contributed to exhibitions at the Salon d'Automne and Salon des Indépendants. Awarded a medal at an exhibition held in Paris in 1925 (decorative art). From 1936 to 1955, artist at the Porcelain Factory in Leningrad.

Shchukin, Yury Prokopyevich
1904 Voronezh – 1935 Moscow
Painter, stage designer, and designer of revolutionary festivities. From 1919 to 1922, trained at the Free Art Studios in Voronezh under Nikolai Maximov and Sergei Romanovich and at VKhUTEMAS–VKhUTEIN in Moscow (1922–30) under Piotr Konchalovsky, Isaac Rabinovich, and Vasily Sakhnovsky. Participant in exhibitions from 1925. Member of the Association of Artists of the Revolution (from 1929). Lived and worked in Moscow from 1922.

Shevchenko, Alexander Vasilyevich
1883 Kharkov – 1948 Moscow
Painter and graphic artist. Studied at the Stroganov School in Moscow (1899–1907) under Konstantin Korovin, Mikhail Vrubel, and Nikolai Andreyev as well as at the Moscow Institute of Painting, Sculpture, and Architecture (1907–10) under Valentin Serov and Konstantin Korovin. In Paris, he worked at the studio of Eugène Carrière and the Académie Julian (1905–06) under Alphonse Dinet and Jean-Paul Laurens. Participant in exhibitions from 1903. Member of the following associations and participant in their exhibitions: World of Art (1904, 1917, 1922), Donkey's Tail (1912), Makovets (1922), and Painters' Workshop (1926–30). Taught at the First Free State Art Studios–VKhUTEMAS–VKhUTEIN in Moscow (1918–29), the Ukrainian Academy of Arts (1921), the Repin Institute in Leningrad (from 1930), the Stroganov School in Moscow, and the Moscow Textile Institute (from 1940). Lived and worked in Moscow from 1898.

Shterenberg, David Petrovich
1881 Zhitomir – 1948 Moscow
Painter, graphic artist, and stage designer. Studied in art studios in Odessa (1906), in Paris at the Ecole des Beaux-Arts and the Académie Vitti under Henri Martin, Kees van Dongen, and Ermenhildo Anglado-y-Camarasa (1906–12). Participant in exhibitions from 1912 (including the Salon du Printemps, Salon d'Automne, and Salon des Indépendants in Paris). In 1917, participated in a group exhibition together with Henri Matisse, Amedée Ozenfant, and Maurice Utrillo (Paris). In 1922, participated in the Exhibition of Three with Nathan Altman and Marc Chagall in Moscow and the L'Araignée (Spider) group (1925) in Paris. One of the organizers and chairman of the Society of Easel Painters (1925–32). In 1917–18, Commissar for Art Affairs. From 1918

to 1920, head of the Fine Arts Department of the People's Commissariat for Education. From 1920 to 1930, professor at VKhUTEMAS–VKhUTEIN in Moscow. Visited Vienna in 1906 and Paris in 1925. Lived and worked in Zhitomir (1881–1906), Odessa (1906), Paris (1906–12), Petrograd (1917–18), and Moscow (from 1918).

Sinezubov, Nikolai Vladimirovich
1891 Moscow – 1948 Paris
Painter and graphic artist. Studied at the Moscow Institute of Painting, Sculpture, and Architecture (1912–17) and at the same time studied law. Participant in exhibitions from 1918. Member of the following associations and participant in their exhibitions: Moscow Association of Artists (1918, 1922, 1924), the World of Art (1921, 1922, Moscow), and Makovets (1924, 1926). In 1920, participated in the "Exhibition of Four" with Wassily Kandinsky, Alexander Rodchenko, and Varvara Stepanova. Headed the Proletkult Studio (1919). Lived and worked in Moscow (1891–1921, 1923–28) and Paris (from 1928).

Slonim, Ilya Lvovich
1906 Tashkent – 1973 Moscow
Sculptor. Studied sculpture under Marina Ryndziunskaya in Moscow (1923) and at VKhUTEMAS–VKhUTEIN in Moscow (1924–29) under Ivan Yefimov and Iosif Chaikov. Member of the Society of Russian Sculptors from 1931. Participant in exhibitions from 1931.

Sokolov, Mikhail Ksenofontovich
1885 Yaroslavl – 1947 Moscow
Painter and graphic artist. Studied at the Stroganov School in Moscow (1904–07) under Stanislav-Witold Noakovsky and Sergei Yaguzhinsky. Participant in exhibitions from 1912. Showed his works at the exhibitions of the World of Art. Taught at art studios in Tver and Sergach (1919–21), the Fine Arts Studio of Proletkult in Moscow (1922–25), the Pedagogical Art School in Yaroslavl (1925–29) and on advanced courses for artists in Moscow.

Sokolov, Piotr Ivanovich
1892 Moscow – 1943
Painter, graphic artist, book and stage designer. Studied at the Ivan Kopylov Art School in Irkutsk (1910–13), in private studios in Paris (1913–14), and in the Petrograd Free Art Studios–VKhUTEMAS (1918–22) under Kuzma Petrov-Vodkin. Participant in exhibitions from 1920, including that of the Sixteen society (1923–24). From 1926 to 1928, headed the fine arts studio at the Faculty

of the Northern Peoples of the Yenukidze Oriental Institute in Leningrad. In the 1930s, chief artist of the Bolshoi Theater in Moscow. Lived and worked in Irkutsk, Moscow, and Petrograd/Leningrad.

Stenberg, Vladimir Avgustovich
1899 Moscow – 1982 Moscow

Stenberg, Georgy Avgustovich
1900 Moscow – 1933 Moscow
Painters, graphic artists, stage designers, sculptors, designers, and architects. Studied at the Stroganov School in Moscow (1912–17), in the Theater-Art Section of the Chasing and Embossing Workshop. Further studies included the Free State Art Studios (1917–20) at the Painting and Sculpture Departments in a studio without a master (with Nikolai Denisovsky, Vasily Komardenkov, Konstantin Medunetsky, Sergei Svetlov, and Nikolai Prusakov). Participants in exhibitions from 1919. Members of the Society of Young Artists (1919–21). In 1920, became members of INKhUK in Moscow, where, together with Medunetsky, they organized an exhibition of Constructivists and were among the organizers of the Laboratory of Constructivism. In 1924, participated in the First Discussion Exhibition of the Associations of Active Revolutionary Art (in the group of Constructivists). From 1923 to 1935, associated with the Leftist Art Front. In 1923, began to work on movie posters. From 1924 to 1931, worked for the theater of Alexander Tairov. Between 1929 and 1932, taught at the Moscow Institute of Architecture and Building. Subsequently, Vladimir Stenberg worked on decorations for festivities in Moscow and also as an engineer, designing train cars and subways.

Strzheminsky, Vladislav Maximilyanovich
1893 Minsk – 1952 Lodz (Poland)
Painter, graphic artist, stage designer, and art theorist. Studied at the School of Military Engineering in St. Petersburg (1911–14) and at the Free State Art Studios in Moscow (1918–19). Came under the influence of Kasimir Malevich's Suprematism. Participant in exhibitions from 1919. Fought in the First World War (1914–16), where he was wounded, his right leg and left arm being amputated. In 1918 and 1919, member of the Collegium for Art Affairs of the People's Commissariat for Education in Moscow. In 1920–21, taught at the Free Studios in Smolensk and was a member of the local branch of UNOVIS (from 1919). Headed the Smolensk branch of UNOVIS (1919–21).

In 1922 moved to Poland. In Poland, co-founded the groups Blok (1924–26), Praesens (1926–29), and A. R. (1929–36). Created his own version of abstract painting – Unism. From 1925 to 1936, compiled the book *Teoriya videniya* [*The Theory of Vision*]. Lived and worked in St. Petersburg, Moscow, Smolensk (1920–21), and Poland (from 1922; in Lodz, from 1931).

Stroyev, Piotr Feonovich
1898 Penza – 1941 killed in action
Painter and sculptor. Studied at the First Irkutsk Art Studio (1922–26) under Ivan Kopylov and at VKhUTEIN in Leningrad (1926–28). Participant in exhibitions from 1927. Member of the union of artists New Siberia (1927–28). Lived in Irkutsk until 1926 and then in Leningrad.

Suetin, Nikolai Mikhailovich
1897 Miatlevskaya Station (Kaluga Province) – 1954 Leningrad
Painter, graphic artist, porcelain decorator, and designer. From 1918 to 1922, studied at the Higher Practical Art Institute in Vitebsk under Kasimir Malevich. Member of the UNOVIS group. Participant in exhibitions from 1920. From 1923, lived in Petrograd and worked at the Porcelain Factory; from 1932, chief artist at the Factory. From 1923 to 1926, member of the GINKhUK in Petrograd/Leningrad, working in the formal-theoretical section and the general ideological section together with Malevich, Yermolayeva, Chashnik, and others. From 1927 to 1930, worked in the Experimental Laboratory of the Institute of Art History in Leningrad. Worked on the design of Industrial Arts Exhibitions (1925, Paris; 1937, New York).

Sulimo-Samuillo, Vsevolod Angelovich
1903 Velikiye Luki – 1965 Leningrad
Graphic artist, stage designer, and designer. Studied at the Leningrad Industrial Arts College (1924–26) under Pavel Mansurov and Mikhail Bobyshov. Attended Pavel Filonov's school known as the Masters of Analytical Art (1926–30). Created designs for festivities, physical culture parades, theatrical and circus shows, and the interiors of theaters, institutes, and sanatoriums in a number of cities across the USSR (1928–33). In the 1950s, participated in designing the pavilions of the All-Russian Agricultural Exhibition in Moscow and at the International Exhibition in Brussels. Taught at the Faculty of Theater Production of the Ostrovsky Theater Institute in Leningrad from 1958. Lived and worked in Leningrad from 1924.

Suvorov, Innokenty Ivanivich
1898 Irkutsk – 1947 Leningrad
Sculptor. Studied at VKhUTEMAS–VKhUTEIN in Petrograd/Leningrad (1922–27) under Alexander Matveyev. Member of the Masters of Analytical Art group (1927–29). Participant in exhibitions from 1927.

Tambi, Vladimir Alexandrovich
1906 St. Petersburg – 1955 Leningrad
Graphic artist. Studied at the Workers–Artists' Studio of Proletkult (1920) and at VKhUTEMAS–VKhUTEIN in St. Petersburg/Petrograd (1921–24). Participant in exhibitions from 1924. Worked in the Children's Section of the State Publishing House under the direction of Vladimir Lebedev and in the experimental graphic workshop of the Leningrad Branch of the RSFSR Union of Artists (1930s). One of the authors of the Fighting Pencil (1941). Art editor of the Estonian SSR State Publishing House (1944–46). Lived and worked in St. Petersburg/Petrograd/Leningrad.

Tatlin, Vladimir Yevgrafovich
1885 Moscow – 1953 Moscow
Painter, graphic artist, stage designer, designer, and author of architectural and engineering design projects. Studied in Penza at the Art School of N. D. Seliverstov (1904–10) under Ivan Goriushkin-Sorokopudov and Alexei Afanasyev and at the Moscow Institute of Painting, Sculpture, and Architecture (1902–03 and 1909–10) under Valentin Serov and Konstantin Korovin. Participant in exhibitions from 1910. Member of the following associations and participant in their exhibitions: Donkey's Tail (1912), World of Art (1913), Jack of Diamonds (1913), Union of Youth (1911–14), Tramway V (1915), The Store (1916), 0.10 (1915–16), and the Union of New Tendencies (1922–23); chairman of the society in 1921. In 1902 and 1904, visited France, Syria, Turkey, and Morocco as a sailor. In 1913, visited Berlin and Paris where he made Pablo Picasso's acquaintance. Upon his return, organized an exhibition of "synthetically static compositions" in his studio, where he also showed counter-reliefs (1914). In 1917, together with Georgy Yakulov and Alexander Rodchenko, did design work for the Café Pittoresque. In 1917, was chairman of the Leftist Federation of Artists in Moscow. In 1918–19, he was head of the Moscow Art Collegium of the Fine Arts Department of the People's Commissariat for Education. He carried out organizational work for Lenin's Plan of Monumental

Propaganda. In 1918–19 (1920?), taught at the Free Art Studios in Moscow. From 1919 to 1924, worked at the Petrograd Free Art Studios–VKhUTEMAS. From 1925 to 1927, professor at the Kiev Art Institute and worked in the Theater and Cinema Department. Between 1927 and 1930, professor at VKhUTEIN in Moscow. From 1921 to 1924, member of the permanent commission and then Head of the Section of Material Culture at the Museum of Artistic Culture of GINKhUK in Petrograd/Leningrad. In 1921, attempted to organize the Laboratory of New Artistic Forms at the New Lessner Factory in Petrograd. In 1922, one of the initiators who created the Institute of Artistic Culture in Petrograd. In 1923–24, worked on new designs of furniture, clothing, and crockery. In 1920, created a model of a monument to the Third International and in 1925, showed the model at the International Exhibition of Decorative Art in Paris (gold medal). From 1929 to 1932, head of the Experimental Research Laboratory at the People's Commissariat for Education and worked on an apparatus known as the Letatlin ("Tatlin Flying Machine," a pun on the verb *letat'*, to fly).
In 1931–32, head of the Ceramics Faculty at the Institute of Silicates in Moscow. Lived and worked in Kharkov (1885–1902), Penza (1904–10), Moscow (1902–03, 1910–19, after 1927), Petrograd (1919–24), and Kiev (1925–27).

Tsaplin, Dmitry Filippovich
1890 village of Maly Melik (Balashov District, Saratov Province) – 1967 Moscow
Sculptor. Studied at the Higher Free Art Studios in Saratov (formerly the Bogoliubov School of Drawing, 1919–20) under Anton Lavinsky. From 1927 to 1935, lived and worked abroad, in France, Spain, and England (he was sent abroad after his first one-man show in Moscow "to perfect his artistic abilities"). Member of the Society of Russian Sculptors from 1926. Participant in exhibitions from 1924.

Tyrsa, Nikolai Andreyevich
1887 Aralakh, Armenia – 1942 Vologda
Painter and graphic artist; also worked with glass. Studied at the Higher Art Institute within the Academy of Arts in St. Petersburg (1905–09, with intervals) and the Yelizaveta Zvantseva studio school in St. Petersburg (1907–10) under Léon Bakst. Participant in exhibitions from 1918. Member of the Union of Youth, the Union of New Tendencies (1922), and The Four Arts (1926–28).

Studied at the Baron Stieglitz Central School of Technical Drawing – the Repin Institute, Petrograd/Leningrad (1917–36), as well as at the Leningrad Institute of Municipal Engineering (1924–42). One of the authors of the Fighting Pencil (1941). Lived and worked in St. Petersburg/Petrograd/Leningrad.

Tyshler (Dzhin-Dzhikh-Shvil), Alexander Grigoryevich
1898 Melitopol – 1980 Moscow
Painter, graphic artist, stage and cinema designer, and sculptor. Studied at the Kiev Art College (1912–17) under A. I. Monastyrsky, Ivan Selezniov, and Nikolai Strunnikov. Also worked in the studio of decorative art of Alexandra Exter in Kiev. In Moscow studied at VKhUTEMAS (1921–23) under Vladimir Favorsky. Participant in exhibitions from 1920. Member of the Society of Easel Painters from 1926. Lived and worked in Moscow from 1921.

Uspensky, Alexei Alexandrovich
1892 St. Petersburg – 1941 Leningrad
Painter and graphic artist; also worked in the decorative arts. Graduate of the Baron Stieglitz Central School of Technical Drawing in St. Petersburg (1917). Member of the Union of New Tendencies in Art (from 1922). Participant in exhibitions from 1922. In the 1920s, worked on the magazines *Begemot* [*Hippopotamus*], *Smekhach* [*The Big Laugher*], *Chizh* [*Siskin*], and *Yozh* [*Hedgehog*]. Illustrated the books of Mikhail Zoshchenko, Yury German, and others. Directed the Children's Art School of the Moscow–Narva District of Petrograd (1918–23). Worked with Vera Mukhina and Nikolai Tyrsa in the Experimental Workshop of the Leningrad Artistic Glass Factory where he created models for Soviet artistic glass (1940). Taught at the Repin Institute (1930–34) and the Yenukidze Oriental Institute of Northern Peoples in (1934–41) Leningrad. Lived and worked in St. Petersburg/Petrograd/Leningrad.

Vasnetsov, Yury Alexeyevich
1900 Viatka (now Kirov) – 1973 Leningrad
Painter and graphic artist; also worked in the decorative arts. Studied at VKhUTEMAS–VKhUTEIN in Petrograd (1921–26) under Alexei Karev, Osip Braz, and Kuzma Petrov-Vodkin. Came under the influence of Mikhail Matiushin. At GINKhUK in Leningrad (1926–28), studied under Kasimir Malevich, and on the advanced level courses of the All-Russian Art Academy (1932–34), under Vladimir Lebedev. Participant in exhibitions from 1932. Worked in the Children's Department of the State Publishing House

under the direction of Vladimir Lebedev. From 1943 to 1945, worked as chief artist of the Research Institute of Toys in Zagorsk. In 1938, worked at the Experimental Lithographic Workshop of the Leningrad Branch of the RSFSR Union of Artists. Lived and worked in Petrograd/Leningrad from 1921.

Vereisky, Georgy Semionovich
1886 Proskurov (Podolsk Province) – 1962 Leningrad
Graphic artist. Studied, with intervals, in the studio of Yegor Shreider in Kharkov (1895–1904), at the Faculty of Law of Kharkov University (1904–12) and at the New Art Workshop in St. Petersburg (1913–16) under Mstislav Dobuzhinsky, Boris Kustodiev, Anna Ostroumova-Lebedeva, and Yevgeny Lanceray. Participant in exhibitions from 1904. From 1915, member of the World of Art. Assistant keeper of the Department of Engravings at the Hermitage (1918); keeper of the same department (1921–30). Taught at the Baron Stieglitz Central School of Technical Drawing (1918), the Higher Institute of Photography and Photographic Technology (1918), and VKhUTEMAS–VKhUTEIN in Petrograd (1921–23). Lived and worked in St. Petersburg/Petrograd/Leningrad from 1913.

Voinov, Sviatoslav Vladimirovich
1890 – 1920 Petrograd
Painter and graphic artist.

Volkov, Alexander Nikolayevich
1886 Fergana – 1957 Tashkent
Painter, graphic artist, and stage designer. Studied at St. Petersburg University in the Faculty of Natural Sciences (1906–08) and attended David Bortniker's private studio in St. Petersburg (from 1907). Studied at the Higher Art Institute within the Academy of Arts in St. Petersburg (1908–11) under Vladimir Makovsky, in the studio of Mikhail Bernstein (1910–12) under Nikolai Roerich, Ivan Bilibin, and Leonid Shervud as well as at the Kiev Art College (1912–16) under Fiodor Krichevsky and Vladimir Menk. Participated in exhibitions from 1920. Member of the following associations and participant in their exhibitions: AKhRR–AKhR (from 1927), Masters of the New East (from 1928), the Tashkent Artists' Association ARIZO (1930). Lived and worked in Tashkent.

Yefimov, Ivan Semionovich
1878 Moscow – 1959 Moscow
Sculptor specializing in animal forms, graphic artist, and stage designer; also worked in the

decorative arts. Studied in the private studio of N. A. Martynov in Moscow (1896–98), in the Yelizaveta Zvantseva studio school in Moscow (1898–1901), with Valentin Serov and Konstantin Korovin, in the Faculty of Natural Sciences of Moscow University (1898–1900), and at the Moscow Institute of Painting, Sculpture, and Architecture (1906–08, 1912–13) under Valentin Serov and Sergei Volnukhin. From 1908 to 1911, lived in Paris and worked in the workshop of Emile-Antoine Bourdelle. Member of the Moscow Partnership of Artists (from 1907), The Four Arts (1925), and the Society of Russian Sculptors (1926). Participant in exhibitions from 1906.

Yepifanov, Gennady Dmitryevich
1900 Rostov Veliky (Yaroslavl Province) – 1985 Leningrad
Graphic artist. Studied at the Rostov Musical College (1919–22), the Yaroslavl College of Industrial Design (1924), and at VKhUTEIN in Leningrad (1925–30) under Dmitry Mitrokhin, Vladimir Konashevich, and Victor Zamirailo. Participant in exhibitions from 1932. Worked at the Rostov Museum of Antiquities (1922–23). Cooperated with publishing houses (from 1930). During the Second World War, an author of the Fighting Pencil (1941–42). Taught at the Leningrad Department of the Moscow Printing Institute (1950–70), and the Repin Institute in Leningrad (1948–50, 1973–78). Lived and worked in Leningrad.

Yermolayev, Boris Nikolayevich
1903 St. Petersburg – 1982 Leningrad
Painter and graphic artist. Studied at the Leningrad Industrial Arts College (1921–25) under Vitaly Fedorovich and Mikhail Avilov. Worked for the magazines *Rezets* [*Cutting Edge*], *Krasnaya panorama* [*Red Panorama*], and *Yuniy proletariy* [*The Young Proletarian*] (1928–31). Member of the Society of Artists (from 1928) and Artists' Guild. Participant in exhibitions from 1928. Lived an worked in St. Petersburg/Petrograd/Leningrad.

Yermolayeva, Vera Mikhailovna
1893 Petrovsk (Saratov Province) – 1938 Karaganda Region (died in the GULAG)
Painter and graphic artist. Studied in St. Petersburg in the studio of Mikhail Bernshtein and Leonid Shervud (1911–14). In 1917, graduated from the Archeological Institute in Petrograd. Member of the Petrograd IZO (1918). In 1918–19, worked in the Petrograd City Museum. In 1918, organized the Today workshop of artists. From 1919 to 1923,

principal of the Vitebsk Practical Art Institute. Member of the UNOVIS group (1920). Participated in UNOVIS exhibitions in Moscow (1920–21). Director of the Color Laboratory at GINKhUK (1923–26). From 1925, worked in the Children's Department of the State Publishing House in Leningrad.

Yevgrafov, Nikolai Ivanovich
1904 Nizhni Novgorod – 1941 killed on the front near Leningrad
Painter and graphic artist. Studied at the State Free Art Workshops in Nizhni Novgorod (1921–23) and at the Industrial Arts College in Petrograd/Leningrad (1923–27). In 1924, accepted as a trainee in the Formal-Theoretical Department of GINKhUK in Leningrad, headed by Kasimir Malevich. Studied at VKhUTEIN– the Repin Institute in Petrograd/Leningrad (late 1920s–1930s). From 1927 to 1932, member of the group Masters of Analytical Art. Lived and worked in Nizhni Novgorod and Leningrad.

Yudin, Lev Alexandrovich
1903 Vitebsk – 1941 killed at the front near Leningrad
Painter, graphic artist, designer, and creator of paper sculptures. Studied at the Vitebsk Practical Art Institute (1919–22) and VKhUTEIN in Petrograd (1922–23). Participant in exhibitions from 1920. Member and participant in the exhibitions of UNOVIS (1920–22). From 1923, member of the Institute of Artistic Culture in Petrograd and a scientific assistant of the Formal Theoretical Section (1923). Influenced by the paintings and theoretical views of Kasimir Malevich. Lived and worked in Vitebsk (until 1922) and in Petrograd/Leningrad thereafter.

Yudovin, Solomon Borisovich
1892 Beshenkovichi (Vitebsk Province) – 1964 Leningrad
Graphic artist. Studied in the studio of Yury Pen in Vitebsk (1906–10), at the Drawing School of the Society for the Promotion of the Arts in St. Petersburg (1911–13), in the studio of Mikhail Bernshtein (1911–13), under Mstislav Dobuzhinsky (up to 1919), and at the Vitebsk Practical Art Institute (1919–22) under Lazar (El) Lissitzky. Participant in exhibitions from 1916. From 1924, lived and worked in Leningrad.

Zagoskin, David Yefimovich
1900 Surazh (Vitebsk Province) – 1942 Leningrad
Painter and graphic artist. Studied at the Odessa Art College (1916–17),

and at VKhUTEMAS in Saratov (1918–20?). Participant in exhibitions from 1918 (?). From 1922, lived in Petrograd/Leningrad. Member of the Circle of Artists (1926–29). Taught at the Free Art Workshops–Higher Institute of Art and Technical Design in Saratov (1920–22), VKhUTEMAS–VKhUTEIN (1922–26), headed the graphic workshop of IZORAM (Art of Working Youth) (1926–29), taught at the Leningrad Industrial Arts College (1929–32), and the Repin Institute in Leningrad (1930–36).

Zaklikovskaya, Sophia Liudvikovna
1899 St. Petersburg – 1975 Leningrad
Painter and graphic artist; also worked in the decorative arts. Studied at the Pskov Art College (1919–22) and at VKhUTEMAS–VKhUTEIN in Petrograd/Leningrad (1921/2?–26) under Mikhail Matiushin; concurrently (from 1925) studied under Pavel Filonov and was a member of the Masters of Analytic Art group (1927–32). Participated in the creation of illustrations for the Finnish epic *Kalevala* (1933) by Filonov's group. Lived and worked in Pskov (1902–21/2?), Petrograd/Leningrad (1921/2?–41?), from 1943 evacuated in Omsk, Yaroslavl, and Komsomolsk-on-Amur.

Zaltsman, Pavel Yakovlevich
1912 Kishenev – 1985 Alma-Ata
Painter, graphic artist, stage and cinema designer, and art historian. Studied at the Leningrad Institute of the History of Arts (1928–32) and attended Pavel Filonov's group Masters of Analytical Art (1928–30). Designer of the cinema studios "Lenfilm" (1931–43) and "Kazakhfilm" (after 1953). Taught at the Theatrical College (1946–53) and the Kazakh State University (1949–57) in Alma-Ata. From 1924 to 1943, lived and worked in Leningrad and thereafter in Alma-Ata.

Zlatovratsky, Alexander Nikolayevich
1878 St. Petersburg – 1960 Moscow
Sculptor. From 1895 to 1900, studied under Sergei Konionkov in Moscow and from 1902 to 1905, at the Academy of Arts in St. Petersburg under Vladimir Beklemishev and Gugo Zaleman. During trips abroad in 1908–09 and 1911–13, visited Rome, Florence, Berlin, Dresden, and Paris and worked in the workshops of Emile-Antoine Bourdelle, and Aristide Maillol. Participated in realizing Lenin's Plan for Monumental Propaganda. Participant in exhibitions from 1908.

1910

FEBRUARY 16: The Union of Youth set up in St. Petersburg on the initiative of Mikhail Matiushin and Yelena Guro. It produced three issues of the first Russian journal on avant-garde art. "Already by the end of 1909 there was a split, separating the most active participants from Nikolai Kulbin's group. The break was caused by disagreement with the leader's eclecticism, decadence, and 'Vrubelism.' We tried to organize a group with the aim of putting on exhibitions. We had a general meeting on Litseisky, at which we decided to organize the Union of Youth group of artists" (M. Matiushin, "Russkiye kubofuturisty", in *K istorii russkogo avangarda* ["Russian Cubo-Futurists," in *On a History of the Russian Avant-garde*], Stockholm, 1976, p. 141).

MAY: Appearance of Hylaea, the literary group of Cubo-Futurists, consisting of David and Nikolai Burliuk, Yelena Guro, Alexander Gei (Sergei Gorodetsky), Vasily Kamensky, Alexei Kruchonykh, Sergei Miasoyedov, Yekaterina Nizen (Guro), Benedikt Livshitz, Velimir Khlebnikov, and, later, Vladimir Mayakovsky. Publication of Hylaea's first anthology *Sadok Sudei* [*A Trap for Judges*]. "This book fell like a bomb into a meeting of mystics led by Viacheslav Ivanov. The Burliuks wormed their way into the group very piously and Ivanov received them cordially. Then these 'rascals,' leaving the meeting, stuffed a copy of *A Trap* into the pockets of the coats and overcoats of all those present. In this way Alexei Remizov and I, Alexander Blok, Mikhail Kuzmin, Sergei Gorodetsky, and all those who were with us, received a copy of the book" (M. Matiushin, "Nashi perviye disputy," *Literaturniy Leningrad* ["Our First Disputes," *Literary Leningrad*], October 20, 1934).

SUMMER: The Union of Youth sent four of its members (Pavel Filonov, Iosif Shkolnik, Eduard Spandikov, Cesar Shleifer) to Finland for talks about a joint exhibition with the Finnish avant-garde. "In 1911 the St. Petersburg artistic organization the Union of Youth is arranging an exhibition of contemporary art from Russia, Sweden, Norway, and Finland, and also, possibly, from France... Last summer two delegates from the Union of Youth visited Finland, Sweden, and Norway, and thus got to know the art of these countries. At the beginning of last week four delegates of the above-named organization visited Helsingfors" (*Helsingorsbladet*, November 27, 1910).

1911

EARLY DECEMBER: Publication of Wassily Kandinsky's book *Über das Geistige in der Kunst* (Munich), setting out the principles of abstract art. "The ideas which I set forth here are the result of observation and spiritual experience accumulated over the last five or six years" (W. Kandinsky, *O dukhovnom v iskusstve* [*On the Spiritual in Art*], New York, 1967, p. 11). "Non-objective painting is not the expurgation of all that came before in art, but the unusual and extremely important division of the old trunk into two main branches, without which the formation of the crown of a green tree would be unthinkable" (*Kandinsky. Tekst khudozhnika* [*Kandinsky. Text by the Artist*], Moscow, 1918, p. 49).

1912

APRIL and JUNE: Publication of the first and second anthologies [*The Union of Youth*], which included Vladimir Markov's article "*Printsipy novogo iskusstva*" [*The Principles of the New Art*]. Nikolai Punin on Markov: "If he had not died early, he would have been the greatest of us all; he knew better than the others what was then necessary for art; he both saw and understood better than the others" (Quoted in *Pamiatniki kul'tury: Noviye otkrytiya* [*Cultural Monuments: New Discoveries*], Leningrad, 1981, p. 411).

MARCH 14 – LATE AUGUST: Whilst in Tiflis (now Tbilisi) the brothers Kirill and Ilya Zdanevich and their guest Mikhail Le Dantu discovered the works of the painter Niko Pirosmanashvili in taverns. "On the walls hung paintings... We looked on them amazed, confused — before us was painting such as we had never seen before! Totally original, it was the very miracle which we were seeking... The apparent simplicity of the paintings was deceptive; in them one could easily see echoes of the ancient culture of the Orient, but the traditions of Georgian folk art were dominant" (K. Zdanevich, *Niko Pirosmanashvili*, Moscow, 1964, p. 8).

NOVEMBER–DECEMBER: Mikhail Larionov first shows his Rayonist canvases — *Glass (Rayonist Device)* and *Rayonist Study* — at the World of Art Exhibition in Moscow. "Mikhail Larionov brought the refinement of Rayonism not only to Russian but also to European art. Here light, which determines the work of art, serves to express the finest, most bitter, the merriest, and most brutal feelings of contemporary man.
The art of Mikhail Larionov reveals an extremely strong personality, thanks to which he is able to express faithfully the nuances of sensation and feeling which the artist experiences with all that severity which makes his extremely sober and precise light-bearing art a true aesthetic revelation, and some of his works can be considered to have entered the arsenal of modern art" (G. Apollinaire, "L'Exposition N. de Gontcharowa et M. Larionow," *Les Soirées de Paris*, 1914, No. 26–27, pp. 370–371).
Exhibition of Russian *lubok* (popular prints) from the collections of Wassily Kandinsky and Franz Marc held in the Hans Goltz Gallery in Munich.
Pavel Filonov wrote the article "Canon and Law," the first outline of his theory of Analytical Art, which stood in opposition to Cubism. "They give me to understand that C[ubo]-Fut[urism] and Picasso could not somehow or other avoid influencing me and my theory. I know very well what Pic[asso] is do[ing] (although I have not seen his pic[tures]). But I have to say that, personally, he has influenced my work no more than I his, and he has not seen my work even in his dreams... From our studies what could we take from C[ubo]-Fut[urism], which has arrived at a dead end thanks to its mechanical and geometrical bases?" (P. Filonov, "Kanon i zakon" [""], 1912, Manuscript Dept., Institute of Russian Literature, fund 656).
Albert Gleizes and Jean Metzinger published the Cubist manifesto in Paris, declaring the prematurity of the transition to non-objectivity. Matiushin became acquainted with Malevich, Mayakovsky, and Kruchonykh. "In 1912 our group set off for Moscow to reach an agreement with the Muscovites as regards further activities. Those of us who went were Olga Rozanova, Spandikov, Shleifer, Shkolnik,

Ballier, and I. There I first got to know Malevich — who amazed me with his works, with Mayakovsky and Kruchonykh" (M. Matiushin, *Tvorchesky put' khudozhnika* [*The Creative Path of an Artist*], 1934. Manuscript Dept., Institute of Russian Literature, fund 656).

1913

MARCH 23: Debate among members of the Target group "East, Nationality, and West." "We have created our own style of Rayonism, having in mind spatial forms and making painting self-sufficient, living only according to its own laws. We are drawn toward the East and look carefully at national art. We protest against the slavish submission to the West, returning to us our own eastern forms vulgarized and levelled out" (*Mishen'* [*Target*], Moscow, 1913, p. 6).

MARCH 24–APRIL 7: In Moscow, Larionov organized an exhibition entitled "Original Icons and *Lubki*," the basis for which was formed by works from Larionov's own collection. "The *lubok*, painted on trays, on snuff-boxes, on glass, wood, tiles, and tin (by the way, the signs which have survived to the present day are amazingly varied in treatment). Prints, stencils, stamped leather, *lubok*-type brass icon-covers, beads, bugle-beads, embroidery, fancy-shaped spice-cake, and baked dough (an art which is still continued by our bakers and confectioners). Wood-carving, taking both its own path and that of Russian classical forms. Various forms of braiding, lace, etc. All this is the *lubok* in the broad sense of the word and all this is great art" (M. Larionov, "Vstupitel'naya statya," in *Ikonopisniye podlinniki, lubki: Katalog vystavki* ["Introductory Essay," *Original Icons and Lubki: Exhibition Catalog*], Moscow, 1913).

LATE APRIL: Publication of the brochure *Luchizm* [*Rayonism*] by Larionov, who put forward the theory of Rayonism "as a sort of barrier against several rationalist tendencies in Cubism;" in practice it was "the fruit of very fine realistic juxtapositions" (N. Punin, "Impressionisticheskiy period v tvorchestve Mikhaila Larionova," in *Materialy po russkomu iskusstvu* ["The Impressionist Period in the Work of Mikhail Larionov," in *Materials on Russian Art*], vol. 1, Leningrad, 1928, p. 291).

SPRING/SUMMER: Vladimir Tatlin traveled to Berlin and Paris, visited Picasso's studio.

JULY 18–19: First All-Russian Congress of Futurists held at Uusikirkko in Finland. The participants (Matiushin, Malevich, Kruchonykh) published a manifesto: "To strive toward the strong-hold of artistic weakness — toward the Russian theater, and to transform it decisively... With this aim the new theater group Budetlianin has been founded" (*Za 7 dnei* [*Over 7 Days*], 1913, No. 28, 15 August). "The Union of Youth society, seeing the domi-nation of old ways in the theater and considering the unusual effect of our evenings, decided to set the affair on a broad base, to show the world 'the first Futurist theater'." "In the summer of 1913, plays were ordered from Mayakovsky and I. We had to produce them before the autumn. I was living in Uusikiirkko (Finland) at Matiushin's dacha, and it was there that I thought up and sketched out my work" (A. Kruchonykh, *Nash Vykhod* [*Our Debut*], 1932. Manuscript. Archive of the Mayakovsky Museum, Moscow, fund K-84).

DECEMBER: Productions organized by the Union of Youth — the tragedy *Vladimir Mayakovsky* (December 2 and 4) and Kruchonykh and Matiushin's opera *Victory over the Sun* (December 3 and 5). "Filonov worked thus: when, for instance, he began to paint the sets for Mayakovsky's tragedy (two backdrops), he ensconced himself in a special theatrical studio as if in a fortress and did not leave it for two whole days; he did not sleep, he ate nothing, he simply smoked a pipe." Essentially, what he produced was not set designs but two huge, virtuoso, carefully produced paintings the size of the stage. "I particularly remember one of these paintings: the uneasy, bright city port with numerous carefully painted small boats, people on the banks, and, beyond, hundreds of urban buildings, each carefully painted down to the last win-dow." (A. Kruchonykh, *K istorii russkogo futurizma. Vospominaniya. Materialy* [*On the History of Russian Futurism. Recollections. Materials*]. Manuscript. Archive of the Mayakovsky Museum, Moscow, fund K-84).
"Malevich painted marvelous sets depicting complex machines, and my portrait. He invented an interesting little trick: in order to make the two strong 'men of the future' in the first act as huge as possible, he placed them with their shoulders at mouth height, their heads in the form of a cardboard helmet — and the result was the impression of two giant human figures." (M. Matiushin, *Tvorcheskiy put' khudozhnika* [*The Creative Path of an Artist*], 1934, Manuscript Dept., Institute of Russian Literature, fund 656).

1914

JANUARY—FEBRUARY: Marinetti arrived in Russia. On February 1 and 4 he presented lectures in the hall of the Kalashnikov Exchange (St. Petersburg). When the Italian Futurist was already at the lectern, Velimir Khlebnikov ran into the hall, clasping to his chest a packet of freshly printed sheets. Having given half of them to Benedikt Livshits, he began to give them out along the rows. The appeal, asserting the independence of Russian Futurism from the Italian version, ended with the words: "Foreigner, remember the land in which you have arrived! The lace of servility on the welcoming sheep." "On me Marinetti produced the impression of a talented man with a skilful command of words. He produced good imitations of the sound of a propeller, explosions, drum bangs, as if manifesting the future European war. But on the whole this seemed to be mere trickery, not only to me but to our whole group" (M. Matiushin, *Tvorcheskiy put' khudozhnika* [*The Creative Path of an Artist*], 1934. Manuscript Dept., Institute of Russian Literature, fund 656).

MARCH: Pavel Filonov organized the Made Paintings society of painters and draftsmen. "I, together with people whom I know... founded a society based on an idea which pours organically from the depths of the spiritual needs of Russian art, the art which must unmistakeably enjoy world supremacy, which I will bring about, even if I have to do it alone" (Pavel Filonov. Letter to Mikhail Matiushin, 1914. Manuscript Dept., Tretyakov Gallery, fund 25, No. 11, f. 1). Nikolai Berdiayev published an article on Picasso.

MARCH—APRIL: The works of the Russian artists Malevich, Matiushin, David and Vladimir Burliuk, Alexandra Exter, etc., were shown at the Salon des Indépendants in Paris. "I received a letter from Archipenko in Paris, and he writes that I am popular with

the French artists. He himself is delighted" (Kasimir Malevich. Letter to Mikhail Matiushin, March 1914. Manuscript Dept., Institute of Russian Literature, fund 656).

APRIL—MAY: Exhibition in Rome: Esposizione Libera Futuristi Internazionale. Participants included Olga Rozanova, Nikolai Kulbin, Alexandra Exter, and Alexandre Archipenko.

MAY 10–14: Tatlin first showed his painted reliefs. "On May 10, 11, 12, 13, and 14 this year, from 6 to 8, the studio of the artist Vladimir Tatlin (Ostozhenka 37, apartment 3) will be open, free of charge, for the viewing of his syntheto-static compositions, and on the above-mentioned days from 7 o'clock the Futurist Sergei Podgayevsky will dynamo-declare his latest post-zaum [post-trans-sense] records" (Printed notice. Manuscript Dept., Russian Museum, fund 121, No. 117, f. 61).

MAY 29: Mikhail Larionov and Natalia Goncharova left for Paris to take part in Serge Diaghilev's Ballets Russes. "Dear Mikhail Vasilyevich. Natalia Sergeyevna and I are finally leaving on the 29th. Nijinsky is delayed with the costumes. If something can be arranged in Paris I will write to you. Please send reviews of Natalia Sergeyevna's exhibition to my address in my brother's name" (Mikhail Larionov. Letter to Mikhail Le Dantu, late May 1914. Manuscript Dept., Russian Museum, fund 135, No. 6, f. 2).

JUNE 17–30: Exhibition in Paris: Exposition Natalie de Gontcharowa et Michel Larionow, at the Galérie Paul Guillaume. The poet Guillaume Apollinaire makes a favorable comment on it in *Soirée de Paris*.

1915
MARCH: Mikhail Matiushin published Filonov's book *Chant of Universal Flowering* which included two pre-war poems by the artist with accompanying drawings. "From Filonov, as a writer, I await good things, and some lines in this book are among the best ever written about war... 'Universal Flowering' also sounds very good. I very much like the drawing of the caveman with his bow and arrow, the deer, the dog, wracked by their fury and, as it were, not born, and the careful, timid deer" (V. Khlebnikov, *Neizdanniye proizvedeniya* [*Unpublished Works*], Moscow, 1940, p. 378).

1915–16
DECEMBER 17 – JANUARY 19: "The Last Futurist Exhibition of Paintings 0.10" at which Malevich first showed 49 Suprematist canvases. "Futurism and Cubism dealt almost exclusively with space, but its form, linked with objectivity, did not even give the image the presence of world space; its space was limited by space, dividing the things amongst themselves on the earth. The surface of painterly color suspended on the sheet of white canvas straight off gives our consciousness a strong sense of space. It carries me over into fathomless space, where you can sense the creative points of the universe around you" (Kasimir Malevich. Letter to Mikhail Matiushin, June 1916, published in *Yezhegodnik rukopisnogo otdela Pushkinskogo doma na 1974 god* [*Annual of the Manuscript Department of the Pushkin House for 1974*], Leningrad, 1976, p. 192).

1917
AUGUST: Malevich elected president of the Artistic Department of the Moscow City Soviet. "I have not written to you for a long time. I have a lot of work on right now; I have been elected president of the Artistic Department of the Moscow City Soviet of Soldiers' Deputies. I am in the 56th Reserve Infantry Battalion, and I have to work for the good of society... I have conceived a whole series of tasks — the establishment of the First Moscow People's Academy of Arts. My idea was met with enthusiasm and the ball is rolling. Soon I shall open several small sections of those departments which will form part, on a larger scale, of the Academy" (Kasimir Malevich. Letter to Mikhail Matiushin, September 8, 1917. Manuscript Dept., Institute of Russian Literature, fund 656).

FEBRUARY 6: Narkompros (People's Commissariat for Education) set up in Petrograd under Anatoly Lunacharsky. The Fine Arts Department (IZO) within Narkompros was headed by David Shterenberg, with Nikolai Punin as his deputy.

1918–19
DECEMBER—APRIL: Appearance of *Iskusstvo kommuny* [*The Art of the Commune*], the journal of IZO, its participants including Mayakovsky, Punin, Malevich, Yermolayeva, Puni, etc. Vera Yermolayeva organized the "Today" artists' cooperative, which involved the artists Yury Annenkov, Yekaterina Turova, Nadezhda Liubavina, the writers Mikhail Kuzmin, Sergei Yesenin, and others.

1918–20
Tatlin worked on the Monument to the Third International ("Tatlin's Tower").

NOVEMBER 8 – DECEMBER 19: "Tatlin's Tower" exhibited in the mosaic workshop at the Academy of Arts. "Alongside organizational work we showed the first products of the art of the age of October [i.e. of the Revolution] (Tatlin's Monument to the Third International, Meyerhold's production of *Mystery-Bouffe*, Kamensky's *Stenka Razin*)" (V. Mayakovsky, *Sobraniye sochineniy* [*Collected Works*] in 12 vols., vol. 12, Moscow, 1959, p. 42).

1919
APRIL 13: Opening of the First State Free Exhibition of Works by Artists of All Tendencies in the Winter Palace.
IZO published *Iskusstvo negrov* [*Negro Art*], by Vladimir Markov (V. I. Matvei), written in 1914. "In those years Matvei, like many other artists, was seized by an interest in Negro art. The stimulus behind this interest at that time was Picasso. Matvei was particularly interested in Picasso's Cubist and African periods, and in Braque: he saw in their works a turn toward the strict construction of form and color, liberation from that Academic realism which had become *de rigueur*, killing off any creative thought. I think that I shall not be maligning the memory of Matvei if I say that Matvei was not against figurativeness in art. But he sought a creative approach to the depiction of the visible world — he sought in all peoples of all eras in which art was produced those plastic foundations in which creative depiction was embodied" (V. Bubnova, *Vospominaniya o V. I. Matveye (Vladimire Markove)* [*Recollections of V. I. Matvei (Vladimir Markov)*], 1960. Manuscript, Ye. Kovtun archive, St. Petersburg).

1920

Publication in Vitebsk of Malevich's *Suprematizm. 34 risunka* [*Suprematism. 34 Drawings*], in which the artist prophesied humanity's departure into outer space. Between the Earth and the Moon "we could build a new Suprematist satellite... which would move around in orbit." "In exploring a Suprematist form in movement, we come to the conclusion that straight movement toward some planet or other cannot be overcome any other way than through the circular movement of intermediate Suprematist satellites, which form a straight line of circles from satellite to satellite" (*Suprematizm. 34 risunka* [*Suprematism. 34 Drawings*], Vitebsk, 1920, p. 1).

From this year Malevich begins to work on three-dimensional Suprematism, in the form of his *architektons*.

1921

APRIL 3: Opening of the Painting Department of the Petrograd Museum of Artistic Culture, the exhibits including works by Tatlin, Filonov, Malevich, Larionov, Matiushin, Mansurov, etc. This was the first museum of contemporary art in the world.

Appearance of the new society of artists and poets Art Is Life (Makovets), the theoretical inspiration behind which were the artist Vasily Chekrygin and the philosopher and theologian Pavel Florensky. "The contemporary artist is a philosopher and metaphysicist. Speculation, as an abstract spiritual activity, is attendant on, without contradicting, his sense of the world; as a poet he wraps abstract schemes in plastic forms of direct reality, clearly seeing the idea of unity 'shining through the matter' as beauty which reveal reality" (V. Chekrygin, "O namechayushchemsia novom etape obshcheyevropeiskogo iskusstva," *Makovets* ["On the Burgeoning New Stage in All-European Art," *Makovets*], 1922, No. 2, p. 10).

1922

JANUARY: The First Russian Exhibition in the Van Diemen Gallery, Berlin, at which the Russian avant-garde was widely represented, with works by Malevich, Filonov, Tatlin, Mansurov, Yermolayeva, Rodchenko, etc.

Formation of the Association of Artists of Revolutionary Russia (AKhRR), which saw its task as the "artistic-documentary recording of a great moment in history in all its revolutionary upsurge. We will depict the present day: the life of the Red Army, the life of the workers, peasantry, revolutionaries, and heroes of labour" (*Bor'ba za realizm v iskusstve 1920kh godov* [*The Battle for Realism in the Art of the 1920s*], Moscow, 1962, p. 120).

1923

APRIL 13: Mikhail Matiushin organized the group ZORVED (Seeing and Knowing), which included Boris, Maria, and Xenia Ender, and Nikolai Grinberg. "I posed the question of centrally perceiving man, who consciously acts within his entire surroundings. In the future man will at any instant see, palpably feel, hear, and sense with the amplitude of his full surroundings. I have a presentiment of how the musical score of life, read by the intellect, will create what mankind has not yet found the boldness to dream of" (M. Matiushin, *Tvorcheskiy put' khudozhnika* [*The Creative Path of an Artist*], 1934. Manuscript Dept., Institute of Russian Literature, fund 656).

MAY 11, 13, 30: For the anniversary of the death of Velimir Khlebnikov Vladimir Tatlin staged a production, based on the poet's "superstory" *Zangezi*.

MAY 22: The periodical *Zhizn' iskusstva* [*The Life of Art*] published a declaration by Filonov, Malevich, Matiushin, and Mansurov.

JUNE 9: At a museum conference in Petrograd, Filonov presented a paper in which, "on behalf of groups of leftist artists," he suggested transforming the Museum of Artistic Culture into an "Institute for the Study of the Culture of Contemporary Art."
"In 1923, after the inspection of the Museum of Painting Culture in Leningrad [*sic*], conducted with Filonov as president, he was entrusted by the conference, after his paper on the inspection, with the task, in accordance with the decision made on the reorganization of this museum into an Institute for the Research of Art, of writing the Regulations of the Institute. The regulations he drew up formed the basis for the first Institute for the Research of Art, with a working museum, in Europe" (P. Filonov, *Autobiography*. Manuscript. Central Archives of Literature and Art, fund 2348, part 1, No. 2, f. 2v).

AUGUST 15: Organization of the Petrograd Institute of Artistic Culture (INKhUK). "The Museum of Artistic Culture has now begun its activity: four research departments have been opened, run by Malevich, Tatlin, Filonov, and Matiushin... What is being researched? Artistic Culture. Juxtaposing the academic approach and method to the bases of 'taste' — I like it, I don't like it — we all arrive at a new problem, in which the old conception of the artist disappears and in its place appears the scholar-artist" (K. Malevich, "Zapisnaya knizhka," in *Problemy istorii sovetskoi arkhitektury* ["Notebook," in *Problems in the History of Soviet Architecture*], Moscow, 1978, No. 4, p. 26).

1924

END OF THE YEAR: Samuil Marshak and Vladimir Lebedev organized the Children's Department of the State Publishing House (Detgiz), combining work on children's literature by writers (Boris Zhitkov, Vitaly Bianchi, Yevgeny Schwartz, Daniil Kharms, Alexander Vvedensky) and artists (Nikolai Tyrsa, Vera Yermolayeva, Nikolai Lapshin, Alexei Pakhomov, Yury Vasnetsov, and others).

1925

JUNE–SEPTEMBER: Pavel Filonov ran teaching courses for students in the building of the Academy of Arts. "From June to September a group of participants, at first comprising up to seventy people, worked under my leadership... Members of this group then formed the Masters of Analytical Art collective" (P. Filonov, *Dnevnik* [*Diary*]. Entry for December 11 or 12, 1933. Manuscript Dept., Russian Museum, fund 156).

1926

JUNE 10: The critic Grigory Sery, who was an adherent of the AKhRR group, wrote a political denunciation of GINKhUK in *Leningradskaya Pravda* [*Leningrad Truth*]: "Now, when a huge task is rising full height before proletarian art, when hundreds of genuinely gifted artists are starving, it is criminal to support a truly vast mansion so that three crazy monks can, at state expense, indulge

in artistic masturbation or counter-revolutionary propaganda, which is of no use to anyone" (G. Sery, "Monastyr' na gossnabzhenii," *Leningradskaya Pravda* ["State-Supported Monastery ," *Leningrad Truth*], June 10, 1926).

1927

MARCH 8: Malevich arrived in Warsaw; exhibition of his work and lectures by him held in the Hotel Polonia.
"Dear Misha, I have demonstrated your tables along with mine, and both have given rise to great interest. Oh, they have a wonderful attitude to us. Glory pours down like rain. But obstacles have arisen to change my travel plans, so I shall tell you more in May when I arrive. Send my greetings to all of your lot. The 25th is the banquet and the end" (K. Malevich. *Note to M. Matiushin.* Manuscript Dept., Tretyakov Gallery, fund 25, No. 9, f. 24).

MARCH 29: Malevich arrived in Berlin.

MAY 7: Opening of Malevich's one-man show at the exhibition hall near the Lehrter Station. "The artist Malevich is, of course, for all the exclusiveness of his paintings, a great master. In a country in which the unintelligible Kandinsky can enjoy great success, Malevich is more synthetic, more manly, and, moreover, in the present turn toward a severe and hard painting in general, he cannot but give rise to affection" (A. Lunacharsky, "Russkiye khudozhniki v Berline," *Ogoniok* ["Russian Artists in Berlin", *Light*], 1927, No. 30).

APRIL 17 – MAY 17: Exhibition held in the Leningrad Printing House entitled "Masters of Analytical Art. The School of Filonov."

APRIL: Production of Gogol's *The Inspector General* given in the Printing House, produced by Igor Terentyev, and with stage designs by Filonov's students. "I remember the literary evening in the Printing House in Leningrad... Mayakovsky read has poem *Khorosho* [*Good*] with great inspiration, then as usual answered written questions, and in answer to one of them, after a cutting answer, he pointed to the wall — these pictures are the painting of the present and the future! — said V. V. loudly" (I. Dmitrochenko, *Vospominaniya* [*Reminiscences*]. Manuscript Dept., Russian Museum, fund 156, No. 84).

JUNE 5: Malevich left for home, summoned before the completion of his exhibition. He left his manuscripts in Berlin, along with a "Testament" relating to them: "In the event of my death or imprisonment without cause, and if the owners of these manuscripts should wish to publish them, for this they should be studied and then put into other language, for, having been, in their time, under the influence of the Revolution, they may contain contradictions. With my present approach to art, now, in 1927, I consider these theses to be true. Kasimir Malevich. 1927, May 30. Berlin" (K. Malevich, *Suprematismus. Die gegenstandslöse Welt*, Cologne, 1962, p. 37).

NOVEMBER 1: Opening of the Exhibition of the Newest Tendencies in the Russian Museum, organized by Nikolai Punin and Vera Anikiyeva. "By its very nature the material collected and studied in the Department of Newest Art is forever changing. As concerns the further development of art, relevant works developed in connection with the perfection of this or that new tendency in art must be added to the Department; the collections are then transferred to the Art Department chronologically preceding, in terms of the material concentrated in it, the Department of Newest Art" (N. Punin, "Otdeleniye noveishikh techeniy v iskusstve. Yego obrazovaniye i zadachi," *Otchot Gosudarstvennogo Russkogo muzeya za 1926 i 1927 gg.* ["The Department of the Newest Tendencies in Art. Its Formation and Tasks," *Report of the State Russian Museum for 1926 and 1927*], Leningrad, 1929, p. 45).
The MAI (Masters of Analytical Art) collective given the official right to form an artistic union. "Only those who have been set working according to the principle of Analytical Art by the elder master, the researcher and organizer Filonov, or those following the principle of 'madeness' by one of the masters of the collective, who is already working according to Filonov's principles of Analytical Art, can be received into the collective" (*Materialy dlia ustava i programmy kollektiva masterov analiticheskogo iskusstva* [*Material for the Regulations and Program of the Masters of Analytical Art Collective*]. Manuscript. Private archive).

1929–30

AUTUMN 1929 – DECEMBER 1930: Filonov's one-man exhibition put up in the Russian Museum, but never opened. "In response to questions put to the museum's assistant director, Comrade Ivasenko, a consistent enemy of the exhibition: 'Why is the exhibition still not open?' he answered: 'I am responsible — I explained to party circles that Filonov's art is a negative phenomenon, that it is incomprehensible. I set Soviet society against him. I battled with Moscow, which demanded the opening of the exhibition, and as long as I am here the exhibition will not open. This art is counter-revolutionary'" (P. Filonov, *Vystavka Filonova v Russkom muzeye vsio eshcho ne otkryta* [*The Filonov Exhibition in the Russian Museum Still Hasn't Opened*], 1931. Manuscript. Central Archives of Literature and Art, fund 2348, part 1, No. 23, ff. 1–5).

1929–32

Vladimir Tatlin works on his model "Letatlin" at Novodevichy Monastery, Moscow.

1930

Kasimir Malevich arrested and imprisoned for three months.

1932

NOVEMBER 13: Opening in the Russian Museum of the exhibition "Artists of the Russian Federation over the Past 15 Years," at which the works of Filonov and Malevich were shown for the last time. "Today the exhibition opened at 8, and at 3 it was visited by members of the government. At 12 in the morning I arrived at the museum... The security people got the employees out of the museum. An agent of the GPU summoned 12 militiamen to the museum on the phone. The staircase was decorated with materials and dotted with palms. Young people all dressed up and looking like rich Argentinian planters stood in a crowd at the bottom of the staircase. The employees complained embarrassedly by their cloakroom... The ceremonious, servile spirit dominating

that morning on the staircase of the museum, turning it into a reception hall in a Roman palace, finally determined my decision not to go to the opening" (P. Filonov, *Dnevnik* [*Diary*]. Entry for November 13, 1932. Manuscript Dept., Russian Museum, fund 156, No. 30, ff. 51v–52).

Publication of Matiushin's *Spravochnik po tsvetu* [*Handbook on Color*]. "My book on color is finished. I thought about it in 1926. Half of it was done then to my instructions by the Enders, and now my dear Delacroix, Lena Khmelevskaya, and Liza Astafyeva have finished the second, most important, part" (M. Matiushin, *Dnevnik* [*Diary*]. Entry for February 20, 1930. Manuscript Dept., Institute of Russian Literature, fund 656).

Liquidation of all artistic societies and formation of a single Union of Artists, which quickly created an impossible atmosphere for free creativity. Reduced to despair, Nikolai Tyrsa wrote his friends that the Union "could put into effect a number of measures to make our work easier... For instance, careful personal acquaintance on the part of those responsible in the Politburo and the NKVD with each qualified artist from the Union of Soviet Artists, and then give the right to work without inspection, when and where you want, or, secondly (mistrust) — keep an eye on me. Let me work and keep an eye on me; the suspect is in your hands" (Nikolai Tyrsa. Letter to Lev Yudin and Pavel Kondratyev, August 12, 1939. Manuscript Dept., Russian Museum, fund 146, No. 5).

From this year the NKVD began to keep tabs on the participants of Filonov's group, who were declared to be class enemies. "Leaving, Misha [Tsybasov] said: a few days ago Luppian was summoned by the GPU. He was asked what our collective stood for, why there was a split, who is Kapitanova and her husband — the artist Arapov, who of our group is abroad and who works in a factory. They also asked what Filonov stood for? Luppian answered: 'Filonov should have been made a professor at the Academy a long time ago.' They asked him what Filonov's political convictions were, and he answered that 'Filonov is a Communist.' In answer to further questions respecting Filonov from our comrades at the GPU, Luppian, in reference to me, said: 'I have never met a better person.'

I told Misha what I repeatedly said to our comrades long before the split, that no way could we escape the GPU because of my significance, the significance of the collective and myself together to contemporary art, to Soviet art, and art as a whole (and even more so in the teaching of art), that we could be led to that equally by any of the provocations, gossip or lies, printed or spoken, which surround us in the iron ring of a blockade unprecedented in IZO. And the sooner the GPU takes up our case the better — perhaps this can help me, us, my exhibitions and monograph, that is, proletarian art, and help us to break onto the pedagogical front. I told Misha that the GPU knows, of course, what it is doing, but they had better sort out our case after questioning me personally rather than others" (P. Filonov, *Dnevnik* [*Diary*]. 1932. Manuscript Dept., Russian Museum, fund 156, No. 30, ff. 42–43).

1933

Publication in Leningrad of the poet Benedikt Livshits' book *Polutoraglaziy strelets* [*The One-and-a-half-eyed Archer*], a brilliant summary of the birth of Russian Cubo-Futurism.

1934

The arrests of the artists Piotr Sokolov and Vera Yermolayeva, who later died in concentration camps, and of Vladimir Sterligov. Matiushin finished the manuscript of his still unpublished book *Tvorcheskiy put' khudozhnika* [*The Creative Path of an Artist*] (the manuscript is in the Institute of Russian Literature, fund 656).

1935

OCTOBER 24: Persecuted by the interrogations of the NKVD, Vasily Kuptsov — a friend and student of Filonov — hung himself. "Since the moment that I saw Kuptsov dead there has not been a single day when I have not recalled Kuptsov. Sometimes I think with grief about him several times a day. Often, thinking about him, I recall, how, in Chapyghin's *Stepan Razin*, Stenka lost his comrades one by one... That was Kuptsov. I know that he cannot be torn from the heart, from my memory, ever" (Cited in Ye. Glebova, "Vospominaniya o brate," *Neva* ["Reminiscences of My Brother," *The Neva*], 1986, No. 10, p. 162).

Filonov, deprived of work, leads a poverty-stricken existence. "Now, without any income, I live, to my shame, at the expense — in the full sense of the world — of Daughter [the artist thus described his wife]. I eat a kilo or half a kilo of bread a day, a bowl or two of soup and potato. My situation is becoming dangerous. There is only one way out, to take up any dirty work for the income. But I am stretching out my last farthings in order to put off that 'way out,' and I work the whole day as always, whilst the sun does not put me out of action. As always, I do not spend one second without work, and the more you work the more there is to do. But there is less and less to eat. For all my iron, indestructible constitution, I can sense that my former physical, muscular strength is leaving me. But my working energy, my will to work, my unquenchable desire to work, only gets stronger" (P. Filonov, *Dnevnik* [*Diary*]. Entry for March 6, 1935. Manuscript Dept., Russian Museum, fund 156, No. 32, f. 24).

1936

MARCH 1: Publication in *Pravda* [*Truth*] of an editorial "O khudozhnikakh-pachkunakh" ["On Painter-Daubers"], striking a blow at the artists working on children's books, above all Vladimir Lebedev, whose book (S. Marshak, *Skazki, pesni, zagadki* [*Tales, Songs, Riddles*]) was cruelly slammed. "This is a book which you leaf through with revulsion, like a pathological-anatomical atlas... As if some gloomy, savage *compracicos* had walked through the whole book, ruining everything, soiling it, leaving its dirty mark on everything. And having done its foul business, wrote its name with pleasure: *Drawings by the artist Vladimir Lebedev*" (*Pravda*, March 1, 1936).

1938

Nikolai Glebov-Putilovsky, a friend of Filonov's, and his wife's sons Piotr and Anatoly Serebriakov arrested. Filonov's wife, Yekaterina Serebriakova, a former member of the People's Will movement, struck down with paralysis.

A. Gleizes, J. Metzinger, *O kubizme* [*On Cubism*], St. Petersburg, 1913

M. Matiushin, "O knige Gleza i Metzinger *O kubizme*," *Soyuz Molodiozhi* ["On the Book *On Cubism* by Gleizes and Metzinger," *The Union of Youth*], 1913, No. 3

Intimnaya masterskaya zhivopistsev i risoval'shchikov "Sdelanniye kartiny," [*The Intimate Workshop of Painters and Draftsmen "Made Pictures"*], St. Petersburg, 1914

Kandinsky. Tekst khudozhnika [*Kandinsky. Text by the Artist*], Moscow, 1918

W. Kandinsky, "Malen'kiye stateiki po bol'shim voprosam. 1. O tochke. 2. O linii," *Iskusstvo. Vestnik Otdela IZO Narkomprosa* ["Small Articles on Large Questions. 1. About Full-Stop. 2. About Line," *Art. Bulletin of the Department of Fine Arts of the People's Commissariat for Education*], 1919, Nos. 3, 4

N. Punin, "V Moskve (pis'mo)," *Iskusstvo kommuny* ["In Moscow (A Letter)," *The Art of the Commune*], 1919, February 9

V. Shklovsky, "Prostranstvo v iskusstve i suprematisty," *Zhizn' iskusstva* ["Space in Art and the Suprematists," *The Life of Art*], 1919, Nos. 196–197

V. Shklovsky, "Svobodnaya vystavka vo Dvortse iskusstv," *Zhizn' iskusstva*, 1919, May 29–30 ["The Free Exhibition in the Palace of Arts," *The Life of Art*], 1919, May 29–30

K. Malevich, *Ot Sezanna do suprematizma: Kriticheskiy ocherk* [*From Cézanne to Suprematism: A Critical Essay*], Moscow, 1920

N. Punin, *Tatlin (Protiv kubizma)* [*Tatlin (Against Cubism)*], St. Petersburg, 1921

"Apostol bol'shogo iskusstva" ["The Apostle of a Great Art"], *Makovets*, 1922, No. 2

V. Chekrygin, "O namechayushchemsia novom etape obshcheyevropeiskogo iskusstva" ["On the Brugeoning New Stage in All-European Art"], *Makovets* 1922, No. 2

V. Khlebnikov, *Zangezi*, Moscow, 1922

K. Malevich, *Bog ne skinut. Iskusstvo, tserkov', fabrika* [*God is Not Cast Down: Art, the Church, the Factory*], Vitebsk, 1922

"Nash prolog" ["Our Prologue"], *Makovets*, 1922, No. 1

P. Filonov, "Deklaratsiya 'Mirovogo Rastsveta'," *Zhizn' iskusstva* ["Declaration of 'Universal Flowering'," *The Life of Art*], 1923

N. Lapshin, "Khlebnikov – Miturich," *Russkoye iskusstvo* [*Russian Art*], 1923, Nos. 2–3

K. Malevich, "Suprematicheskoye zerkalo," *Zhizn' iskusstva* ["The Suprematist Mirror," *The Life of Art*], 1923, No. 20

M. Matiushin, "Ne iskusstvo, a zhizn'," *Zhizn' iskusstva* ["Not Art But Life," *The Life of Art*], 1923, No. 20

V. Tatlin, "O Zangezi," *Zhizn' iskusstva* ["About Zangezi," *The Life of Art*], 1923, No. 18

"Vystavka pamiati Khlebnikova," *Zhizn' iskusstva* ["An Exhibition Dedicated to the Memory of Khlebnikov," *The Life of Art*], 1923, No. 27

Filonov. Katalog vystavki [*Filonov: Exhibition Catalog*], the Russian Museum, Leningrad, 1930

M. Matiushin, *Spravochnik po tsvetu* [*Reference-Book on Color*], Leningrad, 1932

N. Khardzhiyev, T. Grits, "Yelena Guro," *Knizhniye novosti* [*Book News*], 1938, No. 7

V. Kostin, *K. S. Petrov-Vodkin*, Moscow, 1966

J. Kriz, *Pavel Nikolajevich Filonov*, Prague, 1966

T. Andersen, *Moderne russisk kunst. 1910–1925*, Borgen, 1967

W. Kandinsky, *O dukhovnom v iskusstve* [*Concerning the Spiritual in Art*], New York, 1967

Petrogradskiye Okna ROSTA. Katalog vystavki [*The Petrograd ROSTA Windows: Exhibition Catalog*], Leningrad, 1968

Vasily Nikolayevich Chekrygin. Risunki. Katalog vystavki [*Vasily Nikolayevich Chekrygin. Drawings: Exhibition Catalog*], Moscow, 1969

N. Khardzhiyev, V. Trenin, *Poeticheskaya kul'tura Mayakovskogo* [*The Poetic Culture of Mayakovsky*], Moscow, 1970

K. Petrov-Vodkin, *Khlynovsk. Prostranstvo Evklida. Samarkandia* [*Khlynovsk. Euclidian Space. Samarkandia*], Leningrad, 1970

V. Marcadé, *Le Renouveau de l'art pictural russe 1863–1914*, Lausanne, 1971

V. Petrov, *Vladimir Vasilyevich Lebedev*, Leningrad, 1972

N. Rozanova, *Piotr Miturich*, Moscow, 1973

L. Zhadova, "B. V. Ender o tsvete i tsvetovoi srede," *Tekhnicheskaya estetika* ["B. V. Ender on Color and Color Medium," *Technical Aesthetics*], 1974, No. 11

Ye. Kovtun, "Khudozhnik knigi Vera Mikhailovna Yermolayeva," in *Iskusstvo knigi 68/69* ["The Book Artist Vera Mikhailovna Yermolayeva," in *The Art of the Book 68/69*], Moscow, 1975

N. Khardzhiyev, K. Malevich, K. Matiushin. *K istorii russkogo avangarda* [*K. Malevich, M. Matiushin. On the History of the Russian Avant-Garde*], Stockholm, 1976

"K. S. Malevich. Pis'ma k M. V. Matiushinu," in *Yezhegodnik Rukopisnogo otdela Pushkinskogo doma na 1974 god* ["K. S. Malevich. Letters to M. V. Matiushin," in *Annual of the Manuscript Department of the Pushkin House for 1974*], Leningrad, 1976

N. Punin, *Russkoye i sovetskoye iskusstvo* [*Russian and Soviet Art*], Moscow, 1976

Z. Ender, C. Masetti, *Boris Ender. Pittore d'Avanguardia nell' Unione Sovietica*, Rome, 1977

Ye. Kovtun, "Yelena Guro. Poet i khudozhnik," in *Pamiatniki kul'tury. Noviye otkrytiya* ["Yelena Guro. The Poet and Artist," in *Cultural Monuments: New Discoveries*], Moscow, 1977

A. Rusakova, *Pavel Kuznetsov*, Leningrad, 1977

L. Zhadova, "V. Ye. Tatlin — odin iz osnovopolozhnikov sovetskoi shkoly dizaina," *Tekhnicheskaya estetika* ["V. Ye. Tatlin, a Founder of the Soviet School of Design," *Technical Aesthetics*], 1977, No. 6

L. Shadowa, *Suche und Experiment. Aus der Geschichte der russischen und sowjetischen Kunst zwischen 1910 und 1930*, Dresden, 1978

J. Bowlt, "L'Œuvre de Vladimir Tatlin," *Cahiers du Musée National d'Art Moderne. Centre Georges Pompidou*, Paris, 1979, No. 2

Ch. Douglas, "Cubisme français, cubo-futurisme russe," *Cahiers du Musée National d'art Moderne. Centre Georges Pompidou*, Paris, 1979, No. 2

"P. N. Filonov. Pis'mo Vere Sholpo," in *Yezhegodnik Rukopisnogo otdela Pushkinskogo doma na 1977 god* ["P. N. Filonov. A Letter to Vera Sholpo," in *Annual of the Manuscript Department of the Pushkin House for 1977*], Leningrad, 1979

Ye. Kovtun, "Iz istorii russkogo avangarda: P. N. Filonov," in *Yezhegodnik Rukopisnogo otdela Pushkinskogo doma na 1977 god* ["From the History of the Russian Avant-Garde," in *Annual of the Manuscript Department of the Pushkin House for 1977*], Leningrad, 1979

Malévich. Actes du Colloque international tenu au Centre Pompidou, Musée National d'Art Moderne, les 4 et 5 mai 1978, publiés sous la direction de Jean-Claude Marcadé, Lausanne, 1979

M. Matiushin, "Tvorchestvo Pavla Filonova," in *Yezhegodnik Rukopisnogo otdela Pushkinskogo doma na 1977 god* ["The Work of Pavel Filonov," in *Annual of the Manuscript Department of the Pushkin House for 1977*], Leningrad, 1979

Paris – Moscou. Catalog de l'exposition, Paris, 1979

E. Kowtun, "Kasimir Malewitsch und seine künstlerische Entwicklung," in *Kasimir Malewitsch. Werke aus sowjetischen Sammlungen*, Düsseldorf, 1980

V. Lapshin, "Iz istorii khudozhestvennoi zhizni Moskvy 1920-kh godov. 'Makovets' (Soyuz khudozhnikov i poetov 'Iskusstvo — zhizn')," *Sovetskoye iskusstvoznaniye 79* ["From the History of the Artistic Life in Moscow in the 1920s. 'Makovets' (The Union of Artists and Poets 'Art is Life')," *Soviet Art Studies 79*], No. 2, Moscow, 1980

A. Shevchenko, *Sbornik materialov* [*A Collection of Materials*], Moscow, 1980

R. Falk, *Besedy ob iskusstve. Pis'ma. Vospominaniya o khudozhnike* [*Talks on Art. Letters. Reminiscences of the Artist*], Moscow, 1981

Ye. Kovtun, "Pis'ma V. V. Kandinskogo k N. I. Kul'binu," in *Pamiatniki kul'tury: Noviye otkrytiya* ["W. Kandinsky's Letters to N. I. Kulbin," in *Cultural Monuments: New Discoveries*], Leningrad, 1981

Russian Avant-Garde Art. The George Costakis Collection, New York, 1981

N. Fiodorov, *Sochineniya* [*Works*], Moscow, 1982

M. Grigar, "Pavel Filonov i voprosy izucheniya avangardnogo iskusstva" ["Pavel Filonov and the Problems of the Study of Avant-Garde Art"], *Russian Literature*, XI–XII, April 1, 1982, Amsterdam

E. Kovtun, "Les 'mots en Liberté' de Marinetti et la 'transmentalité' (zaoum) des futuristes russes," *Presence de Marinetti*, Lausanne, 1982

N. Misler, "Pavel Nikolayevich Filonov — slovo i znak. Po sledam arkhivnykh materialov" ["Pavel Nikolayevich Filonov: the Word and the Sign. After the Traces of the Archive Materials"], *Russian Literature*, vols. XI–XII, April 1, 1982, Amsterdam

Pavel Filonov: A Hero and His Fate. Translated, Edited and Annotated by Nicoletta Misler and John Bowlt, Austin, 1983

P. Florensky, *Sobraniye sochineniy v 6 t, t. 1: Stat'i po iskusstvu* [*Collected Works in 6 vols, vol. 1: Essays on Art*], Paris, 1985

Yury Alexeyevich Vasnetsov: Katalog vystavki [*Yury Alexeyevich Vasnetsov: Exhibition Catalog*], Moscow, 1985

J. Bowlt, *Pavel Andreevich Mansurov (1896–1988)*, Milan, 1987

Ye. Kovtun, "Vstupitelnaya stat'a," in *V. I. Kozlinsky: Sovremenny Peterburg* ["Introduction," in *V. I. Kozlinsky: Contemporary Petersburg*], Leningrad, 1987

E. Guro, *Selected Prose and Poetry*, Stockholm, 1988

Ye. Kovtun, "Dvadtsatiye gody Kurdova," in *Valentin Ivanovich Kurdov. Katalog vystavki* ["Kurdov in the 1920s," in *Valentin Ivanovich Kurdov: Exhibition Catalog*], Moscow, 1988

Ye. Kovtun, "Malevich o teorii pribavochnogo elementa v zhivopisi," *Decorativnoye iskusstvo SSSR* ["Malevich on the Theory of the Surplus Element in Painting," *Decorative Arts of the USSR*], 1988, No. 11

Ye. Kovtun, "Ochevidets nezrimogo: O tvorchestve Pavla Filonova," *Iskusstvo* ["A Witness to the Invisible: On the Work of Pavel Filonov," *Art*], 1988, No. 8

Ye. Kovtun, *Pavel Filonov: Katalog vystavki* [*Pavel Filonov: Exhibition Catalog*], Leningrad, 1988

Ye. Kovtun, "Puti russkogo avangarda," in *Sovietskoye iskusstvo 20–30kh godov* ["The Roads of the Russian Avant-Garde," in *Soviet Art of the 1920s–1930s*], Leningrad, 1988

Russian Art of the Avant-Garde. Theory and Criticism. 1902–1934. Edited and Translated by John E. Bowlt, London, 1988

N. Adaskina, D. Sarabianov, *Liubov Popova*, Paris, 1989

Ye. Kovtun, "Filonov i Khlebnikov," *Volga* ["Filonov and Khlebnikov," *The Volga*], 1989, No. 8

Ye. Kovtun, "Plastichesky mir Sterligova," *Detskaya literatura* ["The Plastic World of Sterligov," *Children's Literature*], 1989, No. 2

Ye. Kovtun, "Vera Yermolayeva," *Tvorchestvo* [*Creativity*], 1989, No. 6

Ye. Kovtun, "Zhiviye istoki (O leningradskikh khudozhestvennykh traditsiyakh)", *Iskusstvo Leningrada* ["Living Sources (On the Leningrad Artistic Traditions)," *The Art of Leningrad*], 1989, No. 2

J.-Cl. Marcadé, *Le Futurisme russe*, Paris, 1989

A. Povelikhina, "SPB., Pesochnaya, 10," *Nashe naslediye* ["St. Petersburg, 10 Pesochnaya St.," *Our Heritage*], 1989, No. 11

A. Strigalev, "'Krestyanskoye,' 'gorodskoye' i 'vselenskoye' u Malevicha," *Tvorchestvo* ["'Peasant,' 'Urban,' and 'Universal' in the Work of Malevich," *Creativity*], 1989, No. 4

Khudozhniki Russkogo teatra. 1880–1930. Sobraniye Nikity i Niny Lobanovykh- Rostovskikh [*Artists of the Russian Theatre: 1890–1930. The Collection of Nikita and Nina Lobanov-Rostovsky*], Text by John Bowlt, Moscow, 1990

E. Kovtoun, "L'Organique contre le Mecanique," *Connaissance des Arts*, 1990, No. 456

Lazar Markovich Lisitsky. Vystavka proizvedeniy k stoletiyu so dnia rozhdeniya [*Lazar Markovich Lissitzky. An Exhibition of His Works Devoted to the Centenary of His Birth*], Eindhoven, 1990

N. Misler, J. Bowlt, *Filonov: Analiticheskoye iskusstvo* [*Filonov: Analytical Art*], Moscow, 1990

L. S. Popova. 1889–1924: Katalog. Vystavka proizvedeniy k 100-letiyu so dnia rozhdeniya [*L. S. Popova. 1889–1924: Catalog. Exhibition of her Works Dedicated to the Centenary of Her Birth*], Moscow, 1990

Pavel Filonov i yego shkola: Katalog [*Pavel Filonov and His School: Catalog*], Cologne, 1990

G. G. Pospelov, *"Bubnovyi valet": Promitif i gorodskoi fol'klor v moskovskoi zhivopisi* [*The Jack of Diamonds: The Primitive and Urban Folklore in Moscow Painting of the 1910s*], Moscow, 1990

Roman Matveyevich Semashkevich: K 90-letiyu so dnia rozhdeniya. Sbornik materialov. Katalog vystavki [*Roman Matveyevich Semashkevich: To the 90th Birthday: A Collection of Materials. Exhibition Catalog*], Moscow, 1990

Russische Avantgarde 1910–1930 aus sowjetischen und deutschen Sammlungen. Wilhelm-Lehmbruch-Museum, Duisburg, Stadt Duisburg, 1990

Alexander Rodchenko. Varvara Stepanova: "Budushcheye — yedinstvennaya nasha tsel" [*Alexander Rodchenko. Varvara Stepanova: "The Future Is Our Only Aim…"*], Munich, 1991

I. Arskaya, T. Liuboslavskaya, "Postanovka V. Ye. Tatlinym sverkhpovesti Velimira Khlebnikova Zangezi (1923)," in *Sovetskaya grafika: Sbornik nauchnykh trudov* ["The Staging of Velimir Khlebnikov's Transstory Zangezi by V. Ye. Tatlin in 1923," in *Soviet Graphic Art: A Collection of Research Works*, Leningrad, 1991

D. Bernstein, "Punin i Tatlin: K estetike kontrre-lyefa," *Tvorchestvo* ["Punin and Tatlin: To the Aesthetics of the Counter-Relief," *Creativity*], 1991, No. 4

Chteniya Matveya: Sbornik dokladov i materialov po istorii latyshskogo avangarda [*The Conference Dedicated to Matvei: A Collection of Papers and Materials on the History of the Latvian Avant-Garde*], Riga, 1991

El Lisitsky (1890–1941): Sbornik k vystavke v zalakh Gosudarstvennoi Tretyakovskoi galerei [*El Lissitzky (1890–1941): A Collection of Essays Published in Connection with His Exhibition in the State Tretyakov Gallery*], Moscow, 1991

Matjuschin und die Leningrader Avantgarde. Ausstellung, Stuttgart–Munich, 1991

A. Parnis, "Khlebnikov i Malevich — khudozhniki-izobretateli. K istorii vzaimotnosheniy," *Tvorchestvo* ["Khlebnikov and Malevich : Artists — Inventors. To the History of Their Interrelations," *Creativity*] , 1991, No. 7

A. Povelikhina, Ye. Kovtun, *Russian Painted Signboards and the Avant-Garde Artists*, Leningrad, 1991

M. P. Lazarev, *David Shterenberg: Khudozhnik i vremia. Put' khudozhnika* [*David Sterenberg: The Artist and the Time. The Artist's Path*], Moscow, 1992

Nikolai Andreyevich Tyrsa: Zhivopis', grafika, khudozhestvennoye steklo: Katalog vystavki [*Nikolai Andreyevich Tyrsa: Painting, Graphic Art, Artistic Glass: Exhibition Catalog*], St. Petersburg, 1992

Ol'ga Rozanova. 1886–1918: Katalog [*Olga Rozanova. 1886–1918: Catalog*], Helsinki, 1992

A. D. Sarabyanov, *Neizvestnyi russkiy avangard v muzeyakh i chastnykh sobraniyakh* [*The Unknown Russian Avant-Garde in Museums and Private Collections*], Moscow, 1992

"Antonina Fiodorovna Safronova (1892–1966): K 100-letiyu so dnia rozhdeniya:Vystavka proizvedeniy. Katalog," in *Iz literaturnogo naslediya: Vospominaniya o khudozhnike* ["Antonina Fiodorovna Safronova (1892–1966): To the Centenary of the Artist's Birth: An Exhibition of Works. Catalog," in *From the Literary Heritage. Recollections of the Artist*], Moscow, 1993

Avangard i yego russkiye istochniki [*The Avant-Garde and Its Russian Sources*], Baden-Baden, 1993

Iskusstvo avangarda: yazyk mirovogo obshcheniya. Materialy mezhdunarodnoi konferentsii 10–11 dekabria 1922g. [*Tha Art of the Avant-Garde: The Idiom of the World Communication. Materials of the International Conference, December 10–11, 1992*], Ufa, 1993

Iwan Puni. 1892–1956, [Cologne], 1993

Kazimir Malevitch. Pavel Filonow. Galerie Gerard Piltzer, [Cologne], 1993

G. F. Kovalenko, *Alexandra Exter: Put' khudozhnika. Khudozhnik i vremia* [*Alexanra Exter: The Artist's Path. The Artist and the Time*], Moscow, 1993

S. Kuskov, "Vopros o prinadlezhnosti Filonova k expressionisticheskoi traditsii," *Kommentarii No. 2*, ["The Question of Filonov's Links with the Expressionist Tradition," *Commentary No. 2*], Moscow, 1993

Alexander Ochertiansky, Gerald Yanchek, Vadim Kreid, Zabytyi avangard. Rossiya. Pervaya tret' XX stoletiya: Sbornik spravochnykh i teoreticheskikh materialov [*The Forgotten Avant-Garde. Russia; First Third of the 20th Century: A Collection of Reference and Theoretical Materials*], New York–St. Petersburg, 1993

Velikaya utopiya: Russkiy i sovetskiy avangard. 1915–1932 [*The Great Utopia: The Russian and Soviet Avant-Garde. 1915–32*], Bern–Moscow, 1993

Vladimir Tatlin: Retrospektiva [*Vladimir Tatlin: A Retrospective*], Cologne, 1993

Voprosy iskusstvoznaniya [*The Questions of Art Studies*], Moscow, 1993, No. 1

A series of publications: Issue 1: *Zhivskul'ptarkh: 1919–1920* [*The Painting, Sculpture and Architecture Group: 1919–20*], Issue 2: *Obmas. Vkhutemas*; Issue 3: *Inkhuk i ranniy konstruktivizm* [*INKhUK and Early Constructivism*]; Issue 4: *ASNOVA, OSA i gruppa Inkhuka* [*The ASNOVA, OSA and INKhUK Groups*], Moscow, 1993–94

D. Burliuk, *Fragmenty iz vospominaniy futurista. Pis'ma. Stikhotvoreniya* [*Fragments from a Futurist's Reminiscences. Letters. Poems*], St. Petersburg, 1994

Europa, Europa. Das Jahrhundert der Avantgarde in Mittel- und Osteuropa, vol. 1–4, Bonn, 1994

Nikolai Kulbin,"Poisk,"in *Apollon: Literaturno-khudozhestvennyi al'manakh* ["A Search," in *Apollon: Literary and Artistic Almanac*], vol. 1, book 1, St. Petersburg, 1994

N. Nesmelov, *Valida Delakroa: Zhivopis', akvarel', risunok: Katalog* [*Valida Delacroix: Paintings, Watercolors and Drawings: Catalog*], St. Petersburg, 1994

D. V. Sarabyanov, N. B. Avtonomova, *Vasily Kandinsky: Put' khudozhnika. Khudozhnik i vremia* [*Wassily Kandinsky: The Artist's Path. The Artist and the Time*], Moscow, 1994

N. Udaltsova, *Zhizn' russkoi kubistki: Dnevniki, statyi, vospominaniya* [*The Life of a Russian Cubist Painter. Diaries, Articles and Reminiscences*], Moscow, 1994

Varvara Stepanova."Chelovek ne mozhet zhit' bez chuda": Pis'ma. Poeticheskiye opyty. Zapiski khudozhnitsy [*Varvara Stepanova."One Cannot Live Without Miracles": Letters. Poetic Essays. The Artist's Notes*], Moscow, 1994

Vladimir Vasilyevich Lebedev: Zhivopis', grafika 1920–1930-kh iz kollektsii Russkogo muzeya [*Vladimir Vasilyevich Lebedev:Paintings and Graphic Works of the 1920s and 1930s from the Collection of the Russian Museum*], St. Petersburg, 1994

Voprosy Iskusstvoznaniya [*The Questions of Art Studies*], Moscow, 1994, No. 1

David Burliuk. 1882–1967: Vystavka proizvedeniy iz Gosudarstvennogo Russkogo muzeya, muzeyev i chastnykh kollektsiy Rossii, SSHA, Germanii [*David Burliuk. 1882–1967. An Exhibition of Works from the Russian Museum and Museums and Private Collections of Russia, the USA and Germany*], St. Petersburg, 1995

J.-F. Jacquard, *Daniil Kharms i konets russkogo avangarda* [*Daniil Kharms and the End of the Russian Avant-Garde*], St. Petersburg, 1995

K. Malevich, *Sobraniye sochineniy v 5 tomakh*, t. 1: *Stat'i, manifesty, teoreticheskiye sochineniya i drugiye raboty. 1913–1929* [*Collected Works, in 5 vols, vol. 1: Articles, Manifestos, Theoretical and Other Works: 1913–29*], Moscow, 1995

Pavel Mansurov. Petrogradskiy avangard [*Pavel Mansurov: The Petrograd Avant-Garde*], St. Petersburg, 1995

LIST OF ABBREVIATIONS

AKhRR, AKhR
The Association of Artists of Revolutionary Russia (from 1928, the Association of Revolutionary Artists)

GINKhUK
The State Institute of Artistic Culture, Petrograd/Leningrad

INKhUK
The Institute of Artistic Culture, Moscow

IZO
The Department of the Fine Arts of Narkompros (People's Commissariat for Education)

NARKOMPROS
The People's Commissariat for Education

PORCELAIN FACTORY
The Imperial Porcelain Factory, St. Petersburg/ Petrograd (until 1917); the State Porcelain Factory, Petrograd/Leningrad (1917–25); the Lomonosov Porcelain Factory (from 1925), Leningrad/ St. Petersburg

PUSHKIN HOUSE
Common name of the Institute of Russian Literature, Russian Academy of Sciences, St. Petersburg

ROSTA
The Russian Telegraph Agency, known mainly for its propaganda posters known as the ROSTA Windows

REPIN INSTITUTE
The Institute of Proletarian Fine Arts, Leningrad (1930–32); Institute of Painting, Sculpture, and Architecture of the USSR Academy of Art (1933–44); the Repin Institute of the USSR Academy of Arts (1944–91); the Repin Institute of the Russian Academy of Arts (from 1991)

STROGANOV SCHOOL
The Stroganov School of Art and Industrial Design, Moscow; the Stroganov Higher School of Art and Industrial Design (from 1945)

SURIKOV INSTITUTE
The Moscow Institute of Fine Arts (1936–39); the Moscow Art Institute (1939–47); the Moscow Art Institute, USSR Academy of Sciences (1947–48); the Surikov Art Institute, USSR Academy of Arts (1948–91); the Surikov Art Institute, Russian Academy of Arts (from 1991)

UNOVIS
The Affirmers of New Art society, Vitebsk

VKhUTEMAS
The Higher Artistic and Technical Studios (1921–26 in Moscow; 1921–22 in Petrograd)

VKhUTEIN
The Higher State Technical Institute (1926–36 in Moscow; 1922–30 in Petrograd/Leningrad)

РУССКИЙ АВАНГАРД 1920-х–1930-х годов

Альбом на английском языке

Издательство «Аврора». Санкт-Петербург. 1996
ЛР № 010131 от 27. 11. 91. Изд. № 2108

Printed and bound in Italy